T0138366

Birth Figures

Birth Figures

EARLY MODERN PRINTS AND
THE PREGNANT BODY

Rebecca Whiteley

The University of Chicago Press　CHICAGO AND LONDON

Publication of this book has been aided by a grant from the
Millard Meiss Publication Fund of CAA.

The University of Chicago Press, Chicago 60637
The University of Chicago Press, Ltd., London
© 2023 by The University of Chicago
Published 2023
Printed in the United States of America

32 31 30 29 28 27 26 25 24 23 1 2 3 4 5

ISBN-13: 978-0-226-82312-6 (cloth)
ISBN-13: 978-0-226-82313-3 (e-book)
DOI: https://doi.org/10.7208/chicago/9780226823133.001.0001

Library of Congress Cataloging-in-Publication Data
Names: Whiteley, Rebecca, author.
Title: Birth figures : early modern prints and the pregnant body /
 Rebecca Whiteley.
Description: Chicago ; London : The University of Chicago Press, 2023. |
 Includes bibliographical references and index.
Identifiers: LCCN 2022018102 | ISBN 9780226823126 (cloth) |
 ISBN 9780226823133 (ebook)
Subjects: LCSH: Obstetrics—Europe, Western—History. | Midwifery—
 Europe, Western—History. | Childbirth in art. | Pregnancy in art. | Fetus
 in art. | Medical illustration—History. | Illustration of books—Europe,
 Western—16th century. | Illustration of books—Europe, Western—
 17th century. | Illustration of books—Europe, Western—18th century.
 | Medicine and art—Europe, Western—History. | BISAC: SCIENCE /
 History | ART / Subjects & Themes / Human Figure
Classification: LCC RG518.E85 W45 2023 | DDC 618.20094—dc23/
 eng/20220608
LC record available at https://lccn.loc.gov/2022018102

Contents

Color plates follow page 136.

Illustrations

Plates

A Note on Terminology

This book treats the culture of pregnancy, midwifery, and childbirth in the early modern period. Where possible, I have endeavored to use contemporary terminology, paying particular attention to the words used in the midwifery manuals that are my primary source. For instance, I use "womb" rather than "uterus," except in cases where I am discussing particularly medicalized and elite forms of knowledge. In some cases, however, choosing which term to use is tricky. For example, I generally use the term "fetus." While this word was used in midwifery manuals, and with increasing frequency over the period discussed, "child" remained more common. However, "child" is a very broad term and might lead to confusion among readers who would not readily associate it with images of the unborn. Using a term that is specific to the unborn has been practically essential in some parts of this book, for example where I compare representations of the fetus with those of children of different ages.

All historians must make such judgment calls on the balance between clarity and the use of historically accurate terminology. It would not normally require a special note, but in the final stages of editing this book, I found that some of my choices were raising questions with contemporary political relevance that I felt needed addressing. First, I considered using the term "pregnant person" rather than "pregnant woman" because, of course, not all people who are pregnant are women. However, the modern notion of gender and its difference from biological sex postdate the period under discussion in this book. Early moderns had their own complex epistemologies linking gender, sex, and bodies. By using "pregnant woman" I follow the terminology in early modern midwifery manuals, but I do not imply that there was, in this period, any simple link between having a uterus and being, socially and culturally, a woman. In the discussion of twenty-first-century culture in the conclusion of this book, I use the term "pregnant person."

Second, I considered using "they/them" when referring to images of the fetus where the sex is not clear. This was driven by my desire to normalize use of the singular "they," something I think is correct practice for academic writing where the gender of an individual is not known, as well as where the individual identifies their pronouns as "they/them." However, in early modern midwifery manuals the convention was to use "it" to refer to the fetus, and as this is relevant to contemporary thinking around personhood, individuality, and fetal life, I felt it was best to use this term. Again, when I write about twenty-first-century culture, I use "they/them." This choice is in no way a statement about fetal personhood in relation to abortion debates. Indeed, as this work is largely focused on images of full-term fetuses and processes of childbirth, rather than early pregnancy and fetal development, debates, both early modern and contemporary, around when a fetus becomes an individual with rights that might conflict with those of the pregnant person are not central to my discussion.

Birth Figures

Rosegarten

So sol die hebam grossen fleiß ankeren/ dz kind sein hend vndersich bringen vnd schybe/ Vnnd wo es möglich wer sol die hebam in gleicher weiß als obstat/ das kind vmb/ wenden/vnd im mit dem haupt zü vßgang helffen. Wo aber das auch nit möglich wer/ so sol sie das entpfahe by den füssen/ vnd die arm vnd hend vndersich wysen nebe den seite hynaß/vnd also vor stat helffen/ Vnd ob diser zweier weg keiner sieglich wer/hindernüß halb/so sol die hebam beid füßlin des kindes zü samen binden mit einer lynen binden/vnd darnach mit senfftem ziehen dem kind zü vßgang helffe/ Vn diß ist die aller sorgklichst geburt.

℥ Wo aber das kind zum ersten kem mit einem füß al/ lein/ So soll man die müter do an rucken legen/ die bein vbersich/ dz haupt vndersich vnd den hindern wol erheben Vn sol die hebam mit ir häd des kindes füß wider hinder/ sich sentfftikliche schybe/ Vn sol die müter sich zum dicker male vmbschybe vnd waltze/ so lang biß dz kind sein haupt vndersich gekeret/zü dem vß/ gäg/ darnach soll die müter widerumb sitzen vff iren stül vn sol ir die hebam wid helf/ fen als obstat.

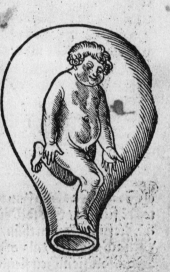

FIGURE 1: Martin Caldenbach (draftsman), [Birth Figure], woodcut, 19 x 12 cm (page). From Eucharius Rösslin, *Der Swangern Frawen und Hebammen Roszengarten* (Hagenau: Heinrich Gran, 1515). Medical (Pre-1701) Printed Collection 2054, University of Manchester Library, Manchester. Copyright of the University of Manchester.

Introduction

This is a birth figure (figure 1): it shows two nested bodies, the pregnant and the gestated. It is an image of something that, to the early modern viewer, was not just invisible but saturated with secrecy, mystery, and power. It shows the hidden world of the bodily interior, the secrets of life before birth, and the unfathomable powers—both human and divine—of generation. The first birth figure to be printed, this illustration for Eucharius Rösslin's 1513 midwifery manual, *Der Swangern Frawen und Hebammen Roszengarten* (The Pregnant Women's and Midwives' Rose Garden) contributed to a project that had already been ongoing for centuries, of exploring, defining, controlling, and making safe the pregnant body.[1]

In the early modern period, the womb was an organ that had secrets and kept them well. It was the seat of generation, a notoriously unpredictable and uncontrollable process, and it was understood to be the cause of many of the diseases and illnesses that afflicted women.[2] It was capricious, too, wandering around the body, throwing things out of balance, leaking or retaining humoral fluids, conceiving not just children but windy matters, molas, and monsters.[3] It was the symbol of the "leaky" female body, undeniable proof of women's physical inferiority,[4] and productive of menstrual blood that, while necessary to the maintenance of humoral balance, was itself polluting and dangerous.[5] Despite all this, it was the place ordained by God for the creation, nourishing, and ensouling of every single human being. Women, with their leaky, inferior, uncontrollable, sinister bodies had also been gifted the privilege of generation and gestation. Thus, while pregnancy and birth were uncertain and physically dangerous processes, they also endowed women with importance and power. Regardless of who you asked, or what frameworks of knowledge you employed, the womb was trouble, and it was potential. Necessary for the perpetuation of humanity, it was a destabilizing element in many spheres of early modern

culture, from medicine and anatomy to family structures and processes of inheritance to politics and religion.[6]

Birth figures, therefore, were images of a subject of great importance, but they were also agents in constructing and negotiating the nature of that importance. In the birth figure we began with, the womb is represented simply and schematically, as a transparent, flask-shaped container. In rendering the organ exposed, and see-through, the image promises knowledge of the mysterious body, a peek into the still-living interior. The fetus is represented as a cherubic toddler, with curly hair, big eyes, chubby cheeks, and a self-conscious expression. With hands and feet neatly placed and head slightly inclined toward us, he seems to acknowledge our presence, our looking at what, by rights, shouldn't be seen. The image might be understood as an attempt to make known the mysterious generative womb; certainly it formed part of a text that had the aim of spreading knowledge about the body and regulating midwifery practice. But the simplicity of the composition—the human figure encircled—gives it the capacity to *mean* in many ways. It points to the universal importance of generation to early modern culture, drawing a link between the fetus *in utero* and the human in the world, and it neatly encapsulates the origins of human life. From this starting point, the birth figure as an iconographic form could be read for significance within a multitude of different spheres of culture and knowledge: anatomy, alchemy, mechanical physiology, medical professionalism, prayer, magic, midwifery practice, haptic knowledge, and portraiture, to name a few addressed in this book.

Birth Figures explores the vast array of ways in which these images were produced to make knowledge and the divergent ways in which they were subsequently interpreted and used by different kinds of viewer. We will be ranging widely when it comes to viewers and their interpretations, but to begin with, we must establish what Rösslin, and the midwifery authors who came after him, declared birth figures to be for. The first piece of evidence for the primary "purpose" of the birth figure is that it comes in sets (figure 2), arrays of disembodied wombs each containing a fetus or fetuses in different positions, because together they describe the different possibilities of fetal presentation.

The period covered in this book saw both change and continuity in how birth figures represented the body. Where authors and artists changed birth figures, they always did so with a strong awareness of the established conventions. The array of figures, for instance, stood at around sixteen in number, depicting a standardized set of presentations in an established order: from headfirst or cephalic, through breech and feet first, to various combinations of other limbs, shoulders, and bellies, with twins last. While,

particularly from the late seventeenth century, some authors began to experiment with what their birth figures represented and increased the number produced, the same standard order was maintained, with presentations moving from more to less common, and less to more dangerous and difficult to deliver. This makes the birth figure an important example in the visual history of copying: both the direct lifting of images and the chains of adoption and adaption that are at work in the production of any image type. This study follows Nick Hopwood's work tracing the many lives of Ernst Haeckel's embryological images, in showing "how copying, the epitome of the unoriginal, has been creative, contested, and consequential."[7]

The trails of productive copying that make up the history of the birth figure began well before the early modern period and continue today, pointing to the equally lasting importance of understanding fetal presentation. However, it was arguably in the period covered in this book that birth figures were culturally most crucial: when print technologies had increased their presence, but before visualizing technologies and effective surgical interventions had rendered presentation less mysterious and less problematic. These images, first and foremost, proposed to explain and categorize fetal presentation, in order to help midwives and surgeons identify and ameliorate problems. In the early modern period, fetal presentation was a matter of life and death for both mother and infant, as a bad presentation and an obstructed birth could lead either to the removal of the fetus surgically in pieces, or to the death of both mother and infant, undelivered. Birth figures, therefore, were infused with crucial medical knowledge, but also with deep social and emotional significance for the early modern viewer.

The birth figure we began with was produced in 1513 in Germany and is the first printed example. The image-form, however, predates the invention of print in the West by roughly a thousand years. The earliest known birth figures were produced to illustrate copies of a Latin translation of Soranus's *Gynaecology* by a North African writer of the fifth or sixth century called Muscio. They abounded in medieval manuscripts on surgery, gynecology, and the "secrets of women" (figure 3). From the early sixteenth century in Europe they entered print culture and formed a core part of a new genre of book: the vernacular midwifery manual. They contributed to the great social and medical changes that surrounded childbirth in the early modern period, and they survived the medicalization and masculinization of midwifery that reached its peak in the nineteenth century. Birth figures still form part of the visual culture of pregnancy and midwifery for professionals and laypeople today.

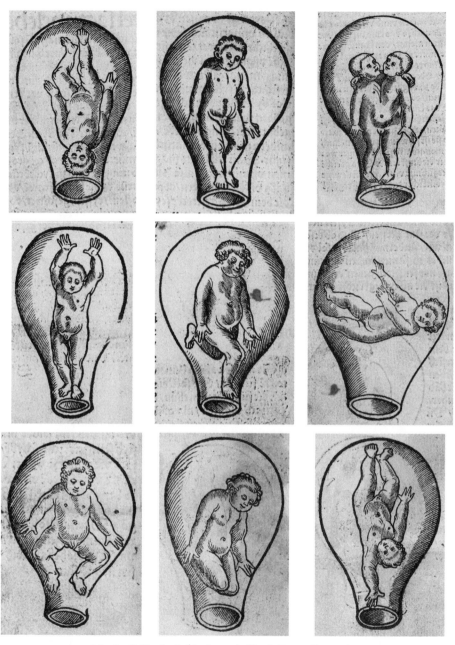

FIGURE 2: Martin Caldenbach (draftsman), [Birth Figures], woodcut, 19 x 12 cm (page). From Eucharius Rösslin, *Der Swangern Frawen und Hebammen Roszengarten* (Hagenau: Heinrich Gran, 1515). Medical (Pre-1701) Printed Collection 2054, University of Manchester Library, Manchester. Copyright of the University of Manchester.

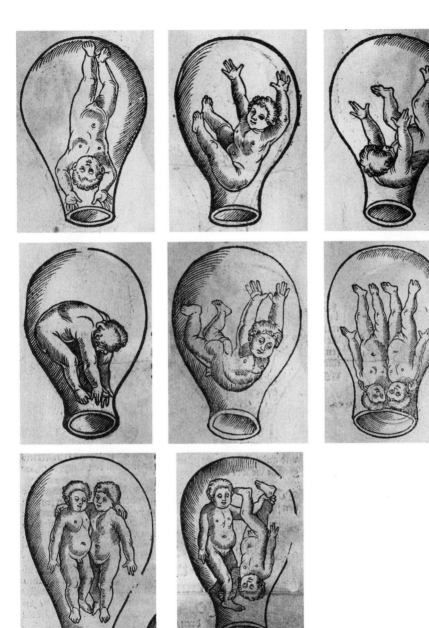

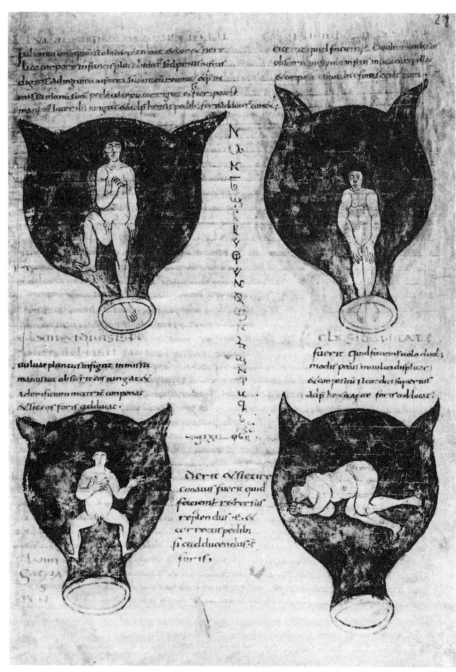

FIGURE 3: Anon., [Birth Figures], ink on parchment, 28.2 x 19.3 cm (page). From Soranus, *Gynaecia* (n.d.). Brussels MS 3714, Bibliothèque Royale de Belgique, Brussels.

That this image-form is so long-lived is not to say, however, that it describes any simple biological truths, that it has provided the same information over time, or that it contributed to linear "developments" in midwifery and medicine. Rather, it is an image-form that has been employed to explore and express constantly changing cultures. In the medieval period, as Monica Green has argued, birth figures helped to establish midwifery as within the purview of the learned male physician.[8] Even though women attended the vast majority of labors throughout the period, the manuscript texts on midwifery were largely restricted to an elite male readership, and birth figures were part of that specific culture.[9] When Rösslin published his manual in 1513, it both was and wasn't different from these earlier manuscripts. The text, for instance, was largely cribbed from existing manuscripts, and the birth figures were also copies of existing illustrations.[10] Rösslin, like many of the gynecological writers who came before him, was a male physician with little direct experience of midwifery. As the physician of the city of Worms, he had the responsibility of examining and licensing the city's midwives, but he did not himself deliver women. He worked within a system of rhetorical medical authority that disempowered women midwives within the medical hierarchy but had minimal power within the lying-in chamber itself.

But his book was also different from the manuscripts from which it borrowed: it was, at least ostensibly, written for women midwives to read. In print, it was also available in many more copies, and at cheaper prices, than previous texts. Written first in German, and then translated into other European vernaculars as well as Latin, it was accessible to readers outside of the Latin-literate elite.[11] As is discussed further in chapter 1, there has been much debate about how many women midwives actually read these midwifery manuals, and how they would have understood and employed the information they contained. But the sheer number of such manuals and birth figures published and available throughout Europe by the seventeenth century points to a widespread interest in issues of generation, pregnancy, and childbirth, and to some level of democratization of knowledge on the topic. These books and their illustrations ushered in a change in which women, both professional and lay, came to engage with textual and visual cultures of knowledge. As readers and occasionally as authors, women became increasingly conversant with printed medical and anatomical knowledge in the early modern period and came to use birth figures for their own personal and professional ends. Birth figures, while not present in every midwifery manual, were present in most that were illustrated as well as some surgical books and loose-leaf prints.[12] They came to have such a wide dissemination that they simply must have informed

how women—midwives and lay—understood and practiced upon the pregnant and laboring body. They worked practically for midwives in dealing with malpresentation and in building for themselves a professional identity. But they also worked in other ways, speaking about the bodily condition of pregnancy and the social and cultural significance of generation, as well as having real power to protect the body in childbirth.

The now-conventional history of midwifery in the early modern period, as set out by feminist historians from the 1970s onward, challenged earlier narratives in which women midwives were cast as superstitious, ineffective, recalcitrant, even as witches. Doing excellent and necessary work in pushing back against these overtly misogynistic histories of women's work, feminist historians described a destruction of the private, powerful all-female authority of the lying-in chamber by male medical practitioners.[13] Midwifery manuals hold a significant place in this narrative as both providing authority to medical practitioners and normalizing that authority for a wider public. However, as more recent scholarship has shown, the story is not so simple.[14] Monica Green has shown that male medical authority over women's bodies, even in childbirth, had been cemented well before the advent of print.[15] And the narrative of gendered war between male physicians and female midwives has more recently been nuanced.[16] While men certainly did slowly encroach upon midwifery, women midwives never really stopped delivering the majority of women, and their authority, while it was often textually questioned, retained a strong social currency.[17] Moreover, evidence suggests that men and women worked together and learned from each other, that fractious antagonism was counterbalanced by cooperation and knowledge-sharing. While gender remains a crucial fulcrum on which the story of midwifery turns, it is by no means the only one: literacy, wealth, geography, training, experience, age, and social standing were all variants that made the world of midwifery a complex spectrum, rather than a binary battle between traditional female and medical male.[18] Midwifery manuals and birth figures were indeed sometimes used to exert masculine authority over women's knowledge and practice, but the same books were *also* used by women themselves to gain knowledge and authority, to empower their practice and to adapt or subvert male medical narratives about their bodies. Birth figures particularly, because they could be interpreted in many different ways, are important resources in recovering the specific experiences and knowledges of early modern women.

In part, *Birth Figures* tells the history of the birth figure's production and proliferation, the chains of copying and adaption that led the image-form to change over time, and the ways in which birth figures both facili-

tated and reflected changes to midwifery practice in the period. A new perspective can thus be gained on histories of women's knowledge and women's work in the early modern period, as well as on their interactions with printed knowledge and male spheres of professional medical practice. But this book is also about what images can tell us about early modern culture much more broadly. Seen and used by many kinds of people, birth figures had multiple agencies and spoke about how people interacted with printed images; how they thought about their bodies; how they understood and exerted control over conception, pregnancy, and the building of a family; how they lived in communities; and their relationships with medical professionals. Accessible to a range of people from the learned to the illiterate, birth figures were a form of knowledge that responded to different kinds of needs: the physician's need to define the female body; the midwife's need to establish why a particular labor was obstructed; the author's need to fashion their own professional persona; the pregnant woman's need to understand and assume control over her own body.

While the history of the birth figure is long, this study focuses on the period in which it had the greatest influence over cultures of midwifery and childbirth. Taking two important books as temporal boundaries, this study focuses on the period between the publication of an English translation of Rösslin's manual in 1540 and that of William Hunter's *Anatomy of the Human Gravid Uterus* in 1774.[19] Rösslin's book brought the birth figure into print culture, and Hunter's contributed to radical changes in midwifery as a medical profession and as a visual culture. My focus is primarily on the English context for birth figures, which presents an interesting case study: over the roughly 250 years treated, England went from importing all of its midwifery literature from the European continent to leading the way in midwifery publications. This book shows, therefore, how we can work with print culture that is often seen by medical histories as "derivative" and "outdated," as well as with culture that was "cutting-edge" and "innovative." European cultural interactions with printed images were various and creative, both across time and across social spectra. While the cultures of midwifery practice and understandings of the pregnant body were different in each country, indeed in each region, this period was also one in which knowledge was becoming more homogenized by the international circulation of print. Texts were exported and translated, and images were even more widely disseminated, through export and through practices of copying and adaption. Birth figures can be found in the print cultures of all Western European countries; indeed, mostly it was the *same* images that were found in all these cultures. I propose a way of looking at print culture that recognizes but is not bound by geographic borders, that

acknowledges the role of print in producing a European culture of medical knowledge. Practices of knowledge sharing and image production in this period were borderless, drawing on an international print culture, and simultaneously intensely local. This work, therefore, proposes to be both a specific history of the birth figure in England, and also a broader history of the agency of images as they circulated over geographic and cultural borders. Those looking at midwifery in other European countries, and indeed in other parts of the world, will be familiar with many of the images discussed here and will see both similarities and differences, shared and distinct cultures, in how they were used and understood. I hope this book will work as a resource and a starting point for scholars working with birth figures in other places and periods, as well as those studying early modern England.

This book takes a roughly chronological trajectory, in three parts dealing with the periods 1540–1672, 1672–1751, and 1751–1774. Each of these periods is bounded by the publication of books crucial to the history of birth figures in England, though the dates are intended neither to be hard boundaries, nor to indicate a narrative of linear medical or visual "progress." I am interested not in the ways in which knowledge of the body or the practice of midwifery "improved," but in how its cultures changed. Indeed, most historians of medicine would agree that medicalization had no direct or simple correlation with improved outcomes or improved experiences of childbirth in this period. My analysis in each part looks both forward and backward, as well as around, at multiple cultures of image interpretation and use that coexisted, even where they were contradictory, and that lasted longer or emerged earlier than teleological histories of invention and progress might suggest. This book traces no march toward modern, "correct" biological knowledge of the body, but rather looks away from such paths, at the wider landscape that Lorraine Daston and Peter Galison, in their germinal *Objectivity*, call the "repertoire of possible forms of knowing."[20]

There is such a lot to say about birth figures, partly because they are images that require us to think about different cultural contexts. Present in books that were read by a diverse array of people, these images challenge the distinctions often placed on print culture between male and female, elite and popular, medical and lay. They are, therefore, a primary resource that requires approaching from multiple methodological standpoints: because they are images, we must employ approaches from art history and visual culture; because they are medical we look to the history of medicine; and because they were used by different kinds of people, we turn to social and gender histories.

From an art-historical perspective, this study is grounded in the methodology of social art history as it was developed from the 1970s.[21] In the broadest terms, this approach involves looking for the social and cultural contexts in which art was produced, used, and understood. Within English-language art history, the work of Michael Baxandall is a key influence on how social art history is practiced today.[22] Baxandall's most well-known methodological proposition is often described as the "period eye" and involves studying as widely as possible the culture in which an artwork was made, in order to assume the visual literacy of a contemporary viewer, to "see" the work as much as possible as the original viewers did.[23] This methodology highlights the fact that the meaning and significance of artworks and images are context-dependent, and that as art historians we need to be aware of our own cultural and visual training when looking at images from another time or place. This approach is now so widespread as to be largely tacit in the discipline, but it is important to recognize here because while Baxandall's own focus is largely on the "fine arts," attention to the interactions between art and its cultural and social context has allowed art history to address a wider array of forms of visual culture, including birth figures. While birth figures do not make fruitful sources for histories of famed artists, specific schools, styles, or techniques, when images are looked at as agents in the formation of culture, birth figures have much to say.

A roughly contemporary movement in various historical disciplines that we might term "body history" has taken a similar approach.[24] Much as art historians argued that art had specific meanings at particular times, so some historians, starting from the 1950s but picking up pace from the 1980s, argued that the body is a cultural construct, rather than a biological constant. Instead of assuming that the body worked and was experienced in the past much as it is today, historians such as Barbara Duden searched for "the reality-generating experience of the body that is unique and specific to a given historical period."[25] This approach allowed medical historians to move away from retrospective diagnoses and narratives of medical discovery and "progress." Instead, the body, both within and beyond medicine, could be understood as specific and unique to its context, as the truth of that period. This methodology would, for instance, explore the contemporary cultural meanings of a womb that moved within the body, or expelled humors, without asking what, in modern medical terms, was "really" going on.[26] This concern at the center of body history was part of a wider shift toward the social in history, and toward the patient in medical history.[27] Particularly since the 1980s, attention to the cultural contexts of both the image and the body has allowed scholars to expand the sources

they use and the stories they tell. In interdisciplinary histories such as this one, these methodologies allow for attention to be paid to the patient rather than the doctor, the experience rather than the explanation of the disease, and the culture rather than the biology of the body.

Birth Figures draws these two methodologies together, approaching birth figures both as artworks in their own right and as resources for histories of the body, medicine, and women's lives. Doing so allows me to address gaps in each discipline. On the one hand, social art history of the early modern period retains a bias toward the prestigious fine arts and the elite, often male cultures that commissioned them. Birth figures give insights into how a much broader swathe of people interacted with images. Body history, on the other hand, has tended to shy away from visual sources, or to use them in uncritical ways to illustrate points derived from textual sources. The developing interdisciplinary fields of material culture and visual culture are changing this, and this book proposes images as a resource that allows us to both enrich and disrupt existing histories of midwifery and women's bodies. Because visual images can be less prescriptive than texts in how they mean, they often address things that are left unsaid in written records or express multiple and ambivalent approaches to a topic. Birth figures, as this book shows, often worked at odds with the texts they illustrated and were interpreted and employed by viewers in many different ways apart from those advised by medical writers.

In this interdisciplinary approach to medical images, this study also contributes to a more recent and still developing interdisciplinary focus on "epistemic images."[28] This focus has drawn together historians of art, science, and medicine to explore how images that have an informational or knowledge-creating purpose can also have broad and diverse significances and cultural contexts. Such images are not simple conduits for knowledge: they interpret and shape knowledge and ideas, they change people's behavior and understandings of the world, and they interact with the wider cultures that produced them. Foundational studies by scholars such as Sachiko Kusukawa, Lorraine Daston and Peter Galison, Susan Dackerman, Horst Bredekamp, and Nick Hopwood have laid out how the study of "epistemic images" can enrich our histories of art, science, and medicine and demonstrate how interlinked they are.[29]

Given the amount of visual material that has been opened up for study by this new methodological approach, there are many images yet to receive attention. The current literature has, for instance, tended to focus on named and famous figures in the history of science and medicine—Andreas Vesalius, John Hunter, Galileo Galilei, Conrad Gessner—and on images that were in some way revolutionary in their representation

and shaping of knowledge. Of course, as work ranging from Melissa Lo's on copies of Vesalius's anatomies to Nick Hopwood's on copies of Ernst Haeckel's embryological series have shown, original and revolutionary images often had long lives in which they were adapted to different contexts, accumulated new meanings, and became "popular" and widespread, available for diverse interpretations by diverse audiences.[30] Yet a bias remains within epistemic image studies generally toward first instances, famous names, and elite reading audiences. However, as is being increasingly emphasized by scholars working on many aspects of print culture, print in the early modern period was everywhere and affected pretty much everyone's lives. In broadside studies, for instance, work in the past decade has, for the first time, turned a serious analytical eye on the significances of woodcut illustrations and the ways in which they could, as accompaniments to text and melody, "render meanings variable, personal, and unstable."[31]

This study draws on these new moves toward interpretation of the anonymous, copied, "popular" printed image, pointing to its significance not just in what is typically thought of as "popular" print—broadsides, ballads, and chapbooks—but in all genres of printed matter. Birth figures were neither radically new, nor associated with any one medical pioneer, but they were accessible to many people, including women and those outside the spheres of the learned elite. In cheap and vernacular books, which became increasingly available over the early modern period, birth figures formed part of a more generalized body knowledge. Instead of telling the story of one invention, discovery, or cultural context, birth figures allow us a glimpse into many small changes in practice, many cultures of midwifery knowledge, and many attitudes toward the pregnant body. *Birth Figures* is a sustained study of an epistemic image-form that examines both different kinds of viewer and the diversity of changes—some successful, some not—that the image underwent over time. This book is an exercise in regarding the radical and the conventional, the new and the old, the female and the male, the prestigious and the everyday in early modern images and demonstrates what we gain by examining them together and as part of a wider cultural whole.

I first embarked on this study of birth figures because the images, of which I was finding increasing numbers, seemed to present a picture of pregnancy and birth that was quite different from the one given by the early modern anatomical images that I was familiar with from art-historical studies. Searching for existing literature on the images, I found that most of the analysis was brief and rather unsatisfying: within medical histories the images were described as anatomically inaccurate and representationally naïve.[32] Within feminist histories of women and childbirth,

it was common to dismiss them as images that enabled male authors to deny the agency of the female body in pregnancy and birth and to establish the assumed-male fetus as the primary patient in labor.[33] In both cases, I felt that these analyses were seeing only part of the picture and perhaps fundamentally misunderstanding the ways in which the images expressed body knowledge. As will be explored further in chapter 1, while both anatomical knowledge and the gender politics of medicine are important in understanding birth figures, they are not the only frameworks within which they speak. Seeing them, for instance, as images of the living body in movement and process, or as images that were employed by women as objects of power, gives a completely different cast to their role in early modern culture.

I felt that the first step in seeing birth figures more completely was to establish them as a distinct and unique kind of image, with their own systems of representation, histories, and contexts. Birth figures are characterized by their representation of the living body in process, their primary focus on fetal presentation, their format showing the living fetus in the disembodied womb,[34] and their presence, always, in sets. They are different, for example, from the anatomical "gravida" figures which show the pregnant uterus in the context of female anatomy, or from the pregnant figures in representations of the Visitation. As such, they require their own name. Historians have not settled on one descriptor for these images; indeed, neither did early modern authors. Lianne McTavish, for instance, calls them "images of the unborn," Lyle Massey "the free-floating uterus," and Monica Green "foetus-in-utero figures."[35] These names, while all descriptive and broadly accurate, show the tendency to elide the birth figure with the anatomical image and to neglect the special focus of the former not just on pregnancy but on birth. Some medical historians have employed more overtly trivializing descriptors, calling them "drawings of adult manikins, masquerading as fetuses 'bottled-up' inside the uterus"; "cartoons"; and "wildly fantastic pictures."[36] These, too, compare birth figures with anatomical images, though here the comparison is expressly unfavorable.

I have chosen to borrow the term "birth figure" from *The Byrth of Mankynde*—the English translation of Rösslin's *Roszengarten* and the first midwifery manual published in England.[37] This term was not consistently used outside of the English editions of Rösslin's manual, but in the absence of an established term, this one both holds a significant place in the image's history in England, and more broadly has a flexibility and receptivity to multiple interpretations that suits these images. A figure, in the early modern period, could refer to an illustration, or it could refer to

the rendering of a person—in this case, it is both. Moreover, figures could refer to positions held by the body in a dance and resonated with the idea of "figuring out" something. Birth figures display the various bodily poses or "figures" of presentation, and they aid in establishing and understanding those presentations. They are figures of figures holding figures that figure out the mysteries of birth. Naming these images, distinguishing them from other kinds of images of the pregnant body, and asserting their cohesiveness across time and space has been the necessary first step in writing their history.

Newly christened, birth figures in this book are studied for the ways they changed over time, but also the ways in which they operated in different cultural contexts simultaneously. Having established what they are *not*— purely anatomical illustrations or simply tools of medical misogyny—in this book I ask what they *are*.

Printed birth figures entered the world of English publishing in 1540 and remained remarkably iconographically cohesive until the late seventeenth century, while also becoming widespread and highly valued as a core part of printed literature on midwifery and surgery. Chapter 1 reassesses the role of these images in early modern midwifery practice and in the wider understanding of the midwife's professional role. Starting from their clear popularity in the late sixteenth and seventeenth centuries, and from the few extant contemporary sources that discuss the images, contextualized by a wider study of midwifery practice and book use, I propose that they triggered a change in how midwives both thought about and treated the laboring body. Birth figures helped midwives to envision the body, and particularly the position of the fetus, in a newly concrete way. Working as a key to malpresentation, birth figures pointed to how a midwife might alter a presentation and physically guide labor. For many midwives not only was this a newly interventionist approach, it fundamentally reformulated midwifery as an active process of aid, rather than a passive attendance on an inherently invisible, mysterious, and uncertain event. Counter to the existing narratives that surround birth figures, I argue that they were agents of change and empowerment for midwives in this period.

But midwives were not the only people looking at and using birth figures. Their widespread popularity in vernacular books indicates their use by people of all kinds, from curious lay readers to learned doctors to pregnant women. For many of these viewers, the images were not primarily ones that provided an anatomically derived and spatially concrete system of body knowledge. Chapter 2 explores birth figures as images at the center of many webs of body knowledge: from humoral to microcosmic systems;

from uroscopy to alchemy; from religion to the maternal imagination. Birth figures, in their iconographic simplicity, offered a flexible, adaptable locus for thinking about the body in many modes, often simultaneously. In this chapter, birth figures are presented as evidence for a pluralistic early modern body culture that is all too often lost in histories of anatomical and medical discovery. This, not least, because birth figures acted not only as representations of body knowledge but as objects of power that through acts of prayer, meditation, and imagination could materially act upon the bodies that looked at them. This chapter privileges the way that lay women might have seen and used birth figures—images that were of them, and often ostensibly for them. Working around the scarcity of written records on how birth figures were used, in this chapter I show how the image, properly situated in its visual and cultural context, can be a historical source in its own right.

From 1672 in England, birth figures began to diversify: the few sets that had been copied and recopied for over a century were joined by a bevy of new creations that were specific to particular authors who, also newly, were also practicing midwives. The second part of this book focuses on these midwife-authors and the birth figures they commissioned. I provide a reassessment of the history of the "rise of man-midwifery" in England and across Western Europe, both establishing the role that visual culture played in medical and social changes, and nuancing the traditional history of acrimonious dispute over practice and profession along gender lines.

Midwife-authors—both men and women—used birth figures to introduce new modes of bodily knowledge and new systems of practice, as well as to further their new ideals of using print to educate and enlighten midwives and a wider reading public. They employed new systems of representation from the field of mechanics, they described the movement of the fetus, bodily changes over time, and the actual physical interventions undertaken by the midwife. In so doing, they contributed to the explosion of how-to books and diagrammatic visual culture in these early years of the Enlightenment. Many modes of knowledge and systems for representing the body that are naturalized within our own culture were first experimented with in this period, and chapter 3 demonstrates the importance of these birth figures as underrecognized but crucial influences on the much better studied images of the mid- to late eighteenth century. I also point to the importance of considering failure in an epistemic image, from the perspective of the commissioning author and the viewer, as a crucial concept for exploring how images and visual conventions change over time.

In part 2, as with part 1, chapter 3 explores how birth figures featured in midwifery practice, while chapter 4 turns to the wider social and cul-

tural life of the birth figure. In this period, these images became a tool for shaping the midwife's professional and public persona. For the first time, midwives were publishing and advertising in the sphere of print, and they were beginning to see themselves as public figures with responsibilities not simply to those local women they might attend, but to national and even international readerships. If the birth figures in these new midwifery manuals taught new practice, they worked just as hard to recast the professional, political, and social identity of the midwife, and did so particularly through visual attention to the complex and fraught issue of touch. While the essential association of midwifery with touch had previously marked it as both a low-status and a feminine profession, in this period midwives rhetorically recast their touch as prestigious, androgynous, enlightening, and lifesaving. They did so not only through text but through the visualization of hands and haptic information in birth figures.

Part 3 and chapter 5 make an argument for the continued importance of the birth figure in a period of midwifery history that is usually associated with the highly detailed and intensely observed obstetrical illustrations produced by Jan van Rymsdyk for William Smellie and William Hunter. This period, 1751–74, saw British authors, for the first time, producing original works on midwifery that were in turn being translated and exported to the rest of Europe and further afield. The illustrations of the fetus *in utero* done by van Rymsdyk in this period have received more attention from historians and art historians than any other, except perhaps those of Leonardo da Vinci. Yet they are almost always assessed within the frameworks of anatomical illustration, medicalized midwifery, and institutionalized misogyny. This, I argue, is only part of their context. By foregrounding the neglected contemporary birth figures produced by George Stubbs for John Burton, and reassessing the illustrations made for William Smellie *as* birth figures, I reframe our histories of midwifery and the body in this period. Birth figures actually remained a necessary and widely used image-form for authors and readers of many kinds and played an active role in the period's changing visual culture of midwifery. Studying Hunter, Smellie, and Burton alongside each other, this chapter challenges the traditional narrative of a pathologizing of childbirth from the mid-eighteenth century, arguing instead for a diversity of approaches and an increasingly eclectic visual culture.

In writing this book, I have often envisaged individual birth figures as points at which a complex weave of strands of thought, culture, and experience intersected. Like beads sewn onto lace, or nodes in a network, these images connected to each other in ways that were not simple or linear;

rather they formed part of the dense mesh of early modern knowledge and experience. I have worked by first focusing on specific images and then tracing out the various threads, seeing where they went and what else they intersected with. Moving in this way from point to point, image to image, I tried to map the weave. In envisaging my work in this way, I have aimed to do two things: The first is to write a history of both the birth figure and the pregnant body that is not limited by discipline, that shows just how creative and interconnected thinking about this subject was for early modern people. The second is to pull objects that have historically been marginalized in histories—cheap, popular, anonymous, "nonart" images, and the work and experience of women—into the center of focus, showing, in the process, how central they actually were to early modern epistemologies. Such a map of images and cultures as is proposed in *Birth Figures* will always, necessarily, be partial. There will always be threads not traced, because the threads are innumerable, and there will also always be lacunas of missing sources and lost experiences. But doing history by beginning with images, and drawing the threads out from them, can give different perspectives on what is important and how things fit together. What I hope to provide with *Birth Figures* is a map of images and their culture that can always be enriched and out of which more maps can be made.

PART I

Early Printed Birth Figures
(1540–1672)

Using Images in Midwifery Practice

We will begin with a seventeenth-century lying-in chamber in a reasonably wealthy household. We know certain likely features of such a room: that it would be dark and warm, with the windows shuttered and a fire burning. We know it would be filled with women—relatives and neighbors—and well provisioned with linens, medicines, and various foods and drinks for the mother and her gossips. In it, the woman would labor on her feet, on a chair, on her bed, or on the special mattress set up near the fire for the delivery itself. Usually such a room would be presided over by a midwife: a respected local woman with authority derived from experience and practice. She would bring with her certain key items: scissors, a needle and thread, possibly a small knife or a hook, perhaps a special birthing stool or chair.[1]

In such a room, we might also find books, printed or handwritten. Books owned by the laboring woman, or brought by the midwife or one of the other attendants. Books that contained prayers or medical recipes, books that taught the skills of midwifery, and ones that contained birth figures. Little infants, floating and twirling in their wombs, exposed as curious hands opened covers and flicked through pages. These little illustrations proliferated from the mid-sixteenth century and became an increasingly core part of the visual culture of early modern childbirth. They may have been studied in private, pored over by midwives and lay women as well as physicians and surgeons. They may have been shared and discussed in groups of colleagues, families, and gatherings of women. They may have been torn from books and displayed, touched, kissed, even eaten. Print was everywhere and touched everyone's lives in early modern England and was an inherently physical, interactive medium. Printed images were used and interpreted in multiple ways, manipulated both intellectually and physically. That birth figures had some role in how women

experienced and understood pregnancy and childbirth is certain. What that role was, we will explore.

In this chapter, I set out an argument for birth figures as images that both shaped and defined a new culture of midwifery practice in the sixteenth and seventeenth centuries in England. They were images that influenced how midwives envisioned and thought about the mysterious bodily interior; defined their identity as medical agents; and practically guided their physical interventions on the laboring body. And beyond this, they were images that came to symbolize the expertise and the professional legitimacy of the newly medicalized midwife for a wider public audience.

The First Printed Birth Figures

The first printed birth figures in England were produced in 1540, in an English translation of Eucharius Rösslin's manual of 1513 by Richard Jonas. Retranslated only five years later by Thomas Raynalde, this second translation saw a further twelve editions, the last of which was published in 1654.[2] Rösslin's *Roszengarten* birth figures were woodcuts produced by Martin Caldenbach and interspersed with the text (figures 1–2).[3] In *The Byrth of Mankynde*, the illustrations were adapted and collected together into a set of engraved plates (figure 4). The English copies employ the same simple balloon-shaped and transparent wombs as the German originals, given form by curved hatched lines. The figures are reasonably close copies, though the English versions have a slightly dour look. They grapple both with new subject matter and a new printmaking technique. If, indeed, they were made in England, these plates would be some of the first engravings made in the country.[4] Clearly, the artist still relied on the representational styles of the woodcut, not taking advantage of the fineness of the engraved line or its capacity for crosshatching and stippling to create tone, and thus producing rather sparse images. Yet they would have been wondrous to their first English viewers, offering an unprecedented peek at the mysterious unborn child, using a technique still so new as to hold an aura of mystery and wonder.[5]

For the rest of the sixteenth century in England, these figures in *The Byrth of Mankynde* dominated the visual culture of midwifery, but in the early seventeenth century another set began to ascend. Jakob Rüff published his midwifery manual in both German and Latin editions in 1554 in Switzerland, though like Rösslin's, his book rapidly spread around Europe.[6] Rüff's manual wasn't translated into English until 1637, where it had only limited success as *The Expert Midwife* (figure 5). But the birth figures produced for him by Jos Murer have a different story.[7] Like Caldenbach's

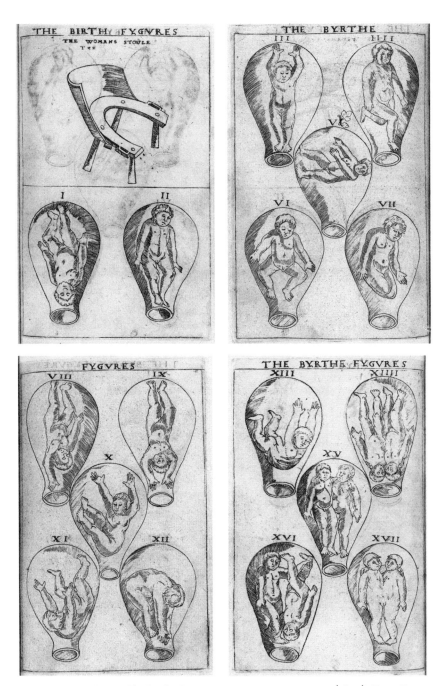

FIGURE 4: Anon., *The Byrthe Fygures*, engraving, 15.7 x 10.5 cm (plate). From Eucharius Rösslin, *The Byrth of Mankynde*, trans. Thomas Raynalde (London: Thomas Raynalde, 1545), EPB/B/7358, Wellcome Collection, London.

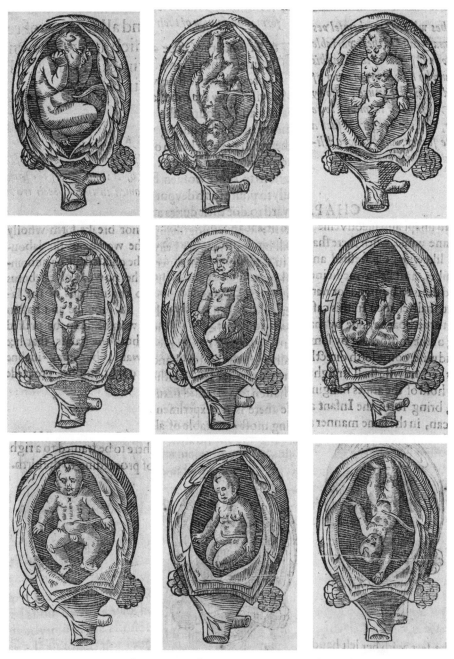

FIGURE 5: Anon., [Birth Figures], woodcut, 7 x 4.5 cm (figures). From Jakob Rüff, *The Expert Midwife or an Excellent and Most Necessary Treatise on the Generation and Birth of Man* (London: E.G., 1637). Medical (Pre-1701) Printed Collection 2105, University of Manchester Library, Manchester. Copyright of the University of Manchester.

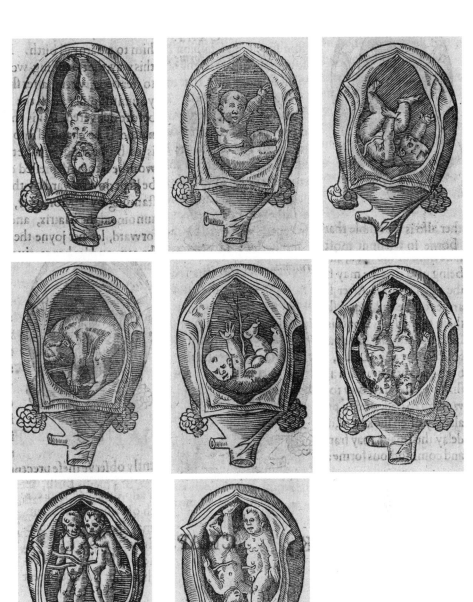

figures for Rösslin, these images are small woodcuts interspersed with the text. But unlike Rösslin's, here the fetuses are given an anatomical framing: the ovaries and umbilical cord are shown, and instead of being see-through, these uteri have been cut open and the uterine wall and membranes fanned out around the fetus. The fetuses themselves are round-bellied and healthy-looking infants with expressions that vary from smiling, to serious, to suffering. Something about these figures clearly caught the early modern imagination and they were copied and reprinted in numerous books. They first appeared in an English text in 1612, in the English translation of Jacques Guillemeau's midwifery manual.[8] They appeared in at least a further six titles, including Rüff's, many of which went through multiple editions.[9]

One final set of birth figures circulated in England before 1672—a single sheet that seems to have originated in William Sermon's medical and midwifery book *The Ladies Companion* (1671) and was copied in the third (1676) and subsequent editions of James Cooke's *Mellificium Chirurgiae* (figure 6).[10] These images were clearly influenced by Rüff's birth figures both in the fetal presentations and in the way the womb seems to have been cut open and folded back. However, the vortex-like concentric lines employed to describe the womb distinguish these from the more direct copies.

The year 1672 is a point of change in this book, though of course changes in visual culture never happened instantly or comprehensively. What did happen in 1672 was the publication in English of François Mauriceau's midwifery manual, along with the birth figures he commissioned.[11] These birth figures looked new, but they also had a newly close relationship to the author who commissioned them and the specific knowledge he proposed to teach. They and the changes they augured will be addressed in part 2. In part 1, I address the period in which birth figures proliferated, approached a visual ubiquity, and became a core part of the midwifery manual, but in which they themselves changed very little. Their iconographic cohesiveness should not, however, be taken to mean that they were used or interpreted in any narrow or limited way. In fact, it is because these few sets of birth figures answered so many cultural needs of the period, in so many ways, that they were so widely reproduced and so little changed. In part 1, most of my discussion is directed generally at the various iterations of the figures that originated with Rösslin's and Rüff's works, as most people at the time would have been generally familiar with one or both sets from various sources. Reproduced here are the earliest English examples of both sets in their entirety. It is important to consider birth figures as sets rather than as individual illustrations: not only were

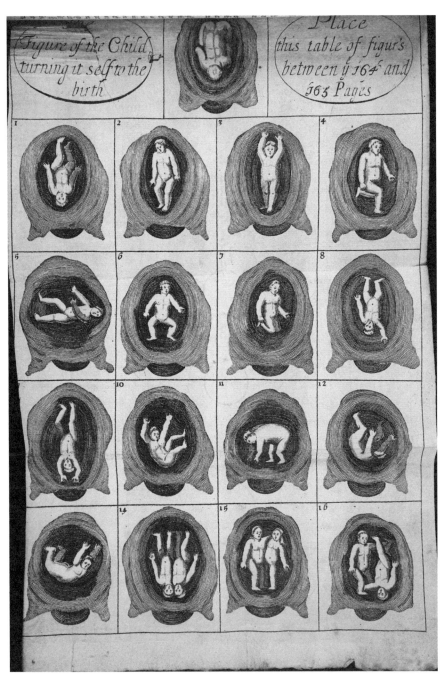

FIGURE 6: Anon., *The Figure of the Child Turning Itself to the Birth*, engraving, 33 x 21.3 cm. From James Cooke, *Mellificium Chirurgiae: Or, the Marrow of Chirurgery Much Enlarged* (London: W. Marshall, 1693). EPB/B/18663/1, Wellcome Collection, London.

they invariably produced in multiples, but the worrying *variety* of fetal presentation was a crucial element of what they said about the body.

Challenging Disregard

Despite their ubiquity, birth figures have received little scholarly attention, and even less that is not openly dismissive. In order to properly assess the significance of birth figures in early modern culture, several historic assumptions must be reassessed. Older schools of medical history have tended to denigrate birth figures as anatomically inaccurate and representationally naïve.[12] Conversely, some feminist histories of midwifery have dismissed them as part of an elite male and medical culture that had no bearing on women's midwifery practice.[13] Wendy Arons has even argued that the images and text of midwifery manuals, where they *were* seen by women, may have degraded their practice.[14]

So on the one hand we have the masculine, teleological histories of obstetrical progress that valorized medical discovery over patient care and credited, overtly or tacitly, the male medical rhetoric of female inferiority. On the other we have feminist histories of midwifery, which tended to present female practice in an idealized light, as forming a harmonious and empowering female community of effective but completely nontextual and nonmasculine practice.[15] These early feminist histories were an absolutely necessary antidote to earlier, overtly misogynist medical histories, but they have left us with a dichotomy in thinking about "man-midwifery" that Lisa Forman Cody has aptly described as "medical glory versus gory misogyny."[16] However, in more recent decades, scholarship has come to recognize not only the difficulties and problems of both men's and women's midwifery practice, but also the ways in which they influenced and integrated with each other.[17]

Midwifery in sixteenth- and seventeenth-century England should be understood as diverse, changing, and working along spectra, rather than strict divisions. Women with no formal medical training still delivered the vast majority of women, but surgeons and physicians were increasingly present in the lying-in chamber, called in during emergencies, or simply monitoring the progress of wealthier women's labors. Male medical practitioners learned skills from midwives, and midwives gained medical and anatomical training from men. Family businesses often included male surgeons and women midwives working in tandem.[18] Later textual vitriol against women midwives by male authors has left us with a feeling that men and women must always have been at war over midwifery. But it is

most likely that, in most cases, occasional differences and struggles for authority and credit were balanced by pragmatic relationships of respect and collaboration.[19]

This model extends to midwifery manuals: while largely written by men and derived from medieval gynecological manuscripts, they were also increasingly influenced by contemporary knowledge gleaned from midwives. Moreover, it is clear that book learning became an increasingly desirable attribute for women midwives, as they incorporated some learned medical knowledge in order to improve their practice and their social standing. Monica Green has argued that in the medieval period, gynecological and obstetrical texts were largely made for and by men, and while women were in charge of delivering babies, "midwifery" as a profession was not widely recognized.[20] What we see happen slowly, from the late-medieval to the modern period, is the engulfing of childbirth by medicine. This does not mean, however, that male medical obstetrics destroyed female midwifery. Rather, the role of the woman midwife arose *alongside and tied to* that of the male surgeon and physician, as a marginalized, limited, oft-denigrated medical profession. Books written by men were, therefore, crucial to midwifery as it was practiced by women in the early modern period. While they presented a particular kind of learned and medicalized midwifery that would have been foreign to some midwives, and inaccessible to others, over the period covered in part 1 such books became an increasingly indispensable tool for learning and improving practice, and for establishing legitimacy and professional status for women. By the 1670s, when Jane Sharp's manual was published, midwifery was understood to be part textual learning and part embodied practice. It was "*Speculative*; and *Practical*, she that wants the knowledge of Speculation, is like to one that is blind or wants her sight: she that wants the Practice, is like one that is lame and wants her legs, the lame may see but they cannot walk, the blind may walk but they cannot see."[21] In England, it is important to note, the male doctor never actually displaced the woman midwife, nor did the medical establishment wish to do away with women's practice. They simply wished to control it by taking it into the fold of medicine and defining its remit, and midwifery manuals played their part in this. We must understand midwifery manuals, therefore, not along gender lines, as representations of masculine medicine, but as influenced and used by both men and women, though they contributed to a medical culture in which men held much of the power. Yet scholars have tended to cast doubt on the extent to which women midwives actually read midwifery manuals, citing not only the divide between learned medical and empirical

knowledge, but also low literacy rates among early modern women.[22] It is worth, therefore, looking in more detail at the evidence for and against female readerships for midwifery manuals.

Midwifery Manuals and Readers

While it is true that women were on the whole less likely than men to be literate and to be book owners, literacy rates rose steadily for both genders from the sixteenth century onward.[23] Adrian Wilson, moreover, has shown that literacy rates were particularly high among midwives, and that most midwives, even those operating in poor and rural areas, could read by the mid-seventeenth century.[24] Evidence from the books themselves suggests that women were reading them. Many texts addressed themselves to women readers, and particularly to women midwives. Some, such as Jonas's translation of Rösslin, also attempted to discourage certain types of male reader—namely, the uneducated and the young.[25] There was a general feeling that the knowledge contained in midwifery manuals belonged, to a certain extent, to women, though it was of course mediated and controlled by learned men. Moreover, the sheer *number* of midwifery texts available in the seventeenth century means that women must have regularly encountered them. Considering that best-sellers such as Culpeper's *Directory for Midwives* went through at least twenty editions between 1651 and 1777, and that single books in this period often had multiple owners and were used over long periods of time, it seems likely that midwifery manuals were a source of body knowledge that spanned many spheres of society, male and female, rich and poor, lettered and unlettered.[26]

There is, moreover, direct evidence of at least some women readers in the form of inscriptions. Given that women were less likely to own the books they read, and to be able to write in them even if they did, the existence of these inscriptions by women readers indicates a much larger number who owned and read but did not mark, or who read or even heard without owning. Some inscriptions seem to defy the silencing of women readers, as in one manual, described by William Sherman, inscribed "Elizabeth Hunt her Booke *not* his."[27] Other women owners were more circumspect. In a 1682 copy of Wolveridge's *The English Midwife Enlarged*, held at the Huntington Library, the owner, Mary Hillyer, wrote:

Mary Hillyer her book
god give her grace ther
unto look not to look but
to understand larn [learning] is beter

then house or land

July ye 2 1790

Another inscription, in a 1662 edition of W. M.'s *The Queens Closet Opened*, a recipe book including remedies for problems associated with pregnancy, birth, and nursing, held at the Wellcome Library, reads, "Mary Busby/ no Great Physitian." In different ways, these women use inscriptions to situate their own identities as readers. With humility they acknowledge their distance from the masculine world of learned medicine, but at the same time they shape their position as women who access both masculine medical knowledge and traditional feminine knowledge.

Other inscriptions point to textual communities of women. One copy of the 1662 edition of Culpeper's *Directory for Midwives* held at the Yale University Medical School Library is inscribed:

> Jeannot Newton hir
> Booke. Being given to
> hir by Mrs White
> in London 1682

It seems likely that this gifting of a book was part of an apprenticeship arrangement between Newton and White. This would correlate with Doreen Evenden's research into the apprenticeship system for training midwives in London in the seventeenth century[28] and with the seventeenth-century surgeon-midwife Percival Willughby's descriptions of the use of midwifery manuals by young and aspiring midwives.[29] Jennifer Richards has identified further evidence of various kinds of readers, including "thoughtful, practical" women readers, in a manuscript manual by Edward Poeten, *The Midwives Deputie* (c. 1630s), held at the British Library.[30]

Evidence from the manuals themselves indicates that over this period it became increasingly important for midwives to be familiar with the literature. By offering works that combined and condensed the wider literature on midwifery, many authors both emphasized the necessity of such knowledge and made it attainable for midwives who might afford one manual but would never amass a large and multilingual medical library. Jane Sharp, in her manual of 1671 for instance, promised that she was "at Great Cost in Translations for all Books, either French, Dutch, or Italian of this kind. All which I offer with my own Experience."[31]

We can, unfortunately, put no great stress on the fact that Jane Sharp herself was a woman author and reader of midwifery manuals, as the jury is still out on whether she was a real person or a pseudonym for a male au-

thor.[32] I cannot, however, agree with Katharine Phelps Walsh that the lack of a strong personal narrative of experience (as later women authors Sarah Stone and Elizabeth Nihell would provide) indicates that the book was *not* written by a woman. Indeed, were a woman to write a manual in this period, it would be a logical decision to acquire authority by adopting the style and form of writing developed by men, who had little direct experience of childbirth. Indeed, it is only *after* male authors had begun to place emphasis on their empirical experiences of childbirth that women writers too began to recount their experiences in published texts. Moreover, even if Sharp is a pseudonym, it is worth noting that a man felt his book would *gain* legitimacy by being authored by a woman. That this would have been a plausible and profitable lie suggests that women midwives did engage with textual culture, even if they left few traces of it.

Even for those women who could not read, the midwifery manual was likely still an accessible text. As Adam Fox has argued, seventeenth-century England has a deeply textual culture, in which "the three media of speech, script, and print infused and interacted with each other in a myriad way. Then, as now, a song or a story, an expression or a piece of news, could migrate promiscuously between these three vehicles of transmission as it circulated around the country, throughout society and over time."[33] The ubiquity of reading aloud, as well as retelling things read, meant that everyone was engaging with print culture in some way. Accordingly, midwifery manuals were not only read by the particularly literate circles of medical practitioners but also engaged with much more widely. One practice, described by both Laura Gowing and Jennifer Wynne Hellwarth, was that of communal reading in the lying-in chamber.[34] This might be undertaken by the midwife or by a literate laywoman, perhaps a member of the local gentry. Indeed, exactly this practice of disseminating text to a local female community by a woman of high standing is described from as early as 1545 in the second translation of Rösslin's text. In his new translation, Raynalde notes: "there be sith the first settynge furth of this booke, right many honourable Ladies and other wourshypfull gentyle wemen, which haue not disdaynyd thoftener by the occasyon of this booke to frequent & haunt wemen in theyr labours, carienge with them this booke in thyr handes, and causynge suche parte of it as doth cheifly concerne the same pourpose, to be red before the mydwife, and the rest of the wemen then beyng present."[35] Many texts directly addressed the lay reader, often arguing that men and women should know at least enough to be able to judge a good midwife from a bad one.[36] The book, therefore, functioned both to teach the midwife and to set up the lay reader as an informed judge. It is easy to see how this textual knowledge would have fitted into exist-

ing communities of women who shared recipes and advice, watched each other's conduct, and regularly assessed, and recommended or denounced, medical practitioners.[37] Other readers, as has been widely noted, sought out midwifery manuals not as medical textbooks but as sex manuals, or as erotica.[38]

Birth Figures and Viewers

So we can safely assume that midwifery manuals had a widespread influence on early modern cultures of medicine and the body: among educated elites and in less learned circles; among medical professionals and lay readers; among men and women. And if this was true, then the images they contained must have had an even wider reach, being directly available to illiterate viewers and allowing for more diverse interpretations and uses. Images, too, take less *time* to consider than a whole text and would have been available not only to book owners but to visitors and guests, to all the women in a lying-in chamber, even to people browsing a bookstall. Moreover, birth figures were highly mobile: small, cheaply produced, usually in hard-wearing woodblocks, they could be easily reprinted, lent out, copied, and recut.

Birth figures were not only mobile in their printing, but also physically mobile as impressions were torn or cut from their original books. This is the case for the birth figures in most known copies of the first edition of Rösslin's *The Byrth of Mankynde*, which suggests not only that birth figures were particularly intriguing to early modern viewers, but that they reached very wide audiences as they left the protective covers of books to circulate alone, to be passed around, pinned to a wall, or pasted onto other objects.[39] Indeed, just as text engaged in circular practices of transfer between print, manuscript, and oral reportage, so images moved back and forth between print and manuscript. Rösslin's first printed figures were modeled on manuscript examples, and his printed versions moved back into that realm as people copied them into compendia and commonplace books. For instance, a full set of Rösslin's figures appear alongside assorted illustrations on a bewildering array of topics in a German commonplace book created around 1524 now held at the Universitätsbibliothek Erlangen-Nürnberg.[40]

As well as being popular and mobile, birth figures were also remarkably cohesive in composition and style. This means that while there was a vast amount of textual material in midwifery for a reader to browse through and selectively read, if a person saw a birth figure, it would likely be one of two quite similar sets. However, these qualities also make birth figures

challenging material for the art historian. They were cheap, often copied, and often anonymous. Addressing them critically has, therefore, involved rejecting many of the typical metrics by which an image is judged "success-ful" or worthy of study. Yet when they are looked at as resources that speak about the culture that produced them, the collective, ubiquitous nature of birth figures makes them more valuable resources than the single vir-tuosic oil painting seen only by the wealthy patron who commissioned it and their social circle. While these birth figures' ubiquity, popularity, and iconographic consistency make it difficult to talk about artistic intention, the fact that so many hands and minds went into their production and reproduction makes them a special kind of record of the period's culture. With each reproduction, birth figures became more culturally present, as well as more divorced from the original intentions of any single author or artist. This approach to visual culture has been modeled by scholars of epistemic images, who point to the crucial importance of copying in disseminating information, but also in making particular images so so-cially and culturally significant. As Hopwood has argued, "The fate of a picture is sealed by whether and how it is reused . . . all successful images have stories of copying to tell."[41] Stories of the copying of early modern anatomical, botanical, and natural historical images have all been told in recent decades, pointing to the importance of presence and reproduction, as well as production.[42] In recent studies of broadside ballads, too, schol-ars have pointed to the ways in which copying actually allowed images to accrue meaning, to become multivalent in the ways they could illustrate texts, because of their presence in other contexts.[43] Birth figures take their place in this canon of ubiquitous copied images that prove to be such remarkable sources for history because they were visible and important to so many different kinds of people.

It is worth, however, digging a little deeper into exactly why birth figures remained so remarkably unchanged between the early sixteenth century, when they entered into print, and the end of the seventeenth century. After all, this was a period that also saw both innovation and visual diversity in many fields of knowledge, including anatomy and medi-cine. The answer has partly to do with the simple lack of models to draw from: in anatomy and botany there was always at least the potential for new images to be made as authors and artists returned to specimens as sources, though copying was also extensively employed in these fields. But particularly where the original object was rare or hard to see, as was the case with Dürer's rhino or Aldrovandi's two-legged centaur, particular images tended to endure.[44] When it came to birth figures, no one could look inside the living pregnant body, and only a small, privileged group

had access to dissections of pregnant cadavers.[45] Copying, therefore, was a practical response to the lack of a model to drawn upon.

Practically speaking, too, copying was often a financial decision, as publishers aimed to recoup the costs of woodblock production by loaning them out or using them for multiple titles.[46] Particularly because midwifery manuals tended to be cheaper works produced for a nonelite audience, new illustrations were likely usually seen as unjustifiable. But copying or reusing existing woodblocks not only was cheaper, it could be good advertising. As Mary Fissell has shown with her study of the frontispiece to *Aristotle's Masterpiece*, widely copied images could become a kind of visual shorthand or trademark for particular kinds of content.[47] Birth figures, too, likely became associated with and emblematic of the midwifery manual as the genre increased in popularity.

But apart from these practical considerations, copying was also an accepted and active practice in the creation of correct and authoritative knowledge. Early modern authors and artists who copied an image weren't doing something forbidden or covert, they were amplifying the virtues of an existing image, and associating themselves with that authority. Susan Dackerman describes the process as artists assuming "each other's authority as a means of deploying their own expertise."[48] Scholars have argued that, in this period, there was also a social pressure to copy, because to diverge or to innovate was to contradict established authority. While there were some pioneers who actively used images to challenge authority and to present new approaches to investigation and knowledge, the seventeenth century, particularly, seems to have been deeply ambivalent about the twin drives to innovate and to adhere to authority. Ashworth notes the strangeness of this—that Renaissance images exerted such a strong hold despite the fact that the seventeenth was "a century when practically all other authority was being rapidly cast aside."[49] Indeed, in botanical and zoological books of the period, as Ashworth, Fabian Krämer, and Sachiko Kusukawa have noted, old images were often retained even where new ones were also produced, as authors built up reliability through encyclopedic collecting.[50] This conflict between authority and innovation, new and old, can be understood through Katherine Eggert's theory of "disknowledge." Eggert argues that the early modern period was so wedded both to old systems of knowing and to new and innovatory ones that it developed a "tricky epistemological maneuver" in which something can be known and not known at the same time, or in which two seemingly contradictory systems of knowledge can coexist.[51] The same "disknowledge" might have been practiced by viewers of old and much-copied images.

However, these theories cannot tell the whole story, because they tend

to assume that an old and outdated image—one that was copied multiple times—was inherently less informative than a new image. In fact, it is entirely possible that old and much-copied images continued to be relevant for early modern viewers, to provide useful modes of knowing that newer kinds of images did not. The birth figures that were produced throughout the seventeenth century and beyond were copied, I argue, because they continued to be specifically useful to viewers.

Practitional Images

To see *how* birth figures were of use to the early modern viewer, we must begin with a term, "practitional," which is employed in this study to describe images of the body that are primarily concerned not with anatomy but with medical practice. These images do not represent the body as it is seen in dissection, and they do not primarily give information about the shape, positioning, and qualities of the body's parts. Rather, they describe the hidden living bodily interior, and they show it changing, moving, and undergoing treatment. A common tendency in scholarship to conflate anatomical with all kinds of medical images has led to something of a blindness to the variety of ways in which the body was represented in the early modern period.

Indeed, the primacy of anatomical images in studies of early modern visual culture of the body is one of the reasons for the general disregard of birth figures. The first print birth figures were produced in the early sixteenth century. As scholars such as Sachiko Kusukawa have demonstrated, this period also saw the rise of images in natural philosophy that adopted a less abstract, more "naturalistic" style and that spoke more of firsthand observation and investigation and less of received authority.[52] In areas such as anatomy and natural history, a new value was being placed on the knowledge gathered from direct and close observation.[53] A prime example of this trend is the images produced for Andreas Vesalius's *De humani corporis fabrica* (1543), which were copied in the second edition of *The Byrth of Mankynde* (figure 7). These images are particularly important not only because they show a new style of representation and a new commitment to firsthand observation of the dissected body, but because they exerted such influence over the production of anatomical images for centuries after.

Particularly because printed birth figures and new Vesalian anatomical images arose concurrently in the sixteenth century, the former have historically been compared with the latter and found wanting. Old and not-so-old studies of medical or obstetric images compare birth figures

with Vesalius's woodcuts, with Leonardo da Vinci's sketches, and with the hyperdetailed eighteenth-century engravings commissioned by William Smellie and William Hunter, and on these grounds dismiss them as "whimsical, naïve, or simplistic," even as "no better than symbolic."[54] Yet birth figures predate the rise of Vesalian observational anatomy by centuries, and their continued presence in early modern print culture points to the multiple modes of representation that made up the visual culture of the body.

Scholars working within the framework of "epistemic images" avoid such overt value judgments as have at earlier times, and in other methodological frameworks, dismissed birth figures. Yet the effects of a continued bias toward the anatomical are still to be felt in the wider silence on these images. It is quite simply *hard to see* what the birth figure says, trained, as we are, to look for anatomical "accuracy," fine detail, and naturalistic style. Mary Fissell and Elaine Hobby have suggested that birth figures are better understood as "mnemonic devices" and "diagrams" that helped midwives to understand and remember the variety of fetal malpresentations.[55] But neither scholar undertakes a more sustained exploration along these lines. Indeed, to my knowledge, the only scholar to engage with birth figures at any length is the art historian Lianne McTavish, who argues that "regarding images of the unborn as diagrams fosters a more historical understanding of them, while providing insight into how they actively produced meaning."[56] McTavish suggests that birth figures were never intended to *look like* the body, but were rather images that helped practitioners to envisage the obscure interior and to practice upon it. But her visual analysis of birth figures is just part of a wider study of midwifery culture, and her research is limited to the French context and a particular Parisian medical milieu in the late seventeenth century. In this chapter, I both undertake a closer study of the modes in which birth figures produced meaning and propose a broader methodology for exploring the practitional—a visual language that wove in and out of other representational modes and different cultures, contributing to the increasingly international realm of printed medical knowledge. Indeed, the practitional is a mode to be found everywhere in early modern epistemic visual culture—from surgical illustrations to mechanical manuals. Just as the term birth figures is proposed in this book to aid in the wider scholarly *seeing* of these images, so I hope the term practitional will help us to see the different ways in which early modern knowledge was visually represented.

As early as 1545, with the second edition of *The Byrth of Mankynde*, midwifery manuals embraced the contemporary in anatomical research. This edition included images from Vesalius's *De humani corporis fabrica* (1543)

FIGURE 7: Anon., [The Anatomical Figures], engraving, 19 x 11 cm (page). From Eucharius Rösslin, *The Byrth of Mankynde*, trans. Thomas Raynalde (London: Thomas Raynalde, 1545). EPB/B/7358, Wellcome Collection, London.

that had only just been reproduced in England for Thomas Geminus's anatomical treatise, *Compendiosa totius anatomie delineatio, aere exarata* (figure 7).[57] This put Raynalde's translation of Rösslin at the cutting edge of anatomical visual culture in England. But the images did not displace birth figures; rather they worked alongside them in a different representational mode. As Kusukawa has argued, Vesalius's anatomical images were produced to aid students in reading dissections—they were keys to and descriptions of the opened body, teaching the initiate how to make sense of the actual body, to locate it within medical and physiological theory.[58] To look at them was, as Raynalde described it, "as thoughe ye were present at the cuttynge open or anathomye of a ded woman."[59] Birth figures,

on the other hand, work in a different register, imagining rather than observing the bodily interior, and rendering it living and in process. In the early modern period, anatomical images and birth figures could function side by side because the anatomical mode had not yet come to dominate how the bodily interior was understood, or, in Duden's words, "the dead body did not yet cast its shadow on the living body."[60] Indeed, Cynthia Klestinec has argued that particularly in vernacular texts, anatomy alone was never sufficient to describe the body: "It was not enough for writers to describe the structural features of the uterus, for example; they also had to describe it as 'joyous,' happy to be the meeting place for male and female sperm."[61] Anatomy was not the only, or even the most important, system for understanding or picturing the bodily interior: it was employed "alongside, not in place of, a wider lexicon of the body."[62]

After the 1545 edition of *The Byrth of Mankynde*, anatomy was regularly included in midwifery manuals, where it was often presented as a kind of theoretical grounding for midwives. In *The Byrth of Mankynde*, for instance, anatomy was described as "the foundation and ground, . . . the better to understand how every thyng cummeth to passe within your bodyes in tyme of conception, of baryng, and of byrth."[63] Almost always restricted to a prefatory section and typically concerning only the female organs of reproduction, anatomy in midwifery manuals was emphasized as theoretical, scholarly knowledge and was heavily associated with the dissected corpse. Authors understood it as peripheral to the main art and skill of midwifery, and as most midwives had no access to education in anatomy, it was, in practical terms, not a necessity. Indeed, even as late as 1737, the midwife and author Sarah Stone was still describing her attendance at public anatomies and her reading of anatomical books as useful, but not a central pillar of the discipline. She states, moreover, that without extensive practical experience, anatomical knowledge "would have signified but little."[64] Birth figures, on the other hand, refer to the living body in labor with which midwives dealt in their daily practice, and used a very different mode of representation. Though they often contain anatomical details, these are always subordinate to the depiction of fetal presentation, represented in more practical, less observational terms, and showing a body not dead and exposed to sight, but living, moving, and inherently various and mysterious. Thus, while birth figures and anatomical images were regularly collected together in midwifery manuals, they would have been widely recognized as practically and perceptually apart. The anatomical was static, theoretical, and academic, while birth figures were active, practical, and practitional.

The early modern period is characterized by a multifarious, imagina-

tive, and inclusive approach to medicine and the body, and one that did not replace "old" ideas with "new" but rather collected them into an ever-richer culture. This is particularly well exemplified in its thinking about the womb: it was an organ shrouded in mystery, the source of many of women's illnesses, and the subject of much analogical and symbolic bodily storytelling.[65] Birth figures show the womb excised from the body, floating in space. This visual system is partly practical, allowing for the production of a series of comparable images. But it also gives a kind of autonomy to the womb, an "otherness" that would have resonated with the widespread early modern understanding, stemming from classical medicine, of the womb as autonomous and mobile within the body. Though by the seventeenth century it was well established by anatomists that the womb did *not* move of its own volition, the way this was explained by many authors betrays a certain ambivalence on the topic.[66] "There is towards the neck of the Womb on both sides a strong ligament near the hanches, binding the womb to the back," writes Jane Sharp, simultaneously describing the stationary womb and evoking the possibility of movement and the need to "bind."[67] Moreover, whatever anatomy books said, among laypeople there was still widespread understanding that both fluids and organs moved around the body and that the womb especially could cause illness by moving out of its place. This understanding was also still credited and engaged with by physicians, who risked losing clients by directly contradicting their perceptions of their bodies.[68] In one midwifery manual of 1656, *The Compleat Midwifes Practice*, the authors describe the mobility of the womb and mention that "some women doe affirme that it ascends as high as their stomach."[69] Cures for uterine diseases often involved coaxing or forcing the womb back into its place, with sweet smells and foul ones, as well as with sex and pregnancy.[70] When a woman looked at a birth figure, therefore, its disembodied nature may well have chimed with her understanding of the organ as not quite of herself—something with autonomy, something to be monitored, coaxed, and controlled.

If pregnancy was effective at quieting the wandering womb, however, it did not make it less inscrutable. If anything, the womb then became more mysterious and uncontrollable, and with more serious consequences. A womb might engender a child, but it might also create a misconception or a monster, it might suddenly let go of a growing child, or it might impress marks or deformities onto that child. During childbirth, too, a labor might go quickly or slowly, the child might fail to come, the mother might hemorrhage or have convulsions, all without clear reasons.[71] For anatomists and physicians the womb was a great conundrum: the fabled seat of generation and an organ that was constantly and miraculously chang-

ing.[72] In the words of the surgeon Jacques Guillemeau: "certainly it is a thing worthy of consideration, to see how in a little space, yea even in the twinckling of an eye, the necke of the wombe, which all the time of the nine moneths was so perfectly and exactly closed and shut, that the point of a needle could not enter therin: how (I say) in an instant is dilated and inlarged, to give passage, and way for the child; the which cannot bee comprehended (as the same *Galen* saith) but only wondred at, and admired."[73] For midwives, too, the womb was a mysterious place, and one that became deeply troubling in the case of obstructed or lingering labors. When the baby did not come, for many midwives and women in the sixteenth and seventeenth centuries, there was no way to work out why, let alone to fix the situation. The opaque and unpredictable danger of obstructed labor lay heavy over the culture of early modern childbirth. The power of this fear, Laura Gowing has argued, spurred the common use of oaths, both before and during labor, that involved a promise being kept or "the child and I will never part."[74] Such an oath had great potency because, as everyone knew, if the child could not be born, both mother and child would die. The fear of this particular outcome was undoubtedly made more powerful by its mystery—the fact that it was often not clear *why* the child would not come, or what a midwife could do to help. Over obstructed labor also loomed the specter of surgical intervention, and the child removed from the womb in pieces. In extremis, many women preferred to put their trust in divine rather than medical agency, and whether the child would come was often talked about in terms of God's will.[75] Labor, in this culture, was a closed system—a black box.

In most cases, labor could be left to progress without physical intervention into the interior. Most fetuses presented headfirst and were born spontaneously, needing only to be received by the midwife. In this period, therefore, the midwife's main tasks included care and encouragement of the mother, the administering of various receipts and medicines, and after birth, the cutting of the umbilical cord, delivery of the placenta, and washing and swaddling of the child.[76] The physical processes of labor were discussed in largely abstract terms, and there was a general reluctance to visualize women's bodies or the movement of the fetus in concrete or mechanical terms.[77] Percival Willughby and Sarah Stone, both authors who were also practicing midwives, described encounters with colleagues who restricted their practice to the bodily exterior and who were unable to visualize what was happening inside.[78] This is also borne out by the complaint of the German midwife-author Justine Siegemund: "there are some midwives who do not think about what they are doing and know no more and wish to know no more than how to receive a child when it

falls into their hands and how to cut the navel string. They do not concern themselves with anything more, even violently dispute the possibility that a midwife can do anything more, because it is hidden from them."[79] Some laypeople reported the same thing: the diarist Alice Thornton, for example, recounts one of her own labors in which her "sweete goodly son was turned wrong by the fall I gott in September before, nor had the midwife skill to turne him right, which was the cause of the losse of his life, and the hazard of my owne."[80] She reports a case in which it was known that the fetus was positioned wrongly for birth but the midwife did not have the skills to visualize the position or turn the child. Indeed, a common solution to malpresentation at this time, and one recommended by Rüff, was to push the fetus back and have the mother toss around, in the hopes of shaking the fetus into a better position. Rüff describes how the presenting limb should be pushed back, and then "let the labouring woman move and roll her selfe to and fro in her bed, her head being lower than her other parts, but her thighes and belly higher than the rest, declining backward, untill the Infant shall be perceived to be turned a little, then she is to be brought againe to her labour and travell, and she is to be furthered with all the help that may be."[81] This solution, while it required that the midwife be aware of the problem of malpresentation, did not require exact thinking about how the fetus was presenting, or the way in which the position might be corrected. Such concrete thinking about fetal position was, I argue, largely outside of the midwife's purview. It was not that people were incapable of concretely visualizing the fetus in a specific position, but that midwifery practice and wider frameworks for thinking about the body did not require this approach. Nonvisualisation of fetal presentation worked, for example, with the widespread understanding of the role of "Nature" in the body. Hannah Newton has argued that, at this time, "Nature" was often understood as an active and personified agent within the body who helped to rebalance the humors and purge disease.[82] Within this framework, the midwife who pushes the fetus back in the hopes that it will return to a "natural," cephalic presentation assumes the role of an assistant, helping the agent "Nature," within the body, to fulfill her duties. Many midwives throughout the sixteenth and seventeenth centuries continued to perceive their role as assistant or attendant to a greater force, be it "Nature" or God. This role left the womb unvisualized and untampered with—the realm of a greater, more powerful force.

However, there also arose in this period a new way of perceiving the body and the midwife's role, with which birth figures were deeply entangled. Slowly and sporadically, midwives began to intervene *inside* the body. Rather than just pushing back the fetus and hoping it would turn

fortuitously, they began to manipulate the fetus itself. At first, this was still couched within the midwife's role as assistant to nature. Rösslin, for instance, advises the midwife faced with a malpresentation to "turn the byrth tenderlye with her annoynted handes, so that it maye be reduced agayne to a naturall byrthe."[83] Rösslin describes the midwife lubricating her hands before introducing one or both into the vagina and womb to turn the child so that it presents headfirst. This idea works within the logical framework of the natural, as it calls for the midwife to help return the body to a state in which the agent Nature can complete the delivery. However, as Adrian Wilson notes, turning to the head, or internal cephalic version, really works only before labor has begun, and even then it requires great skill.[84] Once labor has begun, in practical terms, cephalic version is largely impossible: the head is too large and smooth to be grasped and manipulated by the midwife's hand in the contracted uterus. The advice, therefore, seems to be more theoretically than practically grounded.

One copy of the 1540 edition of Rösslin's *The Byrth of Mankynde* seems to show a reader's confusion over this concept. The book, held at the Huntington Library, has been annotated in ink, mainly with comments and crosses in the margins, and with catchwords at the tops of pages. The terms "stere" and "stearynge" are written multiple times on pages that deal with fetal presentation and turning the fetus. While we cannot know what the annotator thought about "stearing," it seems likely that they repeatedly wrote the word because they considered it a key, and perhaps a tricky, concept. It was an idea that they wished to find easily for repeated readings.

The impracticality of cephalic version began to be remarked upon more widely from the seventeenth century. The midwife speaker of *The English Midwife Enlarged*, for instance, complains that "most Authors advise to change the Figure and place the head so that it may present itself first to the birth; which is very difficult and almost altogether impossible to be performed."[85] This statement is largely true, but it is also a little piece of propaganda, because by the seventeenth century, a better alternative was circulating in manuals and in practice: podalic version.

Podalic version involves finding the feet of a malpresenting fetus and pulling it out by them. The method was first published by the French surgeon Ambroise Paré in the mid-sixteenth century in France and was slowly disseminated in text and practice throughout the seventeenth century in England, beginning in 1612 with the publication of *Child-Birth or, The Happy Deliverie of Women*, a translation of a French manual by Paré's pupil Jacques Guillemeau.[86] Podalic version allows the midwife to gain a firmer grip on a malpresenting fetus, to alter its position and to exert traction to help delivery. Where it was practiced well, it allowed midwives to

deliver fetuses that would otherwise have been delivered using dismemberment or craniotomy. But podalic version was not a simple innovation; it necessitated a completely new way of visualizing the body. The aim was no longer to return the body to a state of unseen and independently functioning "naturalness" but rather to actively intervene in its processes and to deliver the baby in an "unnatural" yet much more convenient presentation. To do this, the practitioner had to engage with a process of concretely visualizing the body. First, they would have to establish the exact position of the fetus, what presented at the cervix or "mouth" and where the feet were; then they would have to move their hand *inside* the womb to manipulate the fetus's position and exert traction on its feet and legs, in order to effect delivery. Midwives who practiced podalic version were no longer attendants at a natural, internal, and unknowable process; they were agents in a new way, intervening in, correcting, and ameliorating the body's processes.

Because this change was so great—not merely practitional, but perceptual—it spread only slowly and sporadically. A midwife needed another midwife or physician trained in the technique, a midwifery manual, or a personal flair for innovation in order to learn it. Birth figures, I argue, were essential to the spread of podalic version because they offered midwives a kind of perceptual key onto which they could map the scant knowledge they had of a particular laboring body, extrapolating and guessing at how the fetus might be positioned. This analysis, I argue, accords with Mary Fissell's description of birth figures as "mnemonic, a brief visual summation of elaborate directions to the midwife and labouring woman."[87] Yet they were not simply systems for remembering, but more fundamentally images that conveyed an entirely new way of *knowing* the body.

Of course, not all midwifery books contained birth figures: some of the most popular, including Culpeper's *Directory*, did not. Reasons might have included the inconvenience or expense of finding or producing woodblocks, or a conviction that such illustrations were not very useful or informative. But largely, it seems, the decision whether to include birth figures had to do with how the author was framing their authority. In works that proposed to teach the manual skills of the newly professionalized and interventionist midwifery, birth figures are common. Willughby, for instance, despite his doubts over the usefulness of birth figures, still intended to include them in his manual, noting that young midwives would find his work "defective" if it were not "furnished with all the schemes, and various figures."[88] In works that stuck to the more traditional medicines and external treatments, or to the more learned anatomy, birth figures were less common. Culpeper's promise not to meddle with his midwife

readers' "Callings nor Manual Operations," for instance, accords with his exclusion of birth figures.[89] The images thus functioned to signal a new kind of specialized and interventionist midwifery knowledge that was distinguished from the learning of physicians on the one hand and the more general authority of women caregivers on the other.

While it is impossible to know exactly how many midwives actually did use birth figures to learn about malpresentation and podalic version, there is evidence suggesting that at least some did. First, we know that more broadly, this period began to see print and printed images used to communicate both abstract knowledge and practical skills. Katie Taylor, for instance, has shown how the reading of a late sixteenth-century vernacular text on mathematics by Thomas Hood was "an active process for most readers, and it was through activity in response to the text that readers could gain knowledge and practice."[90] Through her own reconstruction of the sector described in the text, Taylor was able to understand where the author expected prior knowledge from his readers, where things had to be explained, and how physical as well as mental trial and error could be part of learning from an illustrated book.

While it is not possible, for both practical and ethical reasons, to reconstruct them, there is evidence that similar practices of combining existing knowledge with new, and abstract knowledge with practical experiment, were at the core of how early modern midwives used midwifery manuals and birth figures. As already mentioned, Jennifer Richards has argued for some midwives being "thoughtful, practical readers" of midwifery manuals, who actively mined such books for information and techniques to improve their practice.[91] Some midwifery manuals, moreover, explicitly describe birth figures being used pedagogically, helping midwives to picture specific malpresentations and how they might be rectified. James Wolveridge's *The English Midwife Enlarged* associates birth figures with learning maneuvers from the outset, promising that the book "will not only furnish you with figures, but with directions."[92] The book is written as a dialogue between a midwife and a physician who instructs her. In the text, the physician refers to the images as if the speakers had access to them, asking: "Courteous Mrs. *Eutrapelia*, If you perceive a child come with its feet forwards, and the hands drawn downwards to the thighs, according to the next ensuing form, How will you deliver the woman?"[93] The midwife "Eutrapelia" then explains how she would deliver a fetus in this presentation. So, at least for the author of this text, birth figures were understood as useful pedagogic devices—as keys to remembering and picturing the bodily interior and to working out how to practice on it.

Indeed, the same use of birth figures is recorded in the work of another

author, the German midwife Justine Siegemund. Siegemund was a re-
markable midwife, first because she published a treatise in a field domi-
nated by male authors, and second because she learned her profession not
through the traditional system of apprenticeship and practical experience
but from books. Her understanding of the body and of midwifery practice
is, therefore, extremely important in tracing how books and their images
were understood and used by early modern readers.[94] Siegemund initially
began to read about midwifery to satisfy her own desire for knowledge
after suffering a traumatic misdiagnosis of pregnancy as a young woman.
She later became a practicing midwife when local women and midwives,
aware of her reading, asked her to consult on difficult labors. In her book,
Siegemund describes the first case she was called to attend, one of arm
presentation: "The midwife, that is, her sister-in-law, entreated me, for the
love of God, to advise them because she had seen me with books with il-
lustrations of sundry births. So I got out the books and looked to see what
postures were depicted there. Because, however, it was impossible for this
midwife to determine which picture corresponded to the posture of the
laboring woman's child, they despaired."[95] Siegemund, however, delivered
the child and, winning the confidence of the local midwives, began to be
regularly called to difficult births. As she gained practical experience, she
also honed the skills that allowed her to reconcile actual labors with the
presentations depicted in birth figures, becoming more and more able to
visualize and rectify malpresentations. Siegemund's narrative describes
a community in the midst of great perceptual and practitional changes.
The midwives were aware of the usefulness of birth figures, and of books
more generally, to their practice. Indeed, all were agreed that birth figures
might be useful if they could be matched with the malpresentation in
question. Yet the midwife with her traditional practitional understand-
ing, and Siegemund with her knowledge exclusively from texts and im-
ages, could not readily reconcile the two. It was Siegemund's continued
practice, combining practical and textual knowledge, that allowed her to
more and more easily enact this reconciliation, and so more easily deliver
obstructed births. Eventually, she developed her own method for podalic
version and, when writing her own midwifery manual, produced her own
birth figures.[96] Siegemund's text is also written largely as a dialogue be-
tween herself and a young midwife-pupil. In the same kind of metanar-
rative found in Wolveridge's text, those engravings that are published in
the book are also provided, within the narrative, to the fictional pupil as
learning aids. This pupil gives voice to Siegemund's own deep conviction
that birth figures could teach practice: "I can grasp it better by looking at

a copper engraving together with a detailed report than from the report alone. The copper engravings light up my eyes as it were and place understanding in my hands."[97] Presumably, many other midwives and surgeons who did not produce treatises went through a similar process of learning to reconcile body, text, and image in the pursuit of good practice, though only, it is worth reiterating, where midwives willing to change their habits met with books and those able to interpret them.

The birth figure's capacity to teach a new system for visualizing and practicing on the body was facilitated by its particular representational modes. Birth figures showed the body in variety and aberration, as well as living and in process. This was in complete opposition to the anatomical image, which typically showed the body standardized or idealized, as a reference against which actual bodies, in consultation or dissection, could be checked. The difference can be seen by directly comparing birth figures with contemporary anatomical images of the fetus *in utero*. One such anatomical image, originally produced for Vesalius's *Fabrica*, was widely copied, including in both Raynalde's edition of *The Byrth of Mankynde* and Rüff's *The Expert Midwife* (figure 8). In these images, there is a focus on anatomical detail, and particularly on the number and nature of the uterine membranes, which were under debate at the time.[98] In Rösslin's birth figures (figure 4), in contrast, the membranes are not represented, and in Rüff's (figure 5) they are not labeled or individuated. The anatomical images also take a different approach to the fetus, showing it more "accurately" proportioned and positioned, cramped in the womb with its limbs curled to its body. These fetuses also sit upright, as was understood to be the universal position until late in pregnancy, when they would take a "dive" to be born headfirst.[99] Such images speak about the fetus in terms informed by dissection and by the canon of textual knowledge: they aim to show the body in its "naturall and lawfull forme," drawing a line between the regular, typical, "natural" body and that which was sick, aberrant, and "unnatural."[100] Thus the anatomical view of the fetus is cast in the language of social governance—the normal healthy body obeys nature's laws.[101] Anatomical fetuses are regular not just in the way they sit upright (or head down, if close to birth) in the womb. They also tend to deny the gaze of the viewer in some way, by turning away, or by covering their faces with hands or knees. In the Vesalius image, the fetus partially covers its face with crossed arms, in a clear gesture of protection and denial (figure 8). These fetuses assert their own secrecy: they make the viewer aware of the transgression of bodily and social barriers that has allowed them to be seen. The horror of dissection, and the fact that even

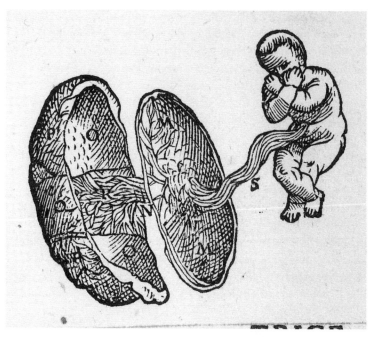

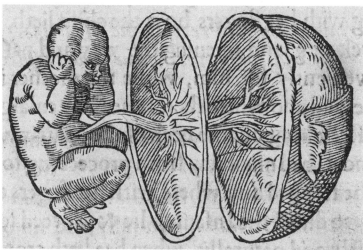

FIGURE 8: (8.1) Jan van Calcar (probable draftsman), *Figure 30*, woodcut, 41 x 31.8 cm (page). From book 5 of Andreas Vesalius, *De humani corporis fabrica libri septem* (Basel: I. Oporini, 1543). EPB/D/6560, Wellcome Collection, London.

(8.2) Anon., [Fetus with Membranes, Placenta, and Uterus], woodcut, 4.5 x 7.2 cm (figure). From Jakob Rüff, *The Expert Midwife or an Excellent and Most Necessary Treatise on the Generation and Birth of Man* (London: E.G., 1637). Medical (Pre-1701) Printed Collection 2105, University of Manchester Library, Manchester. Copyright of the University of Manchester.

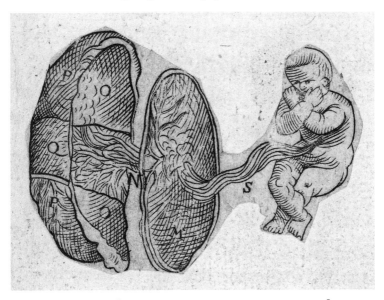

FIGURE 8: (8.3) Anon., [Fetus with Membranes, Placenta, and Uterus], engraving, 19 x 11 cm (page). From Eucharius Rösslin, *The Byrth of Mankynde*, trans. Thomas Raynalde (London: Thomas Raynalde, 1545). EPB/B/7358, Wellcome Collection, London.

dissection cannot expose all the mysteries of generation, are expressed in these poses.[102]

Rösslin's and Rüff's birth figures (figures 4–5), on the other hand, seem to positively invite inspection—the fetuses are posed with limbs akimbo and open eyes. Instead of highlighting the natural secrecy of the fetus *in utero*, these images describe how the malpresenting fetus in labor prematurely loses its secrecy: not because it has entered the world, but because the midwife has brought the world into the womb, inserting a hand or a tool, manipulating position and effecting delivery. Birth figures are also unlike anatomical images of the fetus in that they are not ideal or typical, but various. While some, such as Rüff's, do contain anatomical elements—the ovaries and the various uterine membranes—these are secondary elements, a framing device to the variety of fetal presentations. These are not the regular, natural, or lawful fetuses we see in anatomical images, but irregular and unlawful ones. The job of these figures is not to show the general or the ideal body of anatomical study, but to describe the troubling variety of possible malpresentations that a midwife might encounter in their practice. In their numerousness, they speak of the threatening chaos of a body out of order, of all the different ways in which a birth might go wrong.

Birth figures, moreover, are images geared not to describe what the opened body looked like, but to help midwives picture the specificities of the living body in labor. Authors at this time did know, for example, that the fetus by full term is cramped and curled in the womb, but the womb in birth figures is spacious and the fetus tumbles and turns within, limbs outstretched. The little figure is given plenty of space in these images not from ignorance, but to better display its position: to show what presents at the cervix, and where the rest of the body and limbs are in relation.[103] This mode of representation makes malpresentations more easily understood, memorized, and mapped onto the body. Rosemary Moore has argued that this period saw a new "spatialising" of the body, a new focus on how it fitted together in three dimensions.[104] What study of anatomical and practitional images of the fetus shows is that this spatialization manifested differently in different disciplines. In anatomy artists aimed to show the physical way that the fetus filled the womb, cramped in the small space. In midwifery, spatialization was related to the practicalities of delivery; it required a representational system that was clear about the positions and relative locations of head and limbs. The birth figure's spacious womb and performative fetus pictured the body as it was for the midwife attempting to deliver a malpresenting child.

The specific composition and representational mode of birth figures, therefore, contributed to a wider change in body culture. While the pregnant body remained largely mysterious and unseeable, among midwives a new system for more concretely picturing and intervening in the *laboring* body was emerging. This system came with its own practitional visual culture. Through text, practice, and of course images, midwives began to perceive the interior of the womb and the unborn child as part of their professional sphere. Birth figures, for some midwives, were technical diagrams for guiding internal interventions. But they also pointed more broadly to a new sense in midwifery of intellectual ownership over the mysterious and unseen womb. They offered a new specialist knowledge of the bodily interior, and they acted as proof of that new skill and knowledge. What is certain is that the particular representational modes employed in birth figures were neither naïve nor inaccurate, but consciously and effectively tailored to shape and communicate an increasingly specialist kind of practitional knowledge. They became the emblem of the midwife as midwifery itself was becoming a medical profession.

Pluralistic Images and the Early Modern Body

In *Used Books*, Bill Sherman enjoins his readers to have "an awareness of the gap between the author's words on the page and the meaning particular readers want to derive from them."[1] The same injunction holds for images, which can be deciphered or understood in many different ways depending on the viewer's cultural context, training, and interests. As has been shown by scholars looking at various kinds of early modern printed images in recent years, it was often the potential diversity of meaning that made an image popular and enduring, and this is certainly the case with birth figures.[2]

In chapter 1, I argued for the importance of birth figures as images that were used by midwives who were developing new modes of body knowledge and new practical skills, as well as conceiving of themselves as medical agents in a new way. In counterpoint, this chapter moves away from what we might term the textually sanctioned reading of birth figures as practitional. Focusing on the images themselves and the wider visual and cultural contexts in which they circulated, I will explore other meanings derived from and other uses made of them. On the one hand, birth figures facilitated philosophical thinking about the nature of the human body and its place in the universe. Engaging with the theory of the microcosm, they spoke about astrology, alchemy, botany, and their relations to the body. Such thinking not only provided an order and a system for medicine, it also gave interconnected meaning to the world and the body. On the other hand, birth figures themselves were objects of power, used by women to shape their unborn children and their own health in the deeply entangled realms of magic, meditation, medicine, and prayer.

The Birth Figure and the Universe

We have already seen how the rise of the anatomical did not displace other systems of bodily knowledge in the sixteenth and seventeenth centuries,

and indeed this pluralism of knowledge holds true much more widely. As Michael Stolberg has noted, the seventeenth century saw a massive diversification of systems for understanding the body, with the humoral challenged by mechanistic, Helmontian, spiritualist, and nervous systems. None of these came to dominate, but instead all contributed to an increasingly fractured field of academic medicine. In response, Stolberg argues, people maintained a skepticism toward the advice of doctors, often consulting multiple authorities from doctors and surgeons to quacks, women healers, and family members.[3]

Both learned physicians and the laity accepted that multiple models were used to understand the body. Not only was there diversity within learned medicine, but there were also frameworks that stood without it, and people tended to combine professional prescriptions for medicines and regimes with magic charms, religious talismans, and empiric nostrums. With this shifting, pluralistic, and highly personalized approach to bodily health in mind, we can understand birth figures as providing a highly adaptable resource for picturing, understanding, and treating pregnant and unborn bodies.

One of the most widespread and deeply naturalized systems for understanding the body in this period was the theory of the microcosm. This theory taught that man was a version of the universe or world in miniature. As Nicholas Culpeper explained it to his seventeenth-century readers: "Man is an Epitome of the whole world; nay, he was at first made of the very quintessence of it, that so he might hold forth the wonderful power and wisdom of God, and glorifie and praise God . . . Hence is the reason of the influence of the stars upon the body of man, because he hath a Microcosmical Sun, Moon and Stars in his owne body."[4] Not only was the body of man the world in miniature, but that very connection was the key to understanding the workings of both systems: world and body. Thus, the idea of the body as microcosm led to the practical framework of analogy: things in the body and in the world that resembled each other or worked similarly were in fact more fundamentally connected. Not only could knowledge of one explain the other, but their inherent link meant that they could also influence each other.[5] Knowledge of the stars and planets could, for instance, tell you about a person's health, and the inherent links between celestial and corporeal bodies meant that the planets could also be used to effect healing.[6] The human body was, in this system, the center of all things, as Foucault describes it, "the possible half of a universal atlas" and "the great fulcrum of proportions—the centre upon which relations are concentrated and from which they are once again reflected."[7]

Foucault describes analogy as a fundamental part of knowledge until

the end of the sixteenth century, but among lay people, and even informally among physicians and scholars, there is much evidence to suggest that an analogical worldview remained widespread throughout the seventeenth and even the eighteenth centuries.[8] This understanding of man at the center of many circles of resemblance, his body mirroring and informing the universe, was something that learned readers would have been visually as well as textually familiar with. Astrological and microcosmic man illustrations common in medieval manuscripts showed a figure encircled by the zodiac or planets.[9] Astrological and magical as well as microcosmic encircled figures continued in printed early modern books, describing the relations between man and the planets, or setting out horoscopes.[10] In John Case's *The Angelical Guide* of 1697, a circle with astrological figures and notations surrounds an oval containing a set of illustrations of the developing fetus borrowed from Theodor Kerckring's *Anthropogeniae Ichnographia* (figure 9).[11] The image is accompanied by an English translation of Kerckring's notes on the figures, which describe the age of the embryos and the anatomical parts, but no mention is made by Case of the astrological surround, or the four cherubs in the corners. The image shows how easy it was to combine new anatomical findings with old astrological systems—they did not even need to be mentioned. Case's text discusses the human ovum with a mixture of physiological detail and mystical interpretation. This image makes the link between the circle of the heavens and the circle of the womb explicit, but the analogical resemblance was everywhere, present in birth figures as well as astrological figures. In Rösslin's and Rüff's birth figures (figures 4 and 5), the circle of the womb could also stand for the world or the heavens. Indeed, looked at microcosmically, the birth figure becomes a summation of the microcosmic worldview: if the body was the world in miniature, then the unborn child was a microcosmic person in the world of the maternal body, as well as a person in the circle of the universe.

The Birth Figure and the World

The encircling womb was like the arch of the heavens and like the sphere of the world. The more three-dimensional and anatomical womb in Rüff's birth figures draws out this comparison (figure 5), not only situating the organ within contemporary knowledge gained from dissection, but also exploring its microcosmic resemblances to the verdant earth.[12] Indeed, birth figures not only expressed these microcosmic resonances but pointed the way toward analogical treatments.

In the early modern period, pregnancy was perhaps most widely and

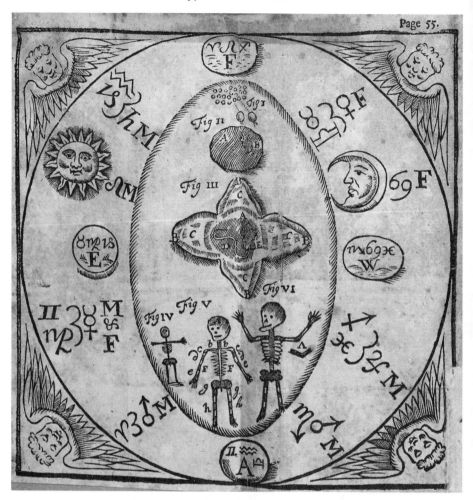

FIGURE 9: Anon., [Anatomical and Astrological Figure], woodcut, 18 x 18 cm. From John Case, *The Angelical Guide Shewing Men and Women their Lott or Chance, in this Elementary Life* (London: Printed by I. Dawkes, 1697). 718.c.32, British Library, London. Courtesy of the British Library, digitized by Google Books.

fundamentally associated and interconnected with the daily processes of the rural agricultural life that most people led. Cyclical processes such as plowing, sowing, and harvesting were regularly used as frameworks for understanding pregnancy and birth.[13] They are, I argue, at least as important in understanding the work birth figures did for early modern viewers as anatomical and practitional frameworks. Rüff's images, for example, which appeared in so many midwifery manuals in the seventeenth century, look extremely fruitlike (figure 5). The uterine wall and

membranes resemble a skin or rind, protecting the tender flesh inside. The ovaries look like raspberries, and the vagina even resembles a stem or stalk. Rüff's anatomical images, too, are remarkably lush, with arteries and veins forming the trunk and branches of a bodily tree, on which organs are hung like fruits (figure 10). Within this internal landscape, the fetus is simultaneously the "fruit" (a common verbal as well as visual analogy for children at this time) and a miniature person dwelling, hermit-like, in the maternal/arboreal environment. From farmers to physicians, this kind of verdant analogy was a powerful tool for thinking about the body. The child grew like a crop—it was fragile and important, a legacy and investment made by the parents. This kind of thinking gave ordinary people a sense of authority over the body, through association with work they knew. Good farmers husbanded land in order to produce healthy crops, and mothers did the same with the fetus.

Indeed, this kind of thinking was utilized not just by the rural laity but also by trained medical practitioners in their explanations and treatments of the body. The medically trained midwife Percival Willughby, for instance, frequently employed agricultural analogy in explaining the logic of his practice: "Let all midwives observe the wayes and proceedings of nature for the production of their fruits in trees, the ripening of walnuts, and almonds, from their first knotting, unto the opening of the husk, and falling of the nut, and considering their signatures, to take notice, how beneficiall their oiles may bee for use in their practice, for the easing of their labouring woman."[14] The midwife is enjoined to look carefully at the natural world, and specifically to look for signatures that related to the pregnant and laboring body. Here Willughby links the process of pregnancy and labor to the ripening of nuts. Of the process of labor, he writes: "as the fruit ripeneth, so, by degrees, this husk, of it self, will separate from the shell, which, at last, by it's own accord, chappeth, and, with a fissure, openeth, and, by degrees, separateth from the fruit. Then doth the husk turn up the edges, and give way, without any enforcement, for the falling off the nut."[15] At the time of Willughby's writing, there were competing theories about how to ensure the safest labor. One held that the quicker the labor was, the better, and some authors, including Rösslin, advised that the midwife manually dilate the vagina and cervix to hasten delivery.[16] Others, including Willughby, held that labor was safest when left to run its own course, however long that was. He enjoins his readers to wait, because "the fruit would fall off it-self, when that it was full ripe."[17] What was known to be true about fruit served also for the womb. His description of the ripening nut brings us back to Rüff's birth figures (figure 5). The peeled membranes enact this "natural" process of birth. The husk, or

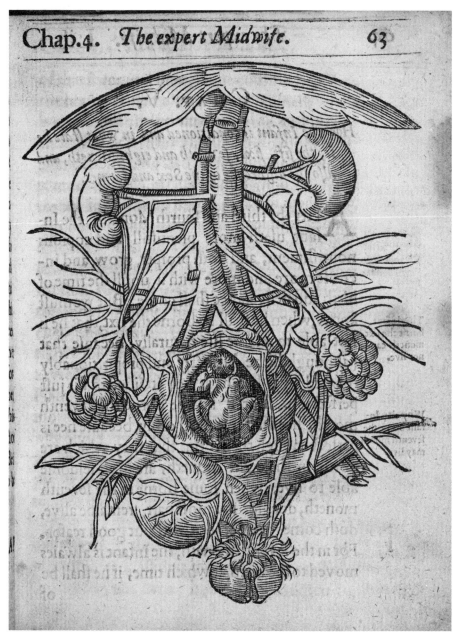

FIGURE 10: Anon., [Pregnant Anatomy], woodcut, 15 x 11.5 cm (figure). From Jakob Rüff, *The Expert Midwife or an Excellent and Most Necessary Treatise on the Generation and Birth of Man* (London: E.G., 1637). Medical (Pre-1701) Printed Collection 2105, University of Manchester Library, Manchester. Copyright of the University of Manchester.

womb, slowly peels away, freeing the fetal fruit without need for violence or intervention. Thus, these openings, typically understood as an imagined anatomical cut, are perhaps better understood as symbolic of the natural capacity of the womb to open during labor.

Systems of analogy could also indicate appropriate medicines. The sympathy between nuts and the womb, for instance, made nut oils appropriate lubricants for childbirth. But such systems were not restricted to the world of flora—all kinds of natural objects had sympathy with the pregnant womb. Another common remedy of the early modern period was the "eagle stone." A complete but hollow stone with a smaller stone inside it, the eagle stone was sympathetic to the womb because it was also "pregnant," and therefore had attractive powers over the organ. Women wore eagle stones around their necks during pregnancy to prevent miscarriage and tied them to their thighs during labor to draw the child out.[18] Culpeper writes that "both Child and Womb follow it as readily as Iron doth the Loadstone, or the Loadstone the North-Star."[19] He situates the body, the stone, and the heavens in relation to each other, linking them all through the system of analogy and sympathy.

In some cases, such as Rüff's figures and verdant analogy, the link is visually emphasized. But it is essential to recognize that for early modern people, thinking analogically was so fundamental that it would have colored their interaction with all bodily images. William Sherman has described one annotated copy of *The Byrth of Mankynde* held at the Huntington Library in which the birth figures have been annotated: "These ar ye campes or feeldes of mankynde to be engendred yr in."[20] Even images that are, to us, seemingly bare of analogy spoke to the early modern viewer of the womb as fertile field, the fetus as both encamped solider and ripe crop. So essential was analogical thinking to early modern body culture that artists did not need to use striking visual associations for the viewer to interpret an image of the body as a reflection of the natural world.

The Birth Figure and the Workshop

In verdant analogy the womb was a field, a tree, a fruit, a stone, but the system also worked for humanmade objects. Physicians and natural philosophers saw the organ in various pots, vases, jugs, and flasks associated with their disciplines. Such visual analogies were often employed in images to make statements about the nature and the failings of women's bodies. Thomas Laqueur sees the vases in the foreground of one of Charles Estienne's erotically charged anatomical prints as symbolizing the womb.[21] Laurinda Dixon has seen the womb in the charcoal burners in

many Dutch genre paintings, their emergence from their wooden hous-
ings an indication of a wandering organ or their breakage an indication of
the loss of virginity.[22] The open and yet enclosing nature of such vessels
has obvious associations with the womb, symbol par excellence of the
"leaky" female body.

But in Rösslin's birth figures (figure 4), the womb resembles a different
kind of container—a round-bottomed glass flask. In the medieval period,
the womb was widely compared to a cupping vessel, including in Muscio's
Gynaecia.[23] Accordingly, in many medieval manuscript birth figures, the
shape of the womb is rounder, with a wider mouth than in Rösslin's first
printed figures. By the sixteenth century, however, the comparison was
more frequently made with the urine flask, which, like Rösslin's figures,
had a longer, thinner neck.

Uroscopy, or the examination of urine, was one of the most widely
used diagnostic tools of the early modern era: the color, consistency, and
sediments in urine were understood as indicators of sickness in the body,
and of pregnancy. Michael Stolberg has recorded that uroscopy was par-
ticularly valued as a test for pregnancy that did not rely on the testimony
of the mother, who might misinterpret or misrepresent the sensations she
felt.[24] In many Dutch genre paintings of the period, the urine flask is the
focus of a scene in which a weeping young woman, often accompanied by
angry relatives, has her pregnancy confirmed by the uroscopist. In such
paintings, the urine flask is a visible and unequivocal test for something
that was otherwise inherently unknowable, mysterious, and troubling. It
not only stood in for the womb, indicating its centrality to the image, but
also *spoke* about the hidden organ, diagnosing and displaying its condi-
tion. This diagnostic capacity is visualized with remarkable literalism in
The Doctor's Examination by Godfried Schalcken (c. 1690, plate 1). In this
painting, the weeping woman, the angry father, and the obscene gesture
made by the grinning boy all point to a pregnancy out of wedlock. And
the viewer's diagnosis is confirmed in the urine flask, where fine white
sediment forms itself into the shape of a child. Such a sight would not have
been strange or incongruous to the early modern viewer, for whom the
womb and the flask were analogous, and by whom the urine flask specifi-
cally was understood to represent and diagnose the womb. The central fo-
cus of the painting, that which the doctor holds up to the light for all to see,
is both the diagnostic test and the condition it confirms—the flask and the
womb simultaneously. Indeed, both the trope of the uroscopic pregnancy
diagnosis and the analogy between flask and womb were so strong and
enduring that they appear even in a watercolor produced in 1829 (plate 2).
This painting may well have been made in response to Schalcken's: the

gesture made by the boy, the weeping young woman, and the little infant in the urine flask are all similar. But the contemporary dress and setting suggest that the situation was seen by the artist not as antiquated but of modern relevance.

Rösslin's birth figures, in this visual context, flicker between test and embodiment, between pregnant womb and flask of urine. Stolberg has argued that uroscopy in the early modern period was a well-respected and reliable diagnostic practice, and one that gave certainty to mysterious internal bodily conditions. The casebooks of physicians Simon Forman and Richard Napier confirm that women in the late sixteenth and early seventeenth centuries regularly sent their urine to be tested for pregnancy, hoping to get a definitive answer well before other physical symptoms could be trusted.[25] Thus the association of urine flask with birth figure gave a kind of authority to the image, linking it with the learned systems of physic. It may also have endowed the image with a kind of predictive power, such as the urine flask had. The image, too, could visualize what was unsensed within the body.

If the uroscopy flask analogically resembled the womb, it also resembled the alchemical flask. The two round-bottomed glass vessels were so similar that it is sometimes hard to distinguish the physician with his urine flask from the alchemist with his alchemical one in genre paintings. This flask was central to the special, complex symbolic language in which alchemical secrets and recipes were often recorded. The Ripley Scrolls, for instance, record the method for making the philosopher's stone using a complex set of visual symbols.[26] As has been noted by scholars, the symbols are intended to be cryptic: indecipherable to the uninitiated, but an enticing puzzle to the scholar familiar with the rich visual language of alchemy.[27] In these scrolls, the flask is often used as a framing device and as a symbol for a generative environment, as well as to describe the actual glassware used in alchemical experiments. In one Ripley Scroll held at the Wellcome Library, London (plate 4), for instance, a large alchemical flask is held by a giant alchemist. Within the flask, roundels depict the stages of making the philosopher's stone using the well-known iconography of marriage between "Sun and Moon, king and queen, Apollo and Diana, or the siblings Gabricus (sulfur) and Beya (quicksilver)," the production of which is the hermaphroditic child the white stone, the balance of opposites and the first stage on the way to the philosopher's stone.[28] In many alchemical illustrations, this symbolic marriage and birth happens inside a flask that is both the literal glass flask and a symbol for the generative womb. Anne-Françoise Cannella notes that the flask in alchemy was often understood as "mother" or "matrix," that the two were analogically and

symbolically intertwined, each standing for and explaining the other—both containers and both sites of generation.[29] The macrocosmic generative earth, the microcosmic generative womb, and the artificial alchemical flask all enacted the same miraculous processes.

In the womb, according to some theories of conception, a process similar to the mixing and heating of sulfur and mercury was enacted. The male and female seeds met, mixed, and were heated and contained by the womb until they formed something finer and purer than the sum of their parts—a child. The two-seeds theory was derived from Galen but was adopted and adapted by many physicians over an extremely long period, and was still being debated in the eighteenth century.[30] The surgeon Ambroise Paré, for instance, describes conception in very alchemical terms: "the male and female yeeld forth their seeds, which presently mixed and conjoyned, are received and kept in the females wombe. For, the seed is a certaine spumous or foamie humour replenished with vitall spirit, by the benefit whereof, as it were by a certain ebullition or fermentation, it is puffed up and swolne bigger."[31] It would have been easy for an educated viewer to look at Rösslin's birth figures and see both the womb and the flask, both the literal fetus *in utero* and the symbol of generation, alchemical and bodily.

But while it was common for alchemists and physicians alike to think about generation in analogical terms, some alchemists went further, claiming they could even create a human fetus in the alchemical workshop. Many kinds of artisanal workshop were cited as generative analogies, with the artisan associated both with God and with the mother,[32] but when it came to the alchemical workshop, there was a particularly close association. Flask and womb were analogical not only in a rhetorical way but in so serious and fundamental a way that the two systems might even blur and come to influence each other materially. William Newman, in *Promethean Ambitions*, describes how alchemy was felt to be an art that had dangerous powers to exceed or better the processes of nature.[33] The earth naturally created precious metals, and the womb the child, but alchemy presented the possibility of doing both of these things artificially, better and faster, in the workshop. Some alchemists, including Paracelsus, believed that it was possible to grow a living human fetus, or homunculus, from semen in the alchemical workshop, using a glass flask as a pseudo-womb.[34] This belief stemmed from the Aristotelian rather than the Galenic theory of conception, which taught that male semen was the sole creative faculty in human generation and that the woman contributed only matter.[35] Within this system, it was entirely feasible for the wonderfully creative semen to produce a child without the womb—such children might even be bet-

ter, purer, or more powerful because they were not subject to the female body's corrupting influences.[36] But Paracelsus was not the only one to experiment with the combination of alchemical and human generation. The alchemist Anna Maria Zieglerin claimed to have invented an alchemical oil that could promote generation and nourish the child both before and after birth.[37] Tara Nummedal suggests that Zieglerin's unique approach to human/alchemical generation had much to do with her gender. Fighting for legitimacy in a discipline heavily dominated by men, "rather than claiming to *be* an alchemist, she presented herself as alchemical vessel and the chosen companion of an adept of mythical stature."[38] Zieglerin alleged that she had physically enacted a version of the symbolic alchemical union with a powerful alchemist husband whom she made up for the purpose. Her body became a mingling of the womb and the alchemical flask, her children a mingling of the human and the humorally balanced, perfectly healthy, and immortal alchemical quintessence.

While it is not likely that many viewers of Rösslin's birth figures in England would have been familiar with Zieglerin's boundary-crossing body knowledge, both the birth figures and Zieglerin's experiments sprang from the same culture in which the flask and the womb were not just similar but tied so deeply by the power of generation that they could blur into each other. For the alchemically literate, birth figures would have been understood as a multifarious symbol of the generative faculty in the womb, in the world, and in the alchemist's flask, and thus they symbolized the principle of generation itself, the power that spurred the turning of the universe.

The Birth Figure and the House

Along with the field and the workshop, the house was a site of rich generative analogy—indeed, for most women viewers, it was perhaps the most important context for analogical readings of the birth figure. Women's chores such as bread and cheese making were common analogies for conception and fetal growth, and the state of pregnancy was widely associated with a wife's duties in hospitality and housekeeping.[39] Many historians have described this system of analogy between the body and the domestic environment,[40] not least Mary Fissell, who writes that the "material realities of day-to-day existence provided a convenient and persuasive analogy for the human body."[41]

Fetuses were regularly described in midwifery manuals as miniature people with agency, who lived in a human relation to the womb, described as a room or cottage. Indeed, it was common in this period to envision

the pregnant body as a house, in which the womb was a private cham-
ber or secret box, housing the inaccessible and much prized fetus. Jakob
Rüff, for instance, describes how "after the third and fourth moneth from
the conception, the Infant doth begin to move and stirre himselfe in the
wombe, and somewhat to display and stretch out himselfe, and also to
enlarge and amplifie his narrow little Cottage."[42] This fetus is the same
autonomous little being found in so many birth figures, and the womb
his "little Cottage." Rüff describes a moment of transition in a pregnancy,
at which the fetus becomes personified, endowed with individuality and
humanity. This transformation was an important one in an early modern
pregnancy. In both theological and medical as well as domestic discourses,
three significant points were associated with it: the complete bodily for-
mation of the fetus; ensoulment; and quickening. While debates raged
about the exact timing of these points, they were linked in their association
with the personification of the fetus.

Formation, or the point at which the fetus reached physical perfection,
though not full size, was identified at varying stages of pregnancy. The pre-
formationists argued that the fetus was fully formed from the moment of
conception and just grew over the course of a pregnancy. Epigenesists, on
the other hand, believed that the fetus developed into human shape during
early pregnancy.[43] One popular theory, dating back to Aristotle, linked
formation with ensoulment, arguing that the body could not gain a ratio-
nal or human soul until it had, in the words of Ambroise Paré, "obtained a
perfect and absolute distinction and conformation of the members in the
wombe."[44] In the early modern period, it was widely understood that Aris-
totle placed this point for boys after forty days and girls after ninety, the
difference accounted for by their different levels of heat.[45] Some medical
writers stuck faithfully to Aristotle's timings, following a long tradition of
the incorporation of ancient medical learning into both Christian theol-
ogy and contemporary medicine.[46] Some religious writers of the period
were disinclined to put such exact numbers to the process: John Oliver,
for example, in his spiritual guide *A Present for Teeming Women*, called it
"too wonderfull for me."[47] Indeed, ensoulment, like formation, could be
identified at any point from conception to birth, though some time during
pregnancy, and perhaps at the moment of formation, was the dominant
stance in the medieval and early modern West.[48]

Some early modern midwifery and medical authors were purposefully
unspecific about the exact timing of formation and ensoulment because
these milestones could not be observed. For them, it was quickening—the
point at which a pregnant woman first feels the fetus move inside her—
that was the most crucial point. While the writings of classical authori-

ties such as Aristotle, Galen, and Hippocrates continued to have great academic capital, they were not so practically useful because accurately dating conception was essentially impossible.[49] Quickening, on the other hand, was not only understood as a concrete milestone in pregnancy but often conceptualized as the point at which a woman could be more certain that she *was* pregnant. For many this added certainty went hand in hand with an inclination to now see the fetus as an individual, a presence, an ensouled human. And quickening had the added advantage for pregnant women of giving them authority over their pregnancies, as only they could sense it.[50] Thus, while male medical authors, including some midwifery authors, sought to cast doubt on the reliability of quickening, it remained (and indeed remains) culturally important as a pregnancy milestone.

So we can say, in this period, there was a transitional moment that might be identified as formation, as ensoulment, as quickening, or as a combination of these. Often at around three or four months, as the pregnant body begins to "show" and the fetus to make its first movements, it went from something uncertain, unformed, still growing and dependent on the mother, to an individual, an ensouled child.[51] As well as showing fetal presentation at the time of birth, for many women viewers birth figures might also have worked as expressions of this great status change. As they became more confident that they *were* truly pregnant, the birth figure seems to embody this certainty, to confirm the presence of the child. Indeed, taken in complete sets, birth figures expressed fetal activity, movement, position changes—the kinds of pokings and rollings that become a part of the experience of pregnancy after quickening.

To return to the quotation from Rüff, the birth figure could also be interpreted more specifically as expressing this moment of stretching out, in which the fetus not only becomes active but molds the womb into "his narrow little Cottage." The spacious womb could be understood as an intentional representational technique aimed at endowing the fetus with a human status, showing it living not covered tightly but in a more human-scaled relation to its environment.

As Fissell shows, the fetus was thought of not just as a miniature human in a domestic environment; he was a houseguest, and the mother was both housewife and house. Fissell argues that "the fetus was imagined as a sort of guest within the mother's body, and it was her job to provide appropriate hospitality to it, just as she would in her own home."[52] This domestic narrative was often used to explain the onset of labor. The womb, the cottage or room of the fetus, would become insufficient for it as it neared full term. The mother would begin to fail in her ability to give the fetus enough room and enough nourishment, and the amniotic fluid (which

was thought to be composed of fetal urine and sweat) would become too oppressive. So like a disgruntled houseguest dissatisfied with the hospitality provided, the fetus would leave. In *The Compleat Midwifes Practice* this process is described: "The third [reason for labor] is the narrowness of the place where the infant lies, so that he is forced to seek room other-where, which makes him to break the membranes wherein he was contained, pressing and constraining the mother by the sharpness of those waters, to do her duty for his release."[53] This understanding of the mother's duties of hospitality toward the fetus, and of the fetus as a human guest with an awareness of its own needs and the ability to leave if they are not met, is reflected in birth figures. The fetuses are endowed with indications of consciousness: in their often-expansive gestures; in the twins' seeming companionship; and in the way that many look downward with fixed or earnest expressions at the cervix, indicating their intention and contemplating their escape (see figures 4 and 5). Indeed, as often as the maternal body was thought of as a house in this period, it was thought of as a prison. So one Scottish writer, James McMath, described childbirth as the fetus "having thus escaped from its *Prison* through *Nature's* triple *Gates*, . . . it appears a new *Guest* upon the World."[54] The womb becomes a prison as the fetus grows, the cervix and vagina the gates it must escape through to become a guest no longer upon the microcosmic maternal body but upon the macrocosmic world.

The personified fetus that we see in birth figures, therefore, was part of a larger system for thinking about the unborn child that helped to explain the internal mysteries of conception, pregnancy, and labor. Thus women were able to adjust their picture of their unborn child as it grew, from something that might be false or monstrous or might simply slip away, to a viable infant. In labor too, the personified fetus helped women to understand their bodily processes. Although it was well understood among midwives that the mother also worked at a labor, a narrative that personified the fetus allowed people to explain difficult deliveries and stillbirths.[55] If the fetus was weak or not ready, a labor would take longer, more so if it had died in the womb. Thus, the mysteries of lingering labors could be rationalized and even blamed on the strength and willingness of the fetus.

From conception to birth, analogical thinking provided a framework for visualizing and understanding the pregnant body. In itself a visually inaccessible and mysterious process, pregnancy could be understood through knowledge of the world. This system allowed people of all skills and conditions to acquire knowledge about the pregnant and laboring body and abilities to treat it. These little images facilitated all kinds of analogous thinking; in their iconographic simplicity they accommodated

many meanings. They indicate that pregnancy was a condition that echoed throughout the spheres of the macrocosm, finding correspondences between body and world that illuminated both.

The image stands for us, too, as a reminder of the richness and pluralism of early modern systems of knowledge. The alchemical, the medical, the astrological, the agricultural, and the domestic were not fundamentally separate ways of knowing—they bled into and informed each other for a culture that expected order and correspondence from the universe. For the early modern person, the birth figure was an emblem of the universe, the lynchpin of life and creation, the innermost point in the great concentric spheres that made up the analogical worldview. For us, it should stand as a reminder both of the complexity, pluralism, and creativity of early modern natural philosophy and of what we miss when we produce histories that are driven by notions of progress and bounded by notions of disciplinarity.

The Birth Figure and the Mother

Print in the early modern period had power. It had power in ways that we recognize from our own culture: in disseminating and shaping knowledge, in allowing disparate people to work with the same visual information, in producing authority.[56] But it also had power in ways that we associate less readily with the reproducible image. As has been argued by Ed Wouk:

> Whereas cultural theorists have paradigmatically ascribed to reproduction the effect of emptying out content and meaning, early modern beholders appear to have maintained the opposite, interpreting the imprint of the intaglio or relief press and the act of dissemination as authorizing processes that imbued the multiple image with transcendent value. The fact that an image could now exist in multiple may have changed modes of viewing and perception, yet, far from diminishing the "aura" of the work of art by stripping away its "authenticity" and "individuality," the printing press built upon and even enhanced the cultic status of images put to a vast range of uses.[57]

In the sixteenth and seventeenth centuries, the image that was made mechanically through impression and could be produced in multiples was remarkable, exciting, and powerful. Print scholars have, in recent years, challenged the extent to which Walter Benjamin's notions of art and mechanical reproduction have been applied to the early modern period.[58] Sean Roberts, for example, notes that the very newness of printing techniques gave them an aura—an almost magical status.[59] And while *we* often

consider printed images as limited in size, texture, tonality, and color, for the early modern viewer, such images were expressive of an entire vibrant sensorium, evoking sound, movement, and color.[60] But not only were they experientially rich, that richness gave them a real power to impress ideas, knowledge, and inclinations on the viewer's mind.[61] In the second part of this chapter, I address birth figures as images that had an aura and a real power to shape the minds and bodies that engaged with them. Looking at these images less as conduits of medical or natural philosophical information, and more as agents of bodily shaping and healing, gives not only a fuller picture of how print worked in early modern culture but also a glimpse of the kinds of viewers often lost to histories of medicine—in this case, pregnant women themselves.

Print in the early modern period is often thought of as a technology that propelled early modern culture toward "modernity," particularly when it came to science and medicine.[62] While much work done along these lines is both valuable and important, the assumption has led to a narrowing of how early modern print is understood. Medical illustrations, for instance, are often interrogated for their power to influence abstract learning or material practice, but they are less often thought about as being materially or magically powerful in themselves, as agents that can directly affect the world. Particularly with images that are not explicitly religious or occult, we are neither culturally primed nor academically inclined to see such power. Yet it is something that we must take seriously, both to understand what birth figures did for early modern viewers, and to understand the role of the visual in early modern culture.

Maternal Erasure

In the case of birth figures, our understanding of their role in early modern culture has been further constrained by some widespread anachronistic analysis, employing what I term the "maternal erasure" theory. The earliest histories that addressed birth figures tended to dismiss them within teleological frameworks of medical progress. From the 1990s, some historians took a wider view, questioning the importance of such images for cultures of pregnancy and childbirth. However, these historians tended to conclude that the images worked, as Karen Newman has argued, to "suppress completely fetal dependence on the female body by graphically rendering that body as a passive receptacle, the scriptural woman as 'vessel.'"[63] Visually, these historians have suggested, birth figures worked to deny women agency, importance, and even the rights of personhood in the process of pregnancy and birth. Linked to this was the rise of the idea

of the fetus as a rights-bearing individual—in Eve Keller's words, "the paradigmatic Enlightenment hero, a self-directed, rationally ordered, thoroughly modern individual."[64] Birth figures, within the "maternal erasure" framework, were images that helped doctors and other educated male viewers to disempower women and to reframe pregnancy from a process in a woman's life to the gestation of an assumed-male child.

However, this "maternal erasure" analysis grew directly out of feminist scholarship's attention to new cultural phenomena, including antenatal ultrasound, debates around women's bodily agency, and so-called "pro-life" campaigns in Europe and the United States from the 1970s. The contemporary loss of authority and agency for pregnant women with regard to both their medical treatment and their civil and political rights has been crucially informed by this theory of "maternal erasure," and indeed the use of fetal imagery that denies the presence of the maternal body has been central in disempowering women and recasting them as "environments" for the fetal person.[65] But when this theory, based in modern political and visual culture, is applied to early modern images, it renders parts of their history invisible and anachronistically reframes others.[66]

The "maternal erasure" theory, for instance, assumes that an early modern image of a fetus must have been a political object, a means for making "scientific" arguments, and a tool for controlling women's bodies, in the same way that it would be today. It also pits men against women, dividing them into male medical agents and female passive objects in a way that ignores the diversity of early modern medical practitioners and the authority that early modern women held over their own bodies. The self-assured, enlightened man midwife whose medical authority overrides and makes passive maternal agency and the maternal body, an idea often found in "maternal erasure" analyses, was simply a textual fiction in the seventeenth and even the eighteenth centuries. Some male and medically trained midwives may have *wished* for patients who were docile and obedient, always submissive to their expert opinion and compliant with their interventions, but this was not the way that any medical practitioner interacted with patients before the nineteenth century. The passive, objectified body of institutionalized medicine, the subject of the Foucauldian medical gaze, had not yet arisen.[67] Some male medical practitioners may have had ideas about the passive maternal body, but none experienced it in practice. People in this period had a much greater level of authority over their own bodies, the nature of their ailments, and their treatment needs.[68] Our more recent histories of etherization, caesarean sections, and hospital births seem to have, to some degree, erased this awareness from our perceptions of early modern so-called "man-midwifery."[69]

In fact, until the nineteenth century, man midwives were admitted to the lying-in chamber only on sufferance. If they did not adequately listen and respond to the wishes of the laboring woman, her family, and even the attending woman midwife, they would not be permitted to practice. Often what they were allowed to do was limited by issues of propriety, and they regularly found themselves adapting the way they approached and explained a labor to the modes of knowing that were familiar to the women involved. Barbara Duden has suggested that "mothers seem to have been the real opponents who meddled in the trade of the *medicus*, since their presence extended right into the sickroom, even if the doctor was there."[70] This, of course, was particularly the case for childbirth, which had always been the province of women healers.

Percival Willughby, for instance, records many and various instances in which other authorities overrode his own. Of one laboring woman, whom Willughby describes as a "Lady, and Kinswoman," he reports, "shee would not hearken unto my desires, and shee gave too much belief to foolish women, that were about her."[71] Especially in childbirth, male practitioners and authors had to accept that "midwives will follow their own wayes, and will have their own wills."[72] Willughby's assessment demonstrates an acceptance of women's authority in childbirth, in which the opinion or advice of midwives was often privileged above that of doctors or family members. Laboring women, too, were expected to speak authoritatively about their own bodies in a time in which physical and visual examinations were far from routine and much diagnosis was conducted on the basis of patient testimonial.[73]

An early modern medical man, therefore, may have looked at a birth figure and seen the maternal body rendered as passive vessel, the fetus as agent. This may have chimed with some wishes he harbored for medical authority over and deference in his women patients. But it cannot have been a widespread interpretation, or one that reflected the practitioner's actual experience of pregnancy or childbirth. The maternal body was too present, the mother and her women attendants too authoritative, and crucially, the maternal body was still firmly the more valued in cases where the midwife had to choose between the life of the mother and that of the child. It was still women who were delivered, not their babies. It is crucial to acknowledge not only that the power of "maternal erasure" in the early modern birth figure was marginal, but that their much stronger capacity, and what made them so generally popular, was their ability to augment the maternal body and to render it powerful.

In the female space of the lying-in chamber, the maternal body in all

its physicality was the very center of attention. For midwives, it was their major professional concern. As Gowing notes, midwives expected the women they attended to be strong and work hard in childbirth.[74] Thus, we should not see these images, as Keller suggests, as "fully dissociated from the *materiality* of the woman's body."[75] Rather, we can understand the absence of the pregnant body from birth figures in terms of Baxandall's idea of complementarity: "The best paintings often express their culture not just directly but complementarily, because it is by complementing it that they are best designed to serve public needs: the public does not need what it has already got."[76] In the seventeenth century, the pregnant body was more impenetrable and more mysterious than it is today. Pregnancy was identified later, and with less certainty. Even a "great belly" was no guarantee of a child. As the author of *The English Midwife Enlarged* describes: "there are several sorts of great bellies belonging to Women, as hath been said before; there are your natural big bellies which contain a living Child, and those may be called true ones, and others unnatural, or against nature, in which, in lieu of a Child, is engendred nothing but strange matters as wind mixed with waters, which may be called dropsies of the Womb, and false conceptions, and Moles or Membranes full of blood and corrupted seed; for which reason they are called false great bellies."[77] The belly was a place of inherent uncertainty, which could not be tested or known. People understood that a supposed pregnancy could end in a number of ways, only one of which was the birth of a living child.[78] Even during labor, the body was mysterious, not visually accessible as women gave birth clothed and covered in sheets. Typically, only the midwife was allowed to touch the belly and genitals of the laboring woman, so the functions of the body remained a black box for most people. Only when labor was finally over would people know whether the pregnancy had been "true" or "false."

Birth figures, therefore, provided what women did *not* have: a picture of what was inside. As Baxandall argues, images are not mirrors of culture: they must be understood not as objective historical records but as participants in that history's culture. Birth figures, by focusing only on the womb and fetus, provided a kind of window into the physically present but opaque pregnant belly—they enriched and supplemented the already complex thinking about the fetus *in utero*, giving a glimpse at what the body guarded and kept secret. In the context of the lying-in chamber and communities of women viewers, these images did not deny women's agency but instead enhanced the viewer's knowledge of women's bodies and mollified fears about the labor's outcome.

Thinking of Wonders

Percival Willughby gives a unique insight into how pregnant women may actually have understood birth figures, describing not how he thought the images *should* be used, but how he saw midwives and women actually using them: "all the schemes, and various figures, on which midwives look, making their women to think of wonders, by shewing them these pictures of children, assuring them, that, by these, they bee directed, and perfected, and much enlightened in the way of midwifery."[79] Willughby describes midwives bringing midwifery manuals into the lying-in chamber and showing the figures to the laboring women and other attendants. These images function, he says, as a kind of visual certification for the midwife's skills—they show the laywomen the special knowledge of the body and the fetus that the midwife has. While for some midwives, birth figures functioned as practitional keys, mnemonics, and instructions, for many women they were images with a different message: symbols of expertise and rarefied knowledge, offering comfort in a time of pain and uncertainty.

The phrase "to think of wonders," used by Willughby to describe the purpose of birth figures in the lying-in chamber, is a significant one. As Lorraine Daston and Katharine Park have demonstrated, the word *wonder* could have a multitude of different significations in this period. Wonder could mean, "depending on context, a prelude to divine contemplation, a shaming admission of ignorance, a cowardly flight into fear of the unknown, or a plunge into energetic investigation."[80] These reactions depended much on who the viewer was: what might strike fear or awe into an uneducated person might spur an educated one into investigation, for instance. Willughby's use of the word is, I suspect, rather disparaging, suggesting that midwives used birth figures to dazzle the women they attended, using the women's ignorance to produce an unquestioning wonder and to claim special or mystical knowledge that the midwives themselves did not really have. But the same showing of a wondrous image could be seen in another light: as an effort to reassure and comfort pregnant women, to explain the position of the infant and the maneuver for delivering it, or simply to replace a fear of the unknown with a wondrous peek at the bodily interior.

Lianne McTavish has noted the strange contradiction, that birth figures sent "discrepant messages, alluding to both danger and health, dismemberment and vitality."[81] These are images of dangerous malpresentations, they illustrate cases in which pain and the risk of death are greatly increased, in which fetuses lie in positions in which they cannot be born, and in which they may well die undelivered. Yet the often-serene facial

expressions, the floral openings of Rüff's images, and the way the fetuses seem to slip, fall, swim, or be poured from the womb evoke natural, successful, and noninterventionist labor. This inherent ambiguity is perhaps a key to why birth figures were so popular. For the midwife, they gave valuable information about fetal presentation in a crisis, while for pregnant and laboring women and their attendants, these images were perhaps most commonly symbols of expert knowledge, wondrous peeks inside the opaque and mysterious body, and expressions of fetal health and liveliness. Indeed, as well as reassuring the laboring woman of the special skills of her midwife, birth figures present a positive and encouraging view of the *child*. On the most fundamental level, they present a picture of what could not be seen and what was, until birth, always uncertain. A birth figure gave a picture of exactly what most women in labor hoped for: a healthy, active, well-grown boy child.[82] Barbara Duden has argued that *all* images of the unborn produced before Samuel Thomas Soemmerring's *Icones Embryonum Humanorum* (1799) "did not represent the tissue inspected by the anatomist as a 'fetus,' but rather as the symbol and emblem of the child-to-be."[83] While this may be too blanket a statement, particularly given the earlier embryological investigations by anatomists such as William Hunter and James Douglas, Duden's argument that in general there was no fetal image-form before the nineteenth century is significant.[84] For medical professionals, and particularly for pregnant women, thinking about and visualizing the unborn was an exercise in positive speculation, in conjuring up the child-to-be.

Understanding birth figures as reassuring epitomes of fetal health and well-being elucidates some of the representational conventions they employ. First, the fetuses in birth figures are usually identifiable as male. Boys in the seventeenth century were not only typically socially and culturally preferred but also considered biologically more perfect. As Thomas Laqueur argues with the "one-sex model," until the mid-eighteenth century, "there had been one basic structure for the human body, and that structure was male."[85] While it has become clear, since the publication of Laqueur's *Making Sex* in 1990, that the one-sex model did not universally apply to early modern understandings of the body and gender, it is an idea expressed in many midwifery manuals of the period.[86] Jane Sharp, for instance, explains how the "whole Matrix considered with the stones and Seed vessels, is like to a mans yard and privities, but Mens parts for Generation are compleat and appear outwardly by reason of heat, but womens are not so compleat, and are made within by reason of their small heat."[87] The female body was, within this framework, only an inferior and imperfect version of the male: a body lacking the heat to extrude its genitalia.

Because the female body was inferior rather than dimorphic, the conception of a boy proved that the child was strong and healthy. Moreover, it also stood as testament to the vigor and health of both parents, who were able to produce a boy child. Many midwives took this preference for boys even further, arguing, as Jane Sharp did, that "a Boy is sooner and easier brought forth than a Girle; the reasons are many, but they serve also for the whole time she goes with Child, for women are lustier that are with Child with Boys, and therefore they wull be better able to run through with it."[88] Thus, an image of a boy child was, for the viewing mother, a picture of her own health and that of her child, and a promise of easier labor.

Second, the fetuses in birth figures are not fragile scrawny neonates but chubby active toddlers—they look like *putti*. Like putti, they are sweet, endearing figures with earnest or cheerful expressions, and if putti frolic, float, and fly, so fetuses in birth figures float and flip in the waters. Lianne McTavish has suggested that fetuses were represented as *putti* because that is what artists were trained to draw.[89] Indeed, given the lack of an actual model to draw from, the many pattern books and drawing guides that showed *putti* striking various poses may well have been an important resource. However, the similarity was surely not *just* an accident of style, but an active choice to present viewers with a reassuringly healthy picture of the infant. Representations of the fetus *in utero* have always been idealized: from the tiny fully formed men of the medieval manuscript birth figure; to the fetuses in twenty-first-century medical illustrations represented as clean, dry, calm, white babies, already chubby and flushed a healthy pink.[90] The early modern visual association of the fetus with putti and cherubim implied not only that the fetuses were living and healthy, but that they were innocent, perfect, and wise, as well as cheeky and playful. Indeed, as Alexander Wragge-Morley has shown, idealizing practices in epistemic image-making were extremely widespread in the seventeenth century, even amongst the Baconian empiricists of the Royal Society.[91]

Putti were a common decorative element in early modern visual culture—from oil paintings and tapestries to frontispieces and furniture.[92] But as Charles Dempsey has argued, a putto could also contribute to the meaning of an image, symbolizing all kinds of things or enacting the behaviors and relationships of adults. Putti had an "iconographic fluidity" and "an almost musical purity and directness of expression."[93] John Heilbron's study of putti in scientific illustrations, for instance, demonstrates how they were used to "domesticate" new techniques and ideas. He argues that "playful small angels demonstrating the laws of optics or working an air pump might indicate the harmlessness, innocence, and correctness of experimental natural philosophy."[94] Putti not only associated natural

FIGURE 11: Anon., [Initial "I"], woodcut, 4.1 x 4.1 cm. From Andreas Vesalius, *De humani corporis fabrica libri septem* (Basel: I. Oporini, 1555 [1543]). Medical (Pre-1701) Printed Collection 2500b, University of Manchester Library, Manchester. Copyright of the University of Manchester.

philosophy with pleasure, amusement, youthful mischief, and love but also embodied the ideal infallible experimenter. In medical books too, we find them working not only as decoration but as agents in the production of knowledge. One of the woodcut initials from the 1555 edition of Vesalius's *Fabrica* depicts a group of putti taking the place of the midwife and gossips and attending a woman in labor (figure 11). They gather around the adult woman, who sits in a birthing chair, protected by a curtained canopy. Two putti carry a large basin, two more comfort and encourage the woman, and a fifth kneels before her, playing the part of the midwife. The set of initials used in this edition of the *Fabrica* show putti enacting all sorts of adult and medically themed activities combining amusement and playfulness with the sense of an infallible ideal suggested by Heilbron. In the "I" initial particularly, there is something apposite about their atten-

dance at a labor, bringing pleasant and reassuring associations, as well as offering an idealized model for the actual infant around whom the image is built but who is yet to arrive.

Given the putto's widespread employment as an amusing, endearing, idealized representation of many aspects of life, it is easy to see how it could be a valuable iconographic element in the birth figure. It replaces the fragility, uncertainty, and vulnerability of the actual fetus and newborn infant with a picture of health, activity, wisdom, playfulness, and perhaps angelic immortality. The fluidity of meaning ascribed to putti by Dempsey is, indeed, similar to the fluidity of meaning that I have identified in the birth figure. The early modern viewer, looking at the fetus-as-putto, would have been free to see the microcosmic man, or the alchemical white stone, or the ideal and much-hoped-for child.

Prayer

But this seeing of the ideal child was not just encouraging for women; it also had the power to materially shape their unborn children and protect them during labor. Birth figures may, for instance, have been used as focuses for prayer and supplication. Walter Melion describes the widespread practice of using images as focuses for devotional meditation. He argues that images could effect a kind of bodily transformation: "the spiritual process whereby pictures are taken in by the eyes and then taken up by the soul, wherein they are imprinted and transformed."[95] The image guides and aids in a moving of the soul toward holiness or resemblance to God. For pregnant women, such devotions could be aimed toward preparing their souls for the possibility of death, preparing their bodies for the trials of labor, or shaping and protecting their unborn children.[96]

After the Reformation, prayer and the use of images were fraught topics across Europe, and practices varied widely. In early modern Italy, the visual culture of infancy included not only putti but also angelic cherubim and holy infants such as the Christ child and John the Baptist. Images of the Madonna and Child and the Birth of the Virgin were common not only in churches but in domestic spaces, where they helped women to frame their maternal and religious duties and acted as aids to prayer.[97] Dolls of the infant Christ were also often part of a woman's trousseau. Dressing, kissing, and playing with such dolls helped young women to envisage themselves as mothers, to enact their devotion to Christ, and to pray for healthy boy children.[98] But it was not just infants that formed part of this religious visual culture; fetuses were also in evidence. Paintings of the Visitation sometimes showed the fetal Christ and John the Baptist encircled and

superimposed on their mothers' bellies in an iconography redolent of the birth figure. Sculptures of the pregnant Virgin also sometimes opened up to reveal the fetal Christ, or incorporated glass windows through which he could be glimpsed.[99] The desire to see inside the pregnant body was manifested, therefore, in both religious and medical visual culture through a shared iconography. In both, the mysterious and impenetrable maternal body is augmented by a framed and bounded peek at the fetus within, though Wiktoria Muryn has recently argued that in the case of Visitation images, this should be understood less as an interest in seeing the anatomical interior, and more as a thinking through of spiritual embodiment and the theology of the Eucharist.[100] Indeed, rather than being physically opened up, as in the visual culture of anatomy, these images provide a miraculous and noninvasive kind of looking. In Visitation images, the frames that contain the fetuses could be round, oval, or almond-shaped. They could point toward the literal framing organ of the womb, and also toward the iconography of the mandorla—an almond-shaped aura indicating the holiness of the risen Christ in medieval and early Renaissance art.[101] The visual resonances between birth figures, Visitation figures, and images of Christ in glory indicate the ways in which medical knowledge of the body could slip into religious knowledge, the birth figure becoming a devotional object, the fetus the infant Christ.

Over the course of the sixteenth and early seventeenth centuries, images and sculptures of the pregnant Virgin fell foul of both Reformation and Counter-Reformation censure, and mandorlas faded out of use. At the same time, the birth figure came to be more widely reproduced. Of course, this is not a story of one kind of image *replacing* another, though for some people the birth figure may have acted as a devotional substitute for suppressed images of holy pregnancy. Rather, it is crucial to remember the *overlap* of these iconographies that allowed them to resonate with each other throughout the period under discussion here.

In Protestant countries such as England, prayer remained absolutely central to the rituals of childbirth, but the use of religious images was more contentious.[102] Traditional narratives of the English Reformation have assumed that the country became rapidly and comprehensively iconophobic, stripping itself of the visual culture of the Catholic church.[103] Indeed, the whitewashing of churches and the destruction of icons were widespread, but as some more recent studies have shown, religious visual culture never actually went away.[104] Many whitewashed churches retained their stained-glass windows, for instance, and kinds of religious images that were removed from churches remained acceptable in domestic spaces and even private chapels. While certain types of image—such as Christ on

the cross or the Madonna and Child—were censured for their associations with idolatry, others either endured or were developed to take their place. Figures from the Old Testament, Bible story illustrations, and images of the Holy Family, as well as religious-adjacent themes such as allegorical figures and "ages of man" cycles, all formed part of the print culture of England in the late sixteenth and seventeenth centuries. While the most puritanical shunned all images, most English Protestants would have felt no compunction about pasting such a printed image on a wall or looking at the stained glass in their church. It was primarily the worship of images that Protestants were meant to avoid, though even this was hard to define and to control among the general population.

Some people remained staunchly Catholic throughout the long Reformation in England, treasuring forbidden icons and images and conducting secret masses. Others adopted the new faith but adapted it to meet their own needs and devotional habits. The lines between contemplation of an image, prayer directed by it, and worship of it were blurred and probably mattered much less to the average woman than they did to the period's clergy and theological writers. Thus, for English women, birth figures may have offered a focus for prayer simply as encouraging images of a healthy child. They may also have been interpreted as "safe" devotional images— ones that could be seen as the Christ child while also offering deniability and avoiding the hallmarks of the "popish" icon. Thus, they may have formed part of a general practice of visual deflection away from the overtly popish or superstitious. We might suggest, for instance, that where images of the Madonna and Child were deeply suspect, allegorical figures of Charity offered the same vision of maternal love, as well as obvious associations with the Virgin Mary, but without the taint of idolatry. The fact that appealing infants appear so frequently in early modern visual culture—from religious images to classical narratives and decorative designs, as well as birth figures—suggests that they were also interpreted in many ways and were generally appreciated and positive or pleasing symbols.

This kind of devotional use of nonreligious images is hard to trace with certainty, as firsthand textual descriptions of how early modern people understood and used printed images are thin on the ground. Moreover, the kind of devotional use of birth figures I am suggesting would have been expressly secret for some people, and unarticulated, even internally, for others. What it is important to establish, I argue, is that religious images were not isolated from visual culture, just as religion itself was not isolated from other frameworks for understanding the world.[105] In post-Reformation England, people were visually literate, attuned to nuance in the reading of images, and practiced in flexible interpretation.[106] Given

the importance of prayer in childbirth, the continued presence and use of religious images in this period, and the iconographic similarities between the birth figure fetus, the putti, and the holy infant, it is simply most likely that meditation, prayer, and devotion formed the response of some early modern viewers to birth figures.

Magic

All over Europe, the use of images as devotional aids and icons blurred into the use of holy relics, printed talismans, and charms. Holy girdles were popular relics for aiding women in childbirth, being passed down through families or lent out by churches and monasteries. The belts were wrapped around the belly of the laboring woman to ease her pain, forming part of a much wider culture of medical girdles. Parchment and paper girdles, printed and manuscript, were produced all over Europe in the sixteenth century. They incorporated prayers and other religious texts, images, and significant measurements (the length of the Virgin's foot, Christ's height).[107] Such texts and images had an immediate healing influence on the body, protecting it from danger and easing pain. The use of textual charms was common in the medieval period, where text would be worn, touched, and even washed off and drunk.[108] In early modern Catholic countries, printed images were touched, worn, and eaten to protect the body from sickness.[109]

While such practices were increasingly denigrated as "superstitious" over the course of the early modern period, and more rapidly in Protestant countries, their actual cessation was slow, especially among women, the poor, and those with little formal education. Moreover, paper itself as well as paper printed with images remained an important part of the household's toolkit of medical remedies and healing charms throughout the period. As has been noted by Elaine Leong and Simon Werrett, paper was a highly adaptable resource that could convey medicines to the body, be they material recipes or printed charms, and could be a medicine in its own right.[110] For most early modern women, therefore, print had a material power that could be framed in various ways, and it is entirely possible that birth figures were touched, kissed, or pressed to the body as healing or protective charms.[111] Indeed, the fact that most surviving first editions of *The Byrth of Mankynde* are missing their birth figures suggests that the images were understood to be useful outside of their role in illustrating a medical text.

The understanding of print's power existed in the massive gray areas in which magic and orthodox and heterodox religious practices met.

Early modern people lived in a world filled with hidden and mysterious powers—some were divine, some were natural, and others were demonic. Sorting them out was a never-ending problem, and answers were diverse, complex, and ever-shifting.[112] Bastions of masculine authority, including the church and the medical colleges, saw much magic and "superstitious" practice in many of the remedies women shared among themselves in the lying-in chamber.[113] That space of female authority, they felt, allowed for unacceptable slippages from religious orthodoxy into popish and magical practices. A desire to control these kinds of ambiguous medical/religious/ magical practices is what lay behind the English midwifery licensing system, which at this time was much more focused on making sure that midwives were upstanding and devout than that they were medically skilled.[114] However, it is not likely that women saw their traditional remedies with the same fear and suspicion. We may assume that women squared their use of relics, charms, and images with their theological convictions, particularly when they used them in the communal space of the birthing chamber. Thus, if birth figures could be devotional aids, they could also be talismans and charms. Indeed, the two uses cannot really be separated, so entangled were they in this period of medical pluralism and religious upheaval.

Maternal Imagination

The power channeled by a birth figure could come from various external forces—divine, natural, occult—but it could also come from the viewer herself, through the phenomenon of maternal imagination. In this period, marks and disfigurements, illnesses and character flaws in the child were routinely attributed to shocks, frights, or strong feelings experienced by the mother during pregnancy.[115] Such beliefs about the power of maternal imagination to impress and shape the unborn child lingered long and were still being actively debated by doctors in the eighteenth century and beyond.[116]

Early modern midwifery manuals tended to focus on the negative consequences of this bodily power—the potential for women to accidentally disfigure their children through looking at disturbing or shocking things, or not sating their cravings. The booming broadside market was also rife with reports of monsters born to uncareful, sinful, or simply unfortunate mothers—though whether such monsters were warnings from God, accidents of nature, or the consequence of maternal imagination was often up for debate.[117] However, there is evidence that maternal imagination was not just an uncontrolled power to be feared—it could be turned by women to the shaping of healthy, beautiful children. Indeed, Frances Gage has argued

that the use of all kinds of images as aids to positive maternal imagination was so widespread and well-known that it was rarely recorded, and so now goes underrecognized by historians.[118] There is also evidence of particular art objects specifically made as focuses for the maternal gaze. Morten Steen Hansen, for example, suggests that a sculpture of the Christ child by Paolo Bernini was made for Queen Maria Theresa because "it was important that pregnant women behold *noble and agreeable objects* as the sight of these would affect the child positively."[119] Katharine Park and Jacqueline Marie Musacchio have both pointed to Italian majolica tableware and painted wooden trays that were produced specifically for pregnant women and often featured putti as focuses for prayer and maternal imagination.[120] "By gazing attentively at these objects," Park argues, "mothers could literally shape their offspring, raising their chances of producing a well-formed son."[121]

The painted trays called *deschi da parto* were typically round and painted on both sides. The upper face would show a religious, classical, or domestic scene, often themed on pregnancy, childbirth, or the dynamics of marriage. In some cases, the reverse would be painted in a different style, showing robust and healthy putti in natural landscapes, holding cornucopias, toys, laurels, or coats of arms, or fighting, playing, or pissing. These figures were images of power, symbolizing the ideal child and focusing on health and playfulness, as well as future prosperity and fame; they were framed to provide a model for positive maternal imagination. They also share much of their iconography with birth figures. One *descho* attributed to Francesco del Cossa (plate 3), for instance, shows a chubby, healthy boy child. He also wears coral—commonly given to children to protect them from illness and associated with the Christ child—and he carries cornucopias symbolizing abundance.[122] The landscape behind him, and the way he is closely bounded by the rim of the tray, give the image the same microcosmic associations as a birth figure. Both tray and birth figure show the unborn child in the microcosmic bodily world, as well as the healthy, grown, ideal child in the macrocosmic one.

Musacchio also notes the significance of the placement of these images of infants on the *reverse* of the birth tray, which meant that in normal use they were hidden from view. Like the erotic paintings on the insides of Italian marriage chests, these images were specifically for married women and not the household at large.[123] Their hiding and deliberate revelation were part of what made them special and powerful. Revealing the infant on the reverse of the tray indicated the intention to meditate upon it, to hope for and shape the health of the unborn child. Birth figures, like these *deschi* infants, were also made special by acts of use. Opening the covers of these books of specialized knowledge, and revealing the images within,

would have had great ritual significance. Imagining a woman seeking out and contemplating a birth figure, perhaps in the company of her midwife, brings us back to Willughby's remark—that these images were valued because they made women "think of wonders." Those wonders were the ability to shape a child inside the body, to make it beautiful, healthy, and male—fundamentally, to take control over the terrifyingly uncertain processes of pregnancy and birth.

The fetuses in birth figures were also idealized in their whiteness. It is important to recognize that notions of race, and understandings of skin color, were very different in the sixteenth and seventeenth centuries. Particularly, what Joan-Pau Rubiés calls "modern 'scientific' racism" or "hard racism," which associated skin color with geographic and genetic origins and systematically hierarchized people along these lines, did not exist.[124] However, this certainly does not mean that discrimination according to skin tone and geographic origin was not widely practiced. Pale or white skin tone was seen as desirable by English people in this period, but the rhetoric was less fixated on the difference between white Europeans and people from other areas of the world. Rather, entangled notions of skin tone and complexion, which incorporated ideas about heredity, climate, and humoral makeup, made discussions of skin and race much more diverse and fluid.[125] "Fairness" in this period, as opposed to "blackness," might refer to beauty and to a good complexion and healthy humoral balance, as well as to a specific pale skin tone.

However, generation was one of the places where anxieties about race and skin tone did emerge in early modern England. The question of whether skin tone was hereditary or environmental raged and became caught up in anxieties over miscegenation and the demise of whiteness in Europe as travel around the globe, both voluntary and forced, became more common.[126] Maternal imagination, too, could affect skin tone, as was demonstrated in the famous frontispiece to many editions of *Aristotle's Masterpiece* depicting two products of it: a hairy woman and a black child. Indeed, the widely circulated image of the black infant, along with the story of the white couple who produced them when the woman looked at a painting of a black man during sex, is symbolic of thinking around maternal imagination.[127]

All birth figures in this period were produced by printing black ink onto white paper, and while this does not necessarily *explicitly* indicate that the fetuses are racially white in modern parlance, it does facilitate an easy association between white skin, white paper, and the standard, normal, or default body. Their paper-whiteness might have been simply a product of the printing process, or it might have been an active part of what made

the birth figure an ideal object for exercising positive maternal imagination. Of course, it is worth pointing out that white paper, white skin, and the color white are all tonally quite different, and each subject to great internal variation. But as Richard Dyer, among others, has pointed out, it was the rhetorical power of whiteness that made it such a valuable term for European skin. White had strong associations with virtue and cleanliness in the Christian tradition, which were readily adopted into a European identity. But as Dyer points out, white also indicates a blank or absence of color, which contributed to the development of the deeply ingrained notion of white skin as the standard, normal, even nonracial, from which all other skin tones are actively "different."[128] Thus the paper-whiteness of the fetus was the white of virtue, the white of European skin, and the white of potential—the blankness onto which the mother could imagine her ideally complexioned child.

Indeed, the power of the birth figure to shape the maternal body came not just from the image but from the medium. Analogy in this period worked to link different kinds of generative object. The link between the womb and the alchemical flask we have already seen, but the womb was also associated with the printing plate, both of which were called the "matrix." Thus, the making of a plate and the making of a child were aligned processes, something that Thomas Bentley makes explicit in one of his prayers for pregnant women:

> And as good Lord thou dooest me make
> thy shop, to shape thy worke therein,
> Thy hand-worke so doo not forsake,
> but end the thing thou dooest begin.[129]

The engraver or artisan, the pregnant woman, and God were all linked through their creative potential. Within this system the printed image was powerful, not only because it was the product of the creative matrix, but because it could in turn impress upon the maternal body.[130] Looking at a printed birth figure, the pregnant woman opened her body to an image that carried over the impression of its making into an impression of her own fetus's creation.

Print had powers to impress the mind, body, and soul of the early modern viewer. The power came from various sources and was explained in many different ways but formed a crucial aspect of print culture generally, and not just the religious icon or the magic charm. It is not enough, therefore, to say that birth figures were part of the culture of childbirth, or that they might have heartened and encouraged the pregnant woman.

These images were deeply entangled with the condition of pregnancy itself, shaping bodies as well as understandings of bodies in a culture that did not make such firm distinctions between the two.

Multifarious Birth Figures

The anatomical flap sheet titled *Autumnus* (figure 12) is one of four prints that describe the four seasons, four ages of man, and many other important

FIGURE 12: Anon., *AUTUMNUS*, *Four Seasons*, seventeenth century, engraving, 45 x 35 cm (plate), David M. Rubenstein Rare Book & Manuscript Library, Duke University.

early modern "sets" of information.[131] Watermarks on the paper date the only extant impression to 1680–1710, but the plates had been used many times before this impression was pulled. An analysis of the content of the prints dates their production to somewhere around 1640, and to England.[132] It is likely, therefore, that they were popularly available for much of the century and indicate both a general interest among laypeople in the body and health and the interconnectedness of modes of body knowledge.

H. F. J. Horstmanshoff, A. M. Luyendijk-Elshout, and F. G. Schlesinger describe the prints as "a kind of health calendar": a condensing of all the different types of knowledge that might inform the viewer about the body or aid in its treatment. They describe the "main themes" in these prints as "medicine, alchemy and astrology," but we also find horticulture, analogy, anatomy, uroscopy, zoology, erotica, palmistry, geography, and religious iconography.[133] The *Autumnus* figures are surrounded by calendars and volvelles; they stand in a luscious landscape, and each carries a urine flask. Everything in this busy print serves to instruct the viewer on the interpretation of the body and the world, how to read their messages and cure their ills. Both figures are composed of multiple superimposed flaps that show anatomical elements of the body. The woman's abdomen is made up of seven flaps that show her skin, womb, membranes, and the fetus she

carries. Such anatomical flap sheets were popular in this period, but what appears to be unique about this example are the twelve tiny birth figures printed on the paper support, beneath the flaps representing the anatomy of the pregnant belly. They are copies of Rüff's figures, migrated out of the midwifery manual and now to be found at the very root and center of the analogical woman.

These fugitive sheets, according to Horstmanshoff, Luyendijk-Elshout, and Schlesinger, "represent a kaleidoscopic bird's-eye view of medical and natural science in an age of transition from ancient tradition to modern science."[134] As such, the print demonstrates neatly the argument of this chapter: that birth figures were entangled with the many and various modes of knowing and treating the body that made up the pluralistic culture of the period. They were ubiquitous, they were receptive to all kinds of interpretation and appropriation, they did many things for many people and were fundamental to the period's body culture. In *Autumnus*, birth figures coexist with—literally inhabiting the same bodily space as—the anatomical, and they both reflect and inform the whole multifarious analogical world within and beyond the body.

Birth figures are images that, in their multiple interactions with body culture, challenge our assumptions about the body as a subject for historical study. They pull together types of knowledge that are more typically treated separately, and they bring to the fore types of popular body knowledge that are often eclipsed by medical innovations. To look at these images is to be confronted with what seem to us to be contradictions—images of medical practice, influenced by anatomy, that are also verdant and analogical, alchemical and humoral, even wondrous. Only by looking at these images as working simultaneously in multiple registers can we reconcile these seeming contradictions and gain a more thorough understanding of early modern body culture. The multiplicity, and the remarkably wide viewership, which makes it so hard to ascribe just *one* function or reading to these images, make them valuable sources for looking at a culture that was essentially inclusive, imaginative, and multifarious in its thinking about the body. Birth figures remind us that this was a period in which learned and vernacular, old and new, male and female ways of knowing met, interacted, and mingled at the site of the pregnant body. Just as the early modern woman could look at a birth figure as a window onto her own mysterious bodily interior, so we can approach these images as windows onto the rich and complex body culture of early modern England.

PART II

Birth Figures as Agents of Change

(1672–1751)

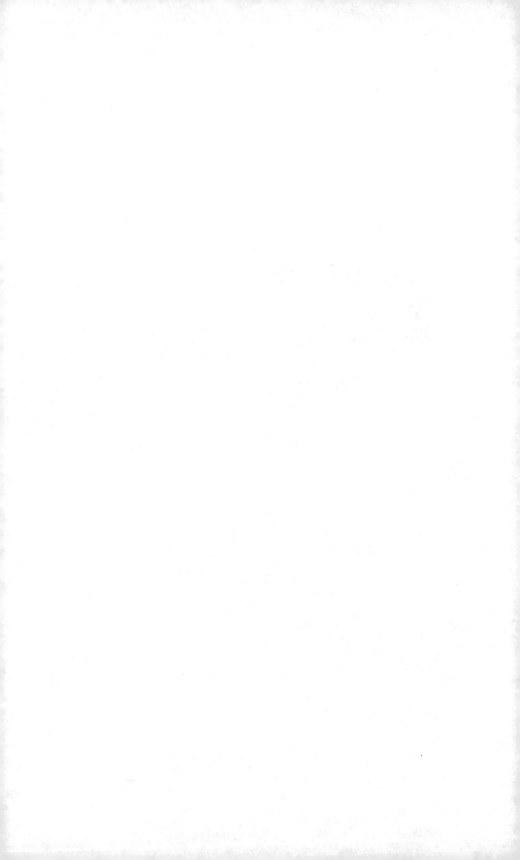

Visual Experiments

Starting in the late seventeenth century, birth figures began to change. Spines, pelvises, and placentae appeared in and around the balloon-like wombs. The practitioner's hand, touching, turning, and pulling, also entered the frame. Figures were rotated, spatialized, and exploded. Observational details proliferated, but at the same time aspects were abstracted and diagrammatized. Processes, movements, and the passage of time all became concerns of the birth figure. Most important, what had been a remarkably iconographically cohesive group of images suddenly diversified, becoming various and experimental, and personalized to individual authors and artists in an entirely new way.

The period of the late seventeenth and early eighteenth centuries was one of change for both the practice and the culture of midwifery, and birth figures offered a place for exploring and facilitating these changes. Part 2 of this book focuses on this period of change and diversification, giving attention to the birth figures produced by a new international cohort of ambitious, professionalized midwife-authors. Beginning, loosely, with the publication in English of Mauriceau's manual in 1672 and ending in 1751 with the publication of John Burton's manual *An Essay Towards a Complete New System of Midwifry*, this period was one of visual diversification in birth figures in England, largely driven by the importation and translation of continental books. It ends in the 1750s, as English midwifery authors themselves began to be renowned and exported—a period treated in part 3 of this book. Following the pattern of part 1, in this chapter I will explore the practitional implications of the newly experimental birth figure, before turning in chapter 4 to the wider cultural and social implications of the changing landscape of practice, and the role of birth figures in that landscape.

While the culture of midwifery changed slowly and sporadically over the course of the early modern period, a definite shift in the nature of

the birth figure can be identified with the publication in 1668 of François Mauriceau's *Traité des maladies des femmes grosses*. This book and its newly individualized birth figures changed the textual landscape of midwifery in many countries through export and translation, including England from 1672 (figures 13–16, 27 and 31).[1] Mauriceau's work was soon followed by others, including Cosme Viardel's *Observations sur la pratique des accouchemens* (1671, figures 22 and 28–29), Justine Siegemund's *Die Kgl. Preußische und Chur-Brandenburgische Hof-Wehemutter* (1690, figures 19 and 23–24), and Hendrik van Deventer's *Manuale operation* (1701, figures 20–21 and 25–26). All of these works were published in multiple languages, and the images they contained circulated even more widely through practices of copying. Part 2 of this book focuses on these authors and the images they commissioned, situating them in longer histories of the birth figure, wider histories of the representation and dissemination of knowledge, and contemporary cultural histories of the body and midwifery. While primarily focusing on the English cultural context, part 2 demonstrates the importance of studying print as an increasingly borderless culture, in which individual prints could have very local influences on culture, while also contributing to international and even global cultures of print and medicine.

Despite their innovations and their popularity in the decades around 1700 all over Europe, these images have received little study. This is, again, partly because they have been overshadowed by the visual culture of anatomy. From the last decades of the seventeenth century, anatomical illustration took a turn toward large, hyperdetailed, and naturalistic representations of body parts that argued for immediacy and "realness" in a new way. These included anatomical images of the fetus *in utero*, such as those produced by Gerard de Lairesse and Abraham Blooteling for Govert Bidloo's atlas, *Anatomia Humani Corporis* (1685).[2] A scholarly focus on this kind of image has led to a neglect of contemporary birth figures and an assumption that they were old-fashioned or less successful, rather than images that worked in completely different modes and to different ends. In the context of English midwifery, the disregard of these birth figures is exacerbated by the rise in the mid-eighteenth century of a dominant new style of midwifery illustration that was not imported from mainland Europe.[3] Works by William Hunter, William Smellie, and Charles Jenty, all published in England, are often seen as constituting a kind of golden age for British midwifery. Their images, which will be treated in chapter 5, are often characterized as being greatly improved and radically new—without visual precedent. This chapter reestablishes the cultural and practitional importance of the birth figures produced and used in the decades around

1700, both in their own right and as sources for the images produced later in the eighteenth century.

The birth figures produced for Mauriceau, Viardel, Siegemund, and Deventer experimented with the possibilities of what a printed image could communicate, and they helped to frame and define new kinds of midwifery knowledge. They are crucial to histories of midwifery and its visual culture, but they are also valuable sources in exploring the ways that knowledge changed and was communicated in this period more generally. They have much to say about the new philosophies of knowledge, new medical discoveries, and new cultures of reading and learning from books. The decades between the 1670s and the 1740s saw new frameworks for understanding the world and the body spring up and circulate—like birth figures, these ideas were diverse and experimental and were part of an optimistic drive toward professional improvement and general education.[4] This period is sometimes characterized as the "Early Enlightenment," and indeed some typically "Enlightenment" ideals of rationality, observation, and educational reform are in evidence in midwifery works of this period.[5] Not only did ideals from medicine, anatomy, and natural philosophy come to be assimilated into midwifery in a new way in this period, but birth figures contributed to the exploration and communication of these new ideals.

Women, Men, and Midwifery

Most histories of midwifery in the period treated here frame their discussion of changing knowledge and practice in terms of gender struggle and the rise of "man-midwifery." The earliest histories of midwifery tended to valorize the increasing involvement of medical men in childbirth, stringing together medical discoveries that improved outcomes and banished the "superstitious" and "irrational" practice of women.[6] From the 1970s, feminist counternarratives recast medical men as villainous, undertrained, and dangerous crooks and women midwives as providing safe, supportive assistance in a space of female empowerment.[7] These feminist histories provided a much-needed check to the teleological histories of medical "improvement," pointing to the loss of agency suffered by women in childbirth and of respected employment for women midwives, as well as the damage caused by the poor or experimental practice of "man-midwives."[8] Most recently, historians have come to see both narratives as extreme and to seek for a middle way. Lisa Forman Cody, for instance, accuses both approaches of "polemical and . . . deeply ahistorical notions."[9] Not only was the influence of medical practice more complex than these histories have suggested—bringing both good and bad to women's experiences of

childbirth—but it was also less tightly defined along gender lines than is typically assumed.

Yet the legacy of these polarized debates has been a focus on the "man-midwife," whether he is seen as medical hero, villain, or something in between. Studies such as Adrian Wilson's influential *The Making of Man-Midwifery* have explored the cultural shift that allowed men to become midwifery practitioners, overcoming social taboos surrounding men's attendance on women patients and the feminine nature of the work of midwifery itself.[10] Historians have posed various explanations for this surprising cultural shift, suggesting improved outcomes from the use of forceps and medical maneuvers, fashion and the attractive distinction that a male attendant offered wealthier women, and what Mary Fissell calls a new "Enlightenment concern for infant life."[11] What is certain is that men began to attend women in labor—for both normal and difficult cases—with increasing frequency over the course of the eighteenth century.[12] Men who practiced midwifery also began to publish treatises and manuals that offered to teach their specialist skills. And as training became more formalized, it was men who held the prestigious lecturing positions at schools and in hospitals. While it is well-known on the one hand that surgeons and physicians had always been consulted in difficult and emergency cases, particularly by the wealthy, and on the other that women midwives continued to deliver the majority of women throughout the eighteenth and even nineteenth centuries, the figure of the eighteenth-century "man-midwife" looms large over our histories.

Mary Fissell has also argued that our attention to the unusually meteoric rise of the male practitioner in eighteenth-century England has unduly influenced our wider histories of the cultural shifts in midwifery practice throughout Europe.[13] And even in England, a focus on textual sources has led us to overplay the importance of the "man-midwife." The manuals written by men, and the polemical pamphlets that argued for the danger and unsuitability of men's practice, have left us with the impression that "man-midwifery" was everywhere and was everywhere fraught with conflict and controversy. These texts tell us about an important political debate about medicine, knowledge, and gender in the eighteenth century, but much less about the actual demographics of practice, the gender division on outcomes for women and infants, or the experience of midwifery for most people in the period. As Monica Green argues, "we have perhaps focused too much attention on obstetrics as a site of combat between professional rivals ('male control' vs 'female control') and too little on obstetrics from the patient's point of view."[14]

While gender is an important factor in histories of early modern mid-

wifery, and while the existence of antagonism between genders is undeniable, professional struggles in midwifery were actually much more nuanced and various. Some women had high levels of medical training, while some men had no formal training or experience at all. Neither authorship[15] nor the use of tools[16] was actually restricted to men, and women were also often teachers through the old apprenticeship system, or through collaboration with male lecturers in private schools and hospitals. Moreover, while evidence from the polemical pamphlets of England in the eighteenth century suggests all-out war between men and women midwives, other sources indicate that women and men worked largely in collaboration, exchanging knowledge, sharing cases, consulting each other, and respecting different areas of expertise. Of course, such relationships could be tense and could flare into conflict, but there were also strong motivations for politeness and collaboration on both sides.[17] This kind of relationship of shifting deference and authority is to be found in the accounts of some male writers, such as William Smellie, who advised cultivating good relationships with midwives.[18] Indeed he denigrates one colleague who "thought himself above being in friendly correspondence with midwives, from too much self-sufficiency."[19] The consequence for this man was exposure and a court case for malpractice. Evidence of Eleanor Willughby shows how a midwife could acquire medical training from male family members while remaining part of the more trusted circle of women practitioners.[20] Relationships of respect and collaboration, as well as conflict, are also to be found in the accounts of women midwives, including the remarkably detailed diaries of the American midwife Martha Ballard.[21] In England, where there were no midwifery schools until the 1730s, men and women learned together through the same channels of apprenticeship, practical experience, and printed books.[22]

In this book, therefore, I use the hyphenated term "man-midwifery" sparingly, only to refer to the political debates that were undertaken in print from the late seventeenth century.[23] Outside of these, the term has come to refer to a caricature of the male practitioner that in turn caricatures the woman midwife, splitting men and women into learned and ignorant, wealthy and poor, authoritative and disempowered. While recognizing the absolutely crucial dynamic of gender in the history of midwifery, in this study I distinguish practice not along a gender line but along one of book use. It was engagement with the new kind of textual, professionalized, medicalized, and learned practice that most characterized midwifery in this period, producing two kinds of practitioner: "regular" and "emergency."[24]

Broadly speaking, most women midwives were "regular." They served

their local area and tended to be booked ahead of the birth, attending the woman for the entirety of her labor and often providing care during pregnancy and after delivery as well. Such "regular" midwives could, as Doreen Evenden has shown, be highly skilled, have served long apprenticeships, and be respected as skilled professionals by both their neighbors and parish authorities.[25] They did not, however, receive institutionalized medical training, and they might well call in a surgeon in a case of complicated or obstructed labor. Broadly speaking, most men midwives were "emergency": they had received some kind of medical training and professed some book-based expertise in midwifery. They served a larger area and attended births when a complication had arisen that could not be remedied by the regular midwife. However, there was no strict gender divide: some men practiced as "regular" midwives; lower down the professional ladder it could be combined with surgery and dispensing in a rural profession Roy Porter describes as a "proto-GP."[26] Some of these men midwives had little or no training or experience to qualify them for this particular work.[27] Some women, moreover, were highly trained, well-read, and medically knowledgeable emergency practitioners. These women sometimes gained their skills from formal, informal, or familial apprenticeships to physicians or surgeons, and sometimes they acquired their skills from books.[28] As Londa Schiebinger, among others, has argued, in science and medicine, a focus on universities, societies, and published material has led to the misconception that women were largely excluded from these disciplines in the early modern period.[29] Yet the fact that much experimentation in natural philosophy and practice in medicine happened in private and domestic spaces meant that women were often key contributors.[30] By making a distinction between "regular" and "emergency," rather than between women and men midwives, I aim to contribute to the wider and ongoing project of making early modern women experts more visible.

One further term will be used in the proceeding chapters to explore the new learned culture of midwifery: the "midwife-author." The midwife-author had practical experience of midwifery and an education that enabled them to write and publish guides and manuals for others to learn from. As noted in part 1, most manuals available in England before the 1670s were written by men who had medical training but little or no direct experience of midwifery practice.[31] The knowledge they provided was a combination of theoretical medical knowledge, practical medicines, and interventions described by women midwives. The new midwife-authors combined learned medicine with midwifery practice, and they used books to establish both the value of the new learned or "emergency" midwifery in the abstract and their own specific preeminence within the profession.

Again, midwife-authors were mostly men, but some women entered the fray, including Justine Siegemund, Madame du Coudray, Elizabeth Nihell, and Sarah Stone. It was these elite midwife-authors who drove the changes both in learned midwifery as a practice and a textual genre, and in birth figures. They form the core of this study, and as such present an elite, privileged view of midwifery as it was largely understood by educated readers and emergency midwives. However, in this and the next chapter, the analysis of birth figures through the intentions of their commissioning authors is balanced by explorations of the ways in which they may have been understood and used by those from the other side of the divide—the regular midwife and the pregnant woman.

Midwifery Manuals in Transformation

Midwife-authors brought together the two previously largely separate realms of learned medicine and midwifery practice, and they were able to do this largely because of a change in attitudes toward knowledge much more generally in the late seventeenth century. This period saw a general shift in focus toward knowledge derived from direct observation and away from adherence to established authority and medical theory. The rise of observation had a very long history and certainly did not begin in the late seventeenth century.[32] However, the ideals of empiricism and observation began to grow and become more widespread and institutionalized in this period: in histories of science, it is often characterized by the adoption of Baconian ideals by the early Royal Society. Charles T. Wolfe and Ofer Gal describe the rhetoric of empirical study on which the Royal Society was founded as "an open, collaborative experimental practice, mediated by specially-designed instruments, supported by civil, critical discourse, stressing accuracy and replicability."[33]

To say that empiricism and observation were rising ideals in the decades around 1700 is useful, but only insofar as we define what these terms *meant* at that time. Histories of science and medicine have themselves a history of assuming that such ideals are consistent over time, but in recent years scholars have begun to question this, arguing that scientific ideals are temporally, culturally, and geographically specific, meaning different things in different periods. Wolfe and Gal, for instance, emphasize the embodied nature of empiricism in the seventeenth century, that it "meant a new attention to the senses and their function from a physiological, practical and epistemological point of view, and all those were never far apart."[34] Alexander Wragge-Morley has shown how images made by these early Royal Academicians actually made use of various aestheticiz-

ing techniques.[35] This is all very different from our modern understanding of empiricism as something detached from individual subjectivities. Daston and Galison in *Objectivity*, and Daston and Lunbeck in *Histories of Scientific Observation*, have made similar arguments, looking at the different "epistemic virtues" associated with the ideas of objectivity and observation.[36] In the seventeenth century, such ideals were often much more situated in the skilled individual, and in the embodied senses combined with and regulated by knowledge and training, than they are in our own mechanical age.[37] Steven Shapin, moreover, has demonstrated the social and cultural nature of the seemingly atemporal idea of "truth," how it was tied up, in the early modern period, with the education, class, and social standing of the "gentleman."[38]

The ideal of empiricism in the late seventeenth and early eighteenth centuries signaled a new value placed on the individual's experience of the world, their reasoning, and the collaborative process of experiment, in opposition to the abstract, theoretical systems of classical medicine. Where an observed symptom or the effect of a medicine conflicted with textual authority or established theory, increasingly weight was given to the observation. For physicians, this created a deep conflict in the nature of medicine as a discipline. For midwives, there was not so great a weight of learned and textual wisdom for the observations to push against, but then traditionally the practitioners themselves were classed with low-status empiric healers. For the physician and the anatomist, empiricism was a challenging and exciting new mode for understanding and treating the body—one that both offered improvements to medicine and yet threatened the basis for their authority. For surgeons and midwives, it was a shining new way into professionalism and authority. Midwives had always developed practice based on their experience, but only from the seventeenth century did that experience qualify them to write books. Indeed, it was not only that they had a new authority. As the personal experience of practitioners became more important, it also became more important to *share* those experiences with a professional network through publication. This new attitude is exemplified in the midwife-author François Mauriceau's address to the reader: "tho I design to instruct you here in whatsoever concerns *Women with Child*, or *in Labour*, yet I would not divert you from reading other learned Authors who treat of it, but only advise you that the most part of them, having never practised the Art they undertake to teach, resemble (in my Opinion) those *Geographers*, who give us the description of many Countries which they never saw."[39] Mauriceau was unwilling to reject outright the wisdom of the ancient authors, but in comparing them to geographers, he associates midwifery with a discipline that was undeniably more advanced in the

modern than in the ancient era. Both geography and midwifery, he argues, had flourished in his own period through new advances in exploration, observation, and discovery. Midwifery manuals such as Mauriceau's broke new ground in making empirical knowledge a basis for professional authority. They did so, moreover, not only through text but also through images, as birth figures were adapted and diversified to communicate new discoveries, new understandings of the body, and new approaches to practice.

Mauriceau was a prestigious Parisian midwife, training and later working at the Hôtel Dieu, a lying-in hospital that trained midwives, an institution that had no equivalent in England until the eighteenth century. He was part of a generation of male practitioners working in Paris who are often credited by medical historians with turning midwifery into a medical discipline.[40] Mauriceau was part of a network that proposed innovations in practice and published manuals and treatises. This network included Mauriceau's cousin Pierre Dionis, his teacher Guillaume Mauquest de La Motte, his antagonist Cosme Viardel, and his teacher and antagonist Philippe Peu.[41] It was the writings of these men, in French and in translation, that English midwives largely depended on throughout the late seventeenth and early eighteenth centuries.

From its earliest appearance Mauriceau's book was agreed to be the best and most informative midwifery manual available in England. It maintained a good reputation well into the eighteenth century, with John Douglas commenting in 1736 that it was the "first rational account we ever had of delivering women in labour."[42] Among modern medical historians, it holds a troubling position between new "effective" and old "ineffective" practice. Thus, while Pam Lieske focuses on how it "helped to dispel folk beliefs about pregnancy and labour, differentiated between the male and female pelvis, originated a method to deliver the head during breech birth, and recognized how to induce labour by rupturing the membranes," Robert Woods and Chris Galley dwell instead on how "the scientific basis of his understanding was virtually non-existent and his practical surgical techniques were rudimentary."[43] This liminal status, combining an adherence to the old textual authorities with a new emphasis on his own empirical discoveries, makes Mauriceau's work—including his birth figures—a valuable resource in exploring cultural changes in midwifery.

The illustrations printed with Mauriceau's book are where we begin to see transformations in the visual culture of midwifery. Thus it is worth giving a detailed history of their production. Mauriceau's images held a new material and intellectual status within the book itself: they were engraved on twenty-eight copper plates that are interspersed amongst, and sometimes share a page with, the text (figure 13). While some earlier texts

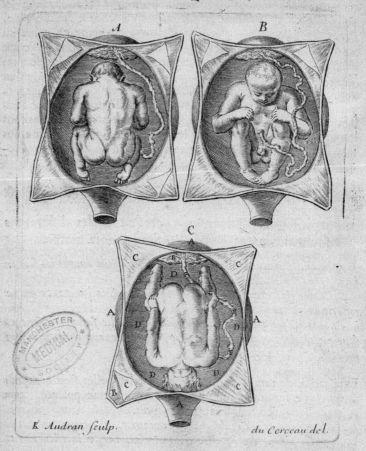

K *Audran sculp.* *du Cerceau del.*

CHAPITRE V.

Des differentes situations naturelles de l'enfant au ventre de
sa mere, selon les differens tems de la grossesse.

L Orsque nous aurons expliqué quelles sont les differentes situa-
tions naturelles de l'enfant, on aura facilement la connoissance

FIGURE 13: Paul Androuet du Cerceau (draftsman) and Karl Audran (engraver), [Birth Figures], engraving, 14.1 x 11 cm (plate). From François Mauriceau, *Traité des maladies des femmes grosses et accouchées* (Paris: chez l'auteur, 1681). Medical (Pre-1701) Printed Collection 1583, University of Manchester Library, Manchester. Copyright of the University of Manchester.

had interspersed woodcuts with letterpress, the process of interspersing intaglio prints is more complex as it involves printing each page twice. This suggests that Mauriceau valued his images highly and felt it was important that they be embedded in the text rather than printed on separate pages. This would allow the reader to consult image and text simultaneously, as media that worked together. The choice of engraving as a medium is also significant: since the early experiment with engraving in *The Byrth of Mankynde*, most birth figures had been produced as cheaper and longer-lasting woodcuts. But engraving was a technique with a higher level of prestige, and it allowed for greater levels of detail and tone. The increased value placed on artistic skill is evident in the fact that many of the plates bear the names of draftsmen and engravers. We know, for instance, that Mauriceau's frontispiece (figure 14) was designed by Antoine Paillet and engraved by Guillaume Vallet. Both artists were members of the Académie Royale de Peinture et de Sculpture in Paris, and the valorizing frontispiece they produced for Mauriceau indicates a new concern for self-presentation and for the establishing of authority on the part of the author. The use of known and institutionally validated artists, the elegant style, and the use of symbolic figures and tools all point to a new social and professional dimension to midwifery. Some of the illustrations also bear the names of artists: the draftsman Paul Androuet du Cerceau and the engravers Karl Audran and one "Lombars." The illustrations are also more complex and appear more geared to the display of artistic skill than many of those produced in the preceding century.

In the English editions, a cheaper method of reproduction was used, and most of the images were re-engraved onto four large copper plates (figure 15). In some copies, the four large plates can be found whole, folded and bound in at the back of the book. In others, each plate has been carefully cut up into its constituent images and each image has been tipped or pasted in as a flap at the relevant page (figure 16). The re-engraving of the images on four large plates suggests that the English publishers were more concerned with reducing production costs than their French counterparts, perhaps because there was a less established professional market for such a work in England. But the careful interspersion of the images in some copies suggests that at least some English readers also valued the images highly, either paying a binder to intersperse them or spending time on the task themselves.

Mauriceau and his contemporaries adopted the new medium of engraving, new representational styles, and new kinds of knowledge in their birth figures in order to raise the status of their practice and to communicate their new understandings of the body. Equally crucial to the culture of the period, however, was the way that these midwife-authors *individualized*

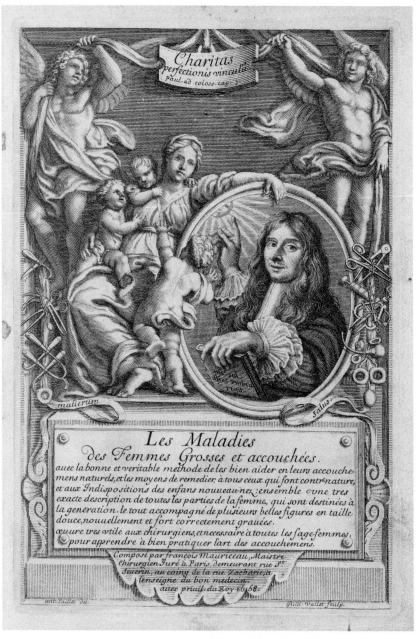

FIGURE 14: Antoine Paillet (draftsman) and Guillaume Vallet (engraver), [Frontispiece Portrait], engraving, 21.8 x 14.5 cm (plate). From François Mauriceau, *Traité des maladies des femmes grosses et accouchées* (Paris: Jean Henault, Jean D'Houry, Robert de Ninville, and Jean Baptiste Coginard, 1668). EPB/C/35949, Wellcome Collection, London.

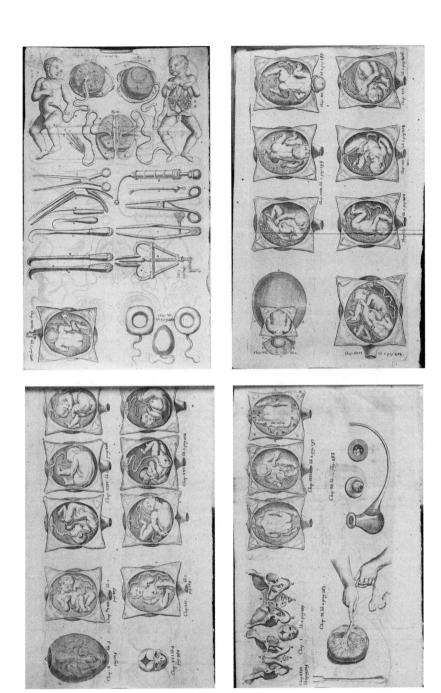

FIGURE 15: Anon., [All the Figures], engraving, 16.6 x 28.5 cm (plate). From Fran-
çois Mauriceau, *The Diseases of Women with Child, and in Child-Bed*, trans. Hugh
Chamberlen (London: Andrew Bell, 1710). Medical (1701–1800) Printed Collection
M2.1 M28, University of Manchester Library, Manchester. Copyright of the University
of Manchester.

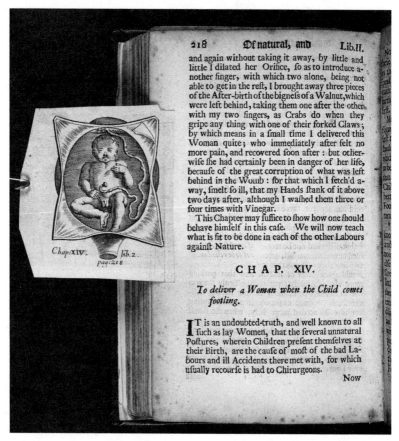

FIGURE 16: Anon., [Birth Figure, Foot Presentation], engraving, 6.5 x 5 cm (figure). From François Mauriceau, *The Diseases of Women with Child, and in Child-Bed*, trans. Hugh Chamberlen (London: printed by John Darby, 1683 [1672]). © The British Library Board (RB.23 a.27392).

their birth figures. Mauriceau's images were not included simply for convention's sake, nor were they added as decoration or as an incentive to buyers, as is sometimes argued of earlier birth figures.[44] Rather, these images were intended to complement Mauriceau's text and to communicate his *specific* ideas on midwifery and the pregnant body.

Observation and Anatomical Style

Mauriceau's images, like his text, are both conventional and innovative. His anatomical images follow the pattern set down by Vesalius of presenting organs in hollow torsos (figure 17). But he also introduced new kinds

FIGURE 17: Paul Androuet du Cerceau (draftsman) and Lombars (engraver), *Figure 1*, engraving, 17.1 x 10.7 cm (plate). From François Mauriceau, *Traité des maladies des femmes grosses et accouchées* (Paris: Jean Henault, Jean D'Houry, Robert de Ninville, and Jean Baptiste Coginard, 1668). EPB/C/35949, Wellcome Collection, London.

of images to the midwifery canon: an image of the external genitalia, legs, and buttocks of a woman (which was censored from the first two English editions); one of the fetus in the uterine membranes; and one of the male and female pelvises. His birth figures (figures 13, 15–16), too, are both like and unlike those produced for Rüff (figure 5): there is the same balloon-like womb, a child-as-fetus floating within. But in Mauriceau's images, the anatomical details have been audited: gone are the fruitlike ovaries, and the umbilical cord now consistently leads to a visible placenta rather than wandering off to stage right. These changes had to do with a refocusing of the birth figure on what knowledge was crucial to midwifery practice: the ovaries and theories of conception were ancillary, but the tying of the umbilical cord and the delivery of the placenta were key duties. These changes are, in fact, indicative of a radical shift enacted in Mauriceau's birth figures, away from the diverse symbolism and analogy of Rüff's, and toward a closer adherence to the body as it was physically experienced by midwives, communicated through an adoption of the new observational, detailed style of contemporary anatomical illustration. Of course, this is not to say that analogy fell out of the visual culture of birth figures: not only did older manuals remain in print and in use throughout the eighteenth century, but practices of *reading* analogy in images of the body also endured. Mauriceau's more anatomical and observational style rather added a new layer of signification.

As already discussed, this period placed a new value on observation and empiricism, and this was reflected in the way that many kinds of medical and philosophical images were made. Matthew Hunter, quoting Robert Hooke, asserts that "philosophy's impending experimental reformation depended . . . on 'a *sincere Hand*, and a *faithful Eye* to examine, and to record, the things themselves as they appear.'"[45] Of course, as Mechthild Fend has argued in her work on anatomical images, investigators and artists were certainly aware of the complexities of such an ideal: that there could be no simple or indexical relationship between object and image.[46] Yet the rhetorical ideal—of skilled investigation, faithful observation, and accurate visual description—largely ruled the way that anatomical illustration changed in this period. This new preoccupation with making images from close observation of specific anatomical preparations is associated, Fend argues, in Lairesse's images for Bidloo, with various representational techniques, including life-size images; the development of rich tonal engravings that emphasize the three-dimensionality of the objects depicted; and the depiction of incidental objects such as pins, knives, and flies that serve to argue for the specificity and "realness" of the image. Fend makes the important point that artists such as Lairesse, who produced images

that were composed to convince the viewer of their faithful, observational relation to the object, were also deeply aware of the complexity and artificiality of such a project. They "aim to be accurate while constantly reminding us of their artificiality."[47] Inventing both a new visual persuasiveness and a pendant visual self-reflexiveness, these images, as Dániel Margócsy has described, move away from the "abstract, idealized image of the human body" and toward "chaotic nature in all its whimsical particularities."[48]

Midwife-authors and their artists were keen to adopt this ideal and style of observational accuracy but had their own issues and complexities to deal with. As well as the necessary work of mediation and representation that goes into any anatomical image, however "naturalistic" it may look, midwife-authors faced the further problem that their subject—the interior of the living pregnant body—could not be drawn from observation at all. Thus, while some artists adopted the veneer of observational "realness," birth figures remained fundamentally practitional—images constructed not from dissection of the dead but from experience and abstract knowledge of the unseen living body and midwifery practice. For instance, in Mauriceau's birth figures (figures 13, 15–16), the uterine wall and membranes are cut with a crucial (cross-shaped) incision and pinned back at four corners, as was commonly done in dissection, and as is described in anatomical images (see figure 17). The fetuses look less like putti; while they still do not have the scrawny bodies of neonates, they are less cherubic and seem more concretely to inhabit the space of the womb. They are also less performative and less conscious of the viewer's gaze; they are more introspective and private. This indicates a move toward, although not a complete adoption of, the unconscious, totemic, secret fetus of anatomical imagery, as discussed in chapter 1.[49] In Rüff's figure of twins (figure 5), for instance, the fetuses arrange themselves side by side as if posing for a portrait, enacting the symbolism of fraternal affection. Mauriceau's (figure 15), by contrast, shows the fetuses less active, discomfited yet unable to untangle themselves from each other, more confined by the limited space of the womb, and unaware of the viewer's gaze.

Originality and Truth-Value

The style and representational conventions of observational anatomy were adopted by midwife-authors and their artists as part of a wider project to make new claims for their profession. These authors wished their images to be read as "true" in a new way, informed by firsthand experience and observation of the living, laboring body, and borrowing from anatomy worked as a shorthand for these ideals. An example of this new approach

to observation and originality is found in Mauriceau's accusation of plagiarism against a fellow midwife-author. Before this period, as discussed in chapter 1, copying images had been an essential way to establish truth-value.[50] Now an opposite drive arose, and Mauriceau accused his colleague and rival Philippe Peu of plagiarizing his images.[51]

Debates over what kind of copying was appropriate in medicine and natural philosophy have a long history. Both Sachiko Kusukawa and Peter Parshall have discussed the lawsuit fought by two German publishers in 1533, wherein Johannes Schott accused Christian Egenolff of copying images made for him by Leonhart Fuchs.[52] Egenolff made the interesting defense that he had not had the images copied, but that images drawn of the same natural object were bound to look alike, if faithfully made. The debate, Kusukawa argues, boils down to the way the relationship between object and image is understood, and how much creative license the artist is believed to have.

Peu, in countering Mauriceau's accusation of plagiarism, performed similar contortions to defend his images. When we compare the two sets (figures 15 and 18), it is clear that some copying has taken place—Peu's wombs look very similar to Mauriceau's—but there are also clear differences in how the fetuses are represented. Such copying and adaption were far from unusual, of course, but the process suddenly became problematic as it became important that images be both original and drawn in some way from observation. Peu, in his published defense, manages to hit both of these new requirements:

A l'égard des enfans & de leurs postures, j'ai fait connoître à mon *dessinateur* ma pensée sur de petites marionettes que vous n'avez pas vûës, & que j'ai chez moi pour cela. Il sufit pour moi qu'il l'ait exprimée. Je m'embarasse peu où il a pris de quoi l'éxécuter; mais j'ai trop bonne opinion de sa capacité tres-connuë d'ailleurs, pour croire qu'il ait eu besoin pour cela de vos marmots, joint que les postures sont évidemments diférentes indépendamment même de *la conduite du cordon*.[53]

[With regard to the children and their postures, I acquainted my draftsman with my thinking on some small puppets which you have not seen, and which I have at my house for that purpose. It suffices for me that he has expressed it. I don't care much where he got what he needed to execute the drawings; but I have too good an opinion of his capacity, by the way well-known, to believe that he had need of your little figurines, in addition the postures are evidently different independent even of the umbilical cord.]

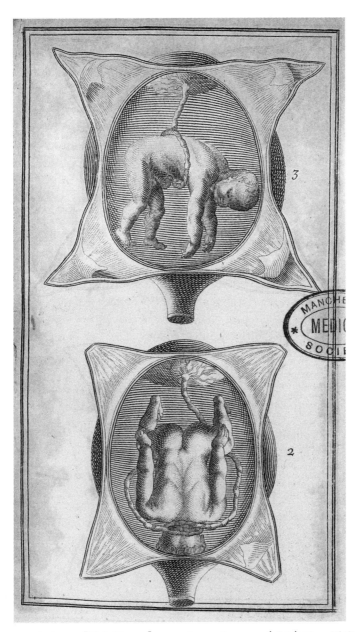

FIGURE 18: Anon., [Birth Figures], engraving, 15.8 x 9.3 cm (plate). From Philippe Peu, *La pratique des acouchemens. Par Mr Peu, maître chirurgien & ancien prevost & garde des maîtres chirurgiens jurez de Paris* (Paris: Jean Boudot, 1694). Medical (Pre-1701) Printed Collection 1876, University of Manchester Library, Manchester. Copyright of the University of Manchester.

Peu argues that his images cannot have been copied from Mauriceau's because they were instead copied from dolls or puppets that he posed and placed in front of his artist like specimens. Unable to actually observe the living pregnant interior, Peu settled for the form and act of observational drawing, using a substitute object. His images gain truth-value at one re-move: the empirical knowledge of the body is transferred by the midwife onto the puppet, and then the puppet is drawn by the artist.

Peu also uses the rhetorical techniques of the observational anatomist. He simultaneously praises the capacities of his artist to draw faithfully what he saw and downplays the process of interpretation by which the art-ist turns what he sees into an image.[54] Noting that Mauriceau has not *seen* his puppets, he denies his rival direct experience of the object represented, and so denies his right to comment on the images' accuracy or quality. Finally, Peu attacks Mauriceau's images in turn: while his own are drawn from "marionettes," flexible objects responsive to the manipulation of the practitioner, Mauriceau's are "marmots," a pejorative meaning grotesque small figurines. They are mere toys to Peu's professional tools.

This is the first instance I have found of copying's being addressed as a problem within the visual culture of midwifery. Before this time, birth figures were a kind of common property, icons of the genre as a whole. As Kusukawa describes it, they were "generally rather than specifically relevant to the text next to which they were placed."[55] What changed is not only that birth figures adopted the rhetoric of observation but that they also became individualized statements about the author's special knowl-edge and skills. When someone copied such images, they were illegiti-mately piggybacking on the author's hard-won knowledge, authority, and professional reputation, and because these authors were also practitioners, protecting their exclusive experience was fiscally as well as professionally important.

This is not to say, of course, that copying ceased completely, or even that it became a universally denigrated practice. New ideals of observation and the individual image were often combined, as in Mauriceau's images, with the continuing use of existing representational forms. Moreover, the "best" of the new images themselves came to be widely copied, as other authors and artists deferred to them. Indeed, Stefan Ditzen, discussing microscopy images by the above-mentioned Robert Hooke, noted that his skills in observation and in illustration were so widely recognized that other microscopists often trusted and reproduced his visual records *over* their own direct observations. Observation was always tempered both by continuing deference to authority, and by the more ingrained visual training that meant that existing images shaped what and how people

observed.[56] Indeed, tensions between faithful observation and reliance on existing visual culture are a constant aspect of epistemic image culture, though the shape and quality of the tension are subject to perpetual change. What happened to the visual culture of midwifery in this period was a sudden shift toward the valuing of observation that broke the visual monopoly of Rösslin's and Rüff's birth figures and triggered a phase of visual experimentation, alongside continued adherence to existing forms.

Empiricism, Experience, and the "Case Study"

Along with the new emphasis on observation and originality in images of the body came a much more fundamental shift in the hierarchies of authority and knowledge. Matthew Hunter describes the shift as a reform that saw "university-educated scholars . . . gaining new contact with and respect for the skilled manipulations of matter achieved by artists and craftsmen."[57] Empiric healers, surgeons, and midwives, as well as artists and craftsmen, were finding that their embodied skills and material knowledge were newly valued by those with more prestigious and abstract skills. This change also destabilized the traditional rhetoric that endowed physicians with more authority than surgeons because the former worked with theory and did not touch their patients, while the latter worked empirically and with their hands.[58] Such hierarchies were never simple or concrete, but this period saw the classical framework that placed theory, sight, and hearing above investigation and touch begin to crumble.

The privileging of makers and artisans of all kinds was also eagerly seized upon by midwifery writers, who, until this time, had suffered within hierarchies of medicine because their job was inextricably linked to physical practice upon the body,[59] and moreover on the female body in the vaguely shameful and polluted state of pregnancy and birth.[60] Indeed, the new value placed on manual skills was fundamental not only to the rise in status of midwifery practice, but also to the development of midwifery manuals: only when manual skills and empirical practice became more acceptable did midwifery become a professional medical discipline, and only then were manuals authored by those who also practiced.

In midwifery manuals, as in other medical texts, an important signifier of the new value placed on practical experience and empirical knowledge was the "observation," or "case study." Lauren Kassell has described how a new genre of casebooks emerged in the second half of the seventeenth century, which recorded not learned theory but empirical experience of practice, and which served "the dual purpose of advertising expertise and establishing credit."[61] Gianna Pomata also notes how the genre of "obser-

vationes" was "an important sign of the new significance of observation it-self in medical culture."[62] Observations, or case studies, were descriptions of a particular patient or problem that the author had treated. As experi-ence of particular instances of a disease, sickness, or medical complication became more important (and as knowledge of abstract classical medical theory became less dominant), collecting such cases became a good way for practitioners to keep a record of their findings, to draw connections, and to prove their experience.

Observations were an important development in midwifery manuals, too, not least because they signified that the author was also a practitioner and had firsthand experience of childbirth.[63] They often also functioned to defend the author's actions in particular cases, or to denigrate the actions of a rival. In the period treated in part 1, cases in midwifery manuals are rare, because the authors tended not to be practitioners. But as soon as midwives did begin to write, we see the genre arise; Percival Willughby's manual, for instance, is full of firsthand accounts of specific labors he at-tended.[64] Mauriceau is again a figure of change in this regard; his mid-wifery manual, published in 1668 in French and 1672 in English, followed the traditional format and contained no cases, but he perhaps came to see this as a flaw, as he published a separate volume of cases in 1694.[65]

An early French work that adopted observations as proof of newly val-ued empirical and manual skills was Cosme Viardel's *Observations sur la pratique des accouchemens naturels contre nature et monstrueux* (Observa-tions on the Practice of Natural, Unnatural, and Monstrous Deliveries) published in 1671, three years after Mauriceau's manual.[66] Viardel's book largely follows the conventional framework, beginning with a section on theories of conception, then a second on labor itself, and a third on ail-ments of the mother and newborn infant. Yet in Viardel's manual, the second book is by far the largest, and it is comprised of "plusieurs observa-tions que j'ay fait sur toutes les sortes d'accouchement, tant naturels que contre nature" (several observations that I have made on all the kinds of delivery, both natural and unnatural).[67]

Little is known about Viardel, except that he was probably advanced in age by the time he published his manual, and that he was the queen's surgeon, but not a member of the guild of surgeons.[68] This is significant because his lack of guild membership might have prevented his advance-ment within the profession, stamping him as a low-status practitioner. Yet his vast practical experience, and his publication of that experience, gave him a different route to prominence. As Pomata notes, the *sharing* of cases by medical professionals was a statement of status: while low-status heal-ers and quacks kept their remedies and experiences secret, knowledge-

able professionals shared theirs for the good of the medical community.[69] While the newness of Viardel's empirical expertise and his outsider status led to criticisms of his book, it wasn't long before practitioners of all kinds were assuming authority through the published case study.[70]

Observations, therefore, both shaped and aided developments in practice, disseminating new discoveries and techniques, and helping midwife-authors to develop a new kind of public persona. The midwife-author Justine Siegemund provides an interesting case of this kind of persona production. As a prominent midwife-author and emergency practitioner, Siegemund faced hostility from male practitioners. In one instance, a physician publicly accused her of malpractice, a libelous claim that she contested successfully in court.[71] Siegemund's manual is largely written as a dialogue between her alter ego, Justina, and an imagined regular midwife, Christina. But the manual also contains observations from Siegemund's practice and testimonials written by women she delivered. For Siegemund, in a precarious position as a woman author in a field dominated by men, not only did observations act pedagogically to teach the reader, they were also a way to publicly defend her actions and to support her claims to authority and knowledge. As Lynne Tatlock puts it, the "format and composition of her book pointedly, indeed aggressively, invoke the authority of her own personhood and experience."[72]

But Siegemund did not just use text to record observations; she took the radical step of turning birth figures into case studies. Indeed, it is important to recognize Siegemund's role in the changes to learned midwifery and its visual culture, as it is a realm so often assumed to be completely masculine and completely divorced from women's experiences of childbirth. Yet in her manual, a set of seven birth figures are presented not as a description of presentations or interventions in general but as a record of a *particular* case of arm presentation that Siegemund attended (figure 19).[73] In the text, Justina describes the details of the case to her pupil with reference to the engravings: "Look at this first engraving which shows you a child lying closed in quite tight and how I found it large and swollen and squeezed by the pains with all the waters run off too, and how it was impossible for me to push the child up high enough so I could get my arm far enough inside even to get to the nearest foot or the child's knee, just as you see here how my arm is swollen up large."[74] Before this, birth figures had a much more abstract, general relationship to the actual body in labor. Siegemund's are specific in a new way—they are visual "observations." They are not, however, images drawn directly *from observation*. They adopt the rhetoric of case studies and observational empiricism, yet they are just as much imagined constructions of an unseen bodily interior

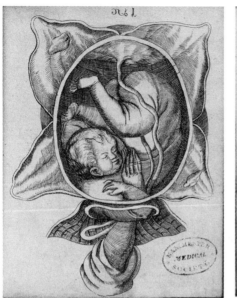 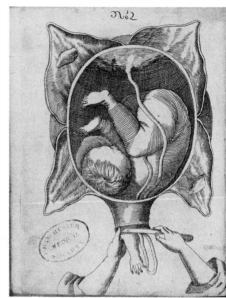

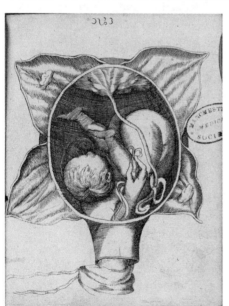 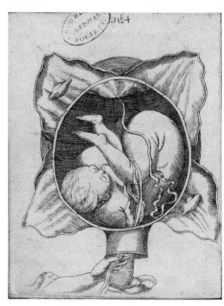

FIGURE 19: Anon., *Figures 1[b]–7[b]*, engraving, 20.2 x 16.2 cm (page). From Jus-tine Siegemund, *Die Kgl. Preußische und Chur-Brandenburgische Hof-Wehemutter* (Cölln an der Spree: Ulrich Liebpert, 1690). Medical (Pre-1701) Printed Collection 685, University of Manchester Library, Manchester. Copyright of the University of Manchester.

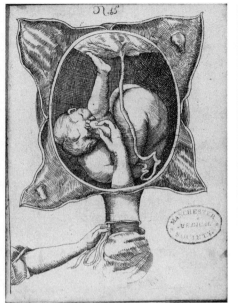

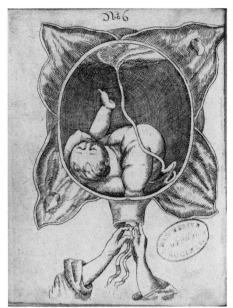

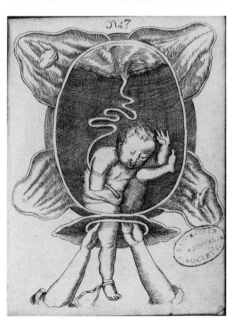

as other birth figures. What these case study birth figures do provide, however, is a more specific description of the conditions of labor. The case they illustrate was one of severely impacted arm presentation, and we see the particular significance of the lack of room in the womb reflected in the way the fetus is depicted as larger and more cramped. In most of Siegemund's birth figures (see figure 23), the vagina is shown cut open to display the cervix, but in this set (figure 19), most show the vagina closed, to emphasize the narrowness of the space in which Siegemund worked.

For Siegemund, the case study birth figure was "true" in a new way. It related specifically to an actual case, provided a record of the situation and a justification for Siegemund's actions—proof that she *had* to remove the arm of the fetus before she could deliver it. The images, used pedagogically within the narrative of the text itself, also make an argument for the importance of case studies and empirical learning in the training of midwives. By publishing cases, in image and text, Siegemund and other midwife-authors ensured that a wide readership could learn from their personal experiences of specific cases. Thus we might understand Siegemund's book as a newly textual, public emulation of the old apprenticeship system, now valorized as empirical learning. Birth figures for Siegemund are an object lesson and a public defense, a teaching aid and a novel kind of professional accreditation.

The Mechanical Body

Along with the rise of empiricism and observation, the late seventeenth century saw the adoption of a new system for understanding the universe and the human body—mechanism. This theory proposed that the workings of nature and of the human body could be explained by mathematical and mechanical laws. For early Enlightenment thinkers, the system provided an attractive rationality in response to the mysteries of nature.[75]

Mechanism was particularly crucial to how anatomy was conceptualized at this time. It offered a framework for understanding the functions and operations of the body, growing in importance as machines and automata also became increasingly culturally present.[76] Indeed, Minsoo Kang argues that "the automaton, or a self-moving machine, emerged as the central intellectual concept of the period."[77] Within this increasingly dominant framework, the body was no longer a place of mysterious humoral variety but rather a concrete, mechanical structure powered, according to Cartesian dualism, by an immaterial soul.[78] Moving into the eighteenth century, mechanistic theory remained crucial to "vitalist" and "materialist" debates over the existence of a soul or driving force for the

body/machine.[79] Within medicine, the idea of the body as a mechanism became entrenched and spread from elite scholars and anatomists to influence how many medical practitioners and laypeople perceived the body.[80]

Bertoloni Meli describes how anatomical dissection began to resemble the process in mechanics of disassembling a machine into its constituent parts in order to understand its makeup and functionality.[81] Mechanism not only made the body rational but offered the possibility of complete knowledge—if the body was a machine, then taking it apart would explain everything about its workings. As Jonathan Sawday notes, anatomists "no longer stood before the body as though it was a mysterious continent. It had become, instead, a system, a design, a mechanically organized structure, whose rules of operation, though still complex, could, with the aid of reason, be comprehended in the most minute detail."[82] Mechanism was also applied to the problem of conception, gestation, and birth, which was widely understood to be "the heart of Nature's mystery."[83] While Keller argues that conception and generation "adamantly resisted reduction to mechanical explanation," this didn't stop anatomists and philosophers from trying.[84] Rebecca Wilkin, for instance, has traced how Descartes and other mechanists investigated the phenomenon of maternal imagination using a mechanical methodology.[85]

In most midwifery manuals, the theory and philosophy of mechanism was not much engaged with. But mechanism's broader influence as a way of understanding the bodily interior is plain to see in changes to how the pregnant and laboring body was described and visually represented. Mauriceau, for instance, exchanges earlier descriptions of pregnancy and birth through analogy to crop growing or housewifery for a mercantile, navigational language.[86] In doing so, he imposes a technological order on nature's variety and creative faculty, engaging with a mathematical mechanism that, Peter Hanns Reill has argued, offered an "escape" from "the perceived horrors of contingent—and hence, unsure—knowledge."[87] Mauriceau describes fetal presentation in the following terms: "just as there are four Cardinal points, to which all the rest of the thirty two Winds may be reduced on the Compass, and to one of the four more than to the other, according as they participate of more or less of that point: so likewise all the particular and different wrong Postures, that a Child may present, can be reduced to the above-named four general ways, according as they approach more to the one than to the other of them."[88] Mauriceau describes fetal presentation plotted onto a set of axes, akin to the four compass points. This system regularizes the previously troubling, mysterious, and multifarious problem of fetal malpresentation, suggesting a system not only for defining it but consequently for controlling and correcting

it. This is reflected, too, in Mauriceau's birth figures (figures 13, 15–16): the regular crucial incision, with four equal corners of uterine wall turned back, creates a square frame and a set of axes onto which fetal malpresentation can be plotted. The earlier floral openings of birth figures such as Rüff's (figure 5), with their variable shapes and baroque, acanthus-like edges, are here regularized, in accordance with a mechanical understanding of the body, to four cardinal points.

However, the most significant development that mechanistic anatomy brought to midwifery was an increased attention to the pelvis.[89] In traditional midwifery, the pelvis had not been much thought of because it could not be seen or felt. Some authors averred that the pelvis broke during childbirth to allow the fetus to pass, while others declared that such a breakage was impossible and would prevent newly delivered women from walking.[90] However, this debate was academic, and the general unconcern for the pelvis among midwives is expressed by Siegemund, who declared: "Let us say the pelvic bones would have to part. Even so, it is not possible to know they do, because you cannot feel the pelvic bones on account of the flesh around the birth passage. Thus it is not necessary for you or me to know whether they separate because we cannot tell or get any information from it."[91] Siegemund, along with many contemporaries, recommended making sure that the fetal chin did not catch on the pubic bone during a podalic or breech delivery, but she does not theorize more broadly on the mechanical process by which the fetus passes through this bony passage.[92] Such a knowledge, because she cannot know it from experience of the body, is irrelevant to her practice.

However, the midwife-author Hendrik van Deventer, who published his midwifery manual *Manuale operatien* in Dutch and Latin in 1701,[93] and in English in 1716, placed a new significance on knowledge of the shape of the pelvis and the relational position of the womb:

> Perhaps it may seem strange to most, to instruct Midwives in the Knowledge of the *Pelvis* and its Bones, and of its various Form and Figure; but it is my Opinion that they are mistaken, who think the Knowledge of the *Pelvis* useless, or not necessary; I am so far from being of their Opinion, that I assert the Contrary; that it is not only useful to Midwives, but highly necessary, so that without a clear Knowledge of that Matter, they proceed uncertainly, and, make use of their Hands, like those that are blind, if they are sent for to assist a Woman in Labour, when the Infant is in an ill or unnatural Posture, so that they must be guilty of a great many Mistakes.[94]

Deventer was born in the Netherlands and joined the Labadist religious sect as a young man. In this community, he trained as a physician, maintaining a special interest in rickets. Likely learning from and working with his wife, who was a midwife, Deventer also came to practice emergency midwifery.[95] Deventer's book introduced many new ideas and became highly influential in English midwifery after its translation in 1716.[96] According to Wilson, it included "the first account of the size, shape and obstetric significance of the female pelvis."[97]

Deventer's major new theory was that the womb could be positioned in various ways in relation to the pelvis: if the womb was tilted, it would direct the fetus against rather than through the pelvis, causing an obstructed labor. Deventer also published a new technique in which the coccyx is pressed back to afford more room for the fetus to pass through the pelvis; and he described the problems that a rachitic pelvis could cause in labor. Deventer's attention to the pelvis involved a much more detailed, mechanical understanding of labor and childbirth than earlier writers', including how parts of the body that could not be seen or felt were shaped, moved, and interacted with each other. As Deventer writes: "a Midwife cannot altogether make a true Judgment by the Touch, who does not know . . . how the Secret Parts of Woman answer the *Pelvis*, &c. For one that is unskilful in these Things, can neither distinguish what is sublime, depressed, direct or oblique, prone, or supine, but labours under a perpetual Confusion of Thought."[98] For Deventer, it was not sufficient for the midwife to know the body's exterior, or even to be able to conduct such interventions as podalic version in the body's accessible interior. He argued that, *on top of* these skills, the midwife needed to have an abstract, mechanical, technical picture of how the body worked and fitted together. Previously, birth figures had provided midwives with pictures of those parts of the body that they could touch but not see: the vagina, cervix, and interior of the womb. But Deventer's birth figures, produced by Philibert Bouttats (figure 20) and copied in the English edition by his pupil Michael van der Gucht (figure 21), incorporate the pelvis and the spine, as well as the contour of the belly, making the picture of childbirth not only more anatomical and mechanical but also more theoretical.[99] While what can be known through sight and touch is still at the heart of Deventer's midwifery, this knowledge is combined with a theoretical grounding in a three-dimensional and mechanistic picture of the entire physiological system of birth. Such images are not a peek into a mysterious bodily interior but a careful, complete description of the mechanics of a labor.

Deventer's ideal of newly mechanical birth figures was, however,

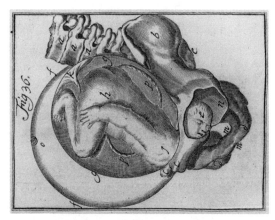

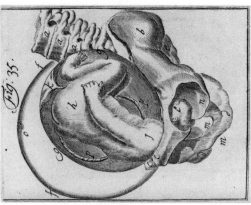

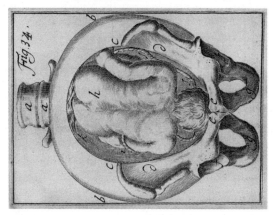

FIGURE 20: Philibert Bouttats (draftsman and engraver), *Figures 34–36*, engraving, 14.5 x 12 cm (plate). From Hendrik van Deventer, *Manuale operatien, I. deel. zijnde een nieuw ligt voor vroed-meesters en vroed-vrouwen, haar getrouwelijk ontdekkende al wat nodig is te doen om barende vrouwen te helpen verlossen* ([The Hague]: n.p., 1734 [1701]). EPB/B/20335, Wellcome Collection, London.

problematic for both the author and the viewer. These birth figures, unlike those that had gone before, showed the body from different perspectives. We tend to assume that all birth figures show a frontal view, with the womb opened at the mother's belly, as it would be in a dissection. However, the roundness of the womb and its excision from the bodily context make this uncertain. Indeed, this uncertainty is manifest in the first two birth figures in Mauriceau's manual (figure 13), which seem to show the fetus facing forward, toward the mother's belly, and backward, toward her spine. The accompanying text, however, indicates that these images actually show the *same* presentation, seen from the front and back.[100] Traditional birth figures, therefore, were ill equipped to describe horizontal rotation, but this was less of a problem before a mechanical understanding of the pelvis was assimilated into midwifery. Fetal rotation was, before this time, not quite irrelevant, but much less important than fetal presentation.

By adding the pelvis and spine, Deventer's birth figures gained a new capacity to describe the horizontal rotation of the body, giving views from the front and the side. While this new kind of view purported to give midwives a more comprehensive understanding of how childbirth worked, and thus more guidance for delivery, it also required new interpretative skills on the part of the viewer in order to *unlock* this new understanding. First, viewers needed to have a three-dimensional understanding of the pelvis in order to read the degree of rotation. Such knowledge was not widespread, as is indicated by Thomas Dawkes's midwifery manual of 1736, which is written as a dialogue between a physician and a midwife. The physician declares that "the PELVIS is of so odd a Figure, that I cannot undertake by Words, to give you any tolerably satisfactory Description of it," electing instead to show the midwife a prepared skeleton because viewing it will give "a better and much truer idea of it, than Words are capable of expressing."[101] Dawkes's use of a skeleton as a midwifery teaching tool is certainly a borrowing from anatomy: it serves to give a more mechanistic and anatomical understanding of childbirth, as well as to establish with rare and specialist objects his authority over the midwife. The text suggests that in the early eighteenth century, knowledge of the pelvis was still something that regular midwives were not expected to have—something that they might learn only from a surgeon or physician. This must have made Deventer's birth figures a distinct interpretive challenge for many midwife viewers.

Apart from osteological knowledge, the viewer is also expected to be able to interpret a mixture of representational systems. In Deventer's birth figures (figures 20–21), the fetus and pelvis are depicted as concrete, three-dimensional objects. The womb is also physically concrete, nestled in the

FIGURE 21: Michael van der Gucht (engraver), [All the Figures], engraving, 17.8 x 31.5 cm (plate). From Hendrik van Deventer, *The Art of Midwifery Improv'd, Fully and Plainly Laying Down Whatever Instructions are Requisite to Make a Compleat Midwife. And the Many Errors in All the Books Hitherto Written Upon this Subject Clearly Refuted* (London: E. Curll, J. Pemberton and W. Taylor, 1716). Medical (1701–1800) Printed Collection M2.1 D28, University of Manchester Library, Manchester. Copyright of the University of Manchester.

basin of the pelvis, but with the traditional imagined cut-through giving a view of the fetus without releasing it or the waters. However, the outline of the belly works in a different mode, a two-dimensional line that does not fit into the three-dimensional world of the bones and womb. It is oddly layered between the spine and the womb and pelvis, rendered in a more abstract mode to show how the body's exterior shape fits with this interior view. Bouttats, in this case, was faced with the problem of representing multiple elements that visually obscure each other. His solution

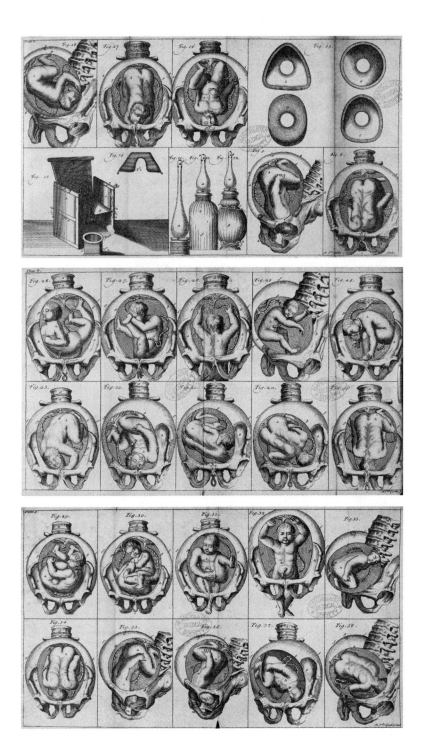

is reminiscent of the way that bodily elements are shuffled together and layered in early modern flap anatomies (see figure 12).[102]

These birth figures, therefore, require the viewer to read in multiple modes: three-dimensional and concrete bodily elements; rotation; imagined cutaways; and bodily elements layered not as they are actually arranged in the body but rather so as to give the most comprehensive view of it. In some birth figures (see figure 20) we are given a side-on view, and the *os ilium*, which would normally obscure the view of the fetus, has a wiggly cut-through window which we are to understand as an imagined rather than a physical property of the bone. While our own visual culture trains us to read such diagrammatic representational systems with ease, it was clearly more of a problem for Deventer, who complained to his reader that "it is very difficult to represent all the Bones which constitute the *Pelvis* in their natural Position or Constitution at once, because the one Part being in view, easily obstructs the Sight of the other."[103]

Indeed, Deventer writes explicitly about the difficulties of producing these newly mechanical, three-dimensional images of the body when glossing figures 34–36 (figure 20): "the Engraver could not satisfy my Desire in expressing accurately the genuine Postures of those Infants: But afterwards most of the Figures being engraved, when I read over again the Description of the 34th Figure, to see if it was to be corrected; then, indeed, I perceived that his Figure would afford but little Light to the Reader, except I explained this by the other two, that he might see one and the same Figure on every Side; wherefore I added this double Figure."[104] The passage gives a rare glimpse into the development process of an illustrated midwifery book. Deventer gave Bouttats an initial brief on the figures and then undertook an extensive editing process. Here, he is both unsatisfied with Bouttats's attempt and frustrated with the incapacity of images in general to describe the body, finding that three images must be made to describe one presentation. Indeed, there is further confusion and disjoint between text and image in that the last of the three figures actually depicts a different presentation from the preceding two: with the fetus's back toward rather than away from the maternal spine. Such experiments, trials, and confusions reveal the great difficulties artists and authors of the period had with inventing and employing new representational modes, and thus how important a project the production of such images was felt to be.

Mechanical and diagrammatic systems of visual representation are highly naturalized in our own visual culture; we read them with ease. It is therefore easy to miss where artists in previous eras were forging new systems, or what Charles Kostelnick and Michael Hasset in *Shaping Information* term "conventions."[105] Conventions allow designers and viewers

to agree on the meanings of particular systems of representation, but they are in a process of constant change driven by both artists and viewers. The development of new conventions allows for innovation and change, but it also opens the possibility of misinterpretation. A convention works only once established, when the artists and viewers are in rough accord as to what it means, and this is the problem faced by Bouttats and Deventer, who found that the new information they wished to impart would necessitate new conventions of visual language that might not be widely readable. Indeed, as Kärin Nickelsen has shown, the creators of epistemic images of all kinds were careful to balance innovations with established image forms to ensure their readability.[106]

In facing this challenge, Bouttats and Deventer turned to the representational systems of other disciplines. In the quest to depict the body as a three-dimensional, mechanical object, for instance, Bouttats adopted conventions from mechanical illustration. Artists working with this genre of image had been developing new and complex systems of representation since the fifteenth century, to communicate increasingly complex mechanical constructions.[107] Wolfgang Lefèvre associates the change in mechanical illustration with the spread of perspective rendering in the fine arts, noting an explosion of systems of representation including "an arsenal of artificial views such as cutaways, exploded views, and so on."[108] Over time, these visual conventions were adopted into medical and anatomical illustration, where they provided a premade visual language and a convincing visual argument for mechanistic anatomy. Indeed, we might say that the development of a visual language of mechanics, and the perception of the body as a machine, developed co-dependently. The increasingly visually available images of machines and mechanical workings, as well as the new representational systems that went with them, allowed for more and more people to perceive the body in these terms. Representational systems common to both subjects included, by the late seventeenth century, the exploded views, rotations, and cut-throughs that we see in Deventer's birth figures. Many such techniques for representing the body were first experimented with by Leonardo da Vinci in his anatomical and mechanical illustrations produced in the early sixteenth century, though they took much longer to percolate through wider and printed visual cultures.[109] It was with the rise of mechanistic anatomy in the seventeenth century that they gained greater traction, represented in anatomical illustrations, as well as in a new proliferation of automata.[110]

In midwifery texts, many of these visual systems were first adopted by Bouttats and Deventer, who declared: "Away with this Negligence, and this pernicious Ignorance of Midwives, who know not how to relieve a

Woman or Infant seasonably. But who shall accuse them, who had never been taught better? Hitherto no Body had explained this Art *upon firm and mathematical Foundations and Demonstrations*; What Wonder is it then, if they continue inn such thick Clouds of Ignorance?" (my italics).[111] However, while the adoption of such a mechanical visual language allowed Deventer to express his new understanding of the body, it was also another way in which the images became less readable to a general audience. Mechanical illustrations, too, were far from universally readable, particularly where they employed new conventions. A good example of this is discussed by Bert Hall, who describes the difficulties faced by Chinese translators trying to read and replicate the illustrations of machines done in planar perspective in European books.[112] Midwife-readers haven't left us the same kind of visual record of their confusion over unfamiliar conventions, but limited education in topics such as anatomy and mechanics makes such interpretative problems likely. And this specialization of visual language was to grow only more marked throughout the eighteenth and nineteenth centuries, as new representational systems became more closely aligned with institutionalized medical training that was available only to a minority of practitioners.

Thus, in his drive to help midwives to a more thorough understanding of the body, Deventer contributed to a rift in practice and understanding—between the untrained regular midwife and the medically trained emergency midwife—that was to stand for centuries.[113] Mechanical birth figures can be understood as an important element of visual culture in the early Enlightenment—as contributing to new understandings of the body. However, the conventions they used were less widely accessible than, for instance, the analogical system that had gone before. With change and complexity came a shrinking and a specialization of audience; what was intended as an educative project also served to sort and exclude viewers on the basis of education and training.

Space and Time

The increased value placed on empirical learning, observation, and manual skills, as well as the rise of a mechanical view of the body, led to wholly new ideas both about how the body could be understood and about how it could be represented. For birth figures, this was reflected not only in the introduction of "observational" and case study images, and the use of a mechanical visual language, but also in the production of diagrammatic conventions for describing movement in time and space.

In this adoption of the technical and the diagrammatic, midwifery

manuals were part of a wider trend in the late seventeenth century, which saw an explosion of printed material describing and discussing knowledge of all kinds, from physics to religion. Particularly, as Lori Anne Ferrell has noted, this period saw the development of the "how-to" genre: "Whether in luxury folio or cheap quarto, the prefaces to how-to books spoke immediately to a non-Latinate class. They flattered readers with the promise of insiders' knowledge, extolled the usefulness of the information they purveyed, and touted the merits of their newly devised methods— especially those methods' capacity to impart information accessibly. They often ascribe their pedagogical effectiveness to the material formatting of their contents."[114] Such books purported to give information and to teach skills that had previously been secret, protected by professional guilds and societies. They formed part of what Ferrell calls the "loudly clamoring world of new information."[115] These books were creative and various in their use of images to teach knowledge and skills and often employed abstract, technical, and diagrammatic modes.[116] Indeed, an indication of the rapid growth of this kind of image can be found in the coining of the word *diagram* itself in the seventeenth century. From early in the century it was used to describe specific kinds of image in geometry and mathematics but also had wider associations with images that were in some way abstracted.[117]

Addressing such diagrammatic or technical images within art-historical research can, however, be challenging. Only in recent decades have diagrams and technical images been brought under the purview of art history, whereas before their status as what James Elkins calls "half-pictures" had disqualified them from close scholarly study.[118] The recent turn toward epistemic images of all kinds has opened up vast new subjects for study and proposed innovative new methodologies for writing history with images. Yet the newness of the field means that we are still establishing systems that work across disciplines for discussing, analyzing, and even describing technical or epistemic images.

One broad distinction that has arisen in the study of epistemic images is between the observational and the diagrammatic image. Brian Baigrie defines the diagram, for instance, as "not meant to depict a world but . . . designed to help us to conceive how it might work."[119] While this distinction is often valuable, it can lead to an assumption that epistemic images are either observational or diagrammatic. Yet many early modern epistemic images, including birth figures, combined both representational systems. Melissa Lo has, for instance, shown how the illustrations in Descartes's *Essais* were fundamentally "multiple," working in various modes simultaneously. Describing, for instance, an illustration of how the eyes see, Lo

lists "four different forms of visual representation: anatomical descrip-
tion . . . , reductive diagramming . . . , geometric analysis . . . , and letters
and numbers that signified location."[120] Fundamentally, Descartes's im-
ages, Lo argues, were able to shift between "empiricism and cogitation."[121]

Birth figures in this period, as already discussed, often adopted an ob-
servational veneer, incorporating both style and content from anatomy.
But they were also abstracted images that described the unseen—not only
the unseen living interior, but the unseen dynamics of force, movement,
and time that made up midwifery practice. Particularly as mechanistic
understandings of the body spread, and as midwifery became more inter-
ventionist, diagram became a crucial form for the birth figure. Recogniz-
ing this is essential for understanding not only the work that birth figures
did but the pluralistic way in which early modern viewers used printed
images much more widely.

Midwifery authors of the seventeenth and eighteenth centuries did not
use the term "diagram" to describe their birth figures. Some, such as De-
venter, did use terms such as "mathematical" or "mechanical" to point to
the ways in which birth figures might be read as diagrams. In other cases,
diagrammatic elements were only tacitly present, or even hidden behind
rhetorics of observational representation. Yet, as I have argued, images
could combine both the abstract and the observational in this period,
exploring a world that saw the body in many different, sometimes con-
flicting ways. Both Siegemund and Viardel, for example, saw their birth
figures as images that could teach not only modes of thinking about and
understanding the body but also specific techniques and maneuvers for
aiding or ameliorating childbirth. They produced birth figures which, for
the first time, described movements in space and time, using two diagram-
matic systems: the operative hand, and the image in series.

The sixteenth century saw the rise of what Janina Wellmann calls "the
rhythmic pictorial series" in books on fencing and military exercises.[122]
These serial images showed the human body performing particular actions
in space over time using a series of sequential "stills." Such image series
allowed for the explanation of actions that were difficult to communicate
in text or single images. Shortly after this, the serial image was adapted
to show the specific work of the hands: E. H. Gombrich has suggested
that "a treatise on the art of catering of 1639" was perhaps "one of the
first to illustrate the exact position of the hands in performing the task as
well as the desired result."[123] Certainly, the disembodied demonstrative
hand is closely associated with the instructional and technical literature
that burgeoned in the seventeenth century. Such hands are to be found
in many surgical illustrations of the seventeenth century, but they were

first introduced into midwifery manuals by Mauriceau and Viardel. Mauriceau's manual contains an illustration showing how the hands should be positioned to pull on the umbilical cord to aid delivery of the placenta (see figure 15). These hands divorce the action of pulling from the actual bodily context of labor, but they may have been an influence on Viardel's images, which introduce the operative hand into the birth figure itself. These images describe how to "touch" the laboring woman—feeling the cervix to establish the progression of labor and fetal presentation—and how to manipulate and exert traction on the fetus in order to deliver it (figure 22). The introduction of hands into the birth figure closes the gap between practice and image, encouraging the viewer to imagine themselves as the practitioner, seeing in the image their own hand and arm operating on the laboring body. If earlier birth figures had helped midwives to understand presentation and podalic version, these images explain that process, both haptically and mechanically.

Siegemund's birth figures also employ the convention of the operative hand, represented up to the elbow, delicately practicing upon the bodily interior (figures 19 and 23). Siegemund understood the potential of images to teach various kinds of knowledge and practice, and they hold a remarkably central position in her pedagogy. As discussed in chapter 1, images were key not only to how Siegemund herself learned to practice midwifery but also to how she taught it.[124] When commissioning her own birth figures, she adopted the latest techniques in instructional images: the operative hand, the image in series, and a new closeness between image and text. The birth figures that Siegemund herself learned from were likely in the model of Rüff's or Rösslin's (figures 4 and 5), and her own images show what she valued in those and how she thought they could teach more effectively. As well as providing a model for envisioning fetal presentation, her birth figures describe maneuvers and techniques by depicting, over a series of images and accompanying text, movement in space and time.

For one set of five birth figures that describe Siegemund's method for podalic version (figure 23), Siegemund provides the following textual gloss:

> look at figure 17; it shows you, as I said before, how the midwife intervenes by introducing her entire arm, along with the little rod, into which a string has been pressed, how her left hand has to get it to her right hand, how her right hand takes hold of the loop from the little rod and removes it, and how she puts the loop round the child's foot. Look at figure 18; you will see how to snare the child and how you can do it in such postures when the child's feet are up above its body. Figure 19

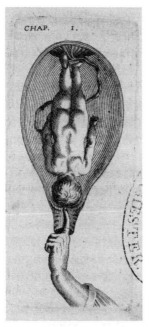

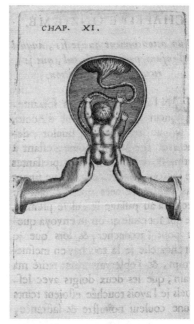

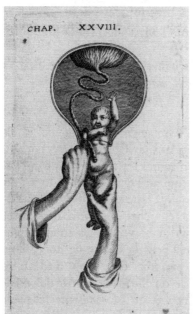

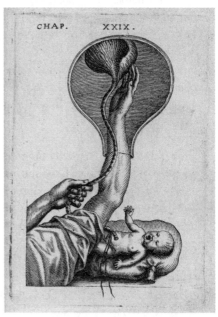

FIGURE 22: Anon., [Birth Figures], engraving, 17.4 x 11 cm (page). From Cosme Viardel, *Observations sur la pratique des accouchemens naturels contre nature et monstrueux* (Paris: The Author, 1674 [1671]). Medical (Pre-1701) Printed Collection 2518, University of Manchester Library, Manchester. Copyright of the University of Manchester.

shows how to intervene by turning the child, namely, how your left hand pulls on the feet, which have had loops put round them, how your right hand makes some space for the feet by pushing up the child from under its arm, and how the child is pulled out little by little. Take a look at the child's legs so you can see the woman cannot be hurried and the midwife cannot pull the feet at once with her hands. Figure 20 shows more of turning where the child is already turned over, how, by being pulled and pushed up, it gradually can yield until it is finally born up to the head, as figure 21 indicates.[125]

Siegemund blurs the divide between the reader and the fictionalized interlocutor Christina: we both sit and look at the same engravings, our eyes and our understandings guided by Siegemund's instructive words. This technique was not new to the epistemic image: as Renée Raphael has shown, some of Galileo's illustrations "are drawn, so-to-speak, 'in real time' and are intended, through the accompanying dialogue, to be understood as a record of the interlocutor's conversation."[126] The image replicates not only movement in space and time but also the physical presence of the teacher, who directs with a combination of words and gestures, telling and showing. When we read Siegemund's text, we as readers join the pupil Christina in looking where she indicates, noting what she thinks is important, and building up a picture of how podalic version works in the hidden bodily interior. The text encourages us to read the images as "snapshots" of the fluid and four-dimensional process of manual intervention. Where the hand goes, how it moves, and over what time are all described by this series of images in a way that single, distinct birth figures could not achieve. Wellmann has noted how this studied segmenting of movement through illustration transformed what could be represented in print, but also more fundamentally, what movements could be conceptualized and enacted in the world. It "made possible a new, controlled mobility," which in its replicability and preciseness was just as important for the midwifery as for the military or the dancing author.[127]

With these images, Siegemund also weds text and image with a new closeness. The two media complement each other, the image giving us a better picture of the placement of the hand in the womb, the text clearing up the vagaries of directional movement and purpose, as well as embellishing the visual medium with haptic descriptions. The text also gives a sense of pace: as we read it, and as our eyes move between it and the images, we are nudged into an awareness of time passing as movements happen. Siegemund's careful, instructional tone guides our interpretation of the images as pictures that together show fluid movement. She encourages us

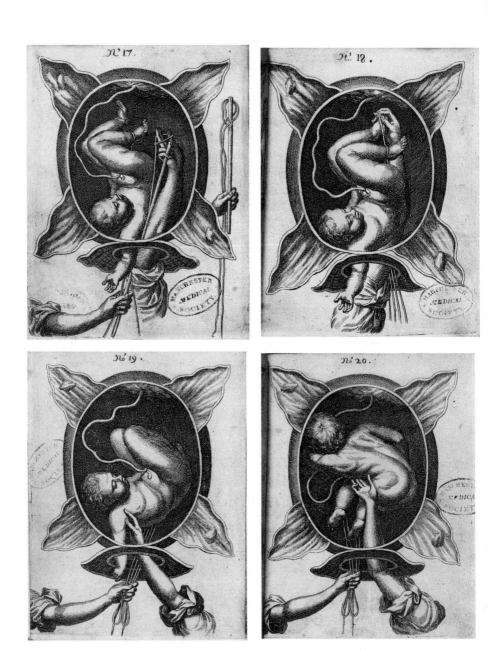

FIGURE 23: Anon., *Figures 17–21*, engraving, 19.7 x 15.2 cm (plate). From Justine Siegemund, *Die Kgl. Preußische und Chur-Brandenburgische Hof-Wehemutter* (Cölln an der Spree: Ulrich Liebpert, 1690). Medical (Pre-1701) Printed Collection 685, University of Manchester Library, Manchester. Copyright of the University of Manchester.

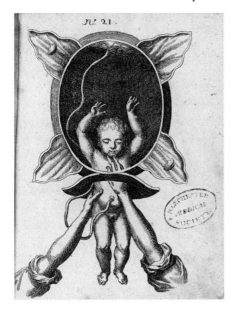

to imagine our own hands making these movements, as well as to imagine the mechanical processes and material reality of the bodily interior: our hand will fit here; we must move slowly at this point; the ribbon will help keep a firm grip on the slippery leg. Siegemund saw, in a new way, how print could be used to evoke the whole sensorium of midwifery practice and to impart, through looking and reading, embodied knowledge.

Indeed, for Siegemund, printed images had the capacity to teach manual skills not simply through visual examination, but through a more fundamental process of intellectual and physical impression. She declares it "particularly necessary for them [midwives] to get a good understanding of deliveries and of the postures of the infant right at the beginning and for them to impress upon themselves thoroughly according to the illustrations how the children lie in the womb and in what manner they present and how they can figure this out and on what basis."[128] By handling her book, touching, turning, and looking at the images, the skills of midwifery would be impressed onto the mind of the viewer. As discussed in chapter 2, print images of the body were materially powerful, able to change the mind and the body of the person who looked at them. The way that a plate impresses an image onto paper mimicked the way that the sight of the image would impress itself onto the understanding of the viewer.[129] While earlier in the century, such material power was often cast in religious or wondrous terms, here it is given an Enlightenment twist. So Siegemund's

fictional pupil declares, "I can grasp it better by looking at a copper engraving together with a detailed report than from the report alone. The copper engravings light up my eyes as it were and place understanding in my hands."[130] The rhetoric of illumination, of making clear and showing truth that was fundamental to the Enlightenment, is here associated with the birth figure. Moreover, the prints convey understanding not only visually into Christina's mind, but physically into her hands. The birth figure becomes a conduit for both empirically observed knowledge and empirically learned skills.

Regarding Failure

Siegemund presented her images as ones that could teach practice not just through reading and study but more fundamentally through the act of holding and beholding them. She sees prints as a powerful tool for teaching ideas, experiences, and embodied knowledge. However, just as Deventer encountered problems in the depiction of the new three-dimensional, mechanistic body, so did Siegemund in reconciling the technical and diagrammatic elements of her birth figures with the drive toward observational, naturalistic representation. These two modes of representation were both part of the midwife-author's project to advance the birth figure, but they represented the laboring body in very different, potentially contradictory ways, and reconciling the two seems to have caused Siegemund a multitude of problems.

As had been the case since Raynalde's *The Byrth of Mankynde*, with its anatomical images copied from Vesalius, Siegemund's manual combined birth figures with the cutting edge in anatomical illustration. She reproduced anatomical images made for Govert Bidloo and Reinier de Graaf (figure 24). But, as already discussed, the new midwife-authors also adopted a more observational, anatomical style in the birth figures, and this new style did not always combine easily with symbolic, diagrammatic, and technical modes. The difficulty seems to have come to a head in a debate over the spaciousness of the womb, an element of the birth figure that troubles and frustrates viewers even today. As discussed in chapter 1, the large, spacious, balloon-shaped womb had always been a representational convention geared toward giving a clear understanding of fetal presentation, rather than an accurate depiction of the amount of space in the womb during labor.[131] And while the spacious womb was retained in the new experimental birth figures because of this capacity, authors became newly anxious that this diagrammatic mode might be misread as observational. Of the spacious womb, Deventer wrote: "it is

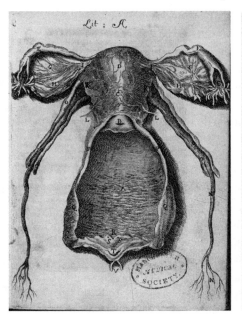 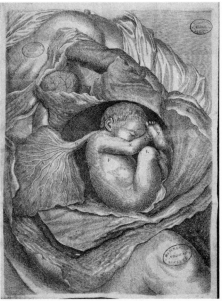

FIGURE 24: Anon., [Anatomies], engraving, 36 x 26.2 cm (plate). From Justine Siegemund, *Die Kgl. Preußische und Chur-Brandenburgische Hof-Wehemutter* (Cölln an der Spree: Ulrich Liebpert, 1690). Medical (Pre-1701) Printed Collection 685, University of Manchester Library, Manchester. Copyright of the University of Manchester.

not to be thought, that an Infant can be turned suddenly at once, and be freely turned every way, as if it were in a wooden Vessel; by no means; if it be too much confined in the Womb, if you should turn it all at once, either you would hurt the Womb or the Infant."[132] Siegemund, too, was anxious to emphasize that the spacious womb was a device that did not literally correlate with the body the midwife encountered in practice. Both authors attempt to counter this potential misinterpretation with quotidian similes. Deventer identifies the womb as *not like* a barrel, Siegemund identifies it as *like* wet cloth clinging to the body: "The child lies in the womb as in a wet cloth that clings to the child's body. So consider this then: what if I had on a wet chemise that was over my head as well and you were to pull me out of it? I will show you the reverse: pulling the chemise off me ought to be possible, while pulling me out of the chemise is certainly possible, but hard; however, it would be harder still if I were to be turned around in it."[133] In both cases, a description of an everyday tactile experience is intended to emphasize, through contrast, the nonmaterial, diagrammatic mode in which the *image* represents the body: one should not read the spacious womb as an observational description of the body; it is

not rigid and spacious like a barrel, but close and clinging like wet cloth. The point is that neither author wants to give up the spacious womb; the mode works much better than observational anatomy for describing fetal presentation and practice. But they *do* want to control the way in which the viewer interprets the image, directing reading in different modes to different aspects.

Siegemund dealt with the disparity between observational and diagrammatic modes by producing one set of birth figures that aimed to give a more materially accurate picture of the bodily interior. This series of images has already been discussed in this chapter for its innovative depiction of a particular case attended by Siegemund (figure 19), and this use of birth figures to describe a specific body clearly brought to the fore the perceptual problem of the spacious womb: "Look at this first engraving which shows you a child lying closed in quite tight and how I found it large and swollen and squeezed by the pains with all the waters run off too, and how it was impossible for me to push the child up high enough so I could get my arm far enough inside even to get to the nearest foot or the child's knee, just as you see here how my arm is swollen up large."[134] Siegemund uses descriptive, haptic language to point to these images' heightened focus on how the body is physically experienced by the midwife. Yet Siegemund also wanted these images to remain practitional—descriptive of both the physical experience and the abstract mechanics of podalic version. Certainly, they show the fetus more cramped in the womb, and they show how little space there is for the practitioner's hand. But in the attempt *also* to show process and position, the artist has produced images that are much less convincing, indeed much less readable, than others in the book. The fetus is not nestled tightly into the womb, as it is in the observational anatomy copied from Bidloo (figure 24), but it is also not clearly demonstrating position and placement of limbs, as the regular birth figures do (figure 23). How the head attaches to the body and where the nonpresenting arm is positioned are often unclear in this set of images. The result is birth figures that, rather unfortunately, bespeak a violent impossibility in the act of turning and delivering a child. They do not seem "realistic," but neither do they have the easy flow of more abstract birth figures.

It is a tricky thing for a modern viewer to grasp—this early modern difficulty with the representation of the fetus nestled tight within the womb. It requires us to think hard about the links between how things are visually represented and how they are understood or envisioned. The smallness of the space, the tight curl of the fetus, the compressing womb were known by midwives through their physical experiences of practice, and

to anatomists who dissected pregnant cadavers. But the dominant visual convention was still one of the floating cherub in the spacious womb, which endured because it was convention, because it was diagrammatically useful, and because it fed into and off of a much wider perception of uterine spaciousness among laypeople. For many women, their unborn child *was* a little person, tumbling and swimming in the little cottage of the womb.[135] For artists too, visual conventions and lay perceptions of the body encouraged the perpetuation of the spacious womb—it was a case not only of lacking an object to draw directly from, but of valuing the meaningful older forms. In one of his lectures, William Hunter recounted a visit made to his anatomy theater by William Hogarth: "he came to me when I had a Gravid Uterus to open and was amazingly pleased, Good God, he cries how Snugg compleat the Child lies, I defy all our Painters in St Martin's Lane to put a child into such a Situation."[136] Hogarth's assertion is not simply that artists are unable to properly draw what they see. It is more complicated than that, more to do with the ways that professional training and body culture shape the act of representation, more to do with the disparity between the old visual and cultural understandings of the fetus and the new visions of it provided by anatomical study.

In producing their birth figures, Deventer, Siegemund, and their artists were thinking about and experimenting with the reconciliation of old modes and new, of representation, of body knowledge, of midwifery practice. Some innovations, such as the inclusion of the pelvis or the operative hand, came to be widely used and to shape midwifery knowledge. Others, such as the "case study" birth figures, were not reproduced and developed by other authors. But looking at both the successes and the failures is crucial to understanding the epistemological as well as the visual work that was done by these author and artist teams in the decades around 1700. Where the observational conflicts with the diagrammatic in these images, there we may see a manifestation of the wider struggles occurring in medicine and its visual culture, as the cohesive hegemony of classical medicine was broken open by a variety of new approaches.[137]

If the struggles of authors and artists to produce images that could communicate new kinds of knowledge and practice are one side of this story, then the other is the work done by viewers to interpret and use them. The learned community of emergency midwives seem to have been able to read birth figures as their authors hoped, as is evidenced by their collecting such books, commenting on them in their own writing, and adapting and responding to each other's birth figures. How regular midwives and lay readers saw them is more uncertain. Such readers have left few records

of what they thought of birth figures, and so midwife-authors themselves often offer one of the richest resources, in moments when they vent frustration at the problems inherent in their educative projects.

Midwife-authors of this period often understood their midwifery manuals as proxies that could teach the reader in place of an instructor. Images and text worked together to communicate the physical experiences, abstract understanding, and manual skills that midwives traditionally gained through practice. Such books were presented by their authors as wondrously portable, reproducible, and affordable reconstructions of the whole empirical, practical experience on which midwifery as a profession was founded. Indeed, Deventer's second volume, *Nader vertoog* (1719), translated into English in 1724, contains several letters of approbation, one of which reports how a physician used the book in exactly this way—as a proxy for Deventer himself—to instruct a local regular midwife: "I, theoretically, at least, instructed her with your Counsel and Admonitions; which having willingly received, and successfully put in practice, it is a wonder how much Benefit thereby accrued to the Public, so that the said *Midwife* is not only called abroad to Women in Labour of the Prime Nobility, but several other Women also, who have hearkened to her Instructions."[138] The book, standing in for Deventer, is credited with turning a regular midwife into an emergency midwife, a practitioner to nobility, and a teacher in her own right. Mission accomplished, except for the tricky presence of the letter's writer—a trained physician who acts as intermediary between book and midwife. It was uncomfortably obvious to these first midwife-authors that as their manuals became more engaged with new kinds of knowledge and practice, they simultaneously became less accessible to the regular midwives for whom they were ostensibly intended. They were, in fact, rather uncertain about how many of these uneducated regular midwives would gain any benefit from the newly technical manuals.

Indeed, authors as widely spaced as Percival Willughby in 1670s England and Madame du Coudray in 1750s France provide examples of regular midwives who, even when presented with both books and teachers, failed to learn or adopt the new practices and understandings they were taught. Both Willughby and du Coudray report cases of midwives who were taught a new technique of emergency midwifery but who were later discovered to have abandoned or even absolutely forgotten it.[139] Whatever midwifery manuals claimed, the developments of empirical observation, mechanical thinking, and medical interventions inside the womb all remained largely foreign, largely unwelcome concepts for many regular midwives and the women they attended. Outside of urban centers such

as London and Paris, traditional practices and systems for understanding the body were upheld by communities and regular midwives. Older mid-wifery manuals were still printed, circulated, and used by midwives, and newer ones may not have been used as intended by the authors, through either an inability or an unwillingness on the part of the reader.

Indeed, authors were all too aware of the actual differences between a printed text or image and how it was experienced by the viewer. Deventer's manual, for instance, includes a remarkable passage in which he imagines a horde of regular midwife readers carping at him from the other side of the medico-perceptual divide:

> But methinks I hear the Midwives crying out against me; *Whatever you write, there is a great deal of Difference betwixt Saying and Doing: Things do not always succeed according to our Thought: Who can know all Things so accurately? And though we could know, yet our Women will not suffer it; they will not be touched, except with one or two Fingers at the most, and so that you must not put them to Pain, for they will suffer no Hardships, especially those that are rich, who will not be handled, except with the soft-est Touch.* I answer, That I am not ignorant that there is a great deal of Difference betwixt Saying and Doing, and that it is easier to write of this Matter, than to perform it well.[140]

Through the voice of these imagined midwives, Deventer is able to admit what all authors knew but were loath to acknowledge: however clear one's writing, however excellent one's images, a book was no substitute for an actual teacher and practice at actual labors. These imagined regular mid-wives, too, found that Deventer's teaching did not always match with their own experience, his practices did not always work, his new medicalized, mechanized midwifery did not fit so neatly into the world in which they worked. And this was not only because of their own inability to think and act precisely as he prescribed; the women they attended also refused these new techniques and new proclamations on how their bodies functioned. Deventer mounts no defense against these attacks—they are, after all, pro-duced by his own pen. What he acknowledges in this lapse of authorial power is that his enlightening project, by and large, existed only in books.

The situation was, arguably, even worse with images than with texts, as they were even more subject to multiple interpretations and appropria-tions. So Siegemund, usually so vociferous about the pedagogic potential of her images, also acknowledges the disparity between her ideals and the way her images might actually be interpreted. Placing, like Deventer, criticisms in the mouth of an imagined regular midwife, she writes of her

figures 17–21 (figure 23): "Many women will be horrified when they have read this book and properly contemplate the copper engravings showing the turning of the child, where you set to work in the belly with your entire arm as well as with a rod with a ribbon wedged into it, as figure 17 indicates. It is hardly possible to believe that it can happen. Plenty of faultfinders will doubtlessly determine that it is impossible and cannot happen."[141] Siegemund's innovative birth figures, employing new representative techniques to impart new skills to readers, could, it turns out, be something entirely different, depending on the viewer. For the regular midwife unwilling to learn about or admit new emergency practices, these birth figures are images of torture, or *impossible* images, showing an intervention inside the body that no woman would permit, and no midwife would be able, physically or conceptually, to complete. In moments of optimism, Siegemund imagined her images impressing knowledge and skills directly onto the viewer's hands and minds in a process of image consumption that left no place for interpretation. But the objection of her pupil Christina gives the lie to this ideal.

All of the new experimental birth figures had this capacity for multiple readings, for a variety of sanctioned and unsanctioned interpretations. Indeed, their very production was part of a deeper fragmentation of midwifery culture into regular and emergency, poor and rich, "ignorant" and educated, female and male. Those who could read and use birth figures as intended entered the latter sphere, and those who couldn't or wouldn't, the former. Part of what makes these images such a valuable historical resource is their pluralism, their complexity, and their fraught divisions over knowledge and its representation. Looking at where birth figures experimented, where they succeeded or failed, and where they were accepted or misread provides a key to those things that were most important and most troublesome to authors, artists, and viewers of the period.

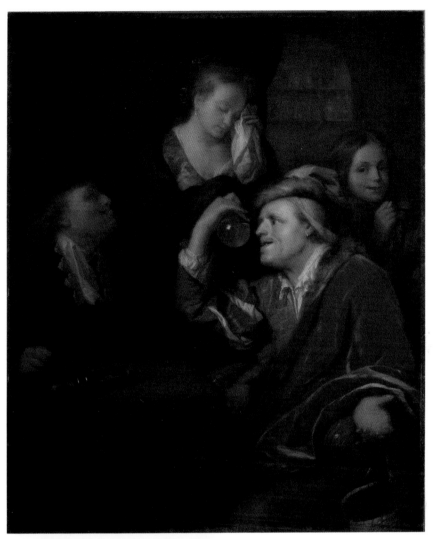

PLATE 1: Godfried Schalcken, *The Doctor's Examination*, c. 1690, oil on panel, 35 x 28.6 cm, Mauritshuis, The Hague.

PLATE 2: I.T., [Uroscopy], 1829, watercolor, 26 x 29.7 cm. 21828i, Wellcome Collection, London.

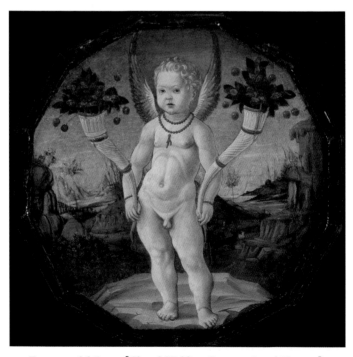

PLATE 3: Francesco del Cossa, [Cherub Holding Cornucopias of Cherries], c. 1450–75, tempera and oil on panel, 61 x 61 cm. Museum of Fine Arts, Boston. Photograph © 2023 Museum of Fine Arts, Boston.

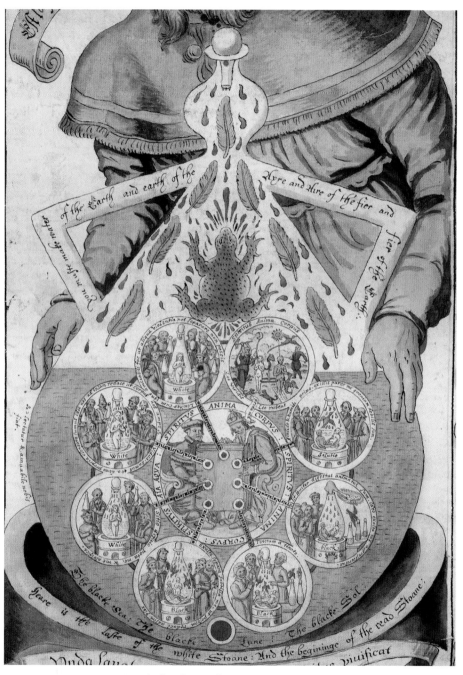

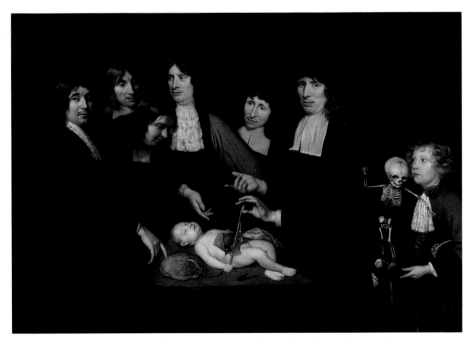

PLATE 5: Jan van Neck, *The Anatomy Lesson of Dr Frederick Ruysch*, 1683, oil on canvas, 141 x 203 cm, SA 2644, Amsterdam Museum, Amsterdam.

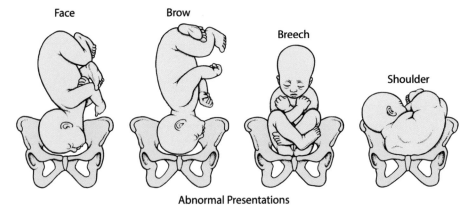

PLATE 6: Anon., *Abnormal Presentations*, digital image. From the MSD Manual Consumer Version (Known as the Merck Manual in the US and Canada and the MSD Manual in the rest of the world), edited by Robert Porter. Copyright 2023 by Merck Sharp & Dohme Corp., a subsidiary of Merck & Co., Inc., Kenilworth, NJ. Available at http://www.msdmanuals.com/home. Accessed 31/08/2021.

* 4 *

Visualizing Touch and Defining a Professional Persona

> I had the pictures of the postures of birth engraved and printed out of love of my neighbour at my own expense, so I could repay the world with love and after my death could leave to the world the enlightenment in this art and experience that God gave me in this world.[1]

Siegemund's birth figures were a gift, purchased at personal expense and given to the world. What she expected in return was recognition as a benevolent, pious, public-spirited professional. This was the bargain she proposed in working so hard to publish her book: that it, and particularly the illustrations, would form her professional, intellectual, and familial legacy. Not only teaching the skills and knowledge of midwifery, these images stood for Siegemund's own expertise and her beneficence in disseminating it.

The fetuses depicted stand for all those infants saved by Siegemund herself and by all the midwives who learned from her. But they also stand as Siegemund's own offspring. Unable to have children herself, Siegemund presents her figures as offspring and legacy: "Thus this book, which was long in seeing the light of day, as if in childbirth, will be what I leave to the world, since I have borne no children."[2] In doing so, she adopts an existing literary conceit in which male authors, including midwifery authors, cast their literary productions as children and their writing as a kind of labor that, being intellectual, was superior to the physical labor of the woman in childbirth.[3] In presenting them as a kind of gift or contribution to the world, Siegemund also aligns herself with the changing conception of both reproduction and midwifery as public duties, to supply the state with sufficient healthy workers and soldiers.[4] Rhetorically, Siegemund uses her birth figures to claim both a feminine physical authority over generation and a masculine intellectual one. She forms, in

text and image, an idea of who she is and the qualities that define her: a professional persona.

From around the 1670s, authors from all around Europe were constructing a new kind of public and textual community—one in which they were visible to readers from many countries and many backgrounds, in which they could interact with, and be judged against, one another. Previously, midwifery authors such as Rösslin, Guillemeau, or Culpeper might be well-known, but they were not professional midwives. Their books were intended to serve not as advertisements for their own midwifery practice but rather as works for the public good that would more generally raise their status as physicians or surgeons. Practicing midwives, on the other hand, while they were certainly concerned with their public reputations, established this reputation almost exclusively by word of mouth.[5] Professional jostling, which certainly did occur, mainly happened among geographically proximate practitioners and in a social rather than a textual arena. Yet beginning with Mauriceau and his contemporaries in Paris, learned midwife-authors began to compete for position and for custom in print. Pamphlets, prefaces, and notes to the reader presented authors with the perfect opportunity to fashion a public persona for themselves, the characteristics of which were typically benevolence, piety, knowledge, pedagogy, and a commitment to the Enlightenment ideals of clarity, reason, and rationality.[6] Siegemund's manual was, for instance "published, at her own expense, . . . to honor God and to serve her neighbor and at the most gracious and fervent desire of many illustrious highborn persons."[7] And Deventer's was "not only of the greatest Use to Midwives, but . . . an excellent Vindication of Divine Providence, and of the Humanity wherewith Midwifery ought to be practiced."[8]

While in the late seventeenth and early eighteenth centuries English midwife-authors were rare, English readers would have been familiar with this form of textual persona construction from imported or translated continental works, and the technique was sometimes adopted by English translators and editors. For instance, Hugh Chamberlen, the emergency midwife who translated Mauriceau's manual, used the work to advertise his own practice by highlighting his ability to deliver obstructed fetuses using forceps (a tool he and his family kept secret at this time) in cases where Mauriceau recommended craniotomy.[9] In the 1720s and '30s, when English midwives began to publish original midwifery manuals, they adopted the same textual systems for persona construction.

Lisa Forman Cody has demonstrated how the midwives of this period

"functioned as public—almost political—authorities," moving between the private domestic space of the lying-in chamber and wider political and public realms, holding "a uniquely privileged position and a duty to serve both mothers and the community."[10] Men midwives, she also emphasizes, created an Enlightenment persona of "idealized masculine subjectivity," "personifying both reason and feeling, showing others how to be a man of the world and one of the home."[11] This chapter will address how both the authors addressed in the previous chapter and the first generation of English midwife-authors employed print to construct public personas, and how they did so through complex debates over the status of touch.[12]

Lorraine Daston and Otto Sibum have defined "persona" as "intermediate between the individual biography and the social institution," "a cultural identity that simultaneously shapes the individual in body and mind and creates a collective with a shared and recognizable physiognomy."[13] A persona is a kind of type, more culturally specific and rich than that conferred simply by doing a particular job, but not so specific as that of the individual. Personae, they argue, "create new ways of being in the world, modifying everything from perception (the botanist's refined sense of color) to character (the patience and perseverance of the precision measurer) to forms of problem solving (the technocrat's pinpoint focus) to bodily demeanor (the professor's voice and posture). No specific individual scientist ever fully incorporates the scientific persona, but individuals can be molded by their masks or portraits, Dorian Gray fashion."[14] Midwifery, as it became professionalized and institutionalized from the late seventeenth century, also developed a persona—one that shaped how midwives practiced and saw themselves, but one that midwife-authors were also keen to actively shape and define in their publications.

Indeed, this new public persona was tied up with the very idea of public knowledge that print facilitated. In places such as Germany and France, where there were public training institutions and public positions to be held, it paid to disseminate one's knowledge in order to gain prestige and clients.[15] This, however, was not the case in places that lacked such public positions for midwives. In England, for example, until about the 1730s, most midwives kept their skills and knowledge secret, as a way to retain their client base and to protect themselves from competition, and so had no reason to publish. But as midwife-authors began to see themselves as public figures as well as private practitioners, the authority and prestige associated with teaching and disseminating knowledge began to outweigh the financial benefits of keeping it secret.[16] Print culture made the public midwife.

The Midwife's Public Persona

The persona of the midwife was, in some ways, similar to those of other Enlightenment public figures such as physicians and natural philosophers. The ideals of public service, of disinterestedness, of a seeking after truth and newly rational systems of knowledge were common to many scientific personas of the period.[17] But for midwives, their identity was fundamentally and specifically bound up with the complex issue of touch.

Midwifery requires the practitioner to touch the laboring woman, to feel parts of her body that are usually both visually and haptically off-limits, as well as to perform medical interventions with the hands. For regular midwives, this kind of touch was part of a well-established tradition of childbirth procedures and rituals, and it was what defined their special social position. Adrian Wilson, for example, argues that what distinguished the midwife from the other attendants was power over the mother and her family (who might have been of a much higher social status), payment for her attendance, and the fact that "she alone was entrusted with the right to touch the mother's 'privities'—her labiae, vagina and cervix."[18] That this touch was well established did not mean, however, that it was uncontentious. The midwife's touch could cause pain, injury, and even death. It could be practiced well, aiding delivery, or badly, injuring women, retarding labor, and mutilating the unborn child. Bad midwives were often accused of rough handling and of rash and uninformed intervention. Percival Willughby, for instance, described poor women who turn to midwifery without proper training and, as a consequence, "travailing women suffer tortures, by their halings, and stretchings of their bodies, after which followeth the ruinating of their healths, and sometimes death."[19]

However, touch gained a new level of contention with the rise of new emergency midwifery. This new type of midwifery involved increased "touching" or digital examination and new interventions such as podalic version or manipulation of the coccyx. It also saw increased practice by man midwives, and an attendant increase in the use of tools, which were officially forbidden to women midwives.[20] While emergency midwives were keen to show how such kinds of touch helped to ensure safe delivery, they were not guaranteed permission to practice them. Such touches were often refused on the grounds of both pain and propriety. Deventer, for instance, gives voice to the complaints of midwives: "though we could know, yet our Women will not suffer it; they will not be touched, except with one or two Fingers at the most, and so that you must not put them to Pain, for they will suffer no Hardships, especially those that are rich, who will not be handled, except with the softest Touch."[21] Indeed, even in the

mid-eighteenth century, when both "touching" and internal intervention in labor were well established in the literature of midwifery and in emergency practice, William Smellie still complained that touching had to be undertaken with one finger because "when two are introduced together, the patient never fails to complain."[22] As emergency midwives began to practice new interventions and move away from the standard rituals of childbirth, they had to negotiate, cajole, and compromise over the kinds of touch that would be performed.

The touch of emergency midwifery was also different in that it was more likely to be isolated: conducted by an unknown practitioner who had been called in only when a difficulty arose, and who was more likely to be a man.[23] The touch of regular midwifery was part of a wider social and cultural process of caregiving that covered pregnancy, birth, and postpartum recovery for mother and child, encompassing roles from prescribing medicines to washing and swaddling the infant and carrying them to their baptism.[24] Emergency midwives, who were often men, had a more medicalized view of the process, intervening in a complicated labor, delivering the infant and placenta, and occasionally prescribing medicines, but largely divorced from the wider social and nursing aspects of the profession, which remained the job of the regular midwife or a hired nurse. The development of this model of emergency midwifery, although it was practiced by some women, clearly benefited men in that it allowed them to make one part of midwifery into a medicalized and professional discipline, to attend and collect fees for larger numbers of labors, and to avoid low-status nursing work.

In Thomas Dawkes's *The Midwife Rightly Instructed*, the difference between regular and emergency midwifery is articulated. The surgeon interlocutor instructs his midwife pupil to manually remove the placenta as soon as the fetus is delivered. The midwife objects:

MIDW. Well, but Sir, if I do this, I must be obliged immediately to commit the Child to some other Woman in the Room; and that is not a customary thing with us midwives.
SURG. True, LUCINA, neither is it customary, with the generality of Midwives, to practice means that are consistent with Reason, and the Nature of Things.[25]

If we move past the overtly misogynistic tone, the exchange neatly demonstrates the difference between regular midwifery, centered in the whole care of mother and child, and emergency midwifery's exclusive focus on internal intervention and the completion of delivery. The regular midwife

is reluctant to give up her important social right—to cut the umbilical cord and to wash and swaddle the infant—in order to enact a manual intervention. But for the learned surgeon, such a qualm indicates the irrationality of the regular midwife's practice. For the regular midwife, their rights to touch were part of a wider role in giving care and protection to the bodies of both mother and child. For the emergency midwife, the right to touch was rarefied and professionalized, associated only with delivery itself and with the rhetoric of rational medical practice.[26]

However, if emergency midwives throughout the seventeenth and eighteenth centuries were negotiating new kinds of touch with their clients, they also faced the disapprobation that touch brought them from the realm of learned medicine. The problem lay in the symbolic associations of touch in the early modern world. Historians of the senses have found that touch held a contradictory position within the hierarchy of the senses.[27] Touch was simultaneously the first sense—that which was developed first and was the most essential and corporeal—and the lowest and basest sense, associated with low-status work, with the sexual and with the bodily rather than the spiritual or intellectual world.[28] The five senses, the humors, the natural elements all fitted together within the system of analogical thinking that placed touch in low and primal association with Earth and with grossness.[29]

Within the realm of medicine, too, touch was integral to the system of professional hierarchy. In the simplest terms, the fact that physicians did not touch their patients, but surgeons did, separated them into intellectual and physical, and therefore high and low, professions. In fact, this distinction was never that simple: as scholars such as Cynthia Klestinec and Michael Stolberg have shown, physicians did touch their patients, and surgeons became increasingly respected during the early modern period, despite their association with touch.[30] A more nuanced distinction might be, therefore, between *kinds* of touch: physicians mainly palpated the body for diagnostic purposes, while surgeons undertook all kinds of treatments on and in the body. Moreover, the *rhetoric* of touch, the fact that physicians were still defined by "superior intellectual activity" and surgeons by "more manual—and thus supposedly more menial—work," certainly remained a potent force in this period.[31]

First surgeons and anatomists, and later emergency midwives, had to deal with the contradiction between a practice based on touch and the desire for recognition as learned and skilled professionals. As Elizabeth Harvey, in discussing Vesalius's practice, explains, "for the anatomist, of course, knowledge necessarily involves touching the corpse, a contact that was essential but one that also dangerously allied the physician—both

actually and symbolically—to the death and disease he studied."[32] Touch was as fundamental to the anatomist's practice as it was to the midwife's, particularly after it became more common for the physician leading the dissection to undertake the physical work of cutting as well as the intellectual work of identification and explanation.[33] While direct observation and empirical study became more valued in the seventeenth and eighteenth centuries, this did not entirely neutralize the problem of touch.

Touch was a particular problem for male practitioners, Constance Classen has argued, because touch and physicality were fundamentally female, in opposition to the fundamentally male intellectual capacity: "Men were above all rational beings, while women were, under it all, sensual beings."[34] So when the man midwife proposed to assume women's work, using a feminine sense on the female body, he did something deeply suspicious and, arguably, counter not only to the social rules of propriety but to the divine rules that distinguished the sexes. The male practitioner was in danger both of violating the laboring woman's body and of degrading his own. Roy Porter has argued that, in this period, all medical professionals were looked on with suspicion because they "were readily associated in the public mind with carnal knowledge."[35] While Porter stresses that physicians refrained from touching their patients for learned reasons as well as those of propriety, the limited use of touch in medicine did help to cast the man midwife as "a sexual infiltrator, a violator of female modesty."[36]

Faced with such obstacles, exactly how men managed to break into the midwifery profession in England and France in the late seventeenth century has puzzled historians.[37] What is generally agreed is that the position of the man midwife in the decades around 1700 was precarious, "its professional right of entry" uncertain.[38] Regardless of how well they practiced, emergency midwives of both genders were subject to wider social and cultural codes on gender roles, propriety, and touch. This meant that new emergency and male practitioners had at least as much to do in creating a culture that would allow them to practice as in ensuring that their practice was actually effective. This project, as I will argue, was focused on the creation of a persona for the midwife that completely recast the cultural associations of touch and that did so largely through print.

Seeing Touch

Because they could not eliminate touch from their practice, the new midwife-authors went about turning the public perception of touch on its head. They attempted, in the decades either side of 1700, to make touch into a high, intellectual, masculine, nonsexual, valorized sense. By dint

of little more than forceful repetition in print and in practice, midwives engineered a cultural shift that Eve Keller has described in the following terms: "the rhetorical representation of the techniques of touch, through a gradual accretion of associations, produces an unprecedented authority for the medical practitioner of childbirth. As it is rhetorically constructed in these texts, touch, traditionally a mark of mere manual labour, becomes over time a sign of almost magical prowess, so that midwifery, historically among the least prestigious of medical practices, becomes the place where the modern image of the medical miracle-worker is born."[39] Historians such as Keller, Wilson, and Forman Cody, as well as the art historian Lianne McTavish, have examined how this process was enacted both in print and in practice.[40] Indeed, it is one of the more thoroughly explored aspects of early modern midwifery. Yet no survey of how images contributed to this shift has been conducted. McTavish is the only scholar that I am aware of to have worked with midwifery illustrations in this context, but her focus is exclusively on French material. In what follows, I will explore the ways in which midwife-authors employed print images both to valorize and recast touch and to shape their public personas.

For his second volume on midwifery, *Nader vertoog* (1719), Hendrik van Deventer produced two new images. He had been unhappy with the description of uterine obliquity in his first manual and so provided two figures intended to give "at least some sort of an Idea of this matter" (figure 25).[41] These images show one womb situated normally in relation to the pelvis and one that is situated obliquely: the two work both to demonstrate how a practitioner might sense an oblique womb and to show how obliquity might complicate birth.[42] In each image, we see the womb vacated by the fetus but newly occupied by the practitioner's hand. The image is intended to give a haptic account of the pregnant body, showing what the hand would feel in both cases, and thus how an invisible yet crucial problem can be diagnosed and understood. Of the first figure, showing a normal womb, Deventer writes: "Every one will easily perceive, that the Hand and Arm, thus thrust up into the Womb, have room enough, that they may turn and roll round every way towards any part of the Womb, to invert the Infant, tho' lying resupine on his Back."[43] The second figure shows a "propendulous" or forward-leaning womb, seen from the side. Here Deventer argues that while there is some leeway for the practitioner's arm in the pelvis when the womb leans to the left or the right, when it leans forwards, "the Arm cannot follow the Hand when put in; for it cannot bend in that place, nor is there room that it may follow the Hand to assist such an oblique situation."[44]

These two figures appear to show how the practitioner can identify

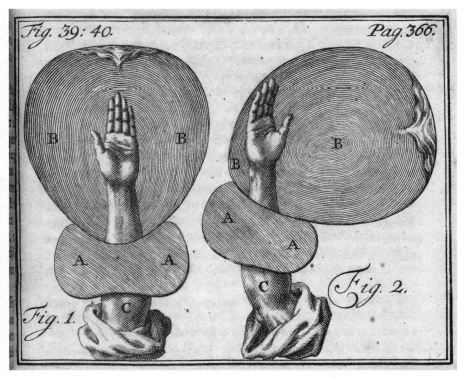

FIGURE 25: Anon., *Figures 39–40*, engraving, 10.6 x 14 cm (plate). From Hendrik van Deventer, *Nader vertoog van de sware baringen, en van de toetsteen en 't schild der vroedvrouwen* (Delft: Reinier Boitet, 1719). © The British Library Board (1178.h.1.(2.)).

an oblique or "propendulous" womb by inserting their hand into it. Yet such an operation cannot have been widely practiced, not least because it was most crucial to identify obliquity *before* the fetus was delivered, when there would be no room in the womb for such a maneuver. While inserting the hand into the womb after delivery was sometimes practiced to "fetch away" the placenta, by this point identifying uterine obliquity was much less important. Rather, then, these two images can be understood as a kind of thought experiment in haptic terms, intended to help the viewer to understand how the bodily interior is formed. Deventer asks us to imagine what one *might* feel if one's arm was inserted into a "propendulous" womb: because there is no joint in the forearm, the top of the womb would be out of reach. Thinking about how the viewer's own arm would fit into a normal and a "propendulous" womb becomes, in this image, a device for helping the viewer to think about how a *fetus* might fit in and move through that space. These images, therefore, exemplify how

haptic knowledge and haptic thinking complemented the practitioner's abstract and mechanical understanding of birth.

Unlike other operative hands in birth figures produced in this period, therefore, these hands do not describe manual practice. Rather, they stand symbolically for the importance of the hand to midwifery, describing how the bodily interior can be known and mastered by the dexterous and haptically sensitive practitioner. In these images, only those parts of the body that are touched or touching are described: the hand and arm of the practitioner have been carefully modeled; the contours of the arm, the pad of the thumb, and each joint of the fingers are carefully delineated. The interior of the womb is hatched with lines that describe its round, hollow shape and give it texture. Indeed, the texture of the womb is further emphasized in the version of the image produced for the English translation, *New Improvements in the Art of Midwifery* (1724, figure 26), where the lines are minutely wavy and irregular. The rest of the body, even the exterior of the womb, which we would normally expect to see in a birth figure, is here omitted because it is not part of the sphere of haptic experience. Because of these omissions, the image becomes symbolic of the midwife's sphere of authority, founded on the skilled hand. The position of these hands and arms, held straight up with open palms and slightly curved fingers, speaks of both assurance and a relaxed open-handedness.[45] There is no tension or violence in these hands and arms, though there doubtless would have been in the actual operation of inserting the hand and arm into the womb. The hatched lines that describe the womb, moreover, highlight and frame the heroic hand in a kind of halo.

Some modes of representation in birth figures—such as Deventer's mechanistic descriptions of the pelvis—aimed to show the body completely and to visualize what midwives could not see for themselves. But other modes were more concerned with the actual experience of practice and faced the problem of visually representing haptic knowledge. A solution came in both textual and visual forms through conflating the senses of touch and sight. In Deventer's figures (figures 25–26), the lines that describe the womb also look like radiant lines, emitted from the hand as if it were a source of light, symbolizing the midwife's "illuminating" touch and making the midwife's hand into the bringer of light, the explorer of the bodily interior and its savior. This conflation of touch and sight in midwifery texts of the period has been remarked upon by Lianne McTavish, who notes that "the dark and mysterious realm of the womb was enlightened by the men's perceptive hands, which 'looked for' the malpresenting child and 'observed' its posture."[46] Practically speaking, birth figures could be informed only by what the practitioner felt—the interior of the

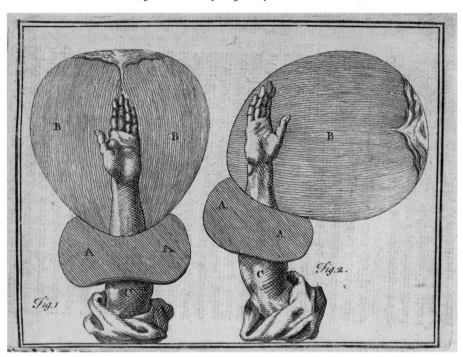

FIGURE 26: Anon., *Figures 1–2*, engraving, 10.5 x 14.1 cm (plate). From Hendrik van Deventer, *New Improvements in the Art of Midwifery* (London: T. Warner, 1728 [1724]). Medical (1701–1800) Printed Collection M2.1 D39, University of Manchester Library, Manchester. Copyright of the University of Manchester.

living womb could not be seen. But more than that, Deventer's figures seek to describe the *quality* of tactile, rather than visual, knowledge, the radiating lines blurring between the illumination of light and the texture of the womb.

Though touch was central to midwifery practice in both gathering knowledge and practicing upon the body, it was a somewhat contentious topic. Particularly male practitioners, and those who proposed to undertake new kinds of internal intervention, battled against objections to touch on the grounds of propriety and pain. Because sight was both a higher and a more intellectual sense, and one that didn't require direct contact between practitioner and patient, its conflation with the midwife's touch elevated, rationalized, and made it acceptable. As Siegemund put it: "touching indicates to a proper midwife all the dangers that can occur in a birth. If she is forbidden to touch the woman, then she works blind, and a woman who forbids it can only blame herself for any misfortune that follows."[47] Indeed, the textual and visual rhetoric of the midwife's touch

was not just that it was necessary but that it was fundamentally so different from the average person's haptic abilities as to be essentially incomparable. Deventer, for instance, argued:

> I am not ignorant, that what I have said, may seem strange to those that are unexperienced, thinking that nothing is more easie, than to distinguish Things by touching, and that a Hand is easily distinguished from a Foot, if one will only be attentive. But what those sort of People say, is to be received without Offence; according to the Proverb, *in a Calm all are Masters*. If the parts hid within the Womb might be as soon distinguished, as those without, a heavy Countryman, or a Boorish Woman would easily perform that Work; but since the Hand is so closely compressed by the narrowness of the Womb, and especially of the Mouth of it, scarce any Thing is more difficult than to distinguish by the Touch, what you hold in your Hand, especially when the Hand is put further up, when the Waters have flowed out for some time. I allow indeed, that by handling of one Part, one may judge of another.[48]

The "heavy countryman" and "boorish woman," who might object to the emergency's midwife's touch, are essentially unqualified to say whether it is appropriate: no outsider ever understands the intricate skills and knowledge of the master of a craft. Within the context of such arguments, Deventer's figures of seeing touch stand for the midwife's specialist haptic knowledge; they valorize it as illuminating, but they also present it as strange, mysterious, and miraculous. They are images that try to explain the sensory knowledge of the midwife and to rarefy that knowledge, both in the service of legitimizing the emergency midwife.

However, if midwives were arguing for the necessity of touch for examination and practice, they were careful to set boundaries on their requests. Laboring women should not be touched more than was absolutely necessary and should be covered with clothes and sheets. Repeated investigations hurt and distressed the mother and risked tearing or inflammation, and unnecessary exposure could embarrass or unsettle them, as well as risk dangerous chills. The midwife's skill was in balancing the need to know with the advantages of leaving well alone, and in turning scanty knowledge to effective practice. While some midwives complained of being denied tactile or visual access, of being relegated to adjoining rooms or refused permission to conduct particular interventions, they were also at great pains to emphasize that they were *not* asking for complete sensory access to the laboring body. As Hendrik van Deventer wrote: "The Woman in Labour will be ashamed, if she is laid more naked than Honesty and

Necessity requires; besides if he [the midwife] handles the Patient cruelly and roughly; if he cuts the Infant to pieces; if he wounds the Mother; lastly, if for the sake of Wicked Delight he should dare to ask the miserable Woman Questions whilst the Body or Head of the Infant is in the Neck of the Womb, the greatest of Wickedness!"[49] Inquiry—by sight, by touch, and even by the asking of questions—was to be limited in the name of calming and making comfortable the laboring woman. The body in midwifery was not meant to be exposed like the body in anatomy: it might be investigated by the midwife's hand, but it retained an essential mystery, a wholeness that refused sight, only partially open to the midwife's special seeing touch. The lying-in chamber, even medicalized emergency practitioners were eager to establish, was not the anatomy theater, and the midwife was neither a surgeon nor an anatomist. So while the irascible, unlimited investigation of the anatomist *informed* the midwife's practice, it did not *constitute* their practice.

This crucial difference can be seen in Deventer's birth figures and images of the hand in the womb (figures 20–21 and 25–26). His birth figures describe an abstract, mechanistic, anatomically informed view of childbirth, exposing the pelvis and spine, as well as the fetal presentation. His images of touch, however, show not the pelvis but instead a rather amorphous flap. Exactly what this flap describes is not immediately clear: the text declares that it "denotes the pelvis," but not in the mechanistic and anatomically detailed manner of the birth figures.[50] Rather, the flap seems to represent less a physical part of the body, and more a barrier to the knowing of those parts. This flap-of-not-knowing points both to the inaccessibility of the pelvis in the mother's body and to the sheets and clothes that hide the mother's body from the midwife's sight. It characterizes the spheres of knowledge in midwifery: the external world, the hidden body, the small realm of internal uterine knowledge. Labeled A and B, the flap and the womb together point to the midwife's illuminating knowledge and the limits of that knowledge.

It was dichotomies of sight and touch, and knowledge and mystery, that characterized the way that the midwife's identity was constructed in this period, and both are encapsulated in one image from Mauriceau's manual: a figure of the fetus seen through the uterine membranes (figure 27). These translucent membranes were an object of fascination for anatomists and artists alike in the early modern period.[51] But Mauriceau and his artist use the image, and an unusual engraving technique, to explore the specific nature of body knowledge in midwifery. Most famously associated with the Parisian engraver Claude Mellan, the technique involves using parallel lines that follow the physical contours of the thing represented, becoming

FIGURE 27: Paul Androuet du Cerceau (draftsman), [Fetus-in-Membranes], engraving, 6 x 4.5 cm (figure). From François Mauriceau, *Traité des maladies des femmes grosses et accouchées* (Paris: chez l'auteur, 1681). Medical (Pre-1701) Printed Collection 1583, University of Manchester Library, Manchester. Copyright of the University of Manchester.

thinner and thicker to represent areas of shadow and light, but also physical depression and projection.[52] The exchange of the traditional system of outline and shading for lines that describe contour and physicality challenges the ways in which an image can communicate touch. In Mauriceau's figure, the spiraling lines describe the shape of the membranes, but their changing width describes the shape of the fetus within. We are given both the shadowy, hazy view of the fetus seen through the membranes, and the

physical presence of the fetus within them, pressing against them. The spiral starting in two places—at the fetus's umbilicus and face—produces a resonance with the shape of a fingerprint, as if a giant finger were laid carefully over the fetus, giving and receiving impression.

The fetus within sits curled, eyes averted, with a knowing smile on his lips. He is secure in the membranes, at once exposed to sight and yet unreachable. The tightly spiraling lines give us a darkening view of him, pointing to both sight and shadow, exposure and mystery, knowing and unknowing. Birth figures and other kinds of midwifery image such as this one worked in complex ways to shape and describe the qualities of the midwife's touch. It was haptic yet illuminating, it was necessary, heroic, yet also limited. The body as represented by these midwife-authors was characterized by light and shadow, by illuminating knowledge and necessary mystery.

The Valorized Hand

In the birth figures of the early midwife-authors, it was not just images of the touched body that served to characterize the midwife, but also images of the touching hand. The hand had always been, to some extent, the symbol of the midwife. From the earliest midwifery manuals, we find descriptions of the ideal midwife's hand—Jacques Guillemeau, for instance, requiring "little hands & not thicke: cleane, and her nailes pared very neere, and even; neither must shee weare rings upon her fingers, nor bracelets upon her armes, when shee is about her business."[53] When Guillemeau was writing, in the early seventeenth century, this ideal hand was female. As male authors began to present themselves as public servants and appropriate practitioners, they adopted this feminine ideal, adapting it to incorporate both physically and intellectually masculine attributes. Deventer, for instance, asserted that "nothing ever is more agreeable to the Art of Midwifery, than slender Hands, long Fingers and quick feeling."[54] Slender fingers and "quick feeling," which implies both physical sensitivity and a mental quickness, are here intertwined. Indeed, more broadly in early modern culture, the hand stood for the low and the high in humans: base sense and manual labor, but also the controlling intellect.[55] As Elizabeth Harvey has argued: "tactility, the fundamental sense, the sense contiguous with and essential to all animal life, which is especially pronounced in the vulnerable skin of human nakedness, is paradoxically differentiated from other animals through the concentration of touch in the apprehending and discerning hand. The hand stands for dominion not only over the other animals, but also over the potential for animality

within human beings."[56] This understanding dated back to antiquity, to the writings of both Aristotle and Galen, who saw the hand as "the physical counterpart of the human psyche," suited not just to particular tasks, but versatile, able to employ various tools and to address "an unrestricted range of subjects."[57] And, of course, according to Galen and many in the seventeenth century who read and followed him, the hand in its special capacities was also the ideal exemplum of God's creative dominion.[58] It was this association of the hand with the superiority of humans over animals, this connection between physical abilities and intellectual agency, sanctioned by God's design, that the new midwife-authors brought to the older physical ideal of slimness.

The operative hands in the birth figures of Mauriceau, Viardel, Siegemund, and Deventer exemplify the complexity of this rhetoric, and particularly the difficulties of reconciling masculine and feminine ideal attributes. Though the rhetoric itself was deeply concerned with gender, it was employed in very similar ways by both men and women. Male authors tended to assimilate traditionally feminine qualities such as small, delicate fingers and soft skin with masculine strength and rationality. Female authors did much the same in reverse, claiming the traditionally masculine attributes of strength and intellectual capability for themselves.

In the birth figures of this period, therefore, we find a unique and curiously androgynous representation of the operative hand. Midwifery hands were unlike the operative hands represented in other genres: instead of being elegantly sleeved and cuffed in lace, or emerging from angelic clouds, as was common in illustrations from other disciplines, they are bare to the elbow, and are circumscribed by simple, loose white sleeves rolled or kilted high up the arm.[59] This convention presents the midwife's hand as a real, physical, sensate tool of the profession: it is neither the purely intellectual, gentlemanly hand, cuffed in lace and divorced from the more strenuous or physical aspects of labor, nor the incorporeal divine hand, descending from the clouds. Caught-up sleeves were, obviously, part of the uniform of midwives, who worked not only with their hands but with their whole arms; if the hand was to be inserted into the womb, then most of the forearm must necessarily be touching the bodily interior. Indeed, the slenderness and strength of the arm as well as the hand was a crucial aspect of the midwife-persona. Moreover, whereas the lace cuff indicated gentility and the clouds divinity, the bare skin of the midwife's operative hand fed into the rhetoric of the deep, specialized sensorial capabilities.

This was the case whether the practitioner was a man or a woman, as William Smellie indicates in his description of ideal dress for man midwives: "the more genteel and commodious dress is, a loose washing night-

gown, which he may always have in readiness to put on when he is going to deliver; his waistcoat ought to be without sleeves, that his arms may have more freedom to slide up and down under cover of the wrapper; and the sleeves of his shirt may be rolled up and pinned to the breasts of his waistcoat."[60] Male midwives adopted a casual, domestic dress, which was both practical and nonthreatening to the laboring woman, distinguishing the midwife in his "loose washing night-gown" from the surgeon in his coat and apron. As Lisa Forman Cody notes, "the most successful men-midwives attempted to cross the boundaries between male and female ways of knowing, and in their public self-presentations, they even vacillated between masculine and somewhat feminine mannerisms, habits and dress."[61] Unsuccessful man midwives could be identified by their inappropriate or ridiculous dress, as a case recorded by William Smellie indicates. He recounts being called to a labor where a young man midwife was already present: "I was struck with his apparatus, which was very extraordinary, for his arms were rolled up with napkins, and a sheet was pinned round his middle as high as his breast."[62] The young practitioner is incompetent, and it shows in his dress. Not only does he look strange, but by wrapping his arms in napkins he has also made touching the laboring woman deeply impractical. He has not understood where sheets are appropriate to protect modesty and hide the body from sight, and where bare skin can be employed as a sign of natural fitness, gentility, and good practice.

While the lack of a coat or lace cuff in birth figures of this period indicated manual labor, the abundant white cloth framing white skin also suggested gentility and a distinctly idealistic level of cleanliness. Such sleeves were part of both men's and women's dress; men's shirts and women's shifts were similarly loose white linen garments. Indeed, Susan Vincent has noted that they could even be used interchangeably, in a pinch.[63] Such linen undergarments were fundamental to the health and cleanliness of the body: they protected the body from the outer clothes, and they soaked up the body's secretions, helping to maintain humoral balance. Changing one's linen in the early modern period, Vincent argues, was equivalent to showering or bathing today. Clean linen, therefore, spoke to health and cleanliness, but also to wealth, as it implied the ability to buy multiple linen shirts or shifts and to have them frequently laundered. The clean white sleeves of these images, therefore, make an argument for the social, economic, and health status of the practitioner, as well as contributing to the authors' androgenizing project.

Much is signified, too, in the physical form of the hands themselves—all are clean and hairless, with long, slender, sinuous arms and tapered

fingers. Lianne McTavish has suggested that those in Siegemund's images (figures 19 and 23) are "slender, feminine arms," as opposed to the more masculine arms produced by male authors.[64] While a little more muscle definition is given to the arms in Deventer's images (figures 25–26), the overall emphasis is, in my view, in all cases of a kind of androgynous slenderness and delicacy. None of the arms have any hair or blemishes, and while some show a smooth definition of muscles, there are also many examples, particularly in Viardel's figures (figures 22 and 28), where the arms seem serpentine, preternaturally bendy—all the better to nontraumatically enter the bodily interior. This is not to say that male authors wanted to represent themselves as female, or vice versa. Rather, the iconography of the operative hand in this period incorporated feminine slenderness with masculine definition and ungendered clothing in an attempt to address the deep problems with men's practice and with increased physical intervention. Something between androgyny and flexibility seems, in the decades around 1700, to have been the answer.

In the figure from Viardel's manual depicting the extraction of a separated fetal head (figure 28), the two arms incorporate different qualities. The right signals masculine strength in the engaged muscles and the vein standing beneath the skin of the forearm. Yet the arm is also slender and smooth, and the overtly thin and tapered fingers are arrayed in a genteel gesture. The composition signals both strain and ease. The left arm is not only less muscular but bends with more elegance than is anatomically possible. Taken all in all, the signals are mixed, because the identity of the new emergency midwife was mixed, confusing to traditional hierarchies of work, of the senses, of knowledge, and of gender.

These operative hands are also notable for their smallness in proportion to the womb they operate upon. I have discussed in the previous chapters why the womb was often depicted as spacious, but the authors and artists of this period depict not just the fetus but also the operative hand on a small scale.[65] Of course, this composition works in much the same way as the small fetus: to clearly depict how the hands operate in what is, in reality, a very cramped space. But the representational convention also neutralizes an invasive, painful, potentially damaging intervention. This is not to say that authors of the period shied away from the physical difficulties of manual intervention in the womb. Siegemund acknowledges that setting "to work in the belly with your entire arm as well as with a rod with a ribbon wedged into it" seems almost impossibly violent to many women but nonetheless insists that, as a good midwife, "I can and must insert my arm up to the elbow to search for the feet if the child is to be turned and the woman rescued."[66] The English midwife Sarah Stone also

FIGURE 28: Anon., [Birth Figure], engraving, 17.4 x 11 cm (page). From Cosme Viardel, *Observations sur la pratique des accouchemens naturels contre nature et monstrueux* (Paris: The Author, 1674 [1671]). Medical (Pre-1701) Printed Collection 2518, University of Manchester Library, Manchester. Copyright of the University of Manchester.

notes the toll such interventions take on the practitioner, recounting one difficult labor after which "I could not turn in my bed, without help, for two or three days after, nor lift my Arm to my Head for near a week; and forced to bathe my Arm with Spirit of Wine several times a day."[67]

Yet the birth figures do not communicate this. In Siegemund's fig-

ures (figures 19 and 23), for example, the hands assume elegant, relaxed positions, and there is no indication of strain or force. Yet this composition was not intended to deny that such operations *were* painful: not only do the texts of midwifery manuals often frankly acknowledge pain, but authors were also expressly anxious that viewers should not misinterpret birth figures as describing manual intervention as easy. Rather, the convention of the slender, relaxed arm in the spacious womb was a visual argument for the *difference* in the pain caused by the touch of a good midwife and a bad one. Deventer indicates this difference in reporting the words of a woman who suffered a protracted labor and was attended first by a bad midwife and then by Deventer's wife: *"how one Womans Actions differ from anothers! As soon as your Wife handled me, I was presently eased, and having recovered my Spirits was able to bring forth my Child, when before the Midwife had only tormented me, that I could not Labour strongly."*[68] Deventer's wife employed the technique of pushing back the coccyx, allowing more room for the fetus to pass through the pelvis. Such an operation was undoubtedly painful for the woman, yet after a protracted labor exacerbated by the interventions of a bad midwife, the touch of the good midwife becomes a positive relief. The hands and arms in birth figures work, therefore, in a didactic mode that did not shy away from the pain of intervention, but rather couched it within the larger context of childbirth as a painful and dangerous event in which the midwife's intervention could be positive or negative, damaging or relieving. Deventer's, Viardel's, and Siegemund's images of operative hands are those of the *ideal* practitioner who does all they can to work fast and smoothly, to ameliorate pain and danger, and to deliver the fetus alive and undamaged.

Problems with the Valorized Hand

In their birth figures, Viardel, Siegemund, and Deventer converged on a visual language that spoke of the practitioner's hand as a seeing organ, as elevated above other hands by a special capability, sensitivity, and heroism of practice. Through this visual language, the authors made an argument for the appropriateness of touch to midwifery practice. Lianne McTavish has argued that the same use of the symbolic, valorized hand can be found in frontispiece portraits that were commonly commissioned by French midwife-authors of the period. She argues that such images were intended to establish for the male practitioner "a direct and physical understanding of childbirth—one capable of substituting for women's bodily experience of maternity."[69] While most of these authors, including Mauriceau, Paul Portal, and Philippe Peu, commissioned quite conventional portraits,

which employed hands gesturing or holding books to emphasize the intellectual aspects of the new midwifery (see figure 14), Viardel's was much more unusual, working, McTavish argues, to "suggest an intimate knowledge of childbirth" (figure 29).[70] These portraits were not reproduced in the English translations, probably both for reasons of economy and because establishing the author's identity was less important for an English audience unlikely to meet or hire them. But I will take some time to address Viardel's here because of the unusual and arguably unsuccessful experiment it makes in reconciling seemingly contradictory aspects of the midwife's touch. While the image is in some ways very specific to Viardel and his Parisian context, it also engages with many themes more broadly common to emergency midwives all over Western Europe in the period.

As discussed in the previous chapter, Viardel was different from many of his French colleagues in that he was not member of the guild of surgeons.[71] As McTavish has argued, he based his authority not on such learned institutions but rather on his own direct physical experience of the body.[72] McTavish suggests that the same distinction is at work here— while Mauriceau and Portal touch copies of their own books (figure 14), Viardel touches the head of a fetus (figure 29). Viardel's gesture is a clear indication of the way in which he constructs his own authority—not from books but from the object itself. Indeed, Viardel's artist, "du guernie" (perhaps Pierre du Guernier, a miniaturist and Academician in Paris), and engraver, Jean Frosne, in making this visual argument, were borrowing from an established iconography in the visual culture of anatomy. Since Vesalius's woodcut portrait of 1543 (figure 30), anatomists had been making the radical statement that their knowledge was empirical and that that was a good thing.[73] Elizabeth Harvey writes that Vesalius's portrait "is an ideological intersection significant to the history of tactility, a confrontation between the hand as a touching instrument and the tactile, obscuring flesh. In other words . . . early modern anatomy involves not only peeling away the body's outward sensory covering in order to discover visually the body's inside but also subduing and harnessing tactility and displacing its distracting sensuality into the mastering agency of the hand."[74] Since the mid-sixteenth century, then, images of anatomists touching the objects of their study made an argument not only for the nature of their authority but for the nature of touch itself. Harvey establishes two key points about the image: First, the ability to sense, to garner tactile stimulus, is removed from the skinned cadaver at the same time as it is conferred on the anatomist's hand. And second, the manner of this tactility is constructed and curated; that which is worryingly sensuous is reordered within the anatomist's hand into something powerful, intellectual, and authoritative.

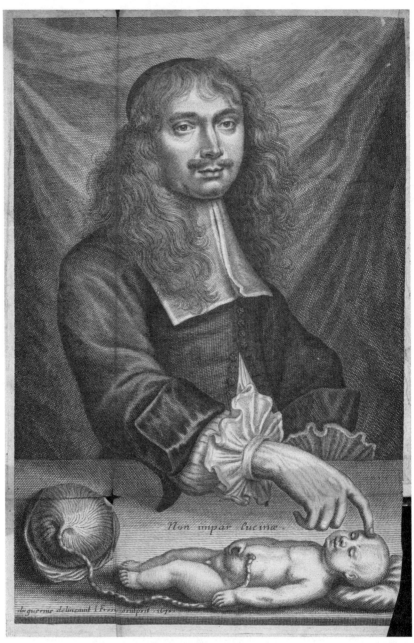

FIGURE 29: Du Guernie (draftsman) and Jean Frosne (engraver), [Frontispiece Portrait], engraving, 23 x 16 cm (sheet). From Cosme Viardel, *Observations sur la pratique des accouchemens naturels contre nature et monstrueux* (Paris: The Author, 1671). Medical (Pre-1701) Printed Collection 2517, University of Manchester Library, Manchester. Copyright of the University of Manchester.

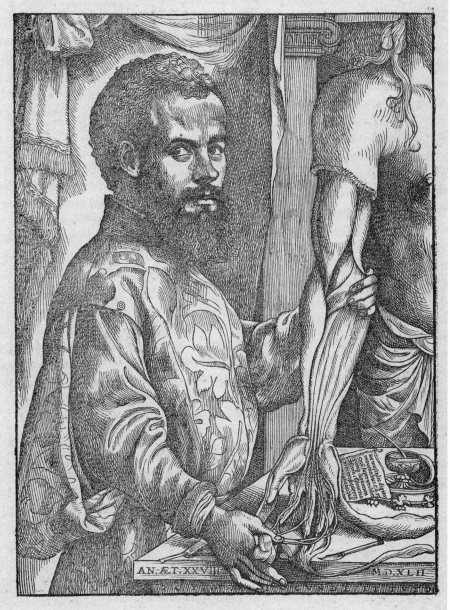

ANDREÆ VESALII.

FIGURE 30: Jan van Calcar (probable draftsman), [Frontispiece Portrait], woodcut, 19.6 x 14.5 cm. From Andreas Vesalius, *De humani corporis fabrica libri septem* (Basel: I. Oporini, 1543). EPB/D/6560, Wellcome Collection, London.

Katherine Rowe makes a similar argument about the importance of touch to investigation and knowledge production, citing Helkiah Crooke in the assertion that "anatomy consists of a fruitful correspondence between cutting, 'the action which is done with the hande,' and the rational 'habite of the minde, that is, the most perfect action of the intellect.'"[75] Viardel, too, MacTavish would argue, used his portrait to define and make safe the kind of touch that was essential to both how he gained knowledge of the body and how he practiced upon it. He gently touches the object of study, both asserting his authority over it and indicating that his knowledge is well founded in study of the body itself. But can this image have been read this way by early modern viewers? I argue that in adopting a visual convention from anatomy, Viardel may actually have confounded, rather than shored up, his valorizing project. Certainly, to a viewer today, Viardel's portrait is troubling and macabre, and early modern viewers may have had similar reactions.

Produced as a frontispiece for Viardel's manual, the engraving can be found facing the title page in all three editions (1671, 1674, 1748). It is larger than the page size and is bound in with the lower and outer edges folded in. In the image, Viardel stands three quarters on, turning his head so that he almost completely faces the viewer. He is boxed into a small space, standing behind a table and in front of a curtain. While such background drapery was common in portraits of the period, it leaves Viardel's location ambiguous: is he in a private study, at the home of a laboring woman, or in a room for public teaching or demonstration? He is dressed in a dark, sober coat and cap, with a large white collar and wide ruffled cuffs. On the table, at the bottom of the image and in the foreground, lies a fetal cadaver, his head resting on a pillow, still attached to the placenta that lies at his feet. Viardel's somewhat overlarge right hand reaches forward, touching a forefinger to the fetus's forehead. The fetus lies as if sleeping, but context tells us that he is dead: all living newborns would immediately have had the umbilical cord cut and then been washed and swaddled. Moreover, no healthy living child would remain under the authority of a male practitioner, rather being absorbed into the family unit and cared for by a woman midwife, nurse, or other attendants. McTavish argues that the image shows Viardel's skill in that he managed "to remove the infant from its mother's womb and to guarantee its eternal repose."[76] While indeed this fetus has not been subject to dismemberment or craniotomy, the image is hardly a positive one: not only is the child dead, but the specter of anatomical dissection hovers over it.

This ambiguity, in which the subject of a dissection is rendered and posed as if simply sleeping, is common in anatomical imagery. In Jan van

Neck's *The Anatomy Lesson of Dr Frederick Ruysch* (1683, plate 5), as well as in print fetal anatomies from Spiegel's *De Formato Foetu* (1626) and Mauriceau's *Traité* (1668, figure 31), the fetus is represented in much the same manner as an anatomical Venus—hovering somewhere between sleep and supine ecstasy, the body cavity opened and yet still seemingly alive.[77] While the convention of representing the anatomized fetus as if sleeping was already established in midwifery and anatomical books, it is particularly disconcerting in Viardel's portrait because it places the midwife—whose job is to deliver living children—in direct contact with a dead fetus and one, presumably, about to be anatomized (figure 29). Not only does the image seem to exacerbate a deep anxiety about the danger to life posed by a difficult labor,[78] it also brings together the realms of midwifery and anatomy that authors were usually at great pains to keep separate.[79] While in portraits of anatomists, such as those of Vesalius and Ruysch, the anatomist derives authority through his touch on the dissected cadaver, Viardel's realm was meant to be the living body, which, at this time, was fundamentally different from the dead, dissected one. Unlike the other examples, Viardel's fetal cadaver is not actually opened, perhaps in an attempt to move the midwife's persona one step away from the visceral, terrible act of dissection.[80] Indeed, Cynthia Klestinec, in a study of touch and complicity in early modern surgical culture, suggests that physicians and surgeons were keen to disassociate their touch, and particularly any cuts they might make, from the touch and the cutting of the anatomist.[81] Midwives, by the same token, wished to disassociate their own touch from both the anatomical and the surgical. Indeed, while the midwife often had some knowledge of anatomy and may also have practiced surgery, the profession of midwifery itself determinedly involved no cutting open. This perhaps explains the ambivalence in the center of the portrait: Viardel was a surgeon and a midwife, and his image attempts to reconcile these two modes of knowing the body and two kinds of touch. The fetus lies somewhere between the dissected fetus of the anatomist's portrait and the living little patient that the midwife dealt with. However, that a newborn child might be both was something that most people of the period were not keen to contemplate.

As McTavish has noted, Viardel's gesture is also employed in van Neck's portrait of Frederick Ruysch (plate 5), by the far-left figure, who reaches out to gently touch the placenta on the table. The gesture is described in John Bulwer's 1644 treatise on gesture entitled *Chirologia* as the "diffidentiam noto."[82] Literally translating to something like "I mark my mistrust," the gesture indicated, in McTavish's words, "the satisfaction of intellectual curiosity through the sense of touch."[83] Thus, while the gesture might

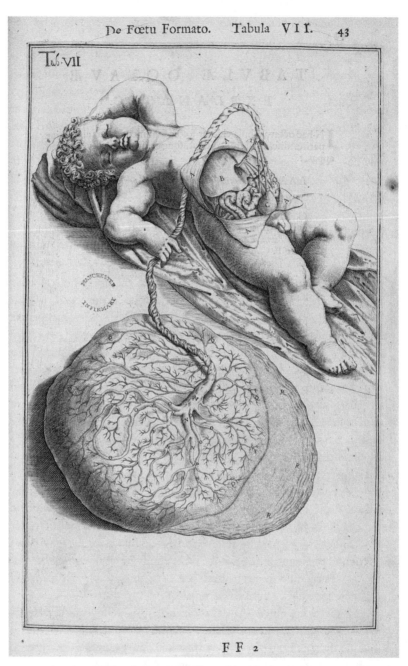

FIGURE 31: (31.1) Odoardo Fialetti (draftsman), *Table 7*, engraving, 34 x 21.5 (plate). From Adriaan van den Spiegel, *Opera Quae Extant Omnia* (Amsterdam: Iohannem Blaeu, 1645). Medical (Pre-1701) Printed Collection 2329, University of Manchester Library, Manchester. Copyright of the University of Manchester.

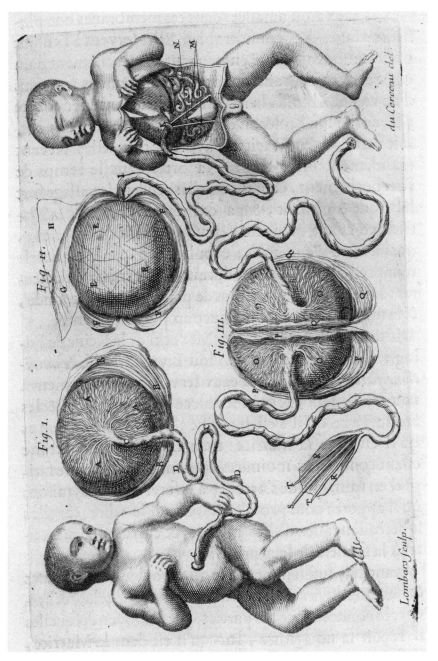

(31.2) Paul Androuet du Cerceau (draftsman) and Lombars (engraver), [Fetal Anatomy], engraving, 11 x 17 cm (plate). From François Mauriceau, *Traité des maladies des femmes grosses et accouchées* (Paris: Jean Henault, Jean D'Houry, Robert de Ninville, and Jean Baptiste Coginard, 1668). EPB/C/35949, Wellcome Collection, London.

seem to a modern eye strange or irreverent, it was more likely to be identi-
fied by at least a section of early modern viewers as a rhetorical gesture of
serious investigation: a physical act aimed at clearing up an uncertainty
or confusion on the part of the investigator.[84] McTavish argues, further,
that Viardel's hand is intended as an embodiment of all the qualities of
the good midwife, that his "manual dexterity . . . is indicated by his gentle
caress of its head."[85] To me, however, while his gesture is not rough, it is
hardly a caress, nor does it seem, in its gentleness, particularly to imply
dexterity. In my view, Viardel's gesture is rather a sanitized enactment of
a gesture key to the practice of midwifery: "touching."

"Touching," as it was called by midwives of the period, involved in-
serting one or two fingers into the vagina to check the dilation of the
cervix and the presentation of the fetus.[86] It was widely practiced and
recommended by midwife-authors of the late seventeenth and eighteenth
centuries and was well-known to midwives at most levels of training or
education. Indeed, "touching" is illustrated in one of Viardel's birth figures
(figure 22). In this image, the midwife inserts the index finger into the
vagina, feeling the fetus's head as it presents at the cervix. Unlike others
of Viardel's birth figures, this one depicts the cervix as a line that separates
the womb from the vagina, pushed up by the pressure from the operator's
finger. The walls of the vagina are also rendered not as a simple tube but
ridged and textured. Like Deventer's images of uterine obliquity, this birth
figure works particularly to depict the haptic experience of "touching."

Returning to Viardel's frontispiece portrait (figure 29), we see that the
gesture made with the hand is much the same as in the birth figure; in both
cases the practitioner gently extends the index finger to touch the top of
the fetal head. The hand in the portrait may be understood, therefore, as
the "diffidentiam noto," but also as the midwife's "touch," here removed
from the context of the maternal body and recast in a nondescript interior
space, and thus both sanitized and made appropriate within the genre of
the professional portrait. The inscription, inserted between the fetal body
and the line of Viardel's arm, reads "non impar lucinae" or "not less than
Lucina"—the Roman goddess of childbirth. Viardel's touch, in this con-
text, becomes a kind of benediction, and a saintly attribute, locating the
surgeon-accoucheur as no less powerful and benevolent than the goddess
of childbirth herself.

However, this image can be read in multiple ways, depending on the
viewer's cultural context, visual training, and stance on male midwifery
practice. If, to a sympathetic viewer, Viardel's portrait combines the
anatomist's empirical investigation through specialized touch with the
midwife's careful examination of and practice on the living fetus, an un-

sympathetic viewer might instead see a man who overreaches, who inappropriately links the worlds of the lying-in chamber and the anatomy theater. Indeed, among other midwife-authors, it seems that the form of Viardel's portrait was not popular: perhaps it was seen as a blunder in the delicate process of constructing a socially acceptable persona for the emergency midwife, for no subsequent authors commissioned similar portraits. They stayed on safer ground: posed formally, dressed respectably, and holding books or other accoutrements of abstract study. If hands were emphasized, what they would have touched in their actual practice was studiously left out.

Indeed, it is possible that some viewers even intentionally regularized Viardel's portrait by removing the object of his touch. One copy of the portrait held at the Wellcome Library has been trimmed, with the bottom section of the portrait cut away along the fold line. The bottom section may have originally been lost accidentally through wear, but subsequently all the edges were trimmed, and the bottom fragment was not retained. It is possible, therefore, that the removal of the bottom section of the image was an intentionally neutralizing act: it removed both fetus and touching hand, leaving a much more conventional portrait of a grave man whose hand reaches down to some unknown object. If this intervention was indeed intentional, it shows that an image that did not align with conventions, or that showed an aspect of a persona that was troubling, ambivalent, or unsettled, could be remarkably powerful. The cut makes the image safe by removing from sight the troubling ambivalence of the midwife's touch, making a much simpler argument for respectability. But it also makes the image literally safe for vulnerable viewers such as pregnant women, whom such a sight may have caused to do damage to their unborn child, or to develop a fear of male practitioners that might later hinder the progress of their delivery.

Whether or not the portrait was considered a success by its artists and its commissioner, by a professional audience, or by a lay one, it was certainly an image that experimented with what a portrait could say about a professional persona and how it could be used to address and perhaps reconcile tensions in that persona. I argue that this image would have been difficult for early modern viewers to interpret or accept, because it highlighted a troubling dissonance inherent in the period's midwifery. It pointed right at the difference between the knowledge of the surgeon-anatomist and that of the midwife, the different meanings and implications of touch, and thus the difficulty the midwife faced in reconciling them. In this, it offers a counterpoint to the idealized operative hands in birth figures. It shows the studied rhetoric that argued that the midwife's

touch was safe and acceptable, but it also indicates that there existed a widespread conviction that the midwife's touch was neither of these.

The Artificial Hand

The work done on constructing the midwife's professional persona by continental authors in the decades around 1700 was certainly known in England, through the translation and importation of their books. From the 1720s, however, English midwifery culture shifted as native authors began to publish their own books, provide lecture courses, vie for public appointments, and perceive themselves as public figures. These English authors borrowed from and adapted the texts, images, and ideals of their continental forebears, but as the culture of midwifery changed, so did conceptions of the midwife's persona. Against the idealizing combination of male and female attributes that allowed men to enter a traditionally female field, and women to claim professional and medical expertise, there arose a backlash. As men gained a surer footing in midwifery, and as women began to see the encroachment of men midwives as a threat to their profession, a new rhetoric arose in which each gender defined its own suitability to practice at the expense of the other. Men criticized women for ignorance, intractability, and inappropriate emotion. Women criticized men for being unfeeling, rough, dangerous, and potentially predatory. And the debates spilled over from midwifery manuals to pamphlets and satirical prints that aimed their arguments at a general readership.[87]

Siegemund, Deventer, and Viardel had presented a midwife's hand that was both neutralized and valorized, not overtly of either gender, and relying on a new concept of medical heroism to turn the problem of touch into a symbol of enlightenment. In England from the 1720s, the problems of gender, touch, and propriety reerupted as some factions fought publicly to exclude men from midwifery practice and others to turn midwifery into a masculine medical discipline. The midwife Elizabeth Nihell, for instance, cast male practitioners as inappropriately feminine: "with those special delicate soft hands of theirs, and their long taper pretty fingers."[88] They were either sexual predators or rough, violent boors: "either the rough manly he-midwife, that in the midst of his boisterous operation, in a mistimed barbarous attempt at waggery or wit, will ask a woman, in a hoarse voice, 'if she has a mind to be rid of her burther,' or the pretty lady-like gentleman-midwife, that with a quaint formal air, and a gratious smirk, primming up his mouth, in a soft fluted tone, assures her, and lies all the while like a tooth-drawer, that his instruments will neither hurt nor mark herself nor child but a little, or perhaps not at all."[89] But the problems with

touch were not restricted to male practitioners, and male authors also denigrated women midwives for being unlearned, intractable, irresponsible, or even sexually suspect themselves. Thus, Tobias Smollett pondered in a pamphlet response to Nihell's treatise, "how far Mrs. Nihell's shrewd, supple, sensitive fingers, may be qualified for the art of titillation."[90]

A core element of these debates around touch, gender, and propriety in this particular period was a new tool. The forceps had been used secretly by the Chamberlen family since the seventeenth century, but they were made public by Hugh Chamberlen II in 1733. Adrian Wilson has identified this publication as the trigger for great changes in English midwifery, not only ushering in a canon of English-authored texts, but also cementing the position of the male practitioner.[91] Forceps allowed midwives to deliver obstructed fetuses who presented with the head. Previously, such problems were solved either by podalic version or, where that was impossible, with craniotomy. As, in theory, only men were allowed to use tools, the forceps gave them a distinct advantage over women midwives. Forceps practice contributed to the medicalizing and masculinizing of midwifery and became a symbol for what Sheena Sommers describes as a new ideal of "detailed, objective, and professional learning," which gave the male practitioner a chance to "harness the growing faith in reason and science and to position himself as working in the interests of the emergent public sphere."[92] Forceps were associated with the new institutionalized midwifery training on offer at lecture courses and lying-in hospitals. Partially staffed but completely controlled by men, these new spaces of learning transformed childbirth, according to Bonnie Blackwell and Pam Lieske, into something that was ideally conducted quickly, on the practitioner's schedule, and under his physical guidance.[93] Forceps, which could exert traction on the fetal head in a way the midwife's hand couldn't, aided this change.

Forceps also offered their own solution to the problem of touch. If both women midwives and many laypeople were unconvinced of the safety and the propriety of the man midwife's touch, then the forceps put distance between male touch and male practice in a revolutionary way. For forceps proponents, they were a technical, medicalized tool that worked *better* than any hand at delivering children. The practitioner William Smellie described his forceps, for instance, as "artificial hands."[94] These artificial hands did not have the social and sexual connotations of the practitioner's actual hands. Thus, while many women midwives were strenuously arguing that only a woman's body had the necessary sympathy, sensitivity, slenderness, and skill to deliver children,[95] some (though not all) men midwives were arguing that medicalized tools augmented their bodies, making them better suited for practice than any woman's body could be.

Indeed, this correlates with Sommers's wider supposition that while fe-
male practitioners in this period based their right to practice on a natural
sympathy, male practitioners "claimed a rational compassion that was
uniquely removed from any association with a specifically sexed body"
and that made them into a "mind/machine."[96]

The importance of forceps to midwifery debates in this period is ex-
emplified in its visual culture. While the first English authors of the 1730s
and '40s did not produce new sets of birth figures, they did produce a new
kind of image: the technical illustration of the forceps. Edmund Chap-
man's *An Essay on the Improvement of Midwifery* (1733) contained the first
textual description of forceps, but was unillustrated. Within a year, two
images of the tool had appeared, in an article by Alexander Butter and in
the posthumously published cases of William Giffard (figures 32–33).[97]
Chapman's treatise was reprinted in 1735, this time with its own image of
forceps (figure 34).[98] Later in the century, more would be produced for
John Leake and William Smellie, among others.[99] While images of tools
had been a conventional part of midwifery illustration, these illustrations
were newly detailed and technical. They described the shape and function
of the tool using multiple, perspectival views and explanatory annotations.

For the forceps proponent, they symbolized the newly dispassionate,
technical, masculine midwifery. Indeed, they did so partly because they
were *not* birth figures. Adrian Wilson has described a wider split between
forceps and nonforceps practitioners in this period, the former identify-
ing with the new forceps publications of Chapman and Giffard among
others, while the latter were allied to Deventer's works, published before
the forceps were made public. Wilson argues that this split was political,
with Tories favoring the forceps and Whigs opposing them, but it was
also iconographic.[100] The forceps proponents, whom Nihell called "In-
strumentarians," had their new technical forceps images—typically the
only illustration in their texts.[101] The opposers, or "Deventerians," had
Deventer's birth figures.[102] This visual distinction was inherently linked to
different approaches to practice and learning. The Deventerians valued the
pedagogic potential of birth figures to describe the mechanistic body and
the process of manual intervention. Thomas Dawkes, for instance, made
clear his preference, declaring Mauriceau's birth figures to be "very false
ones," but Deventer's "most of them just and true."[103] The Instrumentar-
ians, however, rejected the capacity of the birth figure to teach practice.
Edmund Chapman, for instance, declared: "those Cuts which represent
the different Situations of Infants in the Womb, in the Books of Guil-
lemau, Mauriceau, and others, are of very little use, especially since 'tis
not by the Eye, as he [Pierre Dionis] observes, but the Touch only, that an

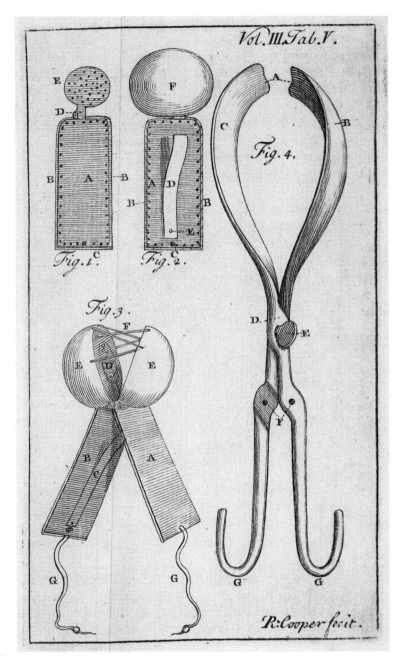

FIGURE 32: R. Cooper (engraver), *Table 5*, engraving, 17 x 10.2 cm. From Alexander Butter, "The Description of a Forceps for Extracting Children by the Head When Lodged Low in the Pelvis of the Mother," in *Medical Essays and Observations*, 3 vols. (Edinburgh: William Monro, 1737 [1733]), 3: 322–24. © The British Library Board (1150.c.1–6).

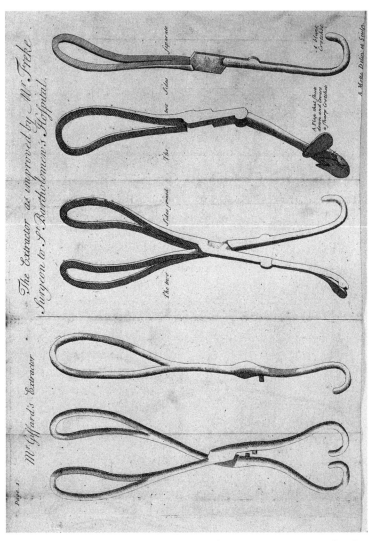

FIGURE 33: A. Motte (draftsman and engraver), *Mr Giffard's Extractor* [and] *The Extractor as Improved by Mr Freke, Surgeon to St Bartholomew's Hospital*, engraving, 19.5 x 25.5 cm (plate). From William Giffard, *Cases in Midwifry: Written by the Late Mr. William Giffard, Surgeon and Man- Midwife. Revis'd and Publish'd by Edward Hody, M.D. and Fellow of the Royal Society* (London: B. Motte, T. Wotton, L. Gilliver, and J. Nourse, 1734). EPB/B/24575/1, Wellcome Collection, London.

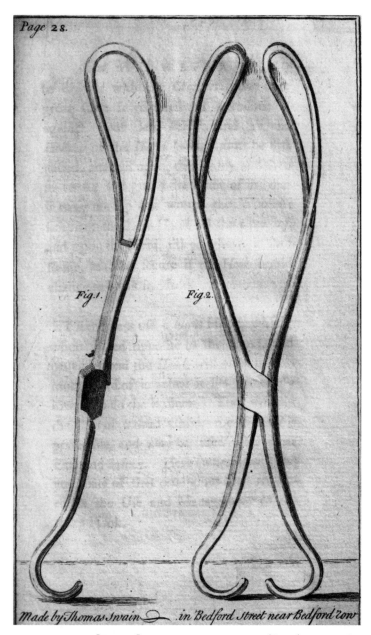

FIGURE 34: Anon., [Forceps], engraving, 18.3 x 10.7 cm (figure). From Edmund Chapman, *A Treatise on the Improvement of Midwifery, Chiefly with Regard to the Operation. To Which are Added Fifty-Seven Cases, Selected from Upwards of Twenty-Seven Years Practice. The Second Edition, with Large Additions and Improvements* (London: John Brindley, John Clarke and Charles Borbett, 1735). 1177.h.4, p. 28, British Library, London. © The British Library Board, digitized by Google Books.

Artist must judge of the Posture."[104] For him, the precise nature of forceps practice could not be communicated in such images, and could be learned only in person, at a lecture course or attendance at labors with an experienced physician. In making this argument, he asserts the superiority of the new medicalized midwifery over such older texts, and rarefies it, excluding those practitioners who could not afford to attend courses. Visually, these texts excised the complicated bodies of midwifery—mother, fetus, midwife—and replaced them with the image of the tool that defined the practitioner's power and the mother and fetus's relief. It stood for bodily separation, of fetus from mother and of midwife from both, and thus it stood for the advantages of the newly medicalized practice and the newly dispassionate medical touch. It also contributed to the separation from older texts and their problems by being, in some sense, an anti-image. Rather than explaining the techniques of forceps use, these images could be used as plans for the production of the instrument itself. Someone buying one of these books could take the plate to an instrument maker and essentially exchange it for the tool itself.[105] The images were less educative ends in themselves than a means to the production of a physical tool.

However, no aspect of the forceps debate in this period was simply binary. While some committed Instrumentarians may have seen the technical image of the forceps as symbolic of a new ideal of practice, for many more they represented a deeply problematic subject. John Maubray denigrated "the Needlessness, and Absurdity of Instrumental Operation; but also . . . the manifest Hazard, and imminent Danger, that the Mechanical Operator inevitably exposes both the Woman, and the Infant to, in Labour."[106] For him, and many other practitioners, the damage done with forceps by untrained or hasty practitioners outweighed their occasional usefulness. Applied incorrectly they could tear the mother's body and damage or crush the fetus's head. And while for some they offered a way of neutralizing the problem of male touch, for others they only made it worse. William Douglas criticized Smellie's identification of his forceps as "artificial hands," arguing that "such *monstrous Hands* are, like *Wooden Forceps*, fit only to hold Horses by the Nose, whilst they are shod by the *Farrier*, or stretch Boots in *Cranburne Alley*."[107] For Douglas, male hands and male forceps are all the same—too rough, low, and violent for the work of midwifery. The same argument was made by Elizabeth Nihell, who demanded of her readers: "where is the kingdom, where is the nation, where is the town, where, in short, is the person that would prefer iron and steel to a hand of flesh, tender, soft, duly supple, dextrous, and trusting to its own feelings of what it is about: a hand that has no need of recourse to such an extremity as the use of instruments, always blind, dangerous,

and especially for ever useless?"[108] For Nihell, forceps were inappropriate because they were *not* the hand; they were insensate, rigid, and cold.

Even those who sometimes used forceps often held them in fear and awe. Fielding Ould, for instance, when embarking on a section on the use of tools in his midwifery manual, wrote that "though I have gone through the foregoing Part of this Treatise with great Pleasure, yet what is to come strikes me with Horror."[109] Many midwives recognized that forceps could as easily harm a patient and destroy a reputation as save a patient and make one. For them, such images probably stood not only for ideals of practice but for its inherent problems and the highly charged public debates that were fracturing the profession.

And if practitioners had mixed feelings about forceps, they were a tool that loomed, large and horrible, in the public imagination, and especially that of the childbearing women who might find themselves suddenly, and in dire circumstances, in intimate contact with them. Ould's cases give further indications of exactly why the forceps were so feared. In one he describes the actions of another man midwife who attended a labor and first tried to intervene with his hands: "at length, the miserable Patient, after the Operation of his Hands had ceased, heard the clashing of Irons against each other, which terrified her prodigiously; and asking him what he was then going to do, he told her, that without having Recourse to the Help of Instruments, her Life was inevitably lost; which she absolutely declared she would not submit to, but chose rather to die."[110] Ould's account shows that for many women, the forceps were a particularly terrible prospect because of their materiality—hard, cold, and clashing—and because their presence was often hidden. The metal instrument was so foreign to the traditional sensorium of the lying-in chamber, and so heavily associated with bodily damage, that many women flatly refused them. For these women, forceps were not a shining symbol of medical improvement but a weaponized tool of masculine authority and aggression. In Ould's account, the practitioner intends to employ the forceps without asking, but the "clashing of Irons"—a phrase that associates the forceps with both weapons and manacles—alerts the woman, who would rather die than have the midwife use them on her.

Indeed, as a consequence of the hardening of the medicalized, authoritative attitude of emergency midwives, smuggling forceps and using them secretly became common practice. Smellie, for instance, advised his readers at length on how to conceal the forceps and use them in secret:

The woman being laid in a right position for the application of the forceps, the blades ought to be privately conveyed between the feather-bed and the cloaths, at a small distance from one another, or on each side of

the patient: that this conveyance may be the more easily effected, the legs of the instrument ought to be kept in the operator's side-pockets. Thus provided, when he sits down to deliver, let him spread the sheet that hangs over the bed, upon his lap, and under that cover, take out and dispose the blades on each side of the patient; by which means, he will often be able to deliver with the forceps, without their being perceived by the woman herself, or any other of the assistants. Some people pin a sheet to each shoulder, and throw the other end over the bed, that they may be the more effectually concealed from the view of those who are present: but this method is apt to confine and embarrass the operator. At any rate, as women are commonly frightened at the very name of an instrument, it is adviseable to conceal them as much as possible, until the character of the operator is fully established.[111]

The frequency with which forceps were hidden from women and used without their consent must certainly have added to the dread and terror in which they were held. Indeed, because midwives began to hide the tool, its potential presence became a constant specter in the lying-in chamber, with women likely to discover it only when they heard what Ould called "the clashing of Irons," or felt what Nihell called "that metalline chill, which is not well to be cured by any warming at the fire."[112] Thus, the forceps became a multisensory monster, hidden from sight yet always potentially present in a noise or a touch that augured pain, bodily damage, and loss of control.[113] Indeed, Nihell described forceps in exactly these terms, as instruments "which often cause more apprehension and terror to a woman in labor, though concealed from her sight, but never from her imagination, than the actual presence of all the apparatus of the rack, where that torture is in use."[114] While treatises from the beginning of the eighteenth century were increasingly written for a professional audience, and increasingly exclusively addressed to male practitioners, they would also have been accessed by lay readers of all kinds, particularly as midwifery became, in this period, a matter for public debate.[115] Certainly, Nihell thought it a possibility that women and lay readers might see these treatises, declaring: "It were to be wished, that all the men-midwives, who had rote on this matter, had suppressed the mention of their instruments; for as their books often fall into the hands of women, so deeply interested as the sex is in that subject, it is not to be imagined what bad effects they have."[116] Thus, while the images of tools (figures 32–34) produced in Instrumentarian texts of the early eighteenth century may seem to a modern viewer to be dry, technical, and devoid of wider cultural or emotional significances, for contemporary viewers they would have engaged with crucial debates

on gender and professionalism; politics; the place of midwifery and medicine; and the safety of various practices. They might, too, have raised deep and intense feelings of fear and antipathy.

Rebecca Zorach has noted that well before the invention of color-printing techniques, "to seventeenth-century viewers—at least according to their accounts—an exquisite engraving could produce the illusion of color and life."[117] She describes the potential of prints to evoke a wider sensory experience, as well as an emotional kind of "ravishment" that is impossible for modern viewers to completely understand.[118] William MacGregor, too, has discussed how early modern prints were understood as things not just looked at but more fundamentally *internalized*, affecting the understanding and knowledge of the viewer through an almost physical act of impression.[119] With this understanding of the intellectual, sensorial, and emotional reception of prints, it is easy to see what kind of power an image of the feared forceps could exert on an eighteenth-century viewer. Indeed, such images might not just frighten and shock; this was a period in which maternal imagination was widely credited as a real and potent force.[120] A pregnant woman stumbling on such an image might, in her shock and fear, do irrevocable damage to her unborn child.

It seems likely that Instrumentarian authors understood that their images might have been read in such ways. In producing them anyway, they made a statement about who the images and midwifery manuals were for and how they expected them to be read. The images were certainly practically useful in enabling readers to commission their own tools, and they stood iconographically for the author's practitional/political allegiance, but they may also have been produced as a kind of challenge to the viewer. If one could see them in a passionless, medicalized, technical way, then one was a suitable viewer.

The visual culture of midwifery changed once again with the publication in 1754 of William Smellie's *A Sett of Anatomical Tables*. In these images, the forceps and the birth figure were brought together, and the tool incorporated into visual descriptions of practice on the living and laboring body. Smellie's figures, drafted by Jan van Rymsdyk and Petrus Camper, owed much to the earlier innovations of Deventer, Viardel, Siegemund, and Mauriceau, as will be discussed in the next chapter. But whereas these earlier authors had worked to describe the action of the operative hand, Smellie replaced these hands with his artificial ones. In doing so, he broke the taboo that had kept the forceps in visual isolation, away from the problem of their contact with the body, and its potential violence.[121] Smellie makes a forceful demand that the forceps be accepted as a technical tool

TAB XVI

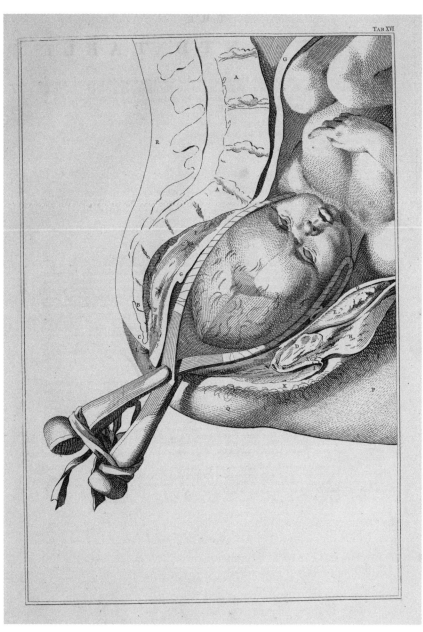

FIGURE 35: Petrus Camper (draftsman) and Charles Grignion (engraver), *Table 16*, engraving with etching, 46.3 x 32.7 cm (plate). From William Smellie, *A Sett of Anatomical Tables, with Explanations, and an Abridgment, of the Practice of Midwifery, with a View to Illustrate a Treatise on that Subject, and Collection of Cases* (London: n.p., 1754). RG93.S57 1754, Claude Moore Health Sciences Library, Virginia. Courtesy of Historical Collections & Services, Claude Moore Health Sciences Library, University of Virginia.

TAB. XXXVI.

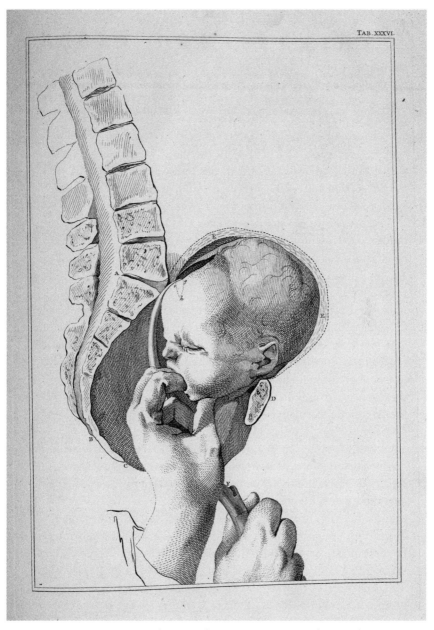

FIGURE 36: Petrus Camper (draftsman) and Charles Grignion (engraver), *Table 36*, engraving with etching, 46.3 x 32.7 cm (plate). From William Smellie, *A Sett of Anatomical Tables, with Explanations, and an Abridgment, of the Practice of Midwifery, with a View to Illustrate a Treatise on that Subject, and Collection of Cases* (London: n.p., 1754). RG93.S57 1754, Claude Moore Health Sciences Library, Virginia. Courtesy of Historical Collections & Services, Claude Moore Health Sciences Library, University of Virginia.

of a medical trade: that with their capacity to save lives, they should have no aura of fear and death. In table 16 (figure 35), in contrast to the birth figures with operative hands discussed above, there is clearly no room for the practitioner's *hand* to grasp and manipulate the fetus's head. But the slim blades of the forceps slip around the fetal head, causing barely a ripple. And while it is made clear that the pressure exerted by the forceps causes the skull plates to shift and even overlap, the fetus in this image is alive, wide eyed, and even pointing didactically with a finger toward the tool, underscoring the lesson of its necessity. The white skin and blank pupils of the fetus associate it with classical sculpture, which, along with the ribbon tied around the forceps' handles, gives the image an air of elegance that also works to further Smellie's point.[122]

Because of Smellie's subsequent fame as an innovator in practice and in publishing, it is tempting to see his images as marking the end of the rocky early years of forceps use, incorporating them into the birth figure and into accepted practice. But, in fact, Smellie faced some of the most vitriolic attacks of the century over his still-controversial forceps use from Elizabeth Nihell and William Douglas, among others.[123] Indeed, the replacement of hands with forceps in many of his images points, I argue, to a continued anxiety over their use. Smellie wished to visually present them as a replacement for the hands—slimmer and better able to grip. But hands were still necessary to hold, position, and pull on them. Not representing the hands removes both agency and movement from the images. It is as if the practitioner has stepped away and the labor has stalled. While Smellie's tables often work in series, like Siegemund's images, the sense of process and movement is in some degree lost along with the operative hand. This compositional choice also disavows the force and physical damage of a forceps delivery, and this is perhaps best indicated by the one figure that *does* show hands (figure 36). As with Viardel's figure, discussed earlier in this chapter (figure 28), here we see the delivery of the separated fetal head. With the fetus undeniably dead, Smellie and his artist appear to be more able to acknowledge the violence of delivery. The tensed hands, the piercing hook, the furrowed brow of the fetal head, all indicate the opposing forces in delivery and the potential for bodily damage. The lack of both hands and force in the forceps images (figure 35) suggests that Smellie felt that representations of the tool needed to be carefully managed and associated with easy and successful deliveries. We may assume, therefore, that the specter of fear and death still hovered over these images for both professional and lay viewers, its presence indicated by the images' attempts to deny it.

PART III

The Birth Figure Persists

(1751–1774)

Challenging the
Hunterian Hegemony

One figure looms large over histories of midwifery and anatomy in the latter half of the eighteenth century: William Hunter. Particularly the massive, obsessively detailed, severely observational engravings produced for his anatomical atlas *The Anatomy of the Human Gravid Uterus* (1774, figure 37) have had an enormous influence over how the visual culture of the pregnant body in the eighteenth century has been understood. Most of the images examined in this book have received almost no serious attention from scholars of art or visual culture, while Hunter's images—mostly drafted by Jan van Rymsdyk and engraved by a host of different engravers—have been much studied.[1] Scholars such as Ludmilla Jordanova, Roberta McGrath, Carin Berkowitz, Lyle Massey, Martin Kemp, Lorraine Daston, and Peter Galison have all addressed them.[2] They have investigated the atlas's production history, the ideals of anatomical investigation and representation framing Hunter's project, and the way the images informed and shaped the body culture of eighteenth-century Britain.

While this work has been important for both my own research and our wider understandings of print and body cultures in the eighteenth century, in this chapter I will show how the disproportionate attention given to Hunter's *Anatomy* has left us with a somewhat skewed view of the period. Particularly, I argue that it has led us to conflate the visual cultures of midwifery and anatomy. In this chapter, I will discuss Hunter's *Anatomy* in the context of other images of the pregnant body made for the midwife-authors William Smellie (figures 35–36 and 38–40) and John Burton (figures 43 and 45–47), in order to gain a better understanding of the *variety* of ways in which the pregnant body was approached and represented in this period. I demonstrate that despite Hunter's ascendance, the birth figure and the practitional mode remained central to the visual culture of midwifery throughout the century.

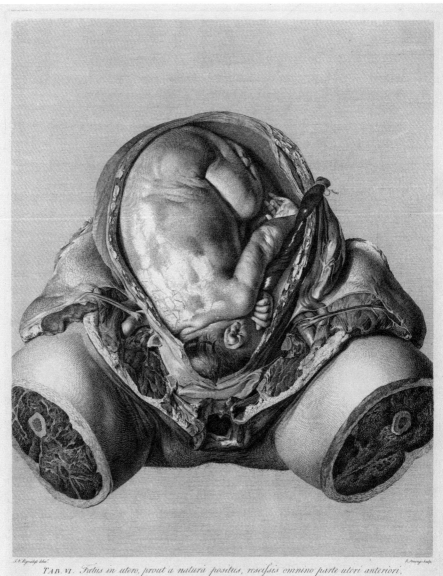

FIGURE 37: Jan van Rymsdyk (draftsman) and R. Strange (engraver), *Table 6*, engraving, 58.3 x 44 cm (plate). From William Hunter, *The Anatomy of the Human Gravid Uterus Exhibited in Figures* (Birmingham: John Baskerville, 1774). EPB/F/438a, Wellcome Collection, London.

William Hunter

William Hunter is a remarkable figure in the history of midwifery, less because of his practice (although he did have a thriving practice) than because of his success at turning midwifery into an elite, medicalized, learned practice, and one that allowed him access to the drawing rooms, as well as the lying-in rooms, of London's elite.[3] Hunter was well-known from the mid-eighteenth century for his attendance on the wealthy and the aristocracy—he even attended the labors of Queen Charlotte, consort of George III. He was also well-known as an anatomist, teaching at his private school in Great Windmill Street and, from 1786, at the Royal Academy of Arts.[4] He worked to build up an extensive collection of anatomical drawings and prints, as well as wet and dry specimens, and in 1774 he published his enormous *Anatomy*, the plates for which had been in production since the early 1750s.[5]

Roy Porter has argued that teaching, collecting, and publishing were all part of Hunter's mission to forge a unique career as anatomist, prestigious midwife, and gentleman. These, along with a cultivated social manner, gave him an entrance into a world of scholarly and social elites that had not previously been open to midwives. The *Anatomy* especially, according to Porter, was "a work of medical illustration in the Vesalian tradition" that was intended "to deploy art to immortalise his rank as a gentleman."[6] Crucially, the *Anatomy* was a work of learned anatomy, not midwifery, and indeed Hunter purposefully did not publish a midwifery manual in order, Porter argues, to keep the value of his midwifery lectures high.[7] This means that Hunter's legacy—his book, his collections, his influence over artists at the Royal Academy—is all scholarly and anatomical.

It is probably because the work was so firmly intended to enter the corpus of remarkable, innovative, important works in anatomy that it has also attracted such attention from scholars. Everything about it, from its size (the book measures 49 x 67 cm) and expense to its intensity of detail, demands attention in a way that smaller, cheaper works do not. The problem is that the disproportionate attention granted to this work has led to an understanding of it as representative of thinking about the pregnant body in the period more widely, and a general conflation of Hunter's brand of gentlemanly and learned anatomy with midwifery and its visual culture. It has even, as I will demonstrate, skewed the way we have understood other images of pregnancy produced in the period.

Hunter's images are remarkably large and highly detailed; they purport to depict specific anatomized specimens dissected and prepared by Hunter and his assistants, including his brother John (see figure 37). The

prints were drafted with a careful eye for the tiniest of details, in a "naturalistic" style that urges belief in their observational faithfulness. They also display a remarkable virtuosity in engraving, employing a diverse range of techniques to achieve the high level of detail, and particularly to communicate various material and textural qualities. These images break with older traditions in anatomical imagery in that there is no suggestion that the subjects are alive; they do not self-display or self-dissect.[8] They are not posed in imagined picturesque or architectural settings. They have a new austerity of style, a new fanatical adherence to the actualities of the dissection room, and a new abundance of anatomical detail.

Let us take perhaps the most studied image from Hunter's atlas: table 6 (figure 37). Drafted by Jan van Rymsdyk and engraved by Robert Strange, it shows the dissected body of a woman who died when nine months pregnant. It has often been remarked that Hunter and his artists seem to flaunt their dispassionate stance, describing the raw flesh and sawn bone where the corpse's legs have been cut off at midthigh.[9] There is no concession to modesty and no move to protect the body's integrity or its mysteries in this and others of Hunter's images. They propose an anatomical interest simply in the material complexities of the body, and not in wider social, cultural, or emotional contexts. If we compare this fetus with others examined in this book, Hunter's special commitment to drawing the subject "just as it was found; not so much as one joint of a finger having been moved to shew any part more distinctly, or to give a more picturesque effect," is evident.[10] This fetus is not alive, nor does it seem to have personality: its skin is livid, its limbs contorted awkwardly; it is covered in a fluid that is drying and cracking through exposure to air; its face is not visible.

Hunter's images are most often characterized as part of a new, austere Enlightenment project for observing and knowing the body. Lyle Massey has described the images, for example, as "stark, brutal, and fetishistically naturalistic."[11] They have been associated with Foucault's concept of the clinical gaze,[12] the medicalization of childbirth, and a new kind of direct, observational truth-value for the anatomical image—what Roberta McGrath calls "an authenticating visual language."[13] As Ludmilla Jordanova describes, "Hunter held up the immediate perception of supposedly unacted-upon nature as an epistemological ideal."[14]

Of course, most scholars acknowledge that this is an unachievable ideal, that there must always be a gap of interpretation between object and image.[15] Indeed, both Hunter and his artists also understood that image-making was much more complex than their own rhetoric implied.[16]

Neither was Hunter's style of severe observational anatomy as radically new as has previously been thought, as recent work by Alicia Hughes has shown. The drawings commissioned and collected by James Douglas, which were inherited by Hunter in 1742, demonstrate that both the close dissection of many pregnant cadavers, and the production of highly detailed "naturalistic" images, were undertaken by Douglas before they were by Hunter.[17] While Douglas never managed to see his images in print, they were a clear influence on Hunter's *Anatomy*.

Despite this, it is important to recognize the success of Hunter's *rhetoric*, that his images were directly and observationally true, and that they were highly original. His ideal was of an image that was a "simple portrait, in which the object is represented exactly as it was seen."[18] This ideal he contrasted against anatomical images produced "under such circumstances as were not actually seen, but conceived in the imagination."[19] Indeed, Hunter's understanding of his images was part of a wider eighteenth-century debate on anatomical illustration that is explored by Daston and Galison. They define observational records of single specimens, such as those images commissioned by Hunter or Govert Bidloo, as "characteristic" images; and imagined, idealized, composite images, such as those produced for Bartolomeo Eustachi's *Tabulae Anatomicae* (1714) or Bernhard Siegfried Albinus's *Tabulae Sceleti* (1747), as "ideal" images.[20] "Ideal" images avoided replicating the individual aberrations or anomalies of the single specimen; thus they were seen by some as much more useful as teaching aids because they established the average or the ideal.[21] They lacked, however, the kind of fundamental claim to truth that "characteristic" images had. In Hunter's words, while the "characteristic" image "shews the object, or gives perception; the other only describes, or gives an idea of it."[22]

The interesting thing about Hunter's "characteristic" images is that they seem to have been remarkably *convincing*. Viewers of all kinds, including today's scholars, are drawn in by the highly detailed, "naturalistic" style. The style persuaded, and still persuades, viewers to interpret the images as accurate, truthful, and bearing a clear and uncomplicated relation to the object represented. This kind of detailed "naturalism" or "realism" is so convincing that scholars such as Jordanova are driven to remind us that "realism is, in fact, itself a historical construct, not an unproblematic and self-evidently valuable analytical term."[23] Martin Kemp also notes the mesmeric quality of this representational style, calling it a "distinctly double-edged sword": because it is so good at convincing the viewer of its truth, its actual relationship to the object represented often goes unexamined.[24]

This desire to simply believe the "truthfulness" of the observed, detailed, naturalistic image has certainly haunted histories of eighteenth-century anatomy, medicine, and midwifery. Ludwig Choulant, whose influential book on anatomical illustration was originally published in German in 1852, but was published in English many times, and as recently as 1993, claimed that "not until Smellie (1754) and William Hunter (1774) published their monumental volumes do we actually find illustrations of the *foetus in utero* which were really observed and faultlessly reproduced from an anatomic point of view."[25] These kinds of histories Steven Shapin has described as "distributing medals (or punishments) for modernity": celebrating those developments and discoveries that seem to lead toward a modern, and "best," practice.[26] In such heroic histories, Hunter's images are seen as a milestone, and a positive development toward the discovery and dissemination of biological "truth." Indeed, because Hunter's rhetoric and his images are so compelling, even scholars who maintain a skeptical stance are still tempted to overstate their importance or pervasiveness in the eighteenth century. For instance, McGrath, who is hardly an admirer of Hunter, argues that from "the eighteenth century onwards, there was no question of distinguishing between bodies and their representation; bodies were seen in the terms set out by the atlases."[27]

Certainly, the observational, naturalistic style of Hunter's *Anatomy* was influential in the latter half of the eighteenth century. However, I argue that his influence has been overstated: there were other ways of understanding and representing the body that were of equal importance and wide dissemination in the eighteenth century, and the body was certainly *not* indistinguishable from its representation in a few rarefied anatomical atlases. Jordanova, McTavish, and Massey have all suggested that the rise of the detailed, naturalistic style in Hunter's and Smellie's books signaled the demise of older modes of representing the pregnant body, that new, "Hunterian" images essentially replaced older birth figures in the visual culture of midwifery.[28] McTavish articulates this general sense of rupture: "unlike seventeenth-century images of the unborn, which were offered as diagrams for conceptualizing what could be found in the womb, eighteenth-century engravings were thought to show what actually was inside the womb."[29] This chapter will demonstrate the fallacy of this simple narrative of rupture. In fact, birth figures were not replaced by anatomical images, nor were diagrammatic modes pushed out by observational ones. Rather, the visual culture of midwifery remained, throughout the eighteenth century, a place of rich and multiple modes, in which the practitional continued to coexist with the anatomical.

William Smellie

Historians have tended to group the images produced by Jan van Rymsdyk for Hunter's *Anatomy* (figure 37), William Smellie's *A Sett of Anatomical Tables* (1754, figures 35–36 and 38–40), and Charles Jenty's *The Demonstrations of a Pregnant Uterus* (1758) and to describe them as indicative of the new anatomical and rarefied culture of midwifery. In most cases, Smellie and Jenty are cast as either followers or precursors of Hunter. Pam Lieske, for instance, asserts that "without question" Smellie's images "*rival* the celebrated anatomical plates later produced under William Hunter" (my italics).[30] Roberta McGrath, in the same vein, notes that Hunter's *Anatomy* can be distinguished from the works of Smellie and Jenty by the "consistency and the scale of its visual and linguistic rhetoric."[31] Both see Hunter as the most committed member of a cohesive group, the pinnacle of a particular ideal of bodily representation. Lyle Massey also groups the works together, describing all three as "obstetric atlases"[32] and arguing that, together, they "contributed substantially to the epistemological reformulation of childbirth as a medical rather than domestic concern in the eighteenth century."[33] It is true that these authors *did* engage with similar ideals and techniques for representing the body, but there are also significant differences in their representational aims, which are rarely discussed.

Particularly in the case of William Smellie, his biographical links with Hunter—the fact that they were both famous midwives practicing in London, that they knew each other and occasionally worked together,[34] and that they commissioned images of similar styles from van Rymsdyk—have led historians to see their aims in publishing as aligned.[35] Though Smellie's *Tables* was published in 1754, well before Hunter's *Anatomy* of 1774, Smellie was familiar with van Rymsdyk's drawings for the plates of Hunter's atlas from the early 1750s and mentioned them with admiration in his own works, calling them "very accurate, useful, and curious plates."[36]

At a time in which there was unprecedented competition for work among a burgeoning number of medical practitioners,[37] Smellie's open praise of Hunter's images may be attributed to a shared anatomical ideal, but also to the fact that they were not in direct competition: they practiced and published in different realms. While Hunter mainly attended London's elite and taught exclusive anatomy and midwifery courses, Smellie plied his trade among London's poor, delivering vast numbers of women and teaching hundreds of students at cheaper rates. He had neither the manners nor the address to practice in high society but nonetheless made a name for himself as a skilled practitioner and teacher.[38] This difference

in profession was also expressed in their images: while Hunter's are ana-
tomical, Smellie's are practitional—they are birth figures. The *Tables* were
produced to accompany Smellie's midwifery manual and two books of
cases, published in 1752, 1754, and 1764 respectively. The images describe
the living body in labor, various interventions, fetal presentations, and
the tools of the midwife's trade, as well as pregnant anatomy. Moreover,
while Smellie's book was at least *intended* for students, Hunter's expensive
volume was marketed at, and only really within the reach of, successful
medical practitioners and anatomists and wealthy amateurs. Lyle Massey,
in her germinal article on Hunter and Smellie, emphasizes their shared
"pathologising" project over their main difference, which she describes as
Smellie's referencing of "his practice as a man-midwife."[39] In this chapter,
I take the opposite approach, focusing on this practitional divide rather
than their shared anatomical aims.

The images in Smellie's *Tables* were not, in fact, all drafted by Jan van
Rymsdyk.[40] Ten were actually drafted by Petrus Camper,[41] and two done
by a third, unnamed artist.[42] They were all engraved by Charles Grignion,
who was an Academician and well-known engraver.[43] While van Rymsdyk
is typically cited as the only artist on the project, there are actually distinct
differences between his work and Camper's, which contribute to a visual
diversity in Smellie's book. Van Rymsdyk's style was more detailed, ana-
tomical, and closely observational; we might call it "Hunterian," but given
that he also produced Hunter's images, it is equally "van Rymsdykian." He
produced all of the anatomical images at the beginning of the work, and his
birth figures make a visual argument for their having been drawn directly
from dissection, though this was not actually the case. According to Petrus
Camper, Smellie arranged fetal cadavers in various positions within a pre-
pared pelvis for van Rymsdyk to draw; the rest of the maternal anatomy
was added with reference to other anatomical preparations (figure 38).[44]
The images, therefore, combined anatomical observation and practitional
knowledge like those of Philippe Peu, with his fetal puppets, described in
chapter 3.[45] Smellie and van Rymsdyk utilized the artist's accomplished
style of representation to make an argument for the observational truthful-
ness of images that were in fact primarily describing the nonobservational,
practitional knowledge that Smellie had gained as a midwife.

Camper, while clearly attempting to work within the visual framework
set out by van Rymsdyk, also had a more stylized, diagrammatic manner,
and he produced images both in full tone and in outline. In this chapter, I
focus on the works produced by Camper, partly because he is not typically
discussed in histories of the book, and partly because his figures give a dif-
ferent perspective on Smellie's project (figures 35–36 and 39–40).

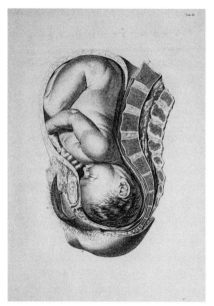
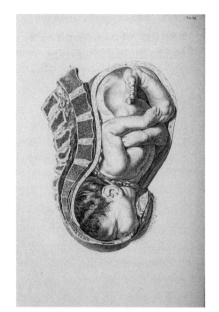
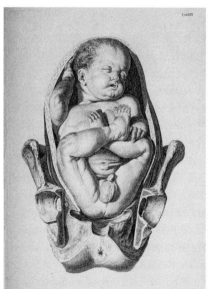
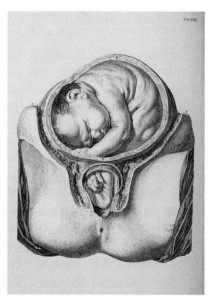

FIGURE 38: Jan van Rymsdyk (artist) and Charles Grignion (engraver), *Tables 20, 23, 30 and 31*, engraving with etching, 53.5 x 36.1 cm (page). From William Smellie, *A Sett of Anatomical Tables, with Explanations, and an Abridgment, of the Practice of Midwifery, with a View to Illustrate a Treatise on that Subject, and Collection of Cases* (London: n.p., 1754). RG93.S57 1754, Claude Moore Health Sciences Library, Virginia. Courtesy of Historical Collections & Services, Claude Moore Health Sciences Library, University of Virginia.

The figures as a complete set are undoubtedly highly detailed, anatomically informed, and starkly naturalistic in a way that was new to the visual culture of midwifery. Indeed, Smellie claimed in the preface that "the greatest part of the figures were taken from Subjects prepared on purpose, to shew every thing that might conduce to the improvement of the young Practitioner."[46] However, the exact wording of this claim marks a difference from Hunter's anatomical project. Smellie is less fanatical about direct observation; indeed his specimens were *prepared*, by which we may understand a variety of manipulations, to give primarily practitional information. If van Rymsdyk's figures were drawn from manipulated anatomical preparations, then Camper's were drawn from a combination of his own experience as a midwife, simulation on cadavers, and experimentation with Smellie's obstetrical machines.[47] His images are a combination of the seen and the imagined, as birth figures had always been.

The figures are also arranged and presented in the conventional format of the midwifery manual: beginning with images of pelvises and pregnant anatomy, moving through various presentations, and concluding with images of tools. Indeed, Smellie was clearly conscious of the "correct" order because he apologized for the placement of the image of twins, which "ought to have been placed among the last Tables" as it represented a complicated delivery.[48] Massey claims that these images were revolutionary in that they link "the practical knowledge of midwifery to a deeper understanding of the female body than can be achieved only by the anatomist."[49] As this book has demonstrated, however, the adoption and adaption of anatomical modes of knowing had always been a part of birth figures, and though Smellie's were newly detailed, they were by no means revolutionary in this combination of the practical knowledge of the midwife with the learned knowledge of the anatomist. The addition of ovaries and the umbilical cord in Rüff's figures, the placenta in Mauriceau's, the pelvis in Deventer's, all represent the incorporation of anatomical knowledge into the visual culture of midwifery practice. If we look at Smellie's figures in the context of midwifery and its visual culture, therefore, we gain a very different perspective on how they communicated knowledge.

For instance, Smellie was clearly influenced by Deventer's birth figures, mentioning the book in his own manual.[50] The two shared an aim of approaching and representing childbirth as a mechanical process.[51] Indeed, Deventer's novel interest in how the fetus passed through the pelvis provided the groundwork for Smellie's later discovery, along with Fielding Ould, of how the fetal head rotates as it passes through the pelvis.[52] Smellie, van Rymsdyk, Camper, and Grignion developed a visual language fitted to describe this complex mechanical movement that borrowed from

the experiments of the previous generation. Like Siegemund, they employed images in series (figure 39) to "shew in what manner the Head of the *Foetus* is helped along with the Forceps as artificial Hands."[53] They also adopted Deventer's and Bouttats's work on rotational views to establish the sagittal section view, which is now a conventional part of midwifery illustration. This view shows a body sectioned along the spine, exposing half of the mother's body, as well as the fetus whole within the half-womb. This kind of sectioning was practiced in the early eighteenth century by James Douglas and Robert Nesbitt.[54] It gave a radically new perspective on the body, though it was also extremely messy and destroyed bodily elements that were preserved whole in the older system of successively peeling back layers.[55] Smellie and his artists saw that this kind of view offered a new way to describe the passage of the fetus through the pelvis, which Deventer had struggled to communicate.[56] Cutting the maternal body in half exposed the crucial narrow space between the sacrum at the back of the pelvis and the pubic bone at the front.

Smellie and his artists incorporated what was an innovative new anatomical technique into their practitional images. But in this case, while we are given anatomical information about the maternal body, we are also encouraged to see the view as an imagined slice of a body still living and in labor. The figures describe various malpresentations and demonstrate the ways in which they become obstructed by the shape of the pelvis and the narrowness of the cervix and vagina. While these images are snapshots of the body's processes, they are not wholly static, they point to the movement and force involved in childbirth, as well as to the potential for damage and pain.

Another place in which the difference between Hunter's and Smellie's projects can be seen is in the representations of the fetus. When we compare Hunter's table 6 (figure 37) with Smellie's table 12 (figure 40), it becomes obvious that Smellie wishes us to read a living body. Hunter's fetus is both clearly dead (the awkward limbs, the cracking mucus) and insensible of our gaze (the head buried in the pelvis and face turned away). Smellie's fetus is clean and whole, its complexion a smooth white, its eyes closed, but its face wears a serene, animate expression. Both images clearly take note of the physical qualities of the neonate, but Smellie's image is subtly idealized: the limbs are chubby rather than scrawny, and they are curled up comfortably around the body, rather than twisted at odd angles. Smellie's fetus also shows no sign of being covered in fluid—it looks dry, warm, and cuddle-able in a way that Hunter's absolutely does not. While Hunter took pride in the fact that "not so much as one joint of a finger" was "moved to shew any part more distinctly, or to give a more

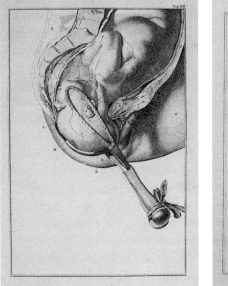

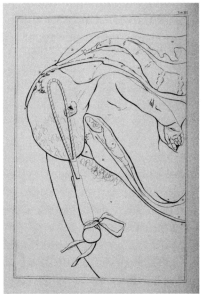

FIGURE 39: Petrus Camper (draftsman) and Charles Grignion (engraver), *Tables 16–19*, engraving with etching, 53.5 x 36.1 cm (page). From William Smellie, *A Sett of Anatomical Tables, with Explanations, and an Abridgment, of the Practice of Midwifery, with a View to Illustrate a Treatise on that Subject, and Collection of Cases* (London: n.p., 1754). RG93.S57 1754, Claude Moore Health Sciences Library, Virginia. Courtesy of Historical Collections & Services, Claude Moore Health Sciences Library, University of Virginia.

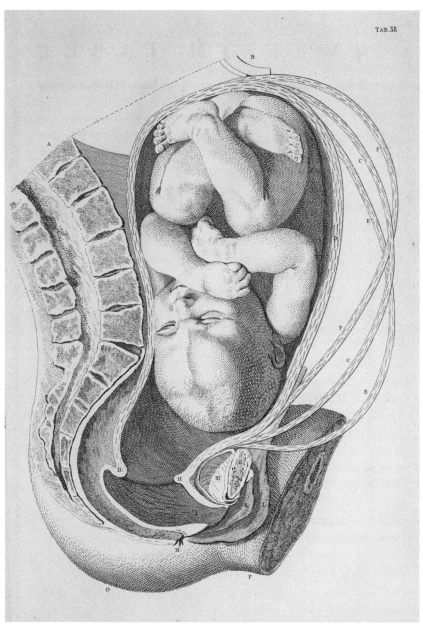

TAB.XII

FIGURE 40: Petrus Camper (draftsman) and Charles Grignion (engraver), *Table 12*, engraving with etching, 48.4 x 33.3 cm (plate). From William Smellie, *A Sett of Anatomical Tables, with Explanations, and an Abridgment, of the Practice of Midwifery, with a View to Illustrate a Treatise on that Subject, and Collection of Cases* (London: n.p., 1754). RG93.S57 1754, Claude Moore Health Sciences Library, Virginia. Courtesy of Historical Collections & Services, Claude Moore Health Sciences Library, University of Virginia.

picturesque effect," Smellie's fetus is intentionally picturesque.[57] Smellie and Camper engage with the tradition of birth figures describing fetuses as healthy, idealized children.

Over the early modern period, the fetuses in birth figures were gradually represented as younger and younger children, following a more general trend in the representation of children and infants in visual culture. Sophie Oosterwijk, for example, notes the gradual shift in art from the fifteenth century away from the representation of children as miniature adults and toward an interest in replicating the bodily proportions and features of children, as well as putti and cherubs.[58] The fetuses in birth figures follow this trend, with miniature adults present in many medieval manuscript examples and some early print books.[59] By the seventeenth century, birth figures tended to represent the fetus as putti,[60] and by the eighteenth, as here, as infants with big, mostly bald heads and pudgy limbs. Smellie's fetuses are less cherubic, less active and performative than previous examples. Following contemporary fashions in portraiture, they are proportioned more like infants and exhibit more childlike behaviors.[61] This shift, of course, was not one in which artists slowly realized how to make more "accurate" images, but rather one in which both the ideal aspects of infancy and childhood, and the systems for representing it, constantly changed.

Indeed, this idealizing of the fetus is also expressed through Grignion's engraving techniques. In "Coming into Line," Martin Kemp traces the way in which early modern engravers developed systems of hatched and crosshatched lines, sometimes interspersed with dots, to describe contoured objects, and particularly smooth skin: the lines work as a kind of fine mesh, seemingly stretched over and molded by the shape of the body. Kemp argues that such techniques were intended to create in the viewer "a delight in the improbability that such overt artifice could function to imitate nature."[62] In the case of the mesh, he notes "how the lines and dots appear to possess their own autonomous logic and yet at the same time control the density of tone with such unerring precision."[63] The viewer was meant to admire the artifice of the system *and* how well it described the object represented. The technique was intended to elevate engraving and to establish the medium as capable of producing high art in its own right.

Its use by Grignion, therefore, elevates Smellie's images, associating them with the higher art of portraiture. In table 12 (figure 40), the mesh technique is employed both on the skin of the mother's buttock and thigh and on that of the fetus. The laboring woman's skin is depicted as pristine, smooth, pale, and almost hairless. The mesh describing the fetus's skin is highly sensitive, describing pudgy baby hands, the shape of kneecap and ankle bone, even the as yet unsutured plates of the fetal skull, visible

beneath a smattering of hair. This fetus is not just livelier and more ideal-
ized than Hunter's; it is an elevated image of a person, a soon-to-be child,
in the style of portrait engraving. In a new eighteenth-century manner,
Smellie makes an old visual argument—the healthy, happy fetus as proof
of good practice.

The technique also references an idealized racial whiteness, deliberately
drawing our attention to the representation of smooth skin, colored a de-
fault white by the paper ground.[64] Indeed, the eighteenth century saw a
heightened interest in the representation of white skin in portraiture, and
particularly what Angela Rosenthal identifies as an obsession with "the
white woman, the 'fair sex,'" which went hand in hand with increased
colonizing activities.[65] The flexible meshes and dots draw an association
between these idealized bodies in birth and those of the colonial European
elite represented in the period's portraiture. In a period that, according to
Rubiés, began to see the hardening of "scientific racism," Smellie's images
must have at least had the potential to represent to viewers the desirable
continuance of racial whiteness through controlled practices of generation
and heredity.[66]

Smellie's images, like all birth figures, use multiple modes of representa-
tion to give a pluralistic account of the pregnant and laboring body. While
in table 12 (figure 40), the skin of the mother and fetus is rendered using a
sophisticated technique of meshed lines, parts of the spine and bodily inte-
rior employ sketchier, etched lines that do not describe minute anatomical
detail but rather give a sense of the variety and texture of the bodily inte-
rior. Moreover, if at the bottom of the image we find the visceral, dispas-
sionate, anatomical cut leg of the mother in the style of Hunter's images,
then at the top, the body seems to fade away into immateriality, the space
above the womb left blank, bounded by a dotted line that indicates not any
bodily component but an abstract measurement. The image, moreover,
uses a diagrammatic technique to describe the contour of the belly in
various situations: at term (C); after the waters have broken (D); in the
case of a "Uterus when *Pendulous*" (E); and in the case of a "*Uterus* when
stretched higher than usual" (F).[67] These four lines of possibility weave
in and out of each other like ribbons, making the image one of multiple
potentialities existing together in an atemporal space.

Thus, we find in this one image observational "naturalistic" anatomi-
cal modes; prestigious modes of portrait engraving; the texturally evoca-
tive sketchiness of etched lines; and various diagrammatic modes that
describe measurement, movement, and possibility. Smellie and his art-
ists engaged in the activity, already familiar in birth figures, of combin-
ing modes of representation and modes of knowing. It is undeniable that

Smellie's images do this with greater detail and more visual complexity than those of previous generations, that they demand of their readers a more rarefied visual literacy. However, it is also clear that they are not mere copies of the representational style employed in Hunter's atlas and that they are fully engaged with the visual culture of midwifery from which they spring. Viewers in the eighteenth century still recognized a difference between the knowledge of midwifery and that of anatomy. The two were not conflated, and the living and laboring body still required its own representational systems. In the previous chapter I discussed how birth figures were employed to define the midwife's profession and persona. Smellie does the same thing in a new visual context, combining anatomical with practitional knowledge to point to the necessity of a midwife's having *both* kinds of expertise.

John Burton

Exploring the differences between Hunter's *Anatomy* and Smellie's *Tables* will not, however, give us a complete picture of the visual culture of midwifery in the period between the 1750s and the 1770s. Both Hunter and Smellie lived and worked in London where the system of midwifery education and practice, with its hospitals, lecture courses, and elite male practitioners, was increasingly divorced from the older systems that endured elsewhere. Within that rarefied urban culture, moreover, both authors were recognized as pioneers. For them, midwifery books were part of a much wider material culture of learning formed of specimens, models, drawings, cadavers, and living women. At London's private lecture courses and lying-in hospitals, both men and women were trained in person by lecturers and senior midwives and were surrounded by a whole host of teaching aids.[68] Midwifery manuals, in this context, stopped being the lone ambassadors of knowledge that they had been for such authors as Siegemund and Deventer, bringing enlightenment to midwives who could not be reached directly. Smellie, therefore, produced images that were less immediately readable by an untrained eye, because his projected reader was not wholly untrained. Thus, the changing landscape of education led to a more rarefied, professionalized visual language in the birth figure. The complexity of the anatomy, the minuteness of the details of presentation, the potentially terrifying cut-open maternal body, all assumed an eye that could interpret rightly. In chapter 3 I discussed the anxieties of Deventer and Siegemund over the readability of their birth figures—the fact that more detailed and technical images could be read correctly by fewer people.[69] This rift, between regular and emergency midwifery and their visual

cultures, only grew in the eighteenth century. This is not to say, however, that all birth figures came to cater only for an educated urban elite.

For most regular midwives in most places, the pregnant body was still thought about and pictured very differently. It was for this readership that many midwifery manuals written in the seventeenth century continued to be reprinted in the eighteenth. Such texts not only were cheaper to produce than new works but also provided a view of midwifery and the body that was more familiar and more legible to many readers. Their images, too, required fewer specialist or elite skills in interpretation. Mauriceau's manual, which was enormously influential from its publication in English in 1672, went through at least seven editions in the eighteenth century.[70] The English translation of Deventer's manual, *The Art of Midwifery Improv'd*, was published five times between 1716 and 1746.[71] Some new books, too, followed the form of the old. Margaret Stephen's book, which was unillustrated, small, cheap, and addressed to a readership of women, was published in 1795. It was expressly *not* written for an urban, medicalized, institutionalized audience. Indeed, Stephen noted that she was "well aware, that this little work is not likely to escape a good dissection by the *literary* anatomists; but this will not deter me from publishing useful truths, which I am confident no man can confute."[72]

A new sheet of seventeenth-century-style birth figures seems also to have been produced in the eighteenth century and can be found illustrating various manuals and encyclopedias, including Lorenz Heister's *A General System of Surgery* (1743, figure 41), Robert James's *A Medicinal Dictionary* (1743–45), and Stephen Freeman's *The New Good Samaritan* (1780?) and *The Ladies Friend* (1780?). The plate also made its way into French works, such as a translation of James's dictionary by Diderot, *Dictionnaire universel de medicine* (1746–48). For many midwives and surgeons, these simpler images were still the most appealing and useful: simpler and more readable, cheaper and more accessible, less likely to horrify potential clients, and able to facilitate the diversity of interpretations discussed in this book.

The example I will examine in detail here is the birth figures produced by the artist George Stubbs for the York physician and midwife John Burton (figures 43 and 45–47). Examining these figures alongside those made for Smellie demonstrates how diverse the visual culture of pregnancy was in the mid- and late eighteenth century, and how the hyperdetailed, "naturalistic" observational style was not dominant, even among works by learned, ambitious midwife-authors. John Burton was classically educated, taking a degree at Cambridge, his MD at Rheims, and studying under Hermann Boerhaave at Leiden. On the completion of his studies, he set up practice as a physician and midwife in York, helping to found

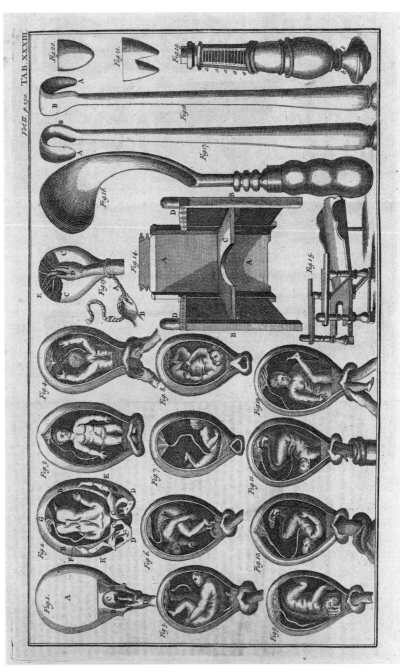

FIGURE 41: Anon., *Table 33*, engraving, 19.8 x 32.1 cm (plate). From Lorenz Heister, *A General System of Surgery*, 2 vols. (London: W. Innys and J. Richardson et al., 1757). EPB/C/28204, Wellcome Collection, London.

and run the York County Hospital. He was a committed Tory, actively supported the Jacobite rising of 1745, and was briefly imprisoned for his involvement.[73] He also engaged in acerbic attacks in print on William Smellie. Forman Cody has noted that this combination of his provincial location, his politics, and his antagonism to Smellie made him "the perfect whipping boy for Scottish Whig men-midwives eager to display themselves as loyal Britons."[74] Indeed, bad press in his own lifetime has continued to the present day, and Burton is often ignored or underacknowledged in histories of midwifery and its visual culture. He is most often dismissed on the grounds of being a detractor of the great Smellie and being the midwife caricatured as Dr Slop in Laurence Sterne's *Tristram Shandy* (1759–67). In his chapter on the management of normal delivery, for example, Edward Shorter acknowledges that the "York MD John Burton is technically entitled to priority" in the practice of nonintervention in the first stage of labor, before quickly negating this achievement: "but Burton was soon forgotten, and would live on only in Laurence Sterne's caricature of him in *Tristram Shandy* as 'Dr Slop.'"[75]

However, this neglect is not well deserved. His attacks on Smellie, while vitriolic, were also largely accurate.[76] His own midwifery manual, while less revolutionary than Smellie's, was no hackwork and went through three English editions (1751, 1758, 1769) and a French translation (1771–73). Moreover, as some scholars have noted, there is little evidence linking Burton to Sterne's Dr. Slop. Traditionally, the reason given for the caricature has been Burton's ongoing enmity with Laurence Sterne's uncle Jacques Sterne. Yet uncle and nephew had broken with each other years before *Tristram Shandy* was written, leaving the nephew with little reason to pander to his uncle by caricaturing his rival.[77] There is also, the *Oxford Dictionary of National Biography* notes, no physical resemblance between the "little, squat, uncourtly figure" of Dr. Slop and Burton, who was said to be tall and well formed.[78] In light of this, I think that Bonnie Blackwell's interpretation of Dr. Slop as a caricature of "man-midwives" in general is much more persuasive.[79]

It seems likely that Burton's birth figures also contributed to his subsequent neglect in histories of midwifery. They are, seen next to Smellie's, rather old-fashioned: small etchings describing chubby, healthy little fetuses in various presentations, in balloon-like wombs excised from the context of the maternal body (figures 43 and 45–47). Perhaps because they look so much like "the little people of early images," which Jordanova, as well as Massey, consign to the seventeenth century, Burton's birth figures are left out of these scholars' narratives.[80] Pam Lieske even erases their existence, stating in her multivolume collection of sources on eighteenth-

century British midwifery that Burton's manual contained only "eighteen illustrations of obstetrical instruments."[81]

Our assumption that highly detailed anatomical images had done away with birth figures has led to a widespread blindness to what was actually still a thriving part of midwifery's visual culture. Burton's birth figures were not inexplicable throwbacks to the culture of the previous century. They were consciously commissioned images, informed by contemporary knowledge and representational practices in both midwifery and anatomy. Rather than seeing them as crude, old-fashioned, or underinformed compared with Smellie's figures, we should understand Burton's as providing a different understanding of the body, for a different kind of audience. Burton worked in a provincial town—an emergency midwife practicing among and assisting many regular midwives. His experience of midwifery was, thus, much less changed from that of the seventeenth century than Smellie's was. Burton's midwifery manual and his birth figures reflect this: the book is smaller and cheaper than Smellie's, it is only one volume, and while his language is learned and technical, as we might expect from the educated Burton, he addresses a mixed audience not only of medical men but also of "all Women and young Practitioners."[82] His book is much as midwifery manuals had always been: a mixture of new knowledge and old. His birth figures indicate that the traditional form was still perceived to be useful—that, in Burton's words, "in describing objects not to be seen, the reader will have a better idea of them from a true representation upon a plate, than only from a bare description."[83]

Another quirk of history that has consigned Burton's book to obscurity is the fact that the young anatomist and artist he hired to illustrate it later became famous as a painter of horses.[84] Hunter and Smellie's primary artist, Jan van Rymsdyk, is mainly known for his anatomical works, but George Stubbs is celebrated as a painter. His birth figures for Burton were an early work, and one for which he had specifically, and rather rapidly, to teach himself to etch.[85] As such, they tend to be dismissed by scholars of the artist as rather embarrassing juvenilia.[86] Indeed, it seems likely that Stubbs himself was not entirely satisfied with his efforts—at least such is the account given by Ozias Humphry, the only contemporary biographical source we have for Stubbs. Humphry recorded that "the prints were certainly very imperfect and therefore our artist wish'd not to set his name to them, but with all their Imperfections doctor Burton was satisfied as they were exact & illustrative."[87] Historians have taken Humphry's summation both literally and partially, agreeing that Stubbs *should* have been embarrassed by the birth figures, while ignoring the significance of Humphry's

qualification that Burton was happy with them. In fact, what may have influenced Stubbs's opinion was less any fundamental failure—they were "exact & illustrative" birth figures—than the fact that they did not tally with the kind of art he wanted to be known for. This would not be surprising, as medical illustration was far from prestigious, and even Jan van Rymsdyk tried hard throughout his career to break into more lucrative and genteel arenas of the art world.[88]

Some of Stubbs's biographers have tried to legitimize the birth figures by describing them as drawn from dissection, recording how Stubbs, who was then teaching anatomy, had his students acquire for him the body of a woman who had died in labor. Stubbs then, "working in a garret, dissected and drew it."[89] Such a story may have appealed to historians because it allowed them to associate the birth figures with Stubbs's later, much lauded, and closely observed anatomical atlas *The Anatomy of the Horse* (1766). As has been noted already in this book, scholars have frequently tried to legitimize birth figures by redefining them as anatomical. Yet even a cursory look will show that Burton's images were not drawn from dissection. First, they have minimal anatomical content, showing only the uterine wall and placenta. Moreover, the fetal presentations they primarily depict cannot be learned from dissecting one cadaver. If Stubbs did dissect a pregnant cadaver, it must have been more for his own information than for the birth figures. To render the fetal presentations, it is most likely that he worked from one or several existing midwifery manuals.

Yet midwifery manuals were not the only influence on these images. Just as Smellie's birth figures borrow partly from Hunter's "characteristic" anatomical style, Burton's birth figures borrow from the "ideal" style of Jan Wandelaar's images for Bernard Siegfried Albinus. It is well-known that both Burton and Stubbs admired Albinus. Burton repeatedly cited Albinus's atlas *Tabulae Sceleti* (1747) as a model to emulate. He referenced Albinus's anatomical discoveries in his manual,[90] and he praised Jan Wandelaar's images in a published attack on Smellie from 1753.[91] Both R. B. Fountain and Oliver Kase note that Stubbs's *The Anatomy of the Horse* borrows heavily from Albinus's atlas in form, style, and approach.[92] Both atlases present the skeleton, Kase argues, as the "architectonic basis" from which knowledge of the muscles and organs can be built up.[93] Both produced "ideal" rather than "characteristic" images: ones that present either a perfect or an average example, informed by multiple dissections. And both show their subjects as if still alive and moving. Indeed, in his own time Stubbs was seen as a kind of successor to Albinus's style of anatomical illustration, with Petrus Camper commenting to Stubbs in

a letter that "you have certainly had before you the scheme of the great Albinus but even his plates have not that delicacy and fullness, nor the expression of yours."[94]

What is much less well-known is that Stubbs's birth figures for Burton were also directly informed by one of Albinus's works: not his famous *Tabulae Sceleti* but a shorter work concerned with the anatomy of pregnancy entitled *Tabulae VII Uteri Mulieris Gravidae Cum Iam Parturiret Mortuae* (1748–51, figures 42 and 44). In 1968, R. B. Fountain pointed out that Stubbs had copied some of his birth figures from this work.[95] But after this article, I have found only three other references to this copying, and in each case the link is treated as only a theory or a possibility.[96] That Stubbs did copy from Albinus is, when the works are compared, undeniable. Table 3 (figure 42) and table 7 from Albinus's *Tabulae VII* were closely copied by Stubbs for table 9, figure 2 (figure 43), and table 4. The fetus depicted in table 5 of Albinus (figure 44) is also exactly copied, though transplanted into a womb, in table 10, figure 1 of Burton's images (figure 45). Moreover, the general style and form developed by Wandelaar for Albinus's atlas are closely copied and adapted to the production of birth figures by Stubbs. As has been explored throughout this book, copying consistently formed a crucial part of how images were produced, be they exact copies, adaptions, or looser borrowings. Here, it is likely that Burton directed Stubbs to take the Albinus atlas as his model, and indeed informed viewers would have spotted the allusion and fitted it with their wider knowledge of Burton's admiration of the Wandelaar illustrations. Though the copying is not directly acknowledged, it can hardly have been a secret. Rather, its tacit presence shows that such borrowing was still entirely naturalized.[97] It is our own modern discomfort with "unoriginal" images and uncredited copying that often leads to a blindness to such paths of copying, and in this case even a spurious story of direct anatomical observation.

Smellie and Burton, therefore, in commissioning practitional images, also took sides on the "ideal" versus "characteristic" debate within anatomy. While a "characteristic," hyperdetailed, naturalistic style allowed Smellie to claim a kind of prestige and observational truthfulness, Albinus's "ideal" style allowed Burton to produce totemic, idealized, evocative birth figures. The "characteristic" style of Hunter is often understood as a radical development of the eighteenth century, while the "ideal" style of Albinus is attached more firmly to the representative conventions of the past, showing the anatomical body idealized and as if still alive. Yet both modes of representation were valued in the eighteenth century, and both kept up with new developments and new knowledge within the discipline. The same can be said for Smellie and Burton: they produced very

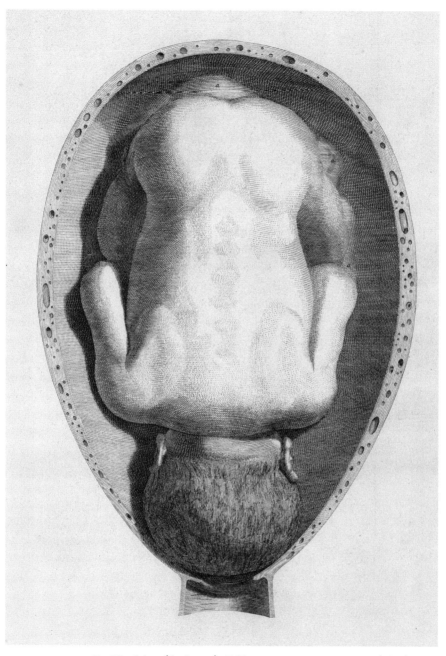

FIGURE 42: Jan Wandelaar (draftsman), *Table 3*, engraving, 56.2 x 40 cm (plate). From Bernhard Siegfried Albinus, *Tabulae VII Uteri Mulieris Gravidae Cum Iam Parturiret Mortuae* (Leiden: Joannem and Hermannum Verbeek, 1748–51). EPB/F/205 (B 379), Wellcome Collection, London.

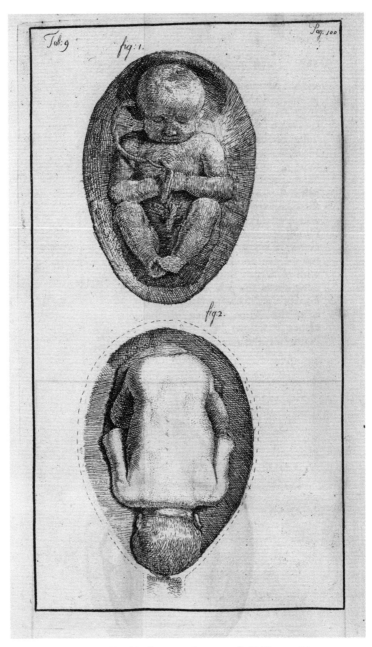

FIGURE 43: George Stubbs (draftsman and engraver), *Table 9*, etching, 20 x 10.8 cm (figure). From John Burton, *An Essay Towards a Complete New System of Midwifry, Theoretical and Practical* (London: James Hodges, 1751). Medical (1701–1800) Printed Collection M2.1 B79, University of Manchester Library, Manchester. Copyright of the University of Manchester.

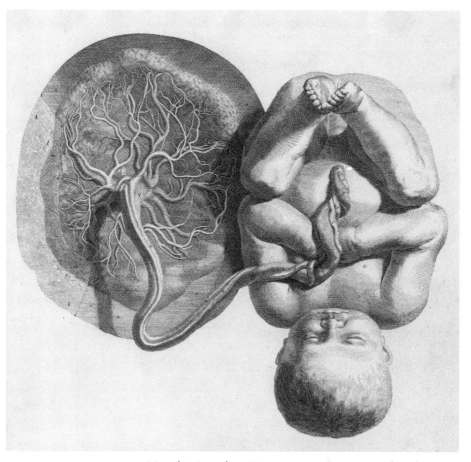

FIGURE 44: Jan Wandelaar (draftsman), *Table 5*, engraving, 56.2 x 40 cm (plate). From Bernhard Siegfried Albinus, *Tabulae VII Uteri Mulieris Gravidae Cum Iam Parturiret Mortuae* (Leiden: Joannem and Hermannum Verbeek, 1748–51). EPB/F/205 (B 379), Wellcome Collection, London.

different images, but both were equally engaged in the contemporary developments, and the history, of both anatomy and midwifery illustration.

There is a totemic simplicity to Wandelaar's images for Albinus: they show not a particular fetus, as Hunter's do, but a general, an ideal, an originary fetus. This approach clearly appealed to Stubbs, providing him with a simple, striking model with which to describe the various fetal presentations. Both Wandelaar's and Stubbs's fetuses are somewhere between putto and neonate; they are curled and fill their uterine environments, but they smile serenely, possessing full heads of hair and well-fleshed bodies. As with many older birth figures, Stubbs's fetuses seem to be conscious

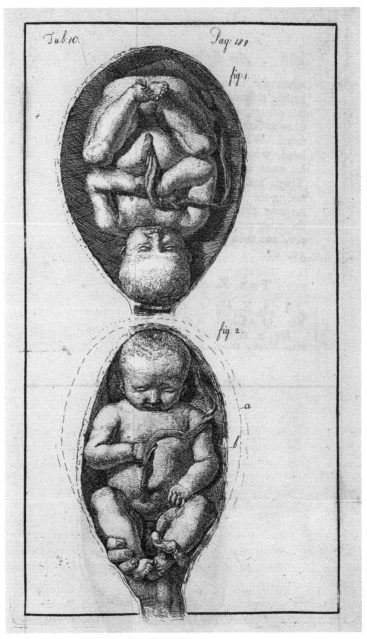

FIGURE 45: George Stubbs (draftsman and engraver), *Table 10*, etching, 19.3 x 10.6 cm (figure). From John Burton, *An Essay Towards a Complete New System of Midwifry, Theoretical and Practical* (London: James Hodges, 1751). Medical (1701–1800) Printed Collection M2.1 B79, University of Manchester Library, Manchester. Copyright of the University of Manchester.

actors in the image, performing their presentations. While those in more normal presentations seem serene, those that enact more dangerous presentations reflect the gravity of their situation with suffering expressions. Stubbs's sketchy, inky etching technique, and the high contrast and use of raking light borrowed from Wandelaar, emphasize the mysteriousness of the unborn, exposing it to sight and yet acknowledging the things that are *not* known about its life in the bodily interior. The strong light produces strong shadows, which are in some cases used to partially obscure the fetus's face. In table 13 (figure 46), for instance, breech presentation is represented by a fetus who leans nonchalantly against the uterine wall, feet braced and head turned casually away. The body language, and the shadowed face, indicate a fetus that consciously refuses our gaze; its performance both gives and denies information, encompassing the twin drives in midwifery to know the body and to leave its mysteries intact.

In table 9, figure 1 (figure 43), a strong beam of light is cast on the fetus's left shoulder, throwing its face into sharp relief. The placenta forms a kind of dark halo around the fetal head, and the beam of light, reflecting off the curved walls of the womb, produces encircling rays of possibly divine light. We see both the projection of the chubby, healthy, hearty child, and also an echo of the holy child, tempered with both holy light and the shadow of death. The religious iconography is continued in table 16 (figure 47), which depicts twins, an arm presentation, and various tools. The difficult and dangerous presentations are associated with the host of tools to which midwives resorted only in dire circumstances. Surrounded by the instruments of their torture, these unfortunate infants bear their pain with the tensed bodies and suffering yet resigned expressions of martyrs. Thus, just as Grignion adopted different kinds of intaglio line to work in different representative modes for Smellie's birth figures, Stubbs developed a style of etching that allowed him to produce images that were descriptive of fetal presentation but also mysterious and expressive of emotional and religious understandings of pregnancy and birth.

Smellie and Burton were antagonists, they aligned themselves with different representational modes within anatomy, and they commissioned images that look very different from each other. However, with respect to the knowledge these sets of birth figures communicate, there are some surprising similarities. Both authors, for instance, were keen to describe the way that the space and shape of the womb change once labor has begun. Burton's images, published three years before Smellie's, were the first to show the change that occurs after the waters break. Of the second figure of table 10 (figure 45), Burton writes that it "shews how the *Uterus* contracts, and closely envelopes the Child when the Waters are run out," declaring

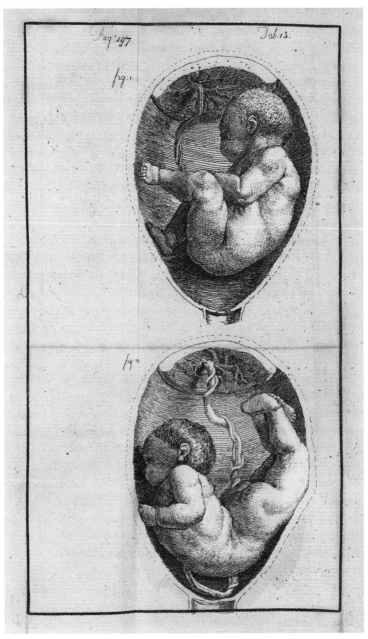

FIGURE 46: George Stubbs (draftsman and engraver), *Table 13*, etching, 19 x 11.2 cm (figure). From John Burton, *An Essay Towards a Complete New System of Midwifry, Theoretical and Practical* (London: James Hodges, 1751). Medical (1701–1800) Printed Collection M2.1 B79, University of Manchester Library, Manchester. Copyright of the University of Manchester.

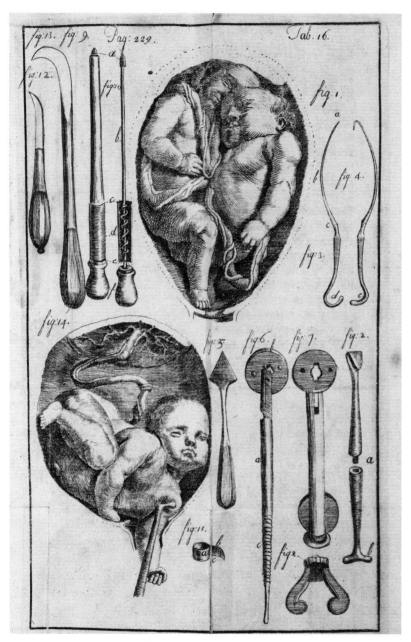

FIGURE 47: George Stubbs (draftsman and engraver), *Table 16*, etching, 19 x 11.2 cm (figure). From John Burton, *An Essay Towards a Complete New System of Midwifry, Theoretical and Practical* (London: James Hodges, 1751). Medical (1701–1800) Printed Collection M2.1 B79, University of Manchester Library, Manchester. Copyright of the University of Manchester.

it "a necessary Observation, which I have never seen in any Copper-Plate before."[98] The same interest is shown in Smellie's table 12 (figure 40), discussed above. The lines of possibility show the profile of the womb before and after the waters have drained away. In both cases, the artists use dotted lines to indicate different possibilities of shape and contour, and both display a preoccupation with space and pressure in the womb, which had been growing in the decades around 1700, treated in part 2, and which is more fully visually expressed in these midcentury images.

Both midwives also show an interest in manual interventions in the womb—another element that first arose in the birth figures addressed in part 2. Smellie, as discussed in chapter 4, was the first to depict the forceps not in isolation, but in use on the body, making an argument for the tool's necessity.[99] Burton, unsurprisingly, took an opposing stance, claiming that "Smellie uses the Forceps in Cases that don't require it, and thereby increases the Dangers to both Mother and Child."[100] Thus, while Smellie's birth figures depict the forceps in action, Burton follows the lead of Siegemund and Viardel in showing the midwife's *hand* practicing upon the body. But while these earlier authors employed hands to describe how manual interventions should be enacted, Burton and Stubbs use the hand more as a meditation on what manual intervention means in midwifery.

Only one hand is extant in Burton's images, in table 10 (figure 45). The midwife's hand enters the womb as the fluids drain away and as labor advances, in order to deliver the fetus by the feet. Early modern childbirth was characterized by the breaking of barriers—bodily and social—and the movement of the fetus from the secret interior world into the world at large. It was a moment of bodily, social, and spiritual significance. In this image, the hand of the practitioner breaks both the barrier of the image's border, and the barrier of the body itself, to grasp the fetus's legs. The world is brought, prematurely, to the fetus not yet born. There is both calmness and violence to this image. The fetus looks at the hand that grasps its feet and seems to make a gentle attempt at communication, one hand held to the chest and the other reaching down. The practitioner's hand, too, holds firmly but not tightly, the fingers intertwining with the fetus's curled toes. The figure encapsulates Burton's ambivalence over manual intervention in childbirth: that while it was sometimes necessary to "touch" or manually deliver the laboring woman, "the less the Parts are handled, the better it is for both Mother and Child."[101] Like Siegemund and Deventer, Burton uses an image of a hand to define the ideal midwife—here firm but gentle, sensitive to and communing with the fetus. Represented in the same textural and tonal range, the two bodies seem to merge. Stubbs employs his sketchy, dark, etched style to give a sense of the fuzzy, hazy tactile knowl-

edge of the midwife. But there is also fine detail in the representation of each finger, carefully curling around the fetus's legs, and in the uterine wall rippling over the knuckles and wrist. This hand, as had often been the case with birth figures, said as much about the midwife's powers of sense as about their powers of operation. Stubbs's image acknowledges the violence and breakage of manual intervention but casts the hand as heroic and sensitive. Where Smellie describes the forceps as smooth, slim, and able to grasp where a hand would be too large, Burton claims ascendancy for the sensitive skin of the hand over cold, insensate metal. Thus, the two midwives continue and develop the debate that had been enacted in text and image in midwifery since the publication of the forceps.

Elegance

Smellie's and Burton's birth figures present two very different examples of midwifery illustration in the mid-eighteenth century. While the authors were often opposed, their images maintained a shared identity as practitional that brought them closer together in their difference from the anatomical image. Part of this identity was the flexibility and plurality of the birth figure as a representational form: the combination of new anatomical knowledge with diagrammatic, practitional, and symbolic forms characterized both Smellie's and Burton's images. This plurality continued to make birth figures an enduring form, but also a complicated and difficult one. In the eighteenth century, this troubling multifarious identity was expressed through discussions of elegance. The term "elegance" is itself an amorphous one, meaning different things at different times and in different places. It tended to imply a refined taste and so a social distinction, but as Marieke Hendriksen has pointed out, such terms are hard for historians to use without falling into anachronism.[102] Indeed, in this period, elegance had a currency in the interrelated worlds of art and medicine that is not extant in modern culture.

In eighteenth-century painting, architecture, and the decorative arts, "elegance" came to be widely associated with the grand and austere style of Neoclassicism, which was sanctioned by the Royal Academy.[103] This was a period in which the increased availability of printed images and printed art criticism, as well as the development of public exhibitions such as those held at the Royal Academy, provided more public forums for the discussion of art—places where styles and techniques could be compared and good taste established or proved.[104] While the specifics of what made up "elegance" were uncertain and complex, it was undeniably a positive term and one that suggested educated and refined taste. William Hogarth, for

instance, frequently employed the term in his *The Analysis of Beauty*, unsurprisingly applying it to his ideal serpentine lines and variable forms.[105]

Within the world of anatomical illustration, too, elegance became a crucial concept. According to Hendriksen, elegance could be found in the body and in the methods employed for representing and preserving it: it was a fundamental part of eighteenth-century anatomy.[106] In anatomical images, elegance could be achieved, and if it was, that elegance would help to make the image both truer and more instructive. Massey, for instance, argues that, in this period, "the epistemological claims of clinical medicine became based on the practitioner's ability to describe the body persuasively and elegantly, in infinitesimal detail from the inside out."[107] These ideals in anatomy were tied to, but not the same as, those in the fine arts. For instance, Joshua Reynolds and William Hunter, colleagues at the Royal Academy, differed over whether elegance was to be found in imagined and idealized forms or in the close replication of nature.[108] As Martin Postle puts it, "taste and beauty were for Reynolds chimerical concepts. For Hunter they evolved directly from an experience of life at its most elemental level."[109] Hunter, predictably, saw his own severely observational "characteristic" images as having the "elegance and harmony of the natural object," where "ideal" images had only "the hardness of a geometrical diagram."[110] For Albinus, who commissioned such "ideal" anatomical images, elegance was created in that very process of idealizing and generalizing that Hunter rejected. Hendrik Punt has argued that for Albinus, there was a "symbiosis" between "objectivity, symmetry and vitality."[111] He saw anatomical investigation as a seeking out of ideal and elegant forms in the body—forms that spoke both of beauty and of perfect health. Burton seems to have subscribed to this idea, praising Albinus's images as ones where "Art and Nature conspire" to create "something like Perfection."[112] For anatomists, therefore, elegance was a didactic tool, a proof of the truth of the image, something to be striven for, though achieved in different ways depending on personal taste and opinion.[113] For them, as Daston and Galison argue, "the beauty of the depiction [was] part and parcel of achieving that accuracy, not a seduction to betray it."[114]

Midwifery authors had a rather different relationship with elegance, approaching the concept as one of multiple, potentially conflicting, ideals to be striven for. For both Burton and Smellie, elegance, like anatomical knowledge itself, was a desirable component of birth figures, but one there *could* be too much of. While eighteenth-century anatomical images *required* elegance in order to be good, truthful works, for which, as Kemp puts it, "stylishness and accuracy were not seen as conflicting aspirations,"

midwifery images had to balance a desire for some elegance with the danger that too much might *reduce* their instructional value.[115]

This difference is partly due to the strong ties between anatomy and fine art in the eighteenth century, ties that did not exist between fine art and midwifery illustration. Anatomical knowledge of the bones and muscles was, for instance, widely understood to be necessary for artists, particularly in the production of figures for history paintings. Images and sculptures of skeletons and écorché figures were used by artists as well as anatomists and physicians. However, not all kinds of medical and anatomical image were considered relevant for artists. Hogarth, for instance, proposed that bones and muscles, because they influenced the form and movement of the human figure, were relevant and had an inherent elegance. He also argued that the parts that are "conceal'd, and not immediately concern'd in movement," were neither relevant nor elegant.[116] Birth figures, because they dealt with interior bodily elements, with the female body and with the private, taboo sex organs, were at a remove from the realm of artistic anatomy. The idealized human form and attendant ideas of elegance, be they anatomical or artistic, had less to do with such practitional images. Elegance might be partly achieved, perhaps in the style of the engraving, or in some of the forms represented. However, not only was the subject matter less inherently elegant, but the birth figure's pluralistic use of representational forms fundamentally prevented it from achieving a complete elegance.

Words such as "elegance," "beauty," and "delicacy" were contentious, therefore, and their place in the birth figure was constantly being debated by midwife-authors. Burton criticized Smellie's images first by quoting from a reviewer who praised them as *"superior to any Figures of the Kind hitherto made public."*[117] Burton then acerbically noted that "I fear he [the reviewer] judges only from a general Knowledge of Things, and from the Beauty of the Drawing; which, indeed may, perhaps, be possibly *superior to any Thing of the Kind hitherto made public*; but that alone will not be sufficient."[118] Whereas beauty and pedagogical usefulness pull together in anatomical drawings, therefore, Burton considers that the beauty or elegance of Smellie's images is immaterial to their instructional usefulness, and even that such qualities might disguise pedagogical faults.

Indeed, it is not surprising that Burton was tetchy about the subject of elegance: while Smellie's images were praised in the press for this quality, his own were condemned for a lack of it. In the same long essay in which he attacks Smellie, Burton defends his own images against the accusation, made in the *Monthly Review*, that they were "wretchedly coarse, and a

discredit to the very term of sculpture."[119] This reviewer also addresses the images in the terms of fine art, categorizing the etchings as a form of sculpture, rather than as medical or technical images. But Burton refutes these criticisms by changing the framework against which they are judged. He argues that "could he [the reviewer] indeed have proved the different Situations of the Child in the Womb, &c. attempted to be shewn, were not thence to be learnt, he might then have had some Reason to inform the Public thereof."[120] Just as with Smellie's, the usefulness of Burton's images is understood by the author as completely separate from their elegance.

Smellie's own writings betray much the same anxiety over elegance and usefulness. He explains that his figures avoid "the extreme Minutiae, and what else seemed foreign to the present design; the situation of parts, and their respective dimensions being more particularly attended to, than a minute anatomical investigation of their structure."[121] As with Burton, he distinguishes the "extreme Minutiae"—which must certainly be a reference to Hunter's style of detailed "characteristic" anatomy—from a kind of mechanical, practical knowledge that was more essential to midwives. Smellie declared: "delicacy and elegance . . . has not been so much consulted as to have them done in a strong and distinct manner, with this view chiefly that from the cheapness of the work it may be rendered of more general use."[122] Delicacy and elegance, while valuable attributes, were, for midwife-authors of the eighteenth century, less important than, and indeed in some ways even opposed to, their pedagogy.

Anatomists such as Hunter and Albinus could, it would seem, pursue an ideal of anatomical representation that accorded with an ideal of artistic elegance—be it elegance located in close observation of nature or in the careful creation of "ideal" figures. They worked in a profession that was increasingly well respected, that produced increasingly prestigious, expensive images that were viewed not just by physicians and surgeons but by artists and interested amateurs of all kinds. While the social and professional star of midwifery was also on the rise, it by no means contended with that of the anatomist. The midwife was still a suspect figure, working with their hands, touching women's bodies, and still unable to shake the frisson of sexual danger. Their images continued, therefore, to mediate all kinds of knowledges and expectations, both about the laboring body and about the midwife that attended, touched, and represented it. Practitional images in midwifery neither could, nor should, be completely elegant—and in this we see the continued fundamental difference between the practitional and the anatomical image. The midwifery image aimed not only for elegance but for a balancing of an anatomical style of elegance with other practical, mechanical, and instructional modes of representation.

For Burton and Smellie, despite the differences in their images, shared difficulties in managing elegance sprang from a shared concern to define their discipline and the body they worked with.

Birth figures, as I have demonstrated, did not disappear in the eighteenth century. Nor were they rendered obsolete by the rise of the newly observational and detailed visual culture of anatomy. Rather, they continued to inform and shape the discipline in a way that, as it always had, combined the new with the old and described the body in multiple modes. It was not even the case that birth figures continued to illustrate cheap books for regular midwives and lay readers while the educated elite moved on to a more "accurate" anatomical visual system. As I have shown, Smellie's images *are* birth figures, though they employed a new representational style.

Considering the visual culture and the visual history of midwifery when addressing the images commissioned by Hunter, Smellie, and Burton, therefore, enables us to better understand how they related to each other and fitted into wider visual cultures, and how they were understood by contemporary viewers. Giving space to this "other" visual history of pregnancy breaks the hegemony that Hunter's images have held, pointing to the variety of representational systems in the eighteenth century and to the cultural *need* for different kinds of images. The anatomical body was still not the same as the living body in labor, and the anatomist's knowledge was still not the same as that of the midwife.

What becomes clear from a study of eighteenth-century birth figures is that anatomy and midwifery remained separate but interlinked disciplines, struggling to work in tandem while also maintaining disciplinary difference. Midwife-authors were deeply engaged in the contemporary debates over anatomy and its visual representation, but they also felt a distinct and specific identity as midwives. Birth figures continued to characterize the discipline because they continued to be useful in both teaching midwifery and shaping how the profession was perceived. What does characterize this period more specifically, I argue, is a widening of the rift between the regular and the emergency midwife, begun in the seventeenth century. This led not simply to a new pathologizing of visual culture and practice, but rather to a diversification in how bodies were thought about and represented. Knowledge and pictures became more specific to particular groups defined by their location, gender, education, wealth, and professional status. Recognizing this difference, and seeking out how regular midwives and lay people, as well as the medicalizing elite, saw and represented the pregnant body they worked with, are crucial to writing a full history of the period.

Conclusion

If you do an online image search for the term "fetal presentation," you will find numerous contemporary birth figures. These images share key characteristics with the birth figures that have been the focus of this book: in series, they describe the variety of fetal presentation. Occasionally rendering the maternal torso, they are usually restricted to the fetus, pelvis, and the outline of the womb. This is because, while this study ends with William Hunter and his eighteenth-century contemporaries, the history of birth figures continues.

Throughout the nineteenth century and beyond, the old style of birth figure was reproduced again and again in midwifery manuals and popular medical guides. One need only sample some of the many editions of *Aristotle's Masterpiece*[1] to find birth figures little changed in form from those of the seventeenth century, alongside woodcuts of "monsters," astrological figures, and simplified copies of illustrations from midwifery works by famous authors ranging from William Smellie and William Hunter to Jean-Louis Baudelocque and Jacques-Pierre Maygrier.[2] We would do well to remember that while the nineteenth century saw the continuing encroachment of medical men into midwifery, and the development of new obstetric techniques including caesarean section, anesthesia, and (eventually) antiseptic practice, most women continued to be delivered by women midwives who had very varying levels of training.[3] Popular guides and old midwifery manuals remained as crucial a part of midwifery visual culture as the newest obstetrical textbooks. New illustrations appeared, were disseminated and copied, became incorporated into popular and cheap works as well as technical and prestigious ones, and so contributed to the ever-continuing stall and change of midwifery's visual culture.

From the early twentieth century, regulation changed the practices of midwifery education and training, and the institution of the National Health Service provided another massive shift in how doctors and mid-

wives provided care and how British people experienced childbirth.[4] Yet the central relevance of fetal presentation, and the need to represent it, remained. While printing methods and representational styles changed, and while midwifery manuals and popular health guides gave way to textbooks and informational pamphlets, the birth figure persisted. These centuries deserve their own visual histories, and I aim here to do no more than point out that they exist, and that they are fundamentally entangled with the visual cultures of the centuries that went before. Birth figures today, just as much as in the seventeenth and eighteenth centuries, are cultural and multifarious objects. Looking at them as such will help us to disentangle ideals of medical objectivity and truth from the lived experience of childbirth and midwifery for people today. With these final few words, I will focus on the birth figures that we see today, in our medical notes, in textbooks, and on the internet.

The presence of birth figures in today's culture accompanies a continued medical preoccupation with fetal presentation, and a continued interest among pregnant people not only in specifically identifying presentation but in visualizing the present-yet-absent child inside. Looking, for example, at one set of birth figures produced in a large digital medical resource for nonprofessional readers (plate 6), we can recognize many of the features of early modern birth figures, as well as some obvious differences. This, like most modern birth figures, is colored and digitally rendered. It employs a uniform style that Martin Kemp has described as "non-style," first developed in the mid-nineteenth century as an "exercise in intellectual and visual restraint."[5] Using black outlines of regular width, block colors, and minimal shading that smooths over textures, aberrations, and minute details, these images propose a view of the body that is both medically informed and yet simple and widely readable. It is intended to cut out extraneous detail and wider cultural signifiers; it makes an argument for a simple "truthfulness" and denies the work of interpretation done by either artist or viewer. It is worth noting that here, as with many images in medical resources today, no information as to the creators of the figures is provided. Changes in midwifery practice are also indicated in such images as these: less attention is given to the rare and dangerous presentations—of the arm, the shoulder, the belly—as these are today usually delivered by caesarean section. In our example, only four "abnormal presentations" are described, though the number in modern sets is much more various, from just a few showing the most common presentations, to a large number encompassing every possible iteration. More specific classifications—the rotation of the head, the different positions of the leg in breech presentation—are now often described, pointing to

both an increased monitoring of and intervention in fetal positioning, and a minute understanding of the mechanics of delivery.

But, of course, these modern birth figures are not just conduits for medical knowledge. They are also images that speak about the culture that produced them. They point, for instance, to our own culture's ingrained association of childbirth with a distant and unquestionable medical authority. When we want to learn about pregnancy and birth we often turn to popular resources, the internet primarily, but also books and other informational literature written for a nonmedical audience, but we expect information that is medically informed and images that look like those in medical textbooks. Our example here (plate 6) is published in both the "Consumer" and the "Professional" versions of the manual. Indeed, modern birth figures point to the strange way in which medical images are totally assimilated into wider visual cultures and yet are also seen as rarefied and specialized. Modern birth figures combine a visual style that promises objectivity, simplicity, and readability with often quite specialized levels of description and technical labeling.

The sheer abundance of such images today, digitally and in print, points, too, to the ever-increasing levels of medical monitoring and medical information that surround pregnancy in the West. The expectation is that women will monitor and understand the details of fetal presentation, along with many other aspects of their pregnancies, that they will simultaneously be their own informed advocates and yet unquestioningly follow medical advice. The images point, too, to the much wider adoption of this medicalization by nonprofessionals, and to societal inclinations to observe and control the behavior of pregnant people in the name of medical prudence.

As always, and despite their visual claims to simple truthfulness, modern birth figures do point to wider cultural assumptions about bodies and pregnancy. The fact that the fetuses are almost invariably colored pink or white indicates our continued visual bias toward racially white bodies. In our example (plate 6), the fuchsia-leaning pink is not exactly an accurate flesh tone, yet it points firmly at racial whiteness. This persistent visual trend perpetuates the ingrained association of white bodies with the ideal and the standard, as well as visually erasing the presence, relevance, and rights of those identified as nonwhite.[6] Indeed, this is particularly problematic given our contemporary culture's inclination to assume objectivity or simple truthfulness in the medical image—we are unused to interrogating such images for what they say, *socially and culturally*, about our bodies. Yet here is where an awareness of the long visual history of the birth figure can help us—these images have always been expressions of the ideal fetal

body. In different periods, the expression of this ideal can give us, for example, an understanding of the period's intertwined issues of race and reproduction.[7] Given the significantly worse rates of maternal mortality for BAME women in the UK and the US today, this kind of visual bias cannot be dismissed as insignificant.[8] Pernicious assumptions about racial difference in medical contexts, as well as ingrained and institutional racism that leads to the neglect and disempowerment of nonwhite people, cannot be separated from our medical visual culture.

Modern birth figures also have a role to play in the disempowerment of pregnant people generally in contemporary Western societies. The visual reduction of the pregnant body to the womb and pelvis feeds into the much wider contemporary cultural practice of maternal erasure, discussed in chapter 2.[9] Photographic and ultrasound images of the fetus have been employed by both medical authorities and antiabortion political bodies to frame them as independent beings and the primary patients in a pregnancy. As has been argued by feminist scholars since the 1980s, this can serve to disempower pregnant people, to remove their agency in pregnancy and childbirth and even to remove an aspect of their own personhood as it is conferred on their fetus.[10] Inevitably, in contemporary (though not, I argue, in early modern) visual culture, the birth figure's partial representation of the pregnant body feeds into this rhetoric. Pregnant people looking at birth figures today may see a confirmation that their own bodies are simply "environments" for the fetus, their own autonomy subject to the requirements the fetus makes upon them.

However, as Rosalind Petchesky argued in her germinal article "Fetal Images," and as I have demonstrated with regard to early modern birth figures, the actual response to these images by viewers is enormously various. As Petchesky points out, it depends largely on the context of a pregnancy, the health of the fetus, and whether the pregnancy is wanted. Since Petchesky wrote her article, ultrasound scans and other tests have enabled the diagnosis of more diseases and developmental problems *in utero*, and private clinics have begun to offer 3D and video scans for people keen to connect with and visualize their unborn. Like the birth figure in the early modern period, therefore, the ultrasound image today has complex and conflicted meanings. It lives in our cultural imagination as a symbol both of personal happiness and of anxiety, fear of illness, even the sudden requirement to make a terrible decision about termination.

Contemporary images of the unborn, including ultrasound scans and birth figures, can work to disempower people in pregnancy and to subject them to medical surveillance and control, but they can also provide assurance and empowerment. They can stand for great joy and deep trauma.

The birth figure's specific capacity to describe fetal presentation, for example, contributes to our culture's increasing knowledge of the unborn, attended by an increasing requirement to make decisions and take actions to maintain a "perfect" pregnancy. These include manipulating the exact position of the fetus as they engage in the pelvis late in pregnancy. From external version to particular sitting and sleeping positions and amount of time spent standing or walking, pregnant people are bombarded with advice on behaviors that relate directly to the positions they see in birth figures. Such viewers may see in birth figures a representation of a notional scale of "idealness" by which they are encouraged to measure their pregnancies, and work to improve them: as such, birth figures are images that can empower or oppress an individual, indeed can do both at once.

Birth figures, as much today as in the early modern period, are a source of bodily knowledge that is both technical and popular, medical and culturally laden. This work has been an exercise in drawing out these cultural complexities and diversities, and an argument for the importance of doing so. I have aimed to demonstrate that the least little image, given the chance, can have so much to say about the culture that made it.

I began this research because birth figures appeared to me to be neglected sources for histories of medical and visual culture. They seemed to have suffered from the focus on the prestigious, the detailed, and the anatomical in studies of medical imagery. Indeed, the process of researching and writing showed me how important these images were in giving us another kind of history. Within histories of women, of medicine and midwifery, and of the body, this book has worked to privilege viewers and experiences that are less considered and less recorded. Asking what pregnant women and women midwives saw when they looked at birth figures has allowed me to write visual histories of medicine that look away from the elite and masculine worlds of learned medicine and to approach ideas and experiences less often recorded textually. Within visual culture studies, too, birth figures themselves are a less-considered subject. While work on epistemic images has flowered in the past few decades and is rapidly growing, there is still a bias toward famous authors and artists, groundbreaking works and visually spectacular images. By looking at images that are not marked out for radical innovation or special prestige, we gain a different perspective on the period, a sense of its pluralistic and sometimes contradictory layers of culture. And looking at birth figures in this way has also led to arguments of wider importance for epistemic image studies: establishing the difference between anatomical and practitional images of the body; addressing cases of both "success" and "failure" in epistemic

images; highlighting the diverse ways in which images create knowledge when different kinds of viewers are recognized; and challenging the hegemonic place of William Hunter's atlas in histories of midwifery and its visual culture.

But most crucially, I have come to see that these marginalized cultures, images, and perspectives are not marginal at all. Birth figures are not just interesting, rich, and underexamined resources; they are also images that informed many of the most fundamental aspects of early modern life. The early modern womb was deeply significant and stubbornly mysterious. It was the organ that defined women's bodies, their health, and their social roles. Questions of fertility and the processes of childbearing regulated most people's lives. Bearing legitimate children within the patriarchal family unit was crucial personally, socially, and politically. Within this culture, the womb became increasingly scrutinized and yet was persistently unfathomable. Medicine raised questions about its workings that no one could answer. Images such as birth figures, therefore, gained an aura of power along with the organ that continued not only to define women's identities and social roles, but to characterize women as different, uncontrollable, and mystifying in relation to men. Birth figures are visualizations of the unseen: not only the unseen physical interior but also the pervasive, invisible meanings that linked women's bodies to their social, political, and cultural lives.

As creators of life, women and their wombs were tricky. Birth figures indicate the ways in which early modern men employed medical authority to define and control women and their reproductive capacities. But birth figures *also* demonstrate how women had their own understandings of their bodies and developed their own systems for establishing and maintaining authority. Birth figures indicate how we can recover the histories not only of marginalized images but of marginalized people. The overarching patriarchal authority of early modern society, and the dominance of medicine by men, has often led us to assume that women feature only as passive subjects and victims in histories of medicine and childbirth, the more so as midwifery became medicalized. Yet a close look at birth figures shows learned women who published and discussed them, regular midwives who used, "misused," and criticized them, and women of all kinds who saw, adapted, and interpreted them according to their own needs.

Birth figures mattered in early modern culture because they offered a space for thinking through the difficult, unfathomable, but important questions about life and its origins, the place of women and the shape of society. In a world where print was becoming ever more prolific and authoritative as a source of knowledge, the birth figure was an image of

power. But its power was as diverse as its interpretations. The same image could serve to concretize and define the womb according to medical knowledge or shape the unborn child and ensure a safe delivery. It could speak symbolically about the human condition or it could define the professional persona of the midwife.

To place pregnancy, and images of pregnancy that were seen and used by women and men of many ages, stations, professions, and places, at the center of historical narratives is, therefore, an act of diversification and enrichment. In centering the birth figure, this book contributes to the growing body of scholarship that acknowledges marginalized people, lives, objects, and subjects. These experiences of women in pregnancy, childbirth, and midwifery are not peripheral—they have simply been made so by much of historical study, until recently. And this, I argue, is what the birth figure can show us: that however these images were used, adapted, praised, and criticized by early moderns, and however they have been reduced, ignored, or vilified by historians, they have always escaped being pinned, defined, refused, or erased. They were widely useful and widely used and therefore are significant not just for "women's history" or "print history" but much more comprehensively, for history. The little figure in the circle was the fetus in the womb, but it was also the person in the world. Thus, these images show us that the pregnant body, and images of it, are fundamental, at the center of early modern webs of culture and society. A symbol at once simple and complex, they have a great capacity to hold ideas and facilitate thinking. Like the bodies they represent, birth figures are crucial in their generative potential.

Acknowledgments

I must begin by thanking Mechthild Fend for her unfailing support, wisdom, and straight-talking throughout the life of this project. I am also very grateful to the many people who encouraged my research and commented kindly and constructively on my writing, including Rose Marie San Juan, Mary Fissell, Joanna Woodall, Laura Gowing, Jack Hartnell, Cynthia Klestinec, Richard Taws, Karen Darling, Tristan Bates, Louise Whiteley, Sandra Racek, Kelly Freeman, Sophie Morris, Emily Vine, Carys Brown, and Leah Astbury. Sara Ayres provided the insightful and thorough index. Many more people at conferences and workshops, in archives, museums, and libraries, have listened to my thoughts and questions and have provided ideas, nuances, and answers. I am indebted to you all.

The research environments in which I have worked as a PhD student and postdoc have also contributed to the formation of this book. The History of Art Department at UCL was a vibrant and rigorous place in which to research it, and the John Rylands Research Institute has been an equally generous, diverse, and interesting place in which to finish it. And I have benefited so much from the excellent collections, material and digital, as well as the knowledge and expertise of the librarians and curators at The Wellcome Library, London; The British Library, London; The Huntington Library, Pasadena; The John Rylands Library, Manchester; and Medical Museion, Copenhagen.

My PhD was funded by the Arts and Humanities Research Council (AHRC), and my subsequent postdoc by Dr. David Shreeve. Without this generous financial support, I could not have written this book. A research trip to the Huntington Library, funded by the International Placement Scheme, AHRC, facilitated new discoveries and avenues of research. The printing of the images that are the heart of this study was also partly financed by a generous grant from the Millard Meiss Publication Fund, College Art Association.

I will finish by thanking the friends and family who have supported me through the long process of researching, writing, and bringing this book to press. There are simply too many kind souls to name, so I will just say: you know if you have listened to me enthuse, obsess, and complain about my work—thank you! My parents, Chris and Adam, need a special mention: they have always encouraged me to work hard and to follow my passions, but also to know that my worth is not connected to my academic success. Their love, care, and encouragement have allowed me to thrive and be happy. Finally, my gratitude and love to my partner, Will, and my daughter, Robin. Will has been unselfish, supportive, kind, helpful—a better partner than I could possibly have hoped for. Robin hasn't been helpful at all, but she is very cute.

Notes

Introduction

1. Eucharius Rösslin, *Der Swangern Frawen und Hebammen Roszengarten* (Strasbourg and Hagenau: n.p., 1513). The figure is reproduced from the second edition of 1515, which appears to have used the same woodblocks.

2. Foundational works on the problematic womb in the early modern world include Lori Schroeder Haslem, "Monstrous Issues: The Uterus as Riddle in Early Modern Medical Texts," in *The Female Body in Medicine and Literature*, ed. Andrew Mangham and Greta Depledge (Liverpool: Liverpool University Press, 2011), 34–50; Mary E. Fissell, *Vernacular Bodies: The Politics of Reproduction in Early Modern England* (Oxford: Oxford University Press, 2004); Laurinda S. Dixon, *Perilous Chastity: Women and Illness in Pre-Enlightenment Art and Medicine* (Ithaca, NY: Cornell University Press, 1995); Cynthia Klestinec, "Sex, Medicine, and Disease: Welcoming Wombs and Vernacular Anatomies," in *A Cultural History of Sexuality in the Renaissance*, ed. Bette Talvacchia (Oxford: Berg, 2011), 113–35; Katharine Park, *Secrets of Women: Gender, Generation, and the Origins of Human Dissection* (New York: Zone Books, 2010); Cathy McClive, "The Hidden Truths of the Belly: The Uncertainties of Pregnancy in Early Modern Europe," *Social History of Medicine* 15, no. 2 (2002): 209–27; Ulinka Rublack, "Pregnancy, Childbirth and the Female Body in Early Modern Germany," *Past & Present* 150 (1996): 84–110; Barbara Duden, *The Woman beneath the Skin: A Doctor's Patients in Eighteenth-Century Germany*, trans. Thomas Dunlap (Cambridge, MA: Harvard University Press, 1991).

3. Isabel Davis, "Love, Wind Eggs, and Mere Conceptions: Non-generation in William Harvey's De Conceptione," *Textual Practice* 33, no. 8 (2019): 1321–40; Paige Donaghy, "Wind Eggs and False Conceptions: Thinking with Formless Births in Seventeenth-Century European Natural Philosophy," *Intellectual History Review* (2021): 1–22.

4. Thomas Laqueur, *Making Sex: Body and Gender from the Greeks to Freud* (Cambridge, MA: Harvard University Press, 1990), 26.

5. Cathy McClive, *Menstruation and Procreation in Early Modern France* (Farnham, UK: Ashgate, 2015); Sara Read, *Menstruation and the Female Body in Early Modern England* (Basingstoke, UK: Palgrave Macmillan, 2013).

6. See, for example, Fissell, *Vernacular Bodies*; Laura Gowing, *Common Bodies: Women, Touch, and Power in Seventeenth-Century England* (New Haven: Yale University Press, 2003).

7. Nick Hopwood, *Haeckel's Embryos: Images, Evolution, and Fraud* (Chicago: University of Chicago Press, 2015), 4.

8. Monica Green, *Making Women's Medicine Masculine: The Rise of Male Authority in Pre-modern Gynaecology* (Oxford: Oxford University Press, 2008), 246–87.

9. Green, 118–62.

10. Green, *Making Women's Medicine Masculine*, 267–73; Monica Green, "The Sources of Eucharius Rösslin's 'Rosegarden for Pregnant Women and Midwives' (1513)," *Medical History* 53 (2009): 167–92; Eucharius Rösslin and Thomas Raynalde, *The Birth of Mankind: Otherwise Named, the Woman's Book*, ed. Elaine Hobby (Farnham, UK: Ashgate, 2009), xv.

11. Green, *Making Women's Medicine Masculine*, 270–71.

12. See chapter 2, pp. 82–84; chapter 5, p. 197.

13. Jean Donnison, *Midwives and Medical Men: A History of Inter-professional Rivalries and Women's Rights* (London: Heinemann, 1977); Wendy Arons, "Introduction," in *When Midwifery Became a Male Physician's Province: The Sixteenth Century Handbook "The Rose Garden for Pregnant Women and Midwives, Newly Englished,"* ed. and trans. Arons (Jefferson, NC: McFarland, 1994).

14. Agnes Arnold-Foster, "Medicine and the Body in Second-Wave Feminist Histories of the Nineteenth Century," *History* (2021): 1–19.

15. Green, *Making Women's Medicine Masculine*.

16. Lisa Forman Cody, "The Politics of Reproduction: From Midwives' Alternative Public Sphere to the Public Spectacle of Man-Midwifery," *Eighteenth-Century Studies* 43, no. 4 (1999): 478; Mary E. Fissell, "Man-Midwifery Revisited," in *Reproduction: Antiquity to the Present Day*, ed. Nick Hopwood, Rebecca Flemming, and Lauren Kassell (Cambridge: Cambridge University Press, 2018), 319–32.

17. See, for example, Doreen Evenden, *The Midwives of Seventeenth-Century London* (Cambridge: Cambridge University Press, 2000).

18. For further discussion of gender and midwifery history see chapter 3, pp. 89–93.

19. William Hunter, *The Anatomy of the Human Gravid Uterus Exhibited in Figures* (Birmingham: John Baskerville, 1774).

20. Lorraine Daston and Peter Galison, *Objectivity* (New York: Zone Books, 2010), 113.

21. B. Aulinger, "Social History of Art," in *Grove Art Online* (Oxford: Oxford University Press, 2003), https://www.oxfordartonline.com/groveart/view/10 .1093/gao/9781884446054.001.0001/oao-9781884446054-e-7000079457; Jeremy Tanner, "Michael Baxandall and the Sociological Interpretation of Art," *Cultural Sociology* 4, no. 2 (2010): 231–56.

22. Michael Baxandall, *Painting and Experience in Fifteenth Century Italy: A Primer in the Social History of Pictorial Style* (Oxford: Oxford University Press, 1988); Michael Baxandall, *The Limewood Sculptors of Renaissance Germany* (New Haven: Yale University Press, 1980); Michael Baxandall, *Patterns of Intention: On the Historical Explanation of Pictures* (New Haven: Yale University Press, 1985).

23. Baxandall, *Painting and Experience*.

24. Caroline Bynum, "Why All the Fuss About the Body? A Medievalist's Perspective," *Critical Inquiry* 22, no. 1 (1995): 1–33; Roger Cooter, "The Turn of the Body: History and the Politics of the Corporeal," *Arbor: Ciencia, Pensamiento y Cultura* 186, no. 743 (2010): 393–405.

25. Duden, *Woman beneath the Skin*, 31.

26. Duden, *Woman beneath the Skin*; Ulinka Rublack, "Fluxes: The Early Modern Body and the Emotions," *History Workshop Journal* 53, no. 1 (2002): 1–16.

27. Roy Porter, "The Patient's View: Doing Medical History from Below," *Theory and Society* 14, no. 2 (1985): 175–98; Flurin Condrau, "The Patient's View Meets the Clinical Gaze," *Social History of Medicine* 30, no. 3 (2007): 525–40; N. D. Jewson, "The Disappearance of the Sick-Man from Medical Cosmology, 1770–1870," *International Journal of Epidemiology* 38 (2009): 622–33.

28. Lorraine Daston, "Epistemic Images," in *Vision and Its Instruments: Art, Science and Technology in Early Modern Europe*, ed. Alina Payne (University Park: Pennsylvania State University Press, 2015), 13–35; James Elkins, "Art History and Images That Are Not Art," *Art Bulletin* 77, no. 4 (1995): 553–71; Alexander Marr, "Knowing Images," *Renaissance Quarterly*, no. 69 (2016): 1000–1013.

29. Sachiko Kusukawa, *Picturing the Book of Nature: Image, Text, and Argument in Sixteenth-Century Human Anatomy and Medical Botany* (Chicago: University of Chicago Press, 2012); Daston and Galison, *Objectivity*; Susan Dackerman, ed., *Prints and the Pursuit of Knowledge in Early Modern Europe* (New Haven: Yale University Press, 2011); Horst Bredekamp, Vera Dünkel, and Birgit Schneider, eds., *The Technical Image: A History of Styles in Scientific Imagery* (Chicago: University of Chicago Press, 2015); Hopwood, *Haeckel's Embryos*.

30. Hopwood, *Haeckel's Embryos*; Melissa Lo, "Cut, Copy, and English Anatomy: Thomas Geminus and the Reordering of Vesalius's Canonical Body," in *Andreas Vesalius and the Fabrica in the Age of Printing: Art, Anatomy, and Printing in the Italian Renaissance*, ed. Rinaldo Fernando Canalis and Massimo Ciavolella (Turnhout: Brepols, 2018), 225–56.

31. Christopher Marsh, "A Woodcut and Its Wanderings in Seventeenth-Century England," *Huntington Library Quarterly* 79, no. 2 (2016): 246; see also Patricia Fumerton and Megan E. Palmer, "Lasting Impressions of the Common Woodcut," in *The Routledge Handbook of Material Culture in Early Modern Europe*, ed. Catherine Richardson, Tara Hamling, and David Gaimster (London: Routledge, 2017), 383–400; Megan E. Palmer, "Picturing Song across Species: Broadside Ballads in Image and Word," *Huntington Library Quarterly* 79, no. 2 (2016): 221–44.

32. See chapter 1, pp. 36–37.

33. See chapter 2, pp. 66–69.

34. Some few examples show more of the pregnant body, such as Albertus Magnus, "De Secretis Mulierum" (c. 1470), fols. 94v–95r, UER MS.B 33, Universitätsbibliothek Erlangen-Nürnberg; S. I. M. D., *Kurtze, Jedoch Außführliche Abhandlung von Erzeugung Der Menschen Und Dem Kinder-Gebähren Nebst Deme, Was Sich Darbey Zuträgt* (Frankfurt am Main: Oehrling, 1700).

35. Lianne McTavish, *Childbirth and the Display of Authority in Early Modern France* (Aldershot, UK: Ashgate, 2005), 191; Lyle Massey, "Pregnancy and Pathology: Picturing Childbirth in Eighteenth-Century Obstetric Atlases," *Art Bulletin* 87, no. 1 (2005): 76; Green, *Making Women's Medicine Masculine*, 102.

36. K. B. Roberts and J. D. W. Tomlinson, *The Fabric of the Body: European Traditions of Anatomical Illustration* (Oxford: Clarendon Press, 1992), 22; Lawrence D. Longo and Lawrence P. Reynolds, *Wombs with a View: Illustrations of the Gravid Uterus from the Renaissance through the Nineteenth Century* (Cham: Springer, 2016), 7; Ludwig Choulant, *History and Bibliography of Anatomic Illustration*, trans. Mortimer Frank (Cambridge, MA: Maurizio Martino, 1993), 74.

37. Eucharius Rösslin, *The Byrth of Mankynde: Otherwyse Named the Womans Booke. Newly Set Furth, Corrected and Augmented*, ed. Thomas Raynalde (London: Thomas Raynalde, 1545).

Chapter One

1. See, for example, Adrian Wilson, *Ritual and Conflict: The Social Relations of Childbirth in Early Modern England* (Farnham, UK: Ashgate, 2013); David Cressy, *Birth, Marriage and Death: Ritual, Religion and the Life-Cycle in Tudor and Stuart England* (Oxford: Oxford University Press, 1997); Gowing, *Common Bodies*; Evenden, *Midwives of Seventeenth-Century London*; Fissell, *Vernacular Bodies*; Sarah Fox, *Giving Birth in Eighteenth-Century England* (London: University of London Press, 2022).

2. Many scholars refer to the English book as Raynalde's rather than Rösslin's, making the excellent argument that his translation was more of an adaption. See, for example, Hobby, in Rösslin and Raynalde, *Birth of Mankind*. However, because this book deals with illustrations that were widely copied and adapted, I have adopted the convention of identifying types or forms of birth figure by the name of the original commissioning author.

3. P. M. Dunn, "Eucharius Rösslin (c. 1470–1626) of Germany and the Rebirth of Midwifery," *Archives of Disease in Childhood: Fetal and Neonatal Edition* 79, no. 1 (1998): 77–78.

4. See LeRoy Crummer, "The Copper Plates in Raynalde and Geminus," *Proceedings of the Royal Society of Medicine* 20, no. 1 (1926): 53–56. Crummer suggests that they may have been the first engravings produced in England, though it is also possible they were produced abroad.

5. See Sean Roberts, "Tricks of the Trade: The Technical Secrets of Early Engraving," in *Visual Cultures of Secrecy in Early Modern Europe*, ed. Timothy McCall, Sean Roberts, and Giancarlo Fiorenza (Kirksville, MO: Truman State University Press, 2013), 182–207.

6. Jakob Rüff, *Ein Schön Lustig Trostbüchle von Den Empfengknussen Und Geburten Der Menschen* (Zurich: Christophorus Froschhoverus, 1554); Jakob Rüff, *De Conceptu et Generatione Hominis et Iis Quae circa h[a]ec Potissimum Consyderantur, Libri Sex Congesti Opera Iacobi Rueff Chirurgi Tigurini* (Zurich: Christophorus Froschhoverus, 1554).

7. Jennifer Spinks, "Jakob Rueff's 1554 Trostbüchle: A Zurich Physician Explains and Interprets Monstrous Births," *Intellectual History Review* 18, no. 1 (2008): 45.

8. Jacques Guillemeau, *Child-Birth, or the Happy Deliverie of Women* (London: Printed by A. Hatfield, 1612).

9. Ambroise Paré, *The Workes of That Famous Chirurgion Ambrose Parey*, trans. Th. Johnson (London: Th. Cotes and R. Young, 1634); Jakob Rüff, *The Expert Midwife or an Excellent and Most Necessary Treatise on the Generation and Birth of Man* (London: E.G., 1637); T. C. et al., *The Compleat Midwifes Practice: In the Most Weighty and High Concernments of the Birth of Man* (London: Nathaniel Brooke, 1656); Jane Sharp, *The Midwives Book: Or the Whole Art of Midwifry Discovered* (London: Simon Miller, 1671); James Wolveridge, *Speculum Matricis: Or, the Expert Midwives Handmaid* (London: n.p., 1671); [James Wolveridge], *The English Midwife Enlarged: Containing Directions to Midwives* (London: Rowland Reynold, 1682).

10. William Sermon, *The Ladies Companion, or the English Midwife* (London: Edward Thomas, 1671); James Cooke, *Mellificium Chirurgiae: Or, the Marrow of Chirurgery Much Enlarged* (London: Benj. Shirley, 1676).

11. François Mauriceau, *The Diseases of Women with Child, and in Child-Bed*, trans. Hugh Chamberlen (London: Printed by John Darby, 1672).

12. For example: Choulant, *History and Bibliography of Anatomic Illustration*, 74–75; Longo and Reynolds, *Wombs with a View*; Roberts and Tomlinson, *Fabric of the Body*, 13–15 and 122; Harold Speert, *Obstetrics and Gynecology: A History and Iconography* (San Francisco: Norman, 1994), chap. 5.

13. For example: Arons, "Introduction"; Donnison, *Midwives and Medical Men*; Audrey Eccles, *Obstetrics and Gynaecology in Tudor and Stuart England* (London: Croom Helm, 1982).

14. Arons, "Introduction," 5.

15. See Arons, "Introduction," 1–18; Eccles, *Obstetrics and Gynaecology in Tudor and Stuart England*, 11; Evenden, *Midwives of Seventeenth-Century London*, 6; Jennifer Wynne Hellwarth, "'I Wyl Wright of Women Prevy Sekenes': Imagining Female Literacy and Textual Communities in Medieval and Early Modern Midwifery Manuals," *Critical Survey* 14, no. 1 (2002): 53.

16. Forman Cody, "The Politics of Reproduction," 478; See also Arnold-Foster, "Medicine and the Body in Second-Wave Feminist Histories of the Nineteenth Century."

17. See, for example, Fissell, *Vernacular Bodies*; Gowing, *Common Bodies*.

18. See Adrian Wilson, "A Memorial of Eleanor Willughby, a Seventeenth-Century Midwife," in *Women, Science and Medicine, 1500–1700*, ed. Lynette Hunter and Sarah Hutton (Stroud, UK: Sutton, 1997), 138–77.

19. This is further discussed in chapter 3, pp. 89–93.

20. Green, *Making Women's Medicine Masculine*.

21. Sharp, *Midwives Book*, 2.

22. See, for example, Fissell, *Vernacular Bodies*, 70–71.

23. David Cressy, *Literacy and the Social Order: Reading and Writing in Tudor and Stuart England* (Cambridge: Cambridge University Press, 1980).

24. Adrian Wilson, *The Making of Man-Midwifery: Childbirth in England, 1660–1770* (London: UCL Press, 1995), 30; See also Evenden, *Midwives of Seventeenth-Century London*, 123.

25. Eucharius Rösslin, *The Byrth of Mankynde: Newly Translated out of Laten into Englysshe: In the Which Is Entreated of All Suche Thynges the Which Chaunce to Women in Theyr Labor, and All Suche Infyrmitees Whiche Happen Unto the Infantes After They Be Delyvered*, trans. Richard Jonas (London: Thomas Raynalde, 1540), fol. 5v.

26. See Elaine Hobby, "'Secrets of the Female Sex': Jane Sharp, the Reproductive Female Body, and Early Modern Midwifery Manuals," *Women's Writing* 8, no. 2 (2001): 201.

27. William H. Sherman, *Used Books: Marking Readings in Renaissance England* (Philadelphia: University of Pennsylvania Press, 2008), 57.

28. See Evenden, *Midwives of Seventeenth-Century London*.

29. Percival Willughby, *Observations in Midwifery*, ed. Henry Blenkinsop (Wakefield, UK: S. R. Publishers, 1972), 72–73. Percival Willughby was a surgeon and midwife practicing in England in the mid-seventeenth century. He wrote a midwifery manual in the early 1670s, and while it wasn't published until the nineteenth century,

it is a rare and valuable firsthand account of what midwifery was like in England in this period, before many midwives were recording their practice.

30. Jennifer Richards, "Reading and Hearing The Womans Booke in Early Modern England," *Bulletin of the History of Medicine* 89 (2015): 461.

31. Sharp, *Midwives Book*, preface.

32. Katharine Phelps Walsh, "Marketing Midwives in Seventeenth-Century London: A Re-examination of Jane Sharp's The Midwives Book," *Gender & History* 26, no. 2 (2014): 223–41.

33. Adam Fox, *Oral and Literate Culture in England, 1500–1700* (Oxford: Oxford University Press, 2011), 6.

34. Hellwarth, "'I Wyl Wright of Women Prevy Sekenes'"; Gowing, *Common Bodies*, 155.

35. Rösslin, *Byrth of Mankynde*, 1545, fol. C8v.

36. Rösslin and Raynalde, *Birth of Mankind*, xv.

37. Gowing, *Common Bodies*; Tim Reinke-Williams, *Women, Work and Sociability in Early Modern London* (Basingstoke, UK: Palgrave Macmillan, 2014).

38. See, for example, Mary E. Fissell, "Hairy Women and Naked Truths: Gender and the Politics of Knowledge in 'Aristotle's Masterpiece,'" *William and Mary Quarterly* 60, no. 1 (2003): 43–74; Chantelle Thauvette, "Sexual Education and Erotica in the Popular Midwifery Manuals of Thomas Raynalde and Nicholas Culpeper," in *Eroticism in the Middle Ages and the Renaissance: Magic, Marriage, and Midwifery*, ed. Ian Frederick Moulton (Turnhout: Brepols, 2016), 151–69.

39. The same is true of the single sheet of birth figures produced in Sermon, *The Ladies Companion, or the English Midwife*, and Cooke, *Mellificium Chirurgiae: Or, the Marrow of Chirurgery Much Enlarged*, copies of which now often lack the plate.

40. Benedictus Rughalm, "Liber Quodlibetarius" (Nüremberg, 1524), fols. 78r–79r, UER MS.B 200, Universitätsbibliothek Erlangen-Nürnberg.

41. Hopwood, *Haeckel's Embryos*, 2.

42. Lo, "Cut, Copy, and English Anatomy"; Kusukawa, *Picturing the Book of Nature*; Brian W. Ogilvie, *The Science of Describing: Natural History in Renaissance Europe* (Chicago: University of Chicago Press, 2006); Fabian Krämer, "The Persistent Image of an Unusual Centaur: A Biography of Aldrovandi's Two-Legged Centaur Woodcut," *Nuncius* 2 (2009): 313–40; William B. Ashworth Jr., "The Persistent Beast: Recurring Images in Early Zoological Illustration," in *The Natural Sciences and the Arts: Aspects of Interaction from the Renaissance to the 20th Century. An International Symposium*, ed. Allan Ellenius (Uppsala: Uppsala University, 1985), 46–66; Kärin Nickelsen, *Draughtsmen, Botanists and Nature: The Construction of Eighteenth-Century Botanical Illustrations* (Dordrecht: Springer, 2006), particularly 185–228.

43. See Fumerton and Palmer, "Lasting Impressions of the Common Woodcut"; Marsh, "Woodcut and Its Wanderings."

44. Krämer, "Persistent Image of an Unusual Centaur"; Susan Dackerman, "Dürer's Indexical Fantasy: The Rhinoceros and Printmaking," in *Prints and the Pursuit of Knowledge in Early Modern Europe*, ed. Dackerman (New Haven: Yale University Press, 2011), 164–71.

45. The scarcity, particularly of pregnant corpses, is noted in Susan C. Staub, "Surveilling the Secrets of the Female Body: The Context for Reproductive Authority in the Popular Press of the Seventeenth Century," in *The Female Body in Medicine and*

Literature, ed. Andrew Mangham and Greta Depledge (Liverpool: Liverpool University Press, 2011), 55.

46. Kusukawa, *Picturing the Book of Nature*, 45–67.

47. Fissell, "Hairy Women and Naked Truths," 66–67.

48. Dackerman, *Prints and the Pursuit of Knowledge*; See also Edward H. Wouk, "Toward an Anthropology of Print," in *Prints in Translation, 1450–1750: Image, Materiality, Space*, ed. Suzanne Karr Schmidt and Edward H. Wouk (London: Routledge, 2017), 1–18; Lo, "Cut, Copy, and English Anatomy."

49. Ashworth, "Persistent Beast," 47.

50. Sachiko Kusukawa, "Copying as a Form of Knowing: Early Modern Scientific Images" (Warburg Institute, 11 January 2017); Krämer, "Persistent Image of an Unusual Centaur."

51. Katherine Eggert, *Disknowledge: Literature, Alchemy and the End of Humanism in Renaissance England* (Philadelphia: University of Pennsylvania Press, 2015), 2.

52. Kusukawa, *Picturing the Book of Nature*; see also Daston, "Epistemic Images."

53. See Gianna Pomata, "Sharing Cases: The *Observationes* in Early Modern Medicine," *Early Science and Medicine* 15 (2010): 199; Gianna Pomata, "Observation Rising: Birth of an Epistemic Genre, 1500–1650," in *Histories of Scientific Observation*, ed. Lorraine Daston and Elizabeth Lunbeck (Chicago: University of Chicago Press, 2011), 45–80.

54. Longo and Reynolds, *Wombs with a View*, 2; Roberts and Tomlinson, *Fabric of the Body*, 15; see also Speert, *Obstetrics and Gynecology*.

55. Fissell, *Vernacular Bodies*, 150; Rösslin and Raynalde, *Birth of Mankind*, xvii.

56. McTavish, *Childbirth and the Display of Authority*, 179.

57. Crummer, "Copper Plates in Raynalde and Geminus"; see also Lo, "Cut, Copy, and English Anatomy."

58. Kusukawa, *Picturing the Book of Nature*, 195–99.

59. Rösslin, *Byrth of Mankynde*, 1545, fol. B3r.

60. Duden, *Woman beneath the Skin*, 106.

61. Cynthia Klestinec, "Practical Experience in Anatomy," in *The Body as Object and Instrument of Knowledge: Embodied Empiricism in Early Modern Science*, ed. Charles T. Wolfe and Ofer Gal (Dordrecht: Springer, 2010), 115.

62. Klestinec, "Practical Experience in Anatomy," 115.

63. Rösslin, *Byrth of Mankynde*, 1545, fol. B3v.

64. Sarah Stone, *A Complete Practice of Midwifery: Consisting of Upwards of Forty Cases or Observations in That Valuable Art, Selected from Many Others, in the Course of a Very Extensive Practice* (London: T. Cooper, 1737), xv.

65. See Park, *Secrets of Women*.

66. Dixon, *Perilous Chastity*, 48–52; Park, *Secrets of Women*, 113.

67. Sharp, *Midwives Book*, 36.

68. Michael Stolberg, *Experiencing Illness and the Sick Body in Early Modern Europe*, trans. Leonhard Unglaub and Logan Kennedy (Basingstoke: Palgrave Macmillan, 2011), 75.

69. T. C. et al., *Compleat Midwifes Practice*, 33.

70. Dixon, *Perilous Chastity*.

71. Gowing, *Common Bodies*; Fissell, *Vernacular Bodies*.

72. Park, *Secrets of Women*, 169.

73. Guillemeau, *Child-Birth*, 85–86.

74. Gowing, *Common Bodies*, 168.

75. Cressy, *Birth, Marriage and Death*, 24; Jennifer Wynne Hellwarth, *The Reproductive Unconscious in Medieval and Early Modern England* (London: Routledge, 2002), 43–87.

76. Wilson, "Memorial of Eleanor Willughby," 143–48.

77. See Park, *Secrets of Women*, 262.

78. Willughby, *Observations in Midwifery*, 276; Stone, *Complete Practice of Midwifery*, 45.

79. Justine Siegemund, *The Court Midwife*, ed. and trans. Lynne Tatlock (Chicago: University of Chicago Press, 2005), 152.

80. Alice Thornton, *The Autobiography of Mrs. Alice Thornton, of East Newton, Co. York.* (Durham: Surtees Society, 1875), 96.

81. Rüff, *Expert Midwife*, 116–17.

82. Hannah Newton, "'Nature Concocts and Expels': The Agents and Processes of Recovery from Disease in Early Modern England," *Social History of Medicine* 28, no. 3 (2015): 465–86.

83. Rösslin, *Byrth of Mankynde*, 1545, fol. 62r; see also Rüff, *Expert Midwife*, 118.

84. Wilson, *Making of Man-Midwifery*, 20–21.

85. [Wolveridge], *English Midwife Enlarged*, 54.

86. It is possible that some midwives were using podalic version before this time, but Paré is widely credited with first publishing the technique. See Janet Doe, *A Bibliography, 1545–1940, of the Works of Ambroise Paré, 1510–1590: Premier Chirurgien & Conseiller Du Roi* (Amsterdam: Gérard Th. van Heusden, 1976), xiii–xiv.

87. Fissell, *Vernacular Bodies*, 150.

88. Willughby, *Observations in Midwifery*, 306 and 341.

89. See Nicholas Culpeper, *A Directory for Midwives: Or, a Guide for Women, in Their Conception, Bearing and Suckling Their Children* (London: Peter Cole, 1651), 172.

90. Katie Taylor, "Reconstructing Vernacular Mathematics: The Case of Thomas Hood's Sector," in *Observing the World through Images: Diagrams and Figures in the Early-Modern Arts and Sciences*, ed. Isla Fay and Nicholas Jardine (Leiden: Brill, 2014), 177.

91. Richards, "Reading and Hearing," 461.

92. [Wolveridge], *English Midwife Enlarged*, 51.

93. [Wolveridge], *English Midwife Enlarged*, 52.

94. Siegemund's testimony is discussed here because it is the only instance I have found of a midwife of the seventeenth century describing how she used birth figures. It is such rare evidence that I believe it is worth examining, despite the fact that Siegemund worked and published in Germany and that her manual wasn't translated into English until 2005. However, the birth figures that were available to Siegemund in Germany in the mid-seventeenth century were very similar to those circulating in England at the time. Moreover, some English practitioners may have read Siegemund's own book in its original German, which went through eight editions, or seen her birth figures in one of the books that subsequently copied them. See Lynne Tatlock, "Volume Editor's Introduction," in *The Court Midwife*, ed. Tatlock (Chicago: University of Chicago Press, 2005), 25.

95. Siegemund, *Court Midwife*, 90.

96. Siegemund's birth figures are further discussed in chapters 3 and 4.

97. Siegemund, *Court Midwife*, 130.

98. See Rüff, *Expert Midwife*, 12–15.

99. See, for example, Rüff, *Expert Midwife*, 62; Rösslin, *Byrth of Mankynde*, 1545, fol. 46b r–v; [Wolveridge], *English Midwife Enlarged*, 29.

100. Rüff, *Expert Midwife*, 115.

101. Newton, "'Nature Concocts and Expels,'" 466.

102. See Jonathan Sawday, *The Body Emblazoned: Dissection and the Human Body in Renaissance Culture* (London: Routledge, 1995), 223.

103. The issue of the "spacious" womb is further discussed in chapter 3, pp. 130–33.

104. Rosemary Moore, "Paper Cuts: The Early Modern Fugitive Print," *Object* 17 (2015): 54–76.

Chapter Two

1. Sherman, *Used Books*, 22; See also Roger Chartier, *The Order of Books: Readers, Authors, and Libraries in Europe between the Fourteenth and Eighteenth Centuries*, trans. Lydia G. Cochrane (Stanford: Stanford University Press, 1994), 4–8.

2. See, for example, Palmer, "Picturing Song across Species," 242–44.

3. Stolberg, *Experiencing Illness*, 73–74.

4. Nicholas Culpeper, *Mr. Culpeper's Treatise of Aurum Potabile: Being a Description of the Three-Fold World. Viz. Elimentary, Celestiall, Intellectuall Containing the Knowledge Necessary to the Study of Hermetick Philosophy* (London: G. Eversden, 1656), 17.

5. Michel Foucault, *The Order of Things: An Archaeology of the Human Sciences* (London: Routledge, 2005), 19.

6. See H. Darrel Rutkin, "Astrology," in *The Cambridge History of Science: Early Modern Science*, ed. Katharine Park and Lorraine Daston, vol. 3 (Cambridge: Cambridge University Press, 2006), 541–61.

7. Foucault, *Order of Things*, 25–26.

8. Foucault, *Order of Things*, 19; See also Duden, *Woman beneath the Skin*, 68–70.

9. See Harry Bober, "The Zodiacal Miniature of the Très Riches Heures of the Duke of Berry: Its Sources and Meaning," *Journal of the Warburg and Courtauld Institutes* 11 (1948): 1–34.

10. See Matilde Battistini, *Astrology, Magic, and Alchemy in Art*, trans. Rosanna M. Giammanco Frongia (Los Angeles: J. Paul Getty Museum, 2004).

11. John Case, *The Angelical Guide Shewing Men and Women Their Lott or Chance, in This Elementary Life* (London: Printed by I. Dawkes, 1697); Theodor Kerckring, *Anthropogeniae Ichnographia: Sive Conformation Foetus Ab Ovo Usque Ad Ossificationis Principa, in Supplementum Osteogeniae Foetum* (Amsterdam: Andreas Frisius, 1671).

12. Kathleen Crowther-Heyck, "Wonderful Secrets of Nature: Natural Knowledge and Religious Piety in Reformation Germany," *Isis* 94, no. 2 (2003): particularly 268 and 273.

13. Kathleen Crowther-Heyck, "'Be Fruitful and Multiply': Genesis and Generation in Reformation Germany," *Renaissance Quarterly* 55, no. 3 (2002): 917–19; Fissell, *Vernacular Bodies*, 201–6; Jacques Gélis, *History of Childbirth: Fertility, Pregnancy and Birth in Early Modern Europe*, trans. Rosemary Morris (Boston: North-

eastern University Press, 1991), 34–41 and 58–59; Holly Tucker, *Pregnant Fictions: Childbirth and the Fairy Tale in Early-Modern France* (Detroit: Wayne State University Press, 2003), 110.

14. Willughby, *Observations in Midwifery*, 276.

15. Willughby, *Observations in Midwifery*, 276–77.

16. Rösslin, *Byrth of Mankynde*, 1540, fol. 21 r.

17. Willughby, *Observations in Midwifery*, 7.

18. Sandra Cavallo, "Exhibit 17—Pregnant Stones as Wonders of Nature," in *Reproduction: Antiquity to the Present Day*, ed. Nick Hopwood, Rebecca Flemming, and Lauren Kassell (Cambridge: Cambridge University Press, 2018), n.p., digital edition; Gélis, *History of Childbirth*, 68.

19. Culpeper, *Directory for Midwives*, 171.

20. Sherman, *Used Books*, 61.

21. Laqueur, *Making Sex*, 131.

22. Dixon, *Perilous Chastity*.

23. See Lesley Annette Bolton, "An Edition, Translation and Commentary of Mustio's Gynaecia," (PhD diss., Calgary, University of Calgary, 2015), 68–69 and 145.

24. Michael Stolberg, *Uroscopy in Early Modern Europe* (Farnham, UK: Ashgate, 2015), 119.

25. Lauren Kassell et al., eds., *The Casebooks of Simon Forman and Richard Napier, 1596–1634: A Digital Edition*, accessed 12 June 2019, https://casebooks.lib.cam.ac.uk; Lauren Kassell, "Fruitful Bodies and Astrological Medicine," in *Reproduction: Antiquity to the Present Day*, ed. Nick Hopwood, Rebecca Flemming, and Lauren Kassell (Cambridge: Cambridge University Press, 2018), 231.

26. For histories of the Ripley Scrolls, see Aaron Kitch, "The 'Ingendred' Stone: The Ripley Scrolls and the Generative Science of Alchemy," *Huntington Library Quarterly* 78, no. 1 (2015): 87–125; Jennifer Rampling, "A Secret Language: The Ripley Scrolls," in *Art and Alchemy: The Mystery of Transformation*, ed. Dedo von Kerssenbrock-Krosigk, Beat Wismer, and Sven Dupré, trans. Susanna Rachel Michael (Düsseldorf: Stiftung Museum Kunstpalast, 2014), 38–45.

27. Rampling, "Secret Language," 41.

28. Battistini, *Astrology, Magic, and Alchemy in Art*, 326.

29. Anne-Françoise Cannella, "Alchemical Iconography at the Dawn of the Modern Age: The Splendor Solis of Salomon Trismosin," in *The Power of Images in Early Modern Science*, ed. Wolfgang Lefèvre, Jürgen Renn, and Urs Schoepflin (Basel: Birkhäuser, 2003), 112.

30. See Eve Keller, *Generating Bodies and Gendered Selves: The Rhetoric of Reproduction in Early Modern England* (Seattle: University of Washington Press, 2007), 106.

31. Paré, *The Workes of That Famous Chirurgion Ambrose Parey*, 885.

32. Crowther-Heyck, "'Be Fruitful and Multiply,'" 915. See also pp. 74–77 below.

33. William Newman, *Promethean Ambitions: Alchemy and the Quest to Perfect Nature* (Chicago: University of Chicago Press, 2004).

34. See Lyle Massey, "The Alchemical Womb: Johann Remmelin's Catoptrum Microcosmicum," in *Visual Cultures of Secrecy in Early Modern Europe*, ed. Timothy McCall, Sean Roberts, and Giancarlo Fiorenza (Kirksville, MO: Truman State University Press, 2013), 208–28; Amy Eisen Cislo, *Paracelsus's Theory of Embodiment:*

Conception and Gestation in Early Modern Europe (London: Pickering & Chatto, 2010).

35. Keller, *Generating Bodies and Gendered Selves*, 106.

36. Newman, *Promethean Ambitions*, 164–237.

37. Tara E. Nummedal, "Alchemical Reproduction and the Career of Anna Maria Zieglerin," *Ambix* 48, no. 2 (2001): 61–62.

38. Nummedal, "Alchemical Reproduction and the Career of Anna Maria Zieglerin," 64.

39. Gélis, *History of Childbirth*, 86.

40. See Klestinec, "Sex, Medicine, and Disease," 131–32; Crowther-Heyck, "'Be Fruitful and Multiply.'"

41. Fissell, *Vernacular Bodies*, 32.

42. Rüff, *Expert Midwife*, 62.

43. Jacques Roger, *The Life Sciences in Eighteenth-Century French Thought*, ed. Keith R. Benson, trans. Robert Ellrich (Stanford: Stanford University Press, 1997), 205–58.

44. Paré, *Workes of That Famous Chirurgion Ambrose Parey*, 895.

45. David Albert Jones, *The Soul of the Embryo: An Enquiry into the Status of the Human Embryo in the Christian Tradition* (London: Continuum, 2004), 18–32.

46. Marie-Hélène Congourdeau, "Debating the Soul in Late Antiquity," in *Reproduction: Antiquity to the Present Day*, ed. Nick Hopwood, Rebecca Flemming, and Lauren Kassell (Cambridge: Cambridge University Press, 2018), 113.

47. John Oliver, *A Present for Teeming Women: Or, Scripture-Directions for Women with Child, How to Prepare for the Houre of Travel* (London: Mary Rothwell, 1663), 47.

48. Jones, *Soul of the Embryo*, 123.

49. Roger, *Life Sciences in Eighteenth-Century French Thought*, 74–123.

50. Gowing, *Common Bodies*, 122.

51. See Eve Keller, "Embryonic Individuals: The Rhetoric of Seventeenth-Century Embryology and the Construction of Early-Modern Identity," *Eighteenth-Century Studies* 33, no. 3 (2000): 321–48.

52. Fissell, *Vernacular Bodies*, 32.

53. T. C. et al., *Compleat Midwifes Practice*, 73.

54. James McMath, *The Expert Mid-Wife: A Treatise of the Diseases of Women with Child, and in Child-Bed* (Edinburgh: George Mosman, 1694), 119–20.

55. For further discussion of how pregnancy featured in and inspired the telling of stories and narratives, see Tucker, *Pregnant Fictions*.

56. See, for example, Carmen Niekrasz and Claudia Swan, "Art," in *The Cambridge History of Science: Early Modern Science*, ed. Katharine Park and Lorraine Daston, vol. 3 (Cambridge: Cambridge University Press, 2006), 773–96; Daston, "Epistemic Images"; Marr, "Knowing Images"; William M. Ivins Jr., *Prints and Visual Communication* (Cambridge, MA: MIT Press, 1978).

57. Wouk, "Toward an Anthropology of Print," 8.

58. Walter Benjamin, *Illuminations*, trans. Leon Wieseltier (New York: Schocken Books, 1968), 217–52.

59. Roberts, "Tricks of the Trade," 186.

60. See Rebecca Zorach, "'A Secret Kind of Charm Not to Be Expressed or Discerned': On Claude Mellan's Insinuating Lines," *RES: Anthropology and Aesthetics* 55/56 (2009): 235.

61. William B. MacGregor, "The Authority of Prints: An Early Modern Perspective," *Art History* 22, no. 3 (1999): 389–420.

62. See, for example, Elizabeth L. Eisenstein, *The Printing Press as an Agent of Change: Communications and Cultural Transformations in Early-Modern Europe*, 2 vols. (Cambridge: Cambridge University Press, 1979); Bruno Latour, "Visualisation and Cognition: Drawing Things Together," in *Knowledge and Society: Studies in the Sociology of Culture Past and Present*, ed. H. Kuklick, vol. 6 (Greenwich, CT: Jai Press, 1986), 1–40.

63. Karen Newman, *Fetal Positions: Individualism, Science, Visuality* (Stanford: Stanford University Press, 1996), 33; See also Gowing, *Common Bodies*, 122–27; Margaret Carlyle and Brian Callender, "The Fetus in Utero: From Mystery to Social Media," *Know: A Journal on the Formation of Knowledge* 3, no. 1 (2019): 28.

64. Keller, *Generating Bodies and Gendered Selves*, 17.

65. See Barbara Duden, "The Fetus as an Object of Our Time," *RES: Anthropology and Aesthetics* 25 (1994): 135; Rosalind Pollack Petchesky, "Fetal Images: The Power of Visual Culture in the Politics of Reproduction," *Feminist Studies* 13, no. 2 (1987): 263–92.

66. See Monica Green, "Gendering the History of Women's Healthcare," *Gender & History* 20, no. 3 (2008): 487–518; Barbara Duden, "The Fetus on the 'Farther Shore': Toward a History of the Unborn," in *Fetal Subjects, Feminist Positions*, ed. Lynn M. Morgan and Meredith Michaels (Philadelphia: University of Pennsylvania Press, 1999), 21.

67. See Michel Foucault, *The Birth of the Clinic: An Archaeology of Medical Perception*, trans. A. M. Sheridan (London: Routledge, 2003).

68. See Duden, *Woman beneath the Skin*; Porter, "Patient's View"; Stolberg, *Experiencing Illness*.

69. For a history of how childbirth changed in the nineteenth century, see Donnison, *Midwives and Medical Men*. The term "man-midwifery" is discussed further in chapter 3, pp. 89–93.

70. Duden, *Woman beneath the Skin*, 75. On the power of the mother as healer, see also Seth Stein LeJacq, "The Bounds of Domestic Healing: Medical Recipes, Storytelling and Surgery in Early Modern England," *Social History of Medicine* 26, no. 3 (2013): 451–68.

71. Willughby, *Observations in Midwifery*, 65.

72. Willughby, *Observations in Midwifery*, 126.

73. See Roy Porter, "The Rise of Physical Examination," in *Medicine and the Five Senses*, ed. W. F. Bynum and Roy Porter (Cambridge: Cambridge University Press, 1993), 179–97.

74. Gowing, *Common Bodies*, 168.

75. Keller, *Generating Bodies and Gendered Selves*, 136.

76. Baxandall, *Painting and Experience*, 48.

77. [Wolveridge], *English Midwife Enlarged*, 139.

78. See Duden, "Fetus as an Object of Our Time," 135.

79. Willughby, *Observations in Midwifery*, 341.

80. Lorraine Daston and Katharine Park, *Wonders and the Order of Nature: 1150–1750* (New York: Zone Books, 1998), 14.

81. McTavish, *Childbirth and the Display of Authority*, 193.

82. Certainly, boy children were not a universal hope in the early modern pe-

riod. Some women wished for girls, and other women did not wish to be delivered of live children at all. However, considering both the general viewership of the images and the wider cultural expectations surrounding the creation of the family, most women would have considered the bearing of legitimate male children as a personal and familial joy and something that elevated their social status. See Reinke-Williams, *Women, Work and Sociability in Early Modern London*, 15–43.

83. Duden, "Fetus on the 'Farther Shore,'" 19.

84. Alicia Hughes, "Creating and Controlling a Visual Language: Image-Making and Authorial Control in William Hunter's Collection of Anatomical Drawings and Prints," PhD diss., University of Glasgow, 2019.

85. Laqueur, *Making Sex*, 10.

86. See Helen King, *The One-Sex Body on Trial: The Classical and Early Modern Evidence* (London: Routledge, 2013); Wendy D. Churchill, "The Medical Practice of the Sexed Body: Women, Men, and Disease in Britain, circa 1600–1740," *Social History of Medicine* 18, no. 1 (2005): 3–22.

87. Sharp, *Midwives Book*, 37.

88. Sharp, *Midwives Book*, 168.

89. McTavish, *Childbirth and the Display of Authority*, 192.

90. See conclusion, pp. 218–19.

91. Alexander Wragge-Morley, *Aesthetic Science: Representing Nature in the Royal Society of London, 1650–1720* (Chicago: University of Chicago Press, 2020), particularly 73–105.

92. For sources in sixteenth- and early seventeenth-century English culture, see Anthony Wells-Cole, *Art and Decoration in Elizabethan and Jacobean England: The Influence of Continental Prints, 1558–1625* (New Haven: Yale University Press, 1997).

93. Charles Dempsey, *Inventing the Renaissance Putto* (Chapel Hill: University of North Carolina Press, 2001), 49.

94. John Heilbron, "Domesticating Science in the Eighteenth Century," in *Science and the Visual Image in the Enlightenment*, ed. W. R. Shea (Canton, MA: Science History Publications, 2000), 1.

95. Walter S. Melion, "Meditative Images and the Portrayal of Image-Based Meditation," in *Ut Pictura Meditatio: The Meditative Image in Northern Art, 1500–1700*, ed. Walter S. Melion, Ralph Dekoninck, and Agnes Guiderdoni-Bruslé (Turnhout: Brepols, 2012), 3.

96. See Rebecca Whiteley, "Prayer, Pregnancy and Print," in *Religion and Life Cycles in Early Modern England*, ed. Caroline Bowden, Emily Vine, and Tessa Whitehouse (Manchester, UK: Manchester University Press, 2021), 38–62.

97. Maya Corry, Deborah Howard, and Mary Laven, eds., *Madonnas and Miracles: The Holy Home in Renaissance Italy* (London: Philip Wilson, 2017); Jacqueline Marie Musacchio, *The Art and Ritual of Childbirth in Renaissance Italy* (New Haven: Yale University Press, 1999), 125–48.

98. Musacchio, *Art and Ritual of Childbirth in Renaissance Italy*, 137.

99. See Marie-France Morel, "Voir et entendre les foetus autrefois: Deux exemples," *Spirale* 36 (2005): 23–35; Gregor Martin Lechner, *Maria Gravida: Zum Schwangerschaftsmotiv in der bildenden Kunst* (Zürich: Schnell & Steiner München, 1981).

100. Wiktoria Muryn, "Transparent Wombs, Holy (Mis)Conceptions: Representations of 'Foetus-Type' Visitation and Women's Monasticism in Late Medieval Germany" (Representing Women's Health, Glasgow, 2020).

101. André Vauchez, ed., "Mandorla," in *Encyclopedia of the Middle Ages* (Cambridge, UK: James Clarke, 2005); Ian Chilvers, ed., "Mandorla," in *The Oxford Dictionary of Art* (Oxford: Oxford University Press, 2004). For discussion of the links between mandorlas, wombs, and Christ's side wound, see Flora Lewis, "The Wound in Christ's Side and the Instruments of the Passion: Gendered Experience and Response," in *Women and the Book: Assessing the Visual Evidence*, ed. Lesley Smith and Jane H. M. Taylor (London: British Library, 1996), 215–16.

102. Cressy, *Birth, Marriage and Death*, 15–34.

103. For an excellent summary, see Tara Hamling, *Decorating the "Godly" Household: Religious Art in Post-Reformation Britain* (New Haven: Yale University Press, 2010), 25–65.

104. Hamling, *Decorating the "Godly" Household*; Tessa Watt, *Cheap Print and Popular Piety, 1550–1640* (Cambridge: Cambridge University Press, 1991), 131–253; Alexandra Walsham, *Providence in Early Modern England* (Oxford: Oxford University Press, 1999), 250–66.

105. See Rivka Feldhay, "Religion," in *The Cambridge History of Science: Early Modern Science*, ed. Katharine Park and Lorraine Daston, vol. 3 (Cambridge: Cambridge University Press, 2006), 727–55.

106. Hamling, *Decorating the "Godly" Household*, 25–65.

107. Thomas Staubli, ed., *Werbung für die Götter: Heilsbringer aus 4000 Jahren* (Freiburg: Universitätsverlag, 2003), 140; Oliver Krüger, *Die mediale Religion: Probleme und Perspektiven der religionswissenschaftlichen und wissenssoziologischen Medienforschung* (Bielefeld: Transcript, 2012), 216–17; Joseph J. Gwara and Mary Morse, "A Birth Girdle Printed by Wynkyn de Worde," *The Library*, 7, 13, no. 1 (2012): 33–62; Keith Thomas, *Religion and the Decline of Magic: Studies in Popular Beliefs in Sixteenth- and Seventeenth-Century England* (London: Penguin Books, 1991), 84 and 222; Don C. Skemer, *Binding Words: Textual Amulets in the Middle Ages* (University Park: Pennsylvania State University Press, 2006).

108. Skemer, *Binding Words*.

109. Rose Marie San Juan, *Vertiginous Mirrors: The Animation of the Visual Image and Early Modern Travel* (Manchester, UK: Manchester University Press, 2011), 9, 86 and 101; Suzanne Karr Schmidt, *Altered and Adorned: Using Renaissance Prints in Daily Life* (New Haven: Yale University Press, 2011), 68; Allison Adair Alberts, "Spiritual Suffering and Physical Protection in Childbirth in the South English Legendary Lives of Saint Margaret," *Journal of Medieval and Early Modern Studies* 46, no. 2 (2016): 305–6; Katharina Wilkens, "Drinking the Quran, Swallowing the Madonna: Embodied Aesthetics of Popular Healing Practices," in *Alternative Voices: A Plurality Approach for Religious Studies*, ed. Afe Adogame, Magnus Echtler, and Oliver Freiberger (Göttingen: Vandenhoeck & Ruprecht, 2013), 243–59.

110. Elaine Leong, "Papering the Household: Paper, Recipes, and Everyday Technologies in Early Modern England," in *Working with Paper: Gendered Practices in the History of Knowledge*, ed. Carla Bittel, Elaine Leong, and Christine von Oertzen (Pittsburgh: University of Pittsburgh Press, 2019), 32–45; Simon Werrett, "The Sociomateriality of Waste and Scrap Paper in Eighteenth-Century England," in ibid., 46–59.

111. Of course, the fact that birth figures showed difficult- and impossible-to-deliver presentations might mean they were also used for malicious magical purposes, perhaps as material for wishing complications in childbirth on enemies. It is

impossible to know the exact extent to which viewers put birth figures to positive or negative magical uses, though I suspect that their use among women was generally positive. This aligns with Willughby's description of them as medically uninformative, and perhaps too appealing to women, but not evil or dangerous.

112. See Brian P. Copenhaver, "Magic," in *The Cambridge History of Science: Early Modern Science*, ed. Katharine Park and Lorraine Daston, vol. 3 (Cambridge: Cambridge University Press, 2006), 518–40.

113. Skemer, *Binding Words*; Gwara and Morse, "Birth Girdle Printed by Wynkyn de Worde," 51.

114. Cressy, *Birth, Marriage and Death*, 63–64.

115. See Paul-Gabriel Boucé, "Imagination, Pregnant Women, and Monsters in Eighteenth-Century England and France," in *Sexual Underworlds of the Enlightenment*, ed. G. S. Rousseau and Roy Porter (Manchester, UK: Manchester University Press, 1987), 86–100; Frances Gage, *Painting as Medicine in Early Modern Rome: Giulio Mancini and the Efficacy of Art* (University Park: Pennsylvania State University Press, 2016), 87–119; Katharine Park, "Impressed Images: Reproducing Wonders," in *Picturing Science, Producing Art*, ed. Caroline A. Jones and Peter Galison (New York: Routledge, 1998), 254–71.

116. See Lisa Forman Cody, *Birthing the Nation: Sex, Science, and the Conception of Eighteenth-Century Britons* (Oxford: Oxford University Press, 2005), 120–51; Rebecca M. Wilkin, "Essaying the Mechanical Hypothesis: Descartes, La Forge, and Malebranche on the Formation of Birthmarks," *Early Science and Medicine* 13, no. 6 (2008): 533–67; Salim Al-Gailani, "'Antenatal Affairs': Maternal Marking and the Medical Management of Pregnancy in Britain around 1900," in *Imaginationen des Ungeborenen/Imaginations of the Unborn: Kulturelle Konzepte pränataler Prägung von der frühen Neuzeit zur Moderne/Cultural Concepts of Prenatal Imprinting from the Early Modern Period to the Present*, ed. Urte Helduser and Burkhard Dohm (Heidelberg: Universitätsverlag Winter, 2018), 153–72; Patricia R. Stokes, "Pathology, Danger, and Power: Women's and Physicians' Views of Pregnancy and Childbirth in Weimar Germany," *Social History of Medicine* 13, no. 3 (2000): 371.

117. Daston and Park, *Wonders and the Order of Nature*, 173–214.

118. Gage, *Painting as Medicine*, 115.

119. Morten Steen Hansen, "The Infant Christ with the 'Arma' Christi: François Duquesnoy and the Typology of the Putto," *Zeitschrift für Kunstgeschichte* 71, no. 1 (2008): 133.

120. Park, *Secrets of Women*, 145; Musacchio, *Art and Ritual of Childbirth in Renaissance Italy*, 125–30.

121. Park, *Secrets of Women*, 145.

122. Abigail Brundin, Deborah Howard, and Mary Laven, *The Sacred Home in Renaissance Italy* (Oxford: Oxford University Press, 2018), 131; Musacchio, *Art and Ritual of Childbirth in Renaissance Italy*, 131–32.

123. Musacchio, *Art and Ritual of Childbirth in Renaissance Italy*, 132.

124. Joan-Pau Rubiés, "Were Early Modern Europeans Racist?," in *Ideas of "Race" in the History of the Humanities*, ed. Amos Morris-Reich and Dirk Rupnow (Cham: Palgrave Macmillan, 2017), 36; see also Marieke M. A. Hendriksen, "The Fate of the Beaded Babies: Forgotten Early Colonial Anatomy," in *The Fate of Anatomical Collections*, ed. Rina Knoeff and Robert Zwijnenberg (Farnham, UK: Ashgate, 2015), 179–94.

125. See Valentin Groebner, "Complexio/Complexion: Categorizing Individual Natures, 1250–1600," in *The Moral Authority of Nature*, ed. Lorraine Daston and Fernando Vidal (Chicago: University of Chicago Press, 2003), 362–83.

126. Angela Rosenthal, "Visceral Culture: Blushing and the Legibility of Whiteness in Eighteenth-Century British Portraiture," *Art History* 27, no. 4 (2004): 579–81; Kim F. Hall, *Things of Darkness: Economies of Race and Gender in Early Modern England* (Ithaca, NY: Cornell University Press, 1996), 11–13.

127. Fissell, "Hairy Women and Naked Truths"; for another example, see Victor I. Stoichita, *Darker Shades: The Racial Other in Early Modern Art*, trans. Samuel Trainor (London: Reaktion Books, 2019), 75–87.

128. Richard Dyer, *White* (London: Routledge, 1997), 41–81.

129. Thomas Bentley, "The Fift Lampe of Virginitie: Conteining Sundrie Forms of Christian Praiers and Meditations, to Bee Used Onlie of and for All Sorts and Degrees of Women, in Their Severall Ages and Callings," in *The Monument of Matrones* (London: Henrie Denham, 1582), 105.

130. Crowther-Heyck, "'Be Fruitful and Multiply,'" 915; Karin Leonhard, "Vermeer's Pregnant Women: On Human Generation and Pictorial Representation," *Art History* 25, no. 3 (2002): 293–318.

131. For a detailed investigation of the history and iconography of these prints, see H. F. J. Horstmanshoff, A. M. Luyendijk-Elshout, and F. G. Schlesinger, eds., *The Four Seasons of Human Life: Four Anonymous Engravings from the Trent Collection* (Rotterdam: Erasmus, 2002); Andrea Carlino, *Paper Bodies: A Catalogue of Anatomical Fugitive Sheets, 1538–1687*, trans. Noga Arikha (London: Wellcome Institute for the History of Medicine, 1999), particularly 310–14.

132. Horstmanshoff, Luyendijk-Elshout, and Schlesinger, *Four Seasons of Human Life*, 15–17.

133. Horstmanshoff, Luyendijk-Elshout, and Schlesinger, *Four Seasons of Human Life*, 84.

134. Horstmanshoff, Luyendijk-Elshout, and Schlesinger, *Four Seasons of Human Life*, 40.

Chapter Three

1. Mauriceau, *Diseases of Women with Child, and in Child-Bed*.

2. See Mechthild Fend, "Drawing the Cadaver 'Ad Vivum': Gérard de Lairesse's Illustrations for Govard Bidloo's Anatomia Humani Corporis," in *Ad Vivum? Visual Materials and the Vocabulary of Life-Likeness in Europe before 1800*, ed. Thomas Balfe, Joanna Woodall, and Claus Zittel (Leiden: Brill, 2019).

3. Both Pam Lieske and Adrian Wilson cite the 1730s as the beginning of this new era. See Pam Lieske, ed., *Continental Midwives in Translation*, vol. 3 of *Eighteenth-Century British Midwifery* (London: Pickering & Chatto, 2007), vii; Wilson, *Making of Man-Midwifery*, particularly 110.

4. See Daston and Galison, *Objectivity*; Lorraine Daston and Elizabeth Lunbeck, eds., *Histories of Scientific Observation* (Chicago: University of Chicago Press, 2011); Matthew C. Hunter, *Wicked Intelligence: Visual Art and the Science of Experiment in Restoration London* (Chicago: University of Chicago Press, 2013); Roy Porter, ed., *The Cambridge History of Science*: vol. 4: *Eighteenth-Century Science* (Cambridge: Cambridge University Press, 2003); Pamela H. Smith, *The Body of the Artisan: Art and Experience in the Scientific Revolution* (Chicago: University of Chicago Press, 2004);

Charles T. Wolfe and Ofer Gal, eds., *The Body as Object and Instrument of Knowledge: Embodied Empiricism in Early Modern Science* (Dordrecht: Springer, 2010).

5. See, for example, Jonathan I. Israel, "Enlightenment, Radical Enlightenment and the 'Medical Revolution' of the Late Seventeenth and Eighteenth Centuries," in *Medicine and Religion in Enlightenment Europe*, ed. Ole Peter Grell and Andrew Cunningham (Aldershot, UK: Ashgate, 2007), 5–28.

6. William Smellie, for example, begins his midwifery manual with a history of the discipline. See William Smellie, *A Treatise on the Theory and Practice of Midwifery*, 3 vols., vol. 1 (London: D. Wilson, 1752). A good example of the kind of medical history written in the nineteenth century can be found in Edward W. Murphy, "Introductory Lecture on the History of Midwifery. Delivered at University College, May 1st, 1864. By Edward W. Murphy, M.A., M.D., Professor of Midwifery," *British Medical Journal* 176, no. 1 (1864): 523–28. Recent works such as Robert Woods and Chris Galley, *Mrs Stone & Dr Smellie: Eighteenth-Century Midwives and Their Patients* (Liverpool: Liverpool University Press, 2014); Longo and Reynolds, *Wombs with a View* follow a similar approach.

7. See, for example, Donnison, *Midwives and Medical Men*; David Harley, "Provincial Midwives in England: Lancashire and Cheshire, 1660–1760," in *The Art of Midwifery: Early Modern Midwives in Europe*, ed. Hilary Marland (London: Routledge, 1993), 27–48; Londa Schiebinger, *The Mind Has No Sex? Women in the Origins of Modern Science* (Cambridge, MA: Harvard University Press, 1989), 104–11.

8. For explorations of this historiography see Evenden, *Midwives of Seventeenth-Century London*, 2–5; Green, "Gendering the History of Women's Healthcare," 488–98; Arnold-Foster, "Medicine and the Body in Second-Wave Feminist Histories of the Nineteenth Century."

9. Forman Cody, "Politics of Reproduction," 478.

10. See Wilson, *Making of Man-Midwifery*, 65–106.

11. Fissell, "Man-Midwifery Revisited," 321.

12. For histories of this change, see Donnison, *Midwives and Medical Men*; Forman Cody, *Birthing the Nation*; Helen King, *Midwifery, Obstetrics and the Rise of Gynaecology: The Uses of a Sixteenth-Century Compendium* (Aldershot, UK: Ashgate, 2007); McTavish, *Childbirth and the Display of Authority*; Wilson, *Making of Man-Midwifery*; Woods and Galley, *Mrs Stone & Dr Smellie*.

13. Fissell, "Man-Midwifery Revisited," 319–32.

14. Green, "Gendering the History of Women's Healthcare," 496–97.

15. Martha Mears, *The Pupil of Nature: Or Candid Advice to the Fair Sex, on the Subject of Pregnancy; Childbirth; the Diseases Incident to Both; the Fatal Effects of Ignorance and Quackery; and the Most Approved Means of Promoting the Health, Strength, and Beauty of Their Offspring, by Martha Mears, Practitioner in Midwifery* (London: The Author, 1797); Elizabeth Nihell, *A Treatise on the Art of Midwifery: Setting Forth Various Abuses Therein, Especially as to the Practice with Instruments* (London: A. Morley, 1760); Sharp, *Midwives Book*; Margaret Stephen, *Domestic Midwife: Or, the Best Means of Preventing Danger in Child-Birth* (London: S. W. Fores, 1795); Stone, *Complete Practice of Midwifery*; Evenden has also argued that T. C. et al., *Compleat Midwifes Practice*, and T. C. et al., *The Compleat Midwifes Practice Enlarged* (London: Nathaniel Brooke, 1659) were authored by women midwives, though the works are more generally attributed to Thomas Chamberlayne; see Evenden, *Midwives of Seventeenth-Century London*, 8–11.

16. Harley, "Provincial Midwives in England: Lancashire and Cheshire, 1660–

1760," notes that women used tools "on occasion" in the seventeenth century (41). The eighteenth-century midwife-author Margaret Stephen was open about her use of tools; see Pam Lieske, ed., *Lying-In Hospitals, Male/Female Midwifery Debates*, vol. 7 of *Eighteenth-Century British Midwifery* (London: Pickering & Chatto, 2007), 263. It seems likely, moreover, that as tools were officially forbidden to midwives, some used them secretly and left no record.

17. See Lianne McTavish, "Blame and Vindication in the Early Modern Birthing Chamber," *Medical History* 50 (2006): 447–64.

18. Smellie, *Treatise on the Theory and Practice of Midwifery*, 1: 442–43. In Smellie's volumes of cases, accounts of incompetent and incalcitrant women midwives are balanced with ones of knowledgeable midwives and those Smellie had trained or worked with professionally; see William Smellie, *A Collection of Cases and Observations in Midwifery*, 3 vols., vol. 2 (London: D. Wilson, 1754); William Smellie, *A Collection of Preternatural Cases and Observations in Midwifery*, 3 vols., vol. 3 (London: D. Wilson and T. Durham, 1764).

19. Smellie, *Collection of Preternatural Cases and Observations in Midwifery*, 3: 147.

20. Wilson, "Memorial of Eleanor Willughby."

21. Laurel Thatcher Ulrich, *A Midwife's Tale: The Life of Martha Ballard, Based on Her Diary, 1785–1812* (New York: Vintage Books, 1991), particularly 47–65, 177–78, and 250–58. While Ballard lived and worked in America and later than the period treated here, her work and her relationship with local medical men bear some strong parallels to the dynamics in England earlier in the eighteenth century; see also Stone, *Complete Practice of Midwifery*.

22. See Evenden, *Midwives of Seventeenth-Century London*, 186–204; Lieske, *Lying-In Hospitals, Male/Female Midwifery Debates*.

23. I do, however, use the terms "woman midwife" and "man midwife" to refer simply to the gender of the practitioner. I have chosen this terminology over "female midwife" and "male midwife" to indicate that my interest is in the gender, not the sex, of the midwife.

24. This distinction is modeled on Wilson's division of "man-midwives" into those attending mainly "emergency" and those attending mainly "booked" calls. However, my distinction is not specific to male practitioners. See Wilson, *Making of Man-Midwifery*, 100.

25. Evenden, *Midwives of Seventeenth-Century London*, 68–78.

26. Roy Porter, "William Hunter: A Surgeon and a Gentleman," in *William Hunter and the Eighteenth-Century Medical World*, ed. W. F. Bynum and Roy Porter (Cambridge: Cambridge University Press, 1985), 16.

27. See Donnison, *Midwives and Medical Men*, 42.

28. As with many professions and branches of natural philosophy, women often attained expertise by helping husbands, fathers, or brothers. Percival Willughby had a daughter who practiced as a midwife and collaborated with him; see Wilson, "Memorial of Eleanor Willughby." Hendrik van Deventer's wife was a midwife, and Lieske argues that she helped Deventer to develop his midwifery practice; see Lieske, *Continental Midwives in Translation*, 159–60. Nicholas Culpeper's wife was also a midwife; see Evenden, *Midwives of Seventeenth-Century London*, 117.

29. Londa Schiebinger, "Women of Natural Knowledge," in *The Cambridge History of Science: Early Modern Science*, ed. Katharine Park and Lorraine Daston, vol. 3 (Cambridge: Cambridge University Press, 2006), 192–205.

30. See, for example, Alix Cooper, "Homes and Households," in *The Cambridge History of Science: Early Modern Science*, ed. Katharine Park and Lorraine Daston, vol. 3 (Cambridge: Cambridge University Press, 2006), 224–37; Heilbron, "Domesticating Science in the Eighteenth Century"; LeJacq, "Bounds of Domestic Healing."

31. See introduction, pp. 7–8, and chapter 1, p. 30.

32. See, for example, Kusukawa, *Picturing the Book of Nature*, 198–248.

33. Wolfe and Gal, *Body as Object*, 1.

34. Wolfe and Gal, *Body as Object*, 3.

35. Wragge-Morley, *Aesthetic Science*.

36. Daston and Galison, *Objectivity*.

37. Daston and Galison, *Objectivity*, particularly 39–42; Daston and Lunbeck, *Histories of Scientific Observation*, particularly 4–5.

38. Steven Shapin, *A Social History of Truth* (Chicago: University of Chicago Press, 1994), particularly 65–125.

39. Mauriceau, *Diseases of Women with Child*, sec. "To the Reader."

40. For histories of Mauriceau, see McTavish, *Childbirth and the Display of Authority*; Lieske, *Continental Midwives in Translation*.

41. Lieske, *Continental Midwives in Translation*, ix.

42. John Douglas, *A Short Account of the State of Midwifery in London, Westminster, &c.* (London: [The Author], 1736), 2.

43. Pam Lieske, ed., *Midwifery Treatises: 1737–1784*, vol. 9 of *Eighteenth-Century British Midwifery* (London: Pickering & Chatto, 2007), xiv; Woods and Galley, *Mrs Stone & Dr Smellie*, 242.

44. Fissell, *Vernacular Bodies*, 6; Kusukawa, *Picturing the Book of Nature*, 64.

45. Hunter, *Wicked Intelligence*, 33.

46. Fend, "Drawing the Cadaver 'Ad Vivum'"; see also Wragge-Morley, *Aesthetic Science*.

47. Fend, "Drawing the Cadaver 'Ad Vivum.'"

48. Dániel Margócsy, *Commercial Visions: Science, Trade, and Visual Culture in the Dutch Golden Age* (Chicago: University of Chicago Press, 2014), 151.

49. See chapter 1, pp. 47–50.

50. See chapter 1, pp. 33–36.

51. This incident is discussed in McTavish, *Childbirth and the Display of Authority*, 33.

52. Kusukawa, *Picturing the Book of Nature*, 87–90; Peter Parshall, "Imago Contrafacta: Images and Facts in the Northern Renaissance," *Art History* 16, no. 4 (1993): 554–79.

53. Philippe Peu, *Réponse de Mr Peu aux observations particulieres de Mr Mauriceau sur la grossesse et l'accouchement des femmes* (Paris: Jean Boudot, 1694), 94.

54. For more on the agency of artists in medical and anatomical imagery, see Daston and Galison, *Objectivity*, 94–97.

55. Kusukawa, *Picturing the Book of Nature*, 65.

56. Stefan Ditzen, "Instrument-Aided Vision and the Imagination: The Migration of Worms and Dragons in Early Microscopy," in *The Technical Image: A History of Styles in Scientific Imagery*, ed. Horst Bredekamp, Vera Dünkel, and Birgit Schneider (Chicago: University of Chicago Press, 2015), 135.

57. Hunter, *Wicked Intelligence*, 34; see also Smith, *Body of the Artisan*.

58. See Klestinec, "Practical Experience in Anatomy."

59. See, for example, Porter, "William Hunter."

60. Pre-Reformation, the postpartum body was widely believed to be impure and in need of reintegration into the Christian community through the ceremony of "churching." By the late seventeenth century, such ceremonies had largely been officially reformulated as "thanksgiving," but it is a matter of debate among scholars as to whether the postpartum body was still considered impure. Cressy, *Birth, Marriage and Death*, 197–232; Wilson, *Ritual and Conflict*, 191–210.

61. Lauren Kassell, "Casebooks in Early Modern England: Medicine, Astrology, and Written Records," *Bulletin of the History of Medicine* 88, no. 4 (2014): 622–23.

62. Pomata, "Sharing Cases," 199.

63. It is important to note that the terms "observation" and "case" had slightly different meanings depending on discipline, geography, and period. "Observation" seems to have been used in midwifery manuals later than it was in the medical texts examined by Kassell and Pomata.

64. Willughby, *Observations in Midwifery*.

65. François Mauriceau, *Observations sur la grossesse et l'accouchement des femmes, et sur leurs maladies et celles des enfans nouveaux-nez, etc.* (Paris: n.p., 1694).

66. Viardel's manual went through three French editions (1671, 1674, 1748), and while it was never translated into English, his birth figures would have been familiar to some English readers because they were copied in Anon., *Bibliotheca Anatomica, Medica, Chirurgica &c.* (London: Printed by John Nutt, 1711).

67. Cosme Viardel, *Observations sur la pratique des accouchemens naturels contre nature et monstrueux* (Paris: The Author, 1671), sec. Contents.

68. McTavish, *Childbirth and the Display of Authority*, 133.

69. Pomata, "Sharing Cases," 231.

70. McTavish, *Childbirth and the Display of Authority*, 133.

71. Tatlock, "Volume Editor's Introduction," 6.

72. Tatlock, "Volume Editor's Introduction," 2.

73. Siegemund's artists and engraver are unidentified, but she does report that she had the plates produced in Amsterdam. The two anatomical plates are copied from Bidloo and Reinier de Graaf, and the birth figures appear to have been influenced by both Viardel's and Mauriceau's images. See Tatlock, "Volume Editor's Introduction," 15.

74. Siegemund, *Court Midwife*, 130–31.

75. See Peter Hanns Reill, "The Legacy of the 'Scientific Revolution,'" in *The Cambridge History of Science: Eighteenth-Century Science*, ed. Roy Porter (Cambridge: Cambridge University Press, 2003), 21–43; Roger, *Life Sciences in Eighteenth-Century French Thought*, 133–204.

76. See Domenico Bertoloni Meli, "Machines and the Body between Anatomy and Pathology," in *Modèle métaphore machine merveille*, ed. Aurélia Gaillard et al. (Bordeaux: Presses Universitaires de Bordeaux, 2012), 53–68; Daniel Black, *Embodiment and Mechanisation: Reciprocal Understandings of Body and Machine from the Renaissance to the Present* (Farnham, UK: Ashgate, 2014), 41–74; Sawday, *Body Emblazoned*.

77. Minsoo Kang, "From the Man-Machine to the Automaton-Man: The Enlightenment Origins of the Mechanistic Imagery of Humanity," in *Vital Matters: Eighteenth-Century Views of Conception, Life, and Death*, ed. Helen Deutsch and Mary Terrall (Toronto: University of Toronto Press, 2012), 150.

78. See Jessica Riskin, "Medical Knowledge: The Adventures of Mr. Machine, with Morals," in *A Cultural History of the Human Body in the Age of Enlightenment*, ed. Carole Reeves (Oxford: Berg, 2010), 73–91.

79. See Timo Kaitaro, "'Man Is an Admirable Machine'—A Dangerous Idea?," *La Lettre de La Maison Française d'Oxford* 14 (2001): 105–22; Kang, "From the Man-Machine to the Automaton-Man"; Ann Thomson, "Mechanistic Materialism vs Vitalistic Materialism?," *La Lettre de La Maison Française d'Oxford* 14 (2001): 21–36.

80. See Séverine Pilloud and Micheline Louis-Courvoisier, "The Intimate Experience of the Body in the Eighteenth Century: Between Interiority and Exteriority," *Medical History* 47 (2003): 460.

81. Bertoloni Meli, "Machines and the Body," 56–57.

82. Sawday, *Body Emblazoned*, 31.

83. Keller, "Embryonic Individuals," 323.

84. Keller, "Embryonic Individuals," 323.

85. Wilkin, "Essaying the Mechanical Hypothesis"; see also Roger, *Life Sciences in Eighteenth-Century French Thought*, 171–74.

86. See Mauriceau, *Diseases of Women with Child*, 57–58. This trend is identified with the period around 1700 more widely by Mary Fissell; see "Remaking the Maternal Body in England, 1680–1730," *Journal of the History of Sexuality* 26, no. 1 (2017): 114–39.

87. Reill, "Legacy of the 'Scientific Revolution,'" 27.

88. Mauriceau, *Diseases of Women with Child*, 201–2.

89. Carlyle and Callender, "Fetus in Utero," 40.

90. See, for example, [Wolveridge], *English Midwife Enlarged*, 44–49.

91. Siegemund, *Court Midwife*, 73.

92. Siegemund, *Court Midwife*, 112.

93. Deventer published an earlier book on midwifery, *Dageraet van vroet-vrouwen*, in 1696, but it was unillustrated and seems not to have been widely known or disseminated. It was the manual of 1701 that was translated into Latin, English, and French, that saw multiple editions, and for which the birth figures were produced.

94. Hendrik van Deventer, *The Art of Midwifery Improv'd: Fully and Plainly Laying Down Whatever Instructions Are Requisite to Make a Compleat Midwife and the Many Errors in All the Books Hitherto Written Upon This Subject Clearly Refuted* (London: E. Curll, J. Pemberton and W. Taylor, 1716), 18.

95. Lieske, *Continental Midwives in Translation*, 159–60.

96. See Lieske, *Continental Midwives in Translation*, 160; Wilson, *Making of Man-Midwifery*, 79–91.

97. Wilson, *Making of Man-Midwifery*, 79.

98. Deventer, *Art of Midwifery Improv'd*, 303.

99. Many of the plates bear the legend "Phi. Bouttats fecit," which suggests that Bouttats, known as an engraver of book illustrations, was both the draftsman and the engraver.

100. François Mauriceau, *Des maladies des femmes grosses et accouchées* (Paris: Jean Henault, Jean D'Houry, Robert de Ninville and Jean Baptiste Coginard, 1668), 229; Mauriceau, *Diseases of Women with Child*, 169–70.

101. Thomas Dawkes, *The Midwife Rightly Instructed: Or, the Way, Which All Women Desirous to Learn, Should Take, To Acquire the True Knowledge and Be Successful in the Practice of, the Art of Midwifery* (London: Printed for J. Oswald, 1736), 24–25.

102. See Karr Schmidt, *Altered and Adorned*; Carlino, *Paper Bodies*; Massey, "Alchemical Womb."

103. Deventer, *Art of Midwifery Improv'd*, 18.

104. Deventer, *Art of Midwifery Improv'd*, 274.

105. Charles Kostelnick and Michael Hassett, *Shaping Information: The Rhetoric of Visual Conventions* (Carbondale: Southern Illinois University Press, 2003).

106. Nickelsen, *Draughtsmen, Botanists and Nature*, 227.

107. See Wolfgang Lefèvre, ed., *Picturing Machines, 1400–1700* (Cambridge, MA: MIT Press, 2004); Paolo Galuzzi, "Art and Artifice in the Depiction of Renaissance Machines," in *The Power of Images in Early Modern Science*, ed. Wolfgang Lefèvre, Jürgen Renn, and Urs Schoepflin (Basel: Birkhäuser, 2003), 47–68.

108. Wolfgang Lefèvre, "Introduction," in *Picturing Machines*, ed. Lefèvre, 6.

109. Martin Kemp, "'The Mark of Truth': Looking and Learning in Some Anatomical Illustrations from the Renaissance and Eighteenth Century," in *Medicine and the Five Senses*, ed. W. F. Bynum and Roy Porter (Cambridge: Cambridge University Press, 1993), 90.

110. See Black, *Embodiment and Mechanisation*; Jessica Riskin, *The Restless Clock: A History of the Centuries-Long Argument over What Makes Living Things Tick* (Chicago: University of Chicago Press, 2016); Sawday, *Body Emblazoned*.

111. Deventer, *Art of Midwifery Improv'd*, 249.

112. Bert S. Hall, "The Didactic and the Elegant: Some Thoughts on Scientific and Technological Illustrations in the Middle Ages and Renaissance," in *Picturing Knowledge: Historical and Philosophical Problems concerning the Use of Art in Science*, ed. Brian S. Baigrie (Toronto: University of Toronto Press, 1996), 22.

113. See, for example, Hopwood, *Haeckel's Embryos*, 50.

114. Lori Anne Ferrell, "Page Techne: Interpreting Diagrams in Early Modern English 'How-To' Books," in *Printed Images in Early Modern Britain: Essays in Interpretation*, ed. Michael Hunter (Farnham, UK: Ashgate, 2010), 115.

115. Ferrell, "Page Techne," 115.

116. See John Bender and Michael Marrinan, *The Culture of Diagram* (Stanford: Stanford University Press, 2010), 1–18; Nicholas Jardine and Isla Fay, eds., *Observing the World through Images: Diagrams and Figures in the Early-Modern Arts and Sciences* (Leiden: Brill, 2014).

117. "Diagram, n.," in *Oxford English Dictionary* (Oxford: Oxford University Press, 2020), oed.com.

118. Elkins, "Art History and Images That Are Not Art," 553.

119. Brian S. Baigrie, "Descartes's Scientific Illustrations and 'La Grande Mécanique de La Nature,'" in *Picturing Knowledge: Historical and Philosophical Problems concerning the Use of Art in Science*, ed. Baigrie (Toronto: University of Toronto Press, 1996), 87.

120. Melissa Lo, "The Picture Multiple: Figuring, Thinking, and Knowing in Descartes's Essais (1637)," *Journal of the History of Ideas* 78, no. 3 (2017): 382–84; for a similar approach to Galileo's diverse visual outputs, see Renée Raphael, "Teaching through Diagrams: Galileo's Dialogo and Discorsi and His Pisan Readers," in *Observing the World through Images: Diagrams and Figures in the Early-Modern Arts and Sciences*, ed. Isla Fay and Nicholas Jardine (Leiden: Brill, 2014), 201–30.

121. Lo, "Picture Multiple," 373.

122. Janina Wellmann, *The Form of Becoming: Embryology and the Epistemology of Rhythm, 1760–1830*, trans. Kate Sturge (New York: Zone Books, 2017), 157.

123. E. H. Gombrich, *The Uses of Images: Studies in the Social Function of Art and Visual Communication* (London: Phaidon, 1999), 236.

124. See chapter 1, pp. 45–47.

125. Siegemund, *Court Midwife*, 111.

126. Raphael, "Teaching through Diagrams," 203.

127. Wellmann, *Form of Becoming*, 164.

128. Siegemund, *Court Midwife*, 54.

129. See chapter 2, pp. 78–82.

130. Siegemund, *Court Midwife*, 130.

131. See chapter 1, p. 50.

132. Deventer, *Art of Midwifery Improv'd*, 229.

133. Siegemund, *Court Midwife*, 105.

134. Siegemund, *Court Midwife*, 130–31.

135. See chapter 2, pp. 70–74.

136. William Hunter, "Lectures Anatomical and Chirurgical by William Hunter" (1775), MS Hunter 1(3), Glasgow University Library, quoted in Peter Black, "Taste and the Anatomist," in *"My Highest Pleasures": William Hunter's Art Collection*, ed. Black (London: The Hunterian, University of Glasgow in association with Paul Holberton Publishing, 2007), 92.

137. Stolberg, *Experiencing Illness*, 73–74.

138. Hendrik van Deventer, *New Improvements in the Art of Midwifery* (London: T. Warner, 1724), xxvii–xxviii.

139. Nina Rattner Gelbart, *The King's Midwife: A History and Mystery of Madame Du Coudray* (Berkeley: University of California Press, 1998), 226; Willughby, *Observations in Midwifery*, 126.

140. Deventer, *Art of Midwifery Improv'd*, 250.

141. Siegemund, *Court Midwife*, 135–36.

Chapter Four

1. Siegemund, *Court Midwife*, 53.

2. Siegemund, *Court Midwife*, 53.

3. Mary D. Sheriff, *Moved by Love: Inspired Artists and Deviant Women in Eighteenth-Century France* (Chicago: University of Chicago Press, 2004), 178; Alexander Marr, "Pregnant Wit: Ingegno in Renaissance England," *British Art Studies* 1 (2015); Katharine Eisaman Maus, "A Womb of His Own: Male Renaissance Poets in the Female Body," in *Printing and Parenting in Early Modern England*, ed. Douglas Brooks (Farnham, UK: Ashgate, 2005), 89–108.

4. See, for example, Forman Cody, "Politics of Reproduction," 482–84; Forman Cody, *Birthing the Nation*, 169 and 269–70; Gelbart, *King's Midwife*, 91; Pam Lieske, ed., *Midwifery Texts for Women*, vol. 4 of *Eighteenth-Century British Midwifery* (London: Pickering & Chatto, 2007), 193; Wilson, *Making of Man-Midwifery*, 5.

5. Evenden, *Midwives of Seventeenth-Century London*, 93.

6. For the French context, see McTavish, *Childbirth and the Display of Authority*; and for the English, see Forman Cody, *Birthing the Nation*; Sheena Sommers,

"Transcending the Sexed Body: Reason, Sympathy, and 'Thinking Machines' in the Debates over Male Midwifery," in *The Female Body in Medicine and Literature*, ed. Andrew Mangham and Greta Depledge (Liverpool: Liverpool University Press, 2011), 8–106.

7. Siegemund, *Court Midwife*, 33.

8. Deventer, *Art of Midwifery Improv'd*, sec. Preface.

9. Mauriceau, *Diseases of Women with Child*, sec. Translator's Preface.

10. Forman Cody, "Politics of Reproduction," 479.

11. Forman Cody, "Politics of Reproduction," 479.

12. For more on seventeenth-century print and ideas of public exchange, see Joseph Monteyne, *The Printed Image in Early Modern London: Urban Space, Visual Representation and Social Exchange* (Aldershot, UK: Ashgate, 2007). Evelyn Lincoln has investigated the way early modern surgeons in Rome used texts and images to construct their professional personae; see *Brilliant Discourse: Pictures and Readers in Early Modern Rome* (New Haven: Yale University Press, 2014), 115–62.

13. Lorraine Daston and H. Otto Sibum, "Introduction: Scientific Personae and Their Histories," *Science in Context* 16, no. 1/2 (2003): 2.

14. Daston and Sibum, "Introduction," 6.

15. In some other Western European countries, midwives were regulated and sometimes instructed by state- and town-elected physicians rather than church bodies. This meant that teaching and regulating midwifery knowledge could be a lucrative career in these countries, in a way that it was not in England. See Evenden, *Midwives of Seventeenth-Century London*, 24–25.

16. This phenomenon is investigated with relation to natural philosophy more widely in William Eamon, "From the Secrets of Nature to Public Knowledge," in *Reappraisals of the Scientific Revolution*, ed. David C. Lindberg and Robert S. Westman (Cambridge: Cambridge University Press, 1990), 333–65.

17. For a summary account of the Enlightenment, see Dorinda Outram, *The Enlightenment* (Cambridge: Cambridge University Press, 2013); for more in-depth investigations of the ideals of natural philosophers in this period, see Hunter, *Wicked Intelligence*; Shapin, *Social History of Truth*, 65–125.

18. Wilson, *Making of Man-Midwifery*, 26.

19. Willughby, *Observations in Midwifery*, 72. Sarah Stone, too, describes some midwives who damage the mother's body in labor; see Stone, *Complete Practice of Midwifery*, 24–25, 41, 52–53, and 89.

20. Though, of course, some women did use tools. See chapter 2, p. 91.

21. Deventer, *Art of Midwifery Improv'd*, 250.

22. Smellie, *Treatise on the Theory and Practice of Midwifery*, 1: 184.

23. See chapter 3, pp. 91–93, for a discussion of regular and emergency midwifery.

24. Cressy, *Birth, Marriage and Death*, 15–96.

25. Dawkes, *Midwife Rightly Instructed*, 56.

26. See Sommers, "Transcending the Sexed Body."

27. Works on the senses that have informed this chapter include W. F. Bynum and Roy Porter, eds., *Medicine and the Five Senses* (Cambridge: Cambridge University Press, 1993); Constance Classen, *The Deepest Sense: A Cultural History of Touch* (Urbana: University of Illinois Press, 2012); Gowing, *Common Bodies*; Elizabeth D. Harvey, ed., *Sensible Flesh: On Touch in Early Modern Culture* (Philadelphia: University of Pennsylvania Press, 2003); Roy Porter, "A Touch of Danger: The Man-Midwife

as Sexual Predator," in *Sexual Underworlds of the Enlightenment*, ed. G. S. Rousseau and Roy Porter (Manchester: Manchester University Press, 1987), 206–32; Herman Roodenburg, ed., *A Cultural History of the Senses in the Renaissance* (London: Bloomsbury, 2014).

28. Elizabeth D. Harvey, "Introduction: The 'Sense of All Senses,'" in *Sensible Flesh: On Touch in Early Modern Culture*, ed. Harvey (Philadelphia: University of Pennsylvania Press, 2003), 1.

29. See, for example, John Maubray, *The Female Physician, Containing All the Diseases Incident to That Sex, in Virgins, Wives and Widows* (London: James Holland, 1724), 14.

30. Cynthia Klestinec, "Touch, Trust and Compliance in Early Modern Medical Practice," in *The Edinburgh Companion to the Critical Medical Humanities*, ed. Anne Whitehead and Angela Woods (Edinburgh: Edinburgh University Press, 2016), 209–24; Michael Stolberg, "Examining the Body, c. 1500–1750," in *The Routledge History of Sex and the Body*, ed. Sarah Toulalan and Kate Fisher (Abingdon, UK: Routledge, 2013), 91–105.

31. Stolberg, "Examining the Body," 100; see also Porter, "Rise of Physical Examination."

32. Harvey, "Introduction,'" 15.

33. See Klestinec, "Practical Experience in Anatomy," 33–58.

34. Classen, *Deepest Sense*, 73.

35. Porter, "Touch of Danger," 208.

36. Porter, "Touch of Danger," 216.

37. See Donnison, *Midwives and Medical Men*, 29–31; Porter, "Touch of Danger," 215; Wilson, *Making of Man-Midwifery*, 2; Fissell, "Man-Midwifery Revisited."

38. Porter, "Touch of Danger," 195.

39. Eve Keller, "The Subject of Touch: Medical Authority in Early Modern Midwifery," in *Sensible Flesh: On Touch in Early Modern Culture*, ed. Elizabeth D. Harvey (Philadelphia: University of Pennsylvania Press, 2003), 68–69.

40. See Forman Cody, "Politics of Reproduction"; Forman Cody, *Birthing the Nation*; Keller, "Subject of Touch"; McTavish, *Childbirth and the Display of Authority*; Wilson, *Making of Man-Midwifery*.

41. Deventer, *New Improvements*, 23.

42. Deventer's understanding of uterine obliquity is discussed in chapter 3, pp. 115–17.

43. Deventer, *New Improvements*, 24.

44. Deventer, *New Improvements*, 28.

45. Katharine Rowe associates this gesture, of the hand held open with the fingers slightly curled, with generosity and liberality. See Rowe, "'God's Handy Worke,'" in *The Body in Parts: Fantasies of Corporeality in Early Modern Europe*, ed. David Hillman and Carla Mazzio (New York: Routledge, 1997), 301.

46. Lianne McTavish, "Concealing Spectacles: Childbirth and Visuality in Early Modern France," in *Editing the Image: Strategies in the Production and Reception of the Visual*, ed. Mark A. Cheetham, Elizabeth Legge, and Catherine M. Soussloff (Toronto: University of Toronto Press, 2008), 100.

47. Siegemund, *Court Midwife*, 204.

48. Deventer, *Art of Midwifery Improv'd*, 220.

49. Deventer, *Art of Midwifery Improv'd*, 14.

50. Deventer, *New Improvements*, 24.

51. See Rebecca Whiteley, "The Limits of Seeing and Knowing: Early Modern Anatomy and the Uterine Membranes," *Object* 19 (2017): 95–119.

52. Zorach, "'Secret Kind of Charm.'"

53. Guillemeau, *Child-Birth*, 84.

54. Deventer, *Art of Midwifery Improv'd*, 326.

55. See Rowe, "'God's Handy Worke,'" 285 and 299.

56. Elizabeth D. Harvey, "The Touching Organ: Allegory, Anatomy, and the Renaissance Skin Envelope," in *Sensible Flesh: On Touch in Early Modern Culture*, ed. Harvey (Philadelphia: University of Pennsylvania Press, 2003), 89.

57. William Schupbach, "The Paradox of Rembrandt's 'Anatomy of Dr. Tulp,'" *Medical History*, supplement no. 2 (1982): 17; see also Galen, *Galen on the Usefulness of the Parts of the Body*, trans. Margaret Tallmadge May (Ithaca, NY: Cornell University Press, 1968), 67–71.

58. Schupbach, "Paradox of Rembrandt's 'Anatomy of Dr. Tulp,'" 18–20.

59. See Heilbron, "Domesticating Science in the Eighteenth Century"; Rowe, "'God's Handy Worke,'" 303.

60. Smellie, *Treatise on the Theory and Practice of Midwifery*, 1: 335.

61. Forman Cody, *Birthing the Nation*, 152; See Smellie, *Treatise on the Theory and Practice of Midwifery*, 1: 335, for his advice on the appropriate dress for a man midwife; and Nihell, *Treatise on the Art of Midwifery*, 11, for a criticism of Smellie's advice.

62. Smellie, *Collection of Cases and Observations in Midwifery*, 2:179.

63. Susan Vincent, *Dressing the Elite: Clothes in Early Modern England* (Oxford: Berg, 2003), chap. 2.

64. McTavish, *Childbirth and the Display of Authority*, 196.

65. See chapter 1, p. 50, and chapter 3, pp. 130–36.

66. Siegemund, *Court Midwife*, 110 and 135–36.

67. Stone, *Complete Practice of Midwifery*, 80.

68. Deventer, *Art of Midwifery Improv'd*, 132.

69. McTavish, *Childbirth and the Display of Authority*, 13.

70. McTavish, *Childbirth and the Display of Authority*, 13.

71. See chapter 3, p. 108.

72. McTavish, *Childbirth and the Display of Authority*, 128–29.

73. See chapter 3, pp. 93–100.

74. Harvey, "Touching Organ," 83.

75. Rowe, "'God's Handy Worke,'" 291.

76. McTavish, *Childbirth and the Display of Authority*, 128.

77. For discussions of the "anatomical Venus," see Bonnie Blackwell, "'Tristram Shandy' and the Theater of the Mechanical Mother," *ELH* 68, no. 1 (2000): 88–89; Ludmilla Jordanova, *Sexual Visions: Images of Gender in Science and Medicine between the Eighteenth and Twentieth Centuries* (New York: Harvester Wheatsheaf, 1989), 44.

78. See Cressy, *Birth, Marriage and Death*, 28–31.

79. As the midwife Sarah Stone asserted, "dissecting the Dead, and being just and tender to the Living, are vastly different." Stone, *Complete Practice of Midwifery*, xiv.

80. For the idea of dissection in the early modern period as compelling, but also fearful and violent, see Sawday, *Body Emblazoned*.

81. Klestinec, "Touch, Trust and Compliance."

82. J. B. [John Bulwer], *Chirologia: Or the Naturall Language of the Hand. Com-*

posed of the Speaking Motions, and Discoursing Gestures Thereof. Whereunto Is Added Chironomia: Or, the Art of Manual Rhetoricke (London: Tho. Harper, 1644), 171–72 and 189.

83. McTavish, *Childbirth and the Display of Authority*, 129.

84. For the significance of gesture in the period, see John Walter, "Gesturing at Authority: Deciphering the Gestural Code of Early Modern England," *Past & Present* 4 (2009): 96–127.

85. McTavish, *Childbirth and the Display of Authority*, 128–29.

86. For Viardel's understanding of how "touching" should be conducted and what it could tell the practitioner, see Viardel, *Observations*, 56–63.

87. For texts, see Douglas, *Short Account of the State of Midwifery in London*; [Frank Nicholls], *The Petition of the Unborn Babes to the Censors of the Royal College of Physicians of London* (London: M. Cooper, 1751); Nihell, *Treatise on the Art of Midwifery*; [Philip Thicknesse], *Man-Midwifery Analysed: And the Tendency of That Practice Detected and Exposed* (London: R. Davis, 1764). For prints, see Samuel William Fores, *A Man-Mid-Wife*, engraving, in John Blunt [Samuel William Fores], *Man-Midwifery Dissected: Or, the Obstetric Family-Instructor. For the Use of Married Couples, and Single Adults of Both Sexes* (London: S. W. Fores, 1793); Thomas Rowlandson, *A Midwife Going to a Labour*, 1811, etching; Anon., *The Man-Midwife, or Female Delicacy After Marriage*, 1773, engraving; and William Hogarth, *Cunicularii, or The Wise Men of Godliman in Consultation*, 1726, etching.

88. Nihell, *Treatise on the Art of Midwifery*, 314.

89. Nihell, *Treatise on the Art of Midwifery*, 463–64.

90. [Tobias Smollett], "Art. IV. A Treatise on the Art of Midwifery," *The Critical Review, or, Annals of Literature* 9 (March 1760): 196.

91. Wilson, *Making of Man-Midwifery*, 99.

92. Sommers, "Transcending the Sexed Body," 89.

93. See Blackwell, "'Tristram Shandy' and the Theater of the Mechanical Mother"; Pam Lieske, "'Made in Imitation of Real Women and Children': Obstetrical Machines in Eighteenth-Century Britain," in *The Female Body in Medicine and Literature*, ed. Andrew Mangham and Greta Depledge (Liverpool: Liverpool University Press, 2011), 69–88.

94. Smellie, *Collection of Cases and Observations in Midwifery*, 2:287.

95. Nihell, *Treatise on the Art of Midwifery*, 59; Stone, *Complete Practice of Midwifery*, xiv–xv.

96. Sommers, "Transcending the Sexed Body," 90 and 100.

97. Alexander Butter, "The Description of a Forceps for Extracting Children by the Head When Lodged Low in the Pelvis of the Mother," in *Medical Essays and Observations*, 3 vols. (Edinburgh: William Monro, 1737); William Giffard, *Cases in Midwifry: Written by the Late Mr. William Giffard, Surgeon and Man-Midwife. Revis'd and Publish'd by Edward Hody, M.D. and Fellow of the Royal Society* (London: B. Motte, T. Wotton, L. Gilliver & J. Nourse, 1734).

98. Edmund Chapman, *A Treatise on the Improvement of Midwifery, Chiefly with Regard to the Operation. To Which Are Added Fifty-Seven Cases, Selected from Upwards of Twenty-Seven Years Practice. The Second Edition, with Large Additions and Improvements* (London: John Brindley, John Clarke and Charles Borbett, 1735).

99. John Leake, *The Description and Use of a Pair of New Forceps* (London: n.p., 1771); William Smellie, *A Sett of Anatomical Tables, with Explanations, and an Abridg-*

ment, of the Practice of Midwifery, with a View to Illustrate a Treatise on That Subject, and Collection of Cases (London: n.p., 1754).

100. Wilson, *Making of Man-Midwifery*, 79–80.

101. See Nihell, *Treatise on the Art of Midwifery*.

102. Wilson, *Making of Man-Midwifery*.

103. Dawkes, *Midwife Rightly Instructed*, 10.

104. Edmund Chapman, *An Essay on the Improvement of Midwifery: Chiefly with Regard to the Operation; to Which Are Added Fifty Cases, Selected from Upwards of Twenty-Five Years Practice* (London: A. Bettesworth, C. Hitch, J. Walthor and T. Cowper, 1733), 7–8.

105. For the development of specialist instrument-makers in London in the eighteenth century, see G. L'E. Turner, "Eighteenth-Century Scientific Instruments and Their Makers," in *The Cambridge History of Science: Eighteenth-Century Science*, ed. Roy Porter (Cambridge: Cambridge University Press, 2003), 509–35. Chapman mentions seeing forceps displayed by an instrument maker in his shop; see *Essay on the Improvement of Midwifery*.

106. Maubray, *Female Physician*, 30–31.

107. William Douglas, *A Letter to Dr. Smellie: Shewing the Impropriety of His New-Invented Forceps; as Also, the Absurdity of His Method of Teaching and Practising Midwifery* (London: J. Roberts, 1748), 18.

108. Nihell, *Treatise on the Art of Midwifery*, 36.

109. Fielding Ould, *A Treatise of Midwifery, in Three Parts* (Dublin: Oli. Nelson and Charles Connor, 1742), 140.

110. Ould, *Treatise of Midwifery*, 77.

111. Smellie, *Treatise on the Theory and Practice of Midwifery*, 1:264–65.

112. Ould, *Treatise of Midwifery*, 77; Nihell, *Treatise on the Art of Midwifery*, 418.

113. In a move to ameliorate the coldness and clashing of forceps, Smellie recommended that practitioners cover the blades in leather. While this move adds to the idea of forceps as a kind of artificial hand—metal bone covered in leather skin—the innovation was criticized as impractical by later authors. See Nihell, *Treatise on the Art of Midwifery*, 418; Smellie, *Treatise on the Theory and Practice of Midwifery*, 1: 271.

114. Nihell, *Treatise on the Art of Midwifery*, 37–38.

115. See Forman Cody, *Birthing the Nation*.

116. Nihell, *Treatise on the Art of Midwifery*, 38.

117. Zorach, "Secret Kind of Charm," 235.

118. Zorach, "Secret Kind of Charm," 235.

119. MacGregor, "Authority of Prints."

120. For the continued acceptance of the power of maternal imagination in the early eighteenth century, see Jenifer Buckley, *Gender, Pregnancy and Power in Eighteenth-Century Literature: The Maternal Imagination* (Cham: Springer, 2017), 1–38; Forman Cody, *Birthing the Nation*, 120–51; Daniel Turner, *De Morbis Cutaneis: A Treatise of Diseases Incident to the Skin* (London: R. Bonwicke et al., 1714), 102–28.

121. Andrew Cunningham credits this visual argument in favor of the forceps largely to Petrus Camper. It is certain that Camper at least played a crucial role, proposing the inclusion of, and drafting, all the figures that depict the use of tools. See Andrew Cunningham, "Petrus ('Peter') Camper: A Dutchman in the Medical World of Eighteenth-Century England," in *Petrus Camper in Context: Science, the Arts, and*

Society in the Eighteenth-Century Dutch Republic, ed. Klaas van Berkel and Bart A. M. Ramakers (Hilversum: Verloren, 2015), 122.

122. Elegance and Smellie's images are further discussed in chapter 5, pp. 211–15.

123. Douglas, *Letter to Dr. Smellie*; Nihell, *Treatise on the Art of Midwifery*.

Chapter Five

1. For a comprehensive study of the artists employed in this project over its long history, see Anne Dulau Beveridge, "The Anatomist and the Artists: Hunter's Involvement," in *William Hunter's World: The Art and Science of Eighteenth-Century Collecting*, ed. E. Geoffrey Hancock, Nick Pearce, and Mungo Campbell (Farnham, UK: Ashgate, 2015), 81–95; Caroline Grigson, "'An Universal Language': William Hunter and the Production of The Anatomy of the Human Gravid Uterus," in *William Hunter's World: The Art and Science of Eighteenth-Century Collecting*, ed. E. Geoffrey Hancock, Nick Pearce, and Mungo Campbell (Farnham, UK: Ashgate, 2015), 59–80.

2. See Carin Berkowitz, "The Illustrious Anatomist: Authorship, Patronage, and Illustrative Style in Anatomy Folios, 1700–1840," *Bulletin of the History of Medicine* 89, no. 2 (2015): 171–208; Daston and Galison, *Objectivity*; Jordanova, *Sexual Visions*; Ludmilla Jordanova, *Nature Displayed: Gender, Science and Medicine, 1760–1820* (New York: Longman, 1999); Martin Kemp, "True to Their Natures: Sir Joshua Reynolds and Dr William Hunter at the Royal Academy of Arts," *Notes and Records of the Royal Society of London* 46, no. 1 (1992): 77–88; Massey, "Pregnancy and Pathology"; Lyle Massey, "Against the 'Statue Anatomized': The 'Art' of Eighteenth-Century Anatomy on Trial," *Art History* 40, no. 1 (2017): 68–103; Roberta McGrath, *Seeing Her Sex: Medical Archives and the Female Body* (Manchester: Manchester University Press, 2002).

3. See Porter, "William Hunter."

4. See Kemp, "True to Their Natures"; Helen McCormack, "The Great Windmill Street Anatomy School and Museum," in *William Hunter's World: The Art and Science of Eighteenth-Century Collecting*, ed. E. Geoffrey Hancock, Nick Pearce, and Mungo Campbell (Farnham, UK: Ashgate, 2015), 13–28.

5. See Carin Berkowitz, "Systems of Display: The Making of Anatomical Knowledge in Enlightenment Britain," *British Journal for the History of Science* 46, no. 3 (2013): 359–87; Stewart W. McDonald and John W. Faithfull, "William Hunter's Sources of Pathological and Anatomical Specimens, with Particular Reference to Obstetric Subjects," in *William Hunter's World: The Art and Science of Eighteenth-Century Collecting*, ed. E. Geoffrey Hancock, Nick Pearce, and Mungo Campbell (Farnham, UK: Ashgate, 2015), 45–58.

6. Porter, "William Hunter," 31.

7. Porter, "William Hunter," 25.

8. On the visual convention of self-dissection, see Elizabeth Hallam, *Anatomy Museum: Death and the Body Displayed* (London: Reaktion Books, 2016); Park, *Secrets of Women*; Sawday, *Body Emblazoned*.

9. Grigson, "'An Universal Language,'" 61; Jordanova, *Nature Displayed*, 184; McGrath, *Seeing Her Sex*, 80.

10. Hunter, *Anatomy of the Human Gravid Uterus*, fig. 6.

11. Massey, "Pregnancy and Pathology," 73.

12. Foucault, *Birth of the Clinic*.

13. McGrath, *Seeing Her Sex*, 80; See also Daston and Galison, *Objectivity*, 75–77; Massey, "Pregnancy and Pathology."

14. Jordanova, *Nature Displayed*, 186.

15. Daston and Galison, *Objectivity*, 55–114.

16. See Whiteley, "Limits of Seeing and Knowing," 107–12.

17. Hughes, "Creating and Controlling a Visual Language."

18. Hunter, *Anatomy of the Human Gravid Uterus*, sec. Preface.

19. Hunter, *Anatomy of the Human Gravid Uterus*, sec. Preface.

20. Daston and Galison, *Objectivity*, 69–84.

21. For a discussion of how Albinus understood his "ideal" images, see Tim Huisman, "Squares and Diopters: The Drawing System of a Famous Anatomical Atlas," *Tractrix* 4 (1992): 1–12; Hendrik Punt, *Bernard Siegfried Albinus (1687–1770): On "Human Nature," Anatomical and Physiological Ideas in Eighteenth Century Leiden* (Amsterdam: Israël, 1983).

22. Hunter, *Anatomy of the Human Gravid Uterus*, sec. Preface.

23. Jordanova, *Nature Displayed*, 193–94.

24. Kemp, "'Mark of Truth,'" 85.

25. Choulant, *History and Bibliography of Anatomic Illustration*, 75.

26. Steven Shapin, *Never Pure: Historical Studies of Science As If It Was Produced by People with Bodies, Situated in Time, Space, Culture, and Society, and Struggling for Credibility and Authority* (Baltimore: Johns Hopkins University Press, 2010), 13.

27. McGrath, *Seeing Her Sex*, 64.

28. See Jordanova, *Nature Displayed*, 198; Massey, "Pregnancy and Pathology," 76.

29. Lianne McTavish, "Practices of Looking and the Medical Humanities: Imagining the Unborn in France, 1550–1800," *Journal of Medical Humanities* 31 (2010): 22.

30. Pam Lieske, ed., *The State of Midwifery Considered, William Smellie and His Critics*, vol. 5 of *Eighteenth-Century British Midwifery* (London: Pickering & Chatto, 2007), 125.

31. McGrath, *Seeing Her Sex*, 77.

32. Massey, "Pregnancy and Pathology." This term is problematic, first because it is anachronistic: "obstetrics" was not a widely used term until the nineteenth century, and Smellie certainly did not use it. Moreover, it creates a false sense of cohesion: while Hunter's *Anatomy* is an anatomical not an obstetrical work, Smellie's *Tables* is arguably not an atlas.

33. Massey, "Pregnancy and Pathology," 73.

34. See, for example, Smellie, *Collection of Preternatural Cases and Observations in Midwifery*, 3: 378–79.

35. For biographies of Hunter and Smellie, see W. F. Bynum and Roy Porter, eds., *William Hunter and the Eighteenth-Century Medical World* (Cambridge: Cambridge University Press, 1985); E. Geoffrey Hancock, Nick Pearce, and Mungo Campbell, eds., *William Hunter's World: The Art and Science of Eighteenth-Century Collecting* (Farnham, UK: Ashgate, 2015); Pam Lieske, "William Smellie's Use of Obstetrical Machines and the Poor," *Studies in Eighteenth-Century Culture* 29 (2000): 65–86; Porter, "William Hunter"; Wilson, *Making of Man-Midwifery*; Woods and Galley, *Mrs Stone & Dr Smellie*.

36. See Smellie, *Collection of Cases and Observations in Midwifery*, 2: 150; Smellie, *Sett of Anatomical Tables*, fig. 9.

37. Evenden, *Midwives of Seventeenth-Century London*, 186.

38. Wilson, *Making of Man-Midwifery*, 124.

39. Massey, "Pregnancy and Pathology," 88.

40. Jan van Rymsdyk drafted figures 1–11, 13–15, 20–23, 25, 28–33, 35, 38.

41. Petrus Camper drafted figures 12, 16–19, 24, 26–27, 34, and 36.

42. The unknown artist drafted figures 37 and 39. See Smellie, *Sett of Anatomical Tables*, sec. Preface.

43. "Grignion, Charles I.," in *Benezit Dictionary of Artists* (Oxford: Oxford University Press, 2011), http://www.oxfordartonline.com.libproxy.ucl.ac.uk/subscriber/book/oao_benz.

44. See Cunningham, "Petrus ('Peter') Camper," 118.

45. See chapter 3, pp. 104–7.

46. Smellie, *Sett of Anatomical Tables*, sec. Preface.

47. Cunningham, "Petrus ('Peter') Camper," 116–17 and 120–21.

48. Smellie, *Sett of Anatomical Tables*, fig. 10. Smellie explains that he placed the image where it was because it also serves to describe how the cervix stretches and becomes thinner as pregnancy develops.

49. Massey, "Pregnancy and Pathology," 77.

50. Smellie, *Treatise on the Theory and Practice of Midwifery*, 1:lxii.

51. Smellie, *Collection of Cases and Observations in Midwifery*, 2:247.

52. See Forman Cody, *Birthing the Nation*, 165; Lieske, "William Smellie's Use of Obstetrical Machines and the Poor," 81.

53. Smellie, *Sett of Anatomical Tables*, fig. 16.

54. See Hughes, "Creating and Controlling a Visual Language."

55. Sawday, *Body Emblazoned*, 132; see also Andrew Cunningham, *The Anatomist Anatomis'd: An Experimental Discipline in Enlightenment Europe* (Farnham, UK: Ashgate, 2010), 55–63.

56. See chapter 3, pp. 115–22.

57. Hunter, *Anatomy of the Human Gravid Uterus*, fig. 6.

58. Sophie Oosterwijk, "Adult Appearances? The Representation of Children and Childhood in Medieval Art," in *The Oxford Handbook of the Archaeology of Childhood*, ed. Sally Crawford, Dawn M. Hadley, and Gillian Shepherd (Oxford: Oxford University Press, 2018), 605.

59. See, for example, Ambroise Paré, *Deux livres de chirurgie* (Paris: André Wechel, 1573), 78–81.

60. See chapter 2, pp. 72–74.

61. See Kate Retford, *The Art of Domestic Life: Family Portraiture in Eighteenth-Century England* (New Haven: Yale University Press, 2006), particularly 4–10; James Christen Steward, *The New Child: British Art and the Origins of Modern Childhood, 1730–1830* (Berkeley: University Art Museum and Pacific Film Archive, University of California, 1995), particularly 15–27.

62. Martin Kemp, "Coming into Line: Graphic Demonstrations of Skill in Renaissance and Baroque Engravings," in *Sight & Insight: Essays on Art and Culture in Honour of E. H. Gombrich at 85*, ed. John Onians (London: Phaidon, 1994), 235.

63. Kemp, "Coming into Line," 234.

64. See also chapter 2, pp. 80–81.

65. Rosenthal, "Visceral Culture," 566.

66. Rubiés, "Were Early Modern Europeans Racist?"

67. Smellie, *Sett of Anatomical Tables*, fig. 12.

68. See Susan C. Lawrence, "Educating the Senses: Students, Teachers and Medical Rhetoric in Eighteenth-Century London," in *Medicine and the Five Senses*, ed. W. F. Bynum and Roy Porter (Cambridge: Cambridge University Press, 1993), 154–78; Berkowitz, "Systems of Display"; Blackwell, "'Tristram Shandy' and the Theater of the Mechanical Mother"; Lieske, "'Made in Imitation of Real Women and Children'"; McDonald and Faithfull, "William Hunter's Sources."

69. See chapter 3, pp. 130–36.

70. Mauriceau's *Diseases of Women with Child* was reprinted in 1673, 1683, 1697, 1710, 1716, 1718, 1727, 1736, 1752, and 1755.

71. Deventer's *The Art of Midwifery Improv'd* was reprinted in 1721, 1723, 1728, and 1746.

72. Stephen, *Domestic Midwife*, 5.

73. For histories of John Burton, see Lieske, *State of Midwifery Considered*, 369–70; Judy Egerton, *George Stubbs, Painter: Catalogue Raisonné* (New Haven: Yale University Press, 2007), 16–17.

74. Forman Cody, *Birthing the Nation*, 161. Forman Cody, among others, has noted the high number of Scottish man midwives who made their careers in London in the eighteenth century, including both Smellie and Hunter.

75. Edward Shorter, "The Management of Normal Deliveries and the Generation of William Hunter," in *William Hunter and the Eighteenth-Century Medical World*, ed. W. F. Bynum and Roy Porter (Cambridge: Cambridge University Press, 1985), 373.

76. King, *Midwifery, Obstetrics and the Rise of Gynaecology*, 108.

77. See, for example, R. B. Fountain, "George Stubbs (1724–1806) as an Anatomist," *Proceedings of the Royal Society of Medicine Journal* 61 (1968): 641.

78. C. Bernard and L. Barr, "Burton, John (1710–1171)," in *Oxford Dictionary of National Biography* (Oxford: Oxford University Press, 2004), https://doi.org/10.1093/ref:odnb/4134.

79. Blackwell, "'Tristram Shandy' and the Theater of the Mechanical Mother," 115.

80. Jordanova, *Nature Displayed*, 198; see also Massey, "Pregnancy and Pathology," 76.

81. Lieske, *State of Midwifery Considered*, 370. In fact, only the last three of the eighteen plates include illustrations of tools. Apart from these, there are nine plates that include anatomical images and eight plates that include birth figures.

82. John Burton, *An Essay Towards a Complete New System of Midwifry, Theoretical and Practical* (London: printed for James Hodges, 1751), 170. Smellie also addressed and taught both men and women, but his books were aimed at readers who were also his pupils and who were therefore relatively wealthy and educated.

83. Burton, *Essay Towards a Complete New System of Midwifry*, xviii.

84. Burton was Stubbs's superior at the York County Hospital when he hired him to illustrate the manual. Egerton, *George Stubbs, Painter*, 17.

85. Christopher Lennox-Boyd, Rob Dixon, and Tim Clayton, *George Stubbs: The Complete Engraved Works* (Culham, UK: Stipple, 1989), 291; Basil Taylor, *The Prints of George Stubbs* (London: Paul Mellon Foundation for British Art, 1969), 7.

86. Fountain, "George Stubbs," 640–41; Lennox-Boyd, Dixon, and Clayton, *George Stubbs*, 291; Taylor, *Prints of George Stubbs*, 7.

87. Quoted in Lennox-Boyd, Dixon, and Clayton, *George Stubbs*, 291.

88. Harry Mount, "Van Rymsdyk and the Nature-Menders: An Early Victim of

the Two Cultures Divide," *British Journal for Eighteenth-Century Studies* 29 (2006): 90–93.

89. Fountain, "George Stubbs," 640; see also Lennox-Boyd, Dixon, and Clayton, *George Stubbs*, 2.

90. Burton, *Essay*, 4, 22, 31, and 371.

91. See John Burton, *A Letter to William Smellie, M.D. Containing Critical and Practical Remarks Upon His Treatise on the Theory and Practice of Midwifery* (London: W. Owen, 1753), 75 and 231.

92. Fountain, "George Stubbs," 640–41; Oliver Kase, "'Make the Knife Go with the Pencil': Science and Art in George Stubbs's 'Anatomy of the Horse,'" in *George Stubbs, 1724–1806: Science into Art*, ed. Herbert W. Rott (Munich: Prestel, 2012), 52–56. Although Aris Sarafianos has convincingly pointed out the flaws in seeing Stubbs's *Anatomy of the Horse* simply as an imitator of Albinus's atlas, he does acknowledge the debt of influence; see "George Stubbs's Dissection of the Horse and the Expressiveness of 'Facsimiles,'" in *Liberating Medicine, 1720–1835*, ed. Tristanne Connolly and Steve Clark (London: Pickering & Chatto, 2009), 169.

93. Kase, "'Make the Knife Go with the Pencil,'" 53.

94. Quoted in Kase, "'Make the Knife Go with the Pencil,'" 52.

95. Fountain, "George Stubbs," 641.

96. See Cunningham, *Anatomist Anatomis'd*, 173; Terence Doherty, *The Anatomical Works of George Stubbs* (London: Secker & Warburg, 1974), 3; Kase, "'Make the Knife Go with the Pencil,'" 59.

97. See Nickelsen, *Draughtsmen, Botanists and Nature*, 185–228.

98. Burton, *Essay*, 188.

99. See chapter 4, pp. 175–78.

100. Burton, *Letter to William Smellie*, vi.

101. Burton, *Essay*, 103; for a discussion of noninterventionist sentiments in this period, see Shorter, "Management of Normal Deliveries."

102. Marieke M. A. Hendriksen, *Elegant Anatomy: The Eighteenth-Century Leiden Anatomical Collections* (Leiden: Brill, 2014), 10–12.

103. See David Irwin, *Neoclassicism* (London: Phaidon, 1997).

104. See Charles Saumarez Smith, *The Company of Artists: The Origins of the Royal Academy of Arts in London* (London: Modern Art Press, 2012).

105. William Hogarth, *The Analysis of Beauty: Written with a View of Fixing the Fluctuating Ideas of Taste* (London: The Author, 1753).

106. Hendriksen, *Elegant Anatomy*, 12.

107. Massey, "Pregnancy and Pathology," 73.

108. See Kemp, "True to Their Natures"; Mount, "Van Rymsdyk and the Nature-Menders"; Martin Postle, "Flayed for Art: The Écorché Figure in the English Art Academy," *British Art Journal* 5, no. 1 (2004): 55–63.

109. Postle, "Flayed for Art," 59.

110. Hunter, *Anatomy of the Human Gravid Uterus*, sec. Preface.

111. Punt, *Bernard Siegfried Albinus*, 18.

112. Burton, *Letter to William Smellie*, 75.

113. See, for example, Carin Berkowitz, "The Beauty of Anatomy: Visual Displays and Surgical Education in Early-Nineteenth-Century London," *Bulletin of the History of Medicine* 85, no. 2 (2011): 272.

114. Daston and Galison, *Objectivity*, 75–77.

115. Martin Kemp, "Style and Non-style in Anatomical Illustration: From Renaissance Humanism to Henry Gray," *Journal of Anatomy* 216 (2010): 198.

116. Hogarth, *Analysis of Beauty*, 74.

117. Burton, *Letter to William Smellie*, 231.

118. Burton, *Letter to William Smellie*, 232.

119. [Kirkpatric], "Review of Burton's 'An Essay Towards a Complete New System of Midwifry,'" *Monthly Review*, September 1751, 290.

120. Burton, *Letter to William Smellie*, 244.

121. Smellie, *Sett of Anatomical Tables*, sec. Preface.

122. Smellie, *Sett of Anatomical Tables*, sec. Preface.

Conclusion

1. See Mary E. Fissell, "When the Birds and the Bees Were Not Enough: Aristotle's Masterpiece," *Public Domain Review*, 2015, http://publicdomainreview.org/2015/08/19/when-the-birds-and-the-bees-were-not-enough-aristotles-masterpiece/.

2. Smellie, *Sett of Anatomical Tables*; Hunter, *Anatomy of the Human Gravid Uterus*; Jean-Louis Baudelocque, *L'art des accouchemens, par M. Baudelocque, membre du collége & adjoint au comité perpétuel de l'Académie royale de chirurgie*, 2 vols. (Paris: Méquignon, 1781); Jacques-Pierre Maygrier, *Nouvelles demonstrations d'accouchemens, avec des planches en taille-douce, accompagnées d'un texte raisonné, proper à en faciliter l'explication, format in-folio* (Paris: Béchet, 1822).

3. Alison Nuttall, "Midwifery, 1800–1920: The Journey to Registration," in *Nursing and Midwifery in Britain since 1700*, ed. Anne Borsay and Billie Hunter (Basingstoke: Palgrave Macmillan, 2012), 128–50; Ornella Moscucci, *The Science of Woman: Gynaecology and Gender in England, 1800–1929* (Cambridge: Cambridge University Press, 1990), 42–74; Anne Summers, "The Mysterious Demise of Sarah Gamp: The Domiciliary Nurse and Her Detractors, c. 1830–1860," *Victorian Studies* 32, no. 3 (1989): 365–86; Frances J. Badger, "Illuminating Nineteenth-Century Urban Midwifery: The Register of a Coventry Midwife," *Women's History Review* 23, no. 5 (2014): 683–705.

4. Tania McIntosh, "Profession, Skill or Domestic Duty? Midwifery in Sheffield, 1881–1936," *Social History of Medicine* 11, no. 3 (1998): 403–20; Billie Hunter, "Midwifery, 1920–2000: The Reshaping of a Profession," in *Nursing and Midwifery in Britain since 1700*, ed. Anne Borsay and Billie Hunter (Basingstoke: Palgrave Macmillan, 2012), 151–76.

5. Kemp, "Style and Non-style in Anatomical Illustration," 205.

6. Dyer, *White*, 1–2.

7. See chapter 2, pp. 80–81, and chapter 5, p. 195.

8. M. Knight et al., "Saving Lives, Improving Mothers' Care—Lessons Learned to Inform Maternity Care from the UK and Ireland Confidential Enquiries into Maternal Deaths and Morbidity 2014–16" (Oxford: National Perinatal Epidemiology Unit, University of Oxford, 2018); Darrick Hamilton, "Post-racial Rhetoric, Racial Health Disparities, and Health Disparity Consequences of Stigma, Stress, and Racism" (Washington, DC: Washington Center for Equitable Growth, 2017).

9. See chapter 2, pp. 66–69.

10. Duden, "Fetus as an Object of Our Time"; Petchesky, "Fetal Images."

Bibliography

Adair Alberts, Allison. "Spiritual Suffering and Physical Protection in Childbirth in the South English Legendary Lives of Saint Margaret." *Journal of Medieval and Early Modern Studies* 46, no. 2 (2016): 289–314.

Albertus Magnus. "De Secretis Mulierum," c. 1470. UER MS.B 33. Universitätsbibliothek Erlangen-Nürnberg.

Albinus, Bernhard Siegfried. *Tabulae Sceleti et Musculorum Corporis Humani.* Leiden: Joannem and Hermannum Verbeek, 1747.

———. *Tabulae VII Uteri Mulieris Gravidae Cum Iam Parturiret Mortuae.* Leiden: Joannem and Hermannum Verbeek, 1748.

Al-Gailani, Salim. "'Antenatal Affairs': Maternal Marking and the Medical Management of Pregnancy in Britain around 1900." In *Imaginationen Des Ungeborenen/ Imaginations of the Unborn: Kulturelle Konzepte Pränataler Prägung von der Frühen Neuzeit zur Moderne/Cultural Concepts of Prenatal Imprinting from the Early Modern Period to the Present,* ed. Urte Helduser and Burkhard Dohm, 153–72. Heidelberg: Universitätsverlag Winter, 2018.

Anon. *Bibliotheca Anatomica, Medica, Chirurgica &c.* London: Printed by John Nutt, 1711.

Arnold-Foster, Agnes. "Medicine and the Body in Second-Wave Feminist Histories of the Nineteenth Century." *History* (2021): 1–19.

Arons, Wendy. "Introduction." In *When Midwifery Became a Male Physician's Province: The Sixteenth Century Handbook "The Rose Garden for Pregnant Women and Midwives, Newly Englished,"* ed. and trans. Arons. Jefferson, NC: McFarland, 1994.

Ashworth, William B., Jr. "The Persistent Beast: Recurring Images in Early Zoological Illustration." In *The Natural Sciences and the Arts: Aspects of Interaction from the Renaissance to the 20th Century. An International Symposium,* ed. Allan Ellenius, 46–66. Uppsala: Uppsala University, 1985.

Aulinger, B. "Social History of Art." In *Grove Art Online.* Oxford: Oxford University Press, 2003. https://www.oxfordartonline.com/groveart/view/10.1093/gao/9781884446054.001.0001/oao-9781884446054-e-7000079457.

B., J. [John Bulwer]. *Chirologia: Or the Naturall Language of the Hand. Composed of the Speaking Motions, and Discoursing Gestures Thereof. Whereunto Is Added Chironomia: Or, the Art of Manual Rhetoricke.* London: Tho. Harper, 1644.

Badger, Frances J. "Illuminating Nineteenth-Century Urban Midwifery: The Register of a Coventry Midwife." *Women's History Review* 23, no. 5 (2014): 683–705.

Baigrie, Brian S. "Descartes's Scientific Illustrations and 'La Grande Mécanique de La Nature.'" In *Picturing Knowledge: Historical and Philosophical Problems concerning the Use of Art in Science*, ed. Brian S. Baigrie, 86–134. Toronto: University of Toronto Press, 1996.

Battistini, Matilde. *Astrology, Magic, and Alchemy in Art*. Trans. Rosanna M. Giammanco Frongia. Los Angeles: J. Paul Getty Museum, 2004.

Baudelocque, Jean-Louis. *L'art des accouchemens, par M. Baudelocque, membre du collége & adjoint au comité perpétuel de l'Académie royale de chirurgie*. 2 vols. Paris: Méquignon, 1781.

Baxandall, Michael. *The Limewood Sculptors of Renaissance Germany*. New Haven: Yale University Press, 1980.

———. *Painting and Experience in Fifteenth Century Italy: A Primer in the Social History of Pictorial Style*. Oxford: Oxford University Press, 1988.

———. *Patterns of Intention: On the Historical Explanation of Pictures*. New Haven: Yale University Press, 1985.

Bender, John, and Michael Marrinan. *The Culture of Diagram*. Stanford: Stanford University Press, 2010.

Benjamin, Walter. *Illuminations*. Trans. Leon Wieseltier. New York: Schocken Books, 1968.

Bentley, Thomas. "The Fift Lampe of Virginitie: Conteining Sundrie Forms of Christian Praiers and Meditations, to Bee Used Onlie of and for All Sorts and Degrees of Women, in Their Severall Ages and Callings." In *The Monument of Matrones*. London: Henrie Denham, 1582.

Berkowitz, Carin. "The Beauty of Anatomy: Visual Displays and Surgical Education in Early-Nineteenth-Century London." *Bulletin of the History of Medicine* 85, no. 2 (2011): 248–78.

———. "The Illustrious Anatomist: Authorship, Patronage, and Illustrative Style in Anatomy Folios, 1700–1840." *Bulletin of the History of Medicine* 89, no. 2 (2015): 171–208.

———. "Systems of Display: The Making of Anatomical Knowledge in Enlightenment Britain." *British Journal for the History of Science* 46, no. 3 (2013): 359–87.

Bernard, C., and L. Barr. "Burton, John (1710–1171)." In *Oxford Dictionary of National Biography*. Oxford: Oxford University Press, 2004. https://doi.org/10.1093/ref:odnb/4134.

Bertoloni Meli, Domenico. "Machines and the Body between Anatomy and Pathology." In *Modèle métaphore machine merveille*, ed. Aurélia Gaillard, Jean-Yves Goffi, Bernard Roukhomovsky, and Sophie Roux, 53–68. Bordeaux: Presses Universitaires de Bordeaux, 2012.

Beveridge, Anne Dulau. "The Anatomist and the Artists: Hunter's Involvement." In *William Hunter's World: The Art and Science of Eighteenth-Century Collecting*, ed. E. Geoffrey Hancock, Nick Pearce, and Mungo Campbell, 81–95. Farnham, UK: Ashgate, 2015.

Bidloo, Govert. *Anatomia Humani Corporis, Centum & Quinque Tabulis, per Artificiosiss. G. de Lairesse Ad Vivum Delineatis*. Amsterdam: the widow of Joannes van Someren, the heirs of Joannes van Dyk, Henry Boom and the widow of Theodore Boom, 1685.

Black, Daniel. *Embodiment and Mechanisation: Reciprocal Understandings of Body and Machine from the Renaissance to the Present.* Farnham, UK: Ashgate, 2014.

Black, Peter. "Taste and the Anatomist." In *"My Highest Pleasures": William Hunter's Art Collection,* ed. Peter Black, 63–100. London: The Hunterian, University of Glasgow in association with Paul Holberton Publishing, 2007.

Blackwell, Bonnie. "'Tristram Shandy' and the Theater of the Mechanical Mother." *ELH* 68, no. 1 (2000): 81–133.

Blunt, John [Samuel William Fores]. *Man-Midwifery Dissected: Or, the Obstetric Family-Instructor. For the Use of Married Couples, and Single Adults of Both Sexes.* London: S. W. Fores, 1793.

Bober, Harry. "The Zodiacal Miniature of the Très Riches Heures of the Duke of Berry: Its Sources and Meaning." *Journal of the Warburg and Courtauld Institutes* 11 (1948): 1–34.

Bolton, Lesley Annette. "An Edition, Translation and Commentary of Mustio's Gynaecia." PhD diss., University of Calgary, 2015.

Boucé, Paul-Gabriel. "Imagination, Pregnant Women, and Monsters in Eighteenth-Century England and France." In *Sexual Underworlds of the Enlightenment,* ed. G. S. Rousseau and Roy Porter, 86–100. Manchester: Manchester University Press, 1987.

Bredekamp, Horst, Vera Dünkel, and Birgit Schneider, eds. *The Technical Image: A History of Styles in Scientific Imagery.* Chicago: University of Chicago Press, 2015.

Brundin, Abigail, Deborah Howard, and Mary Laven. *The Sacred Home in Renaissance Italy.* Oxford: Oxford University Press, 2018.

Buckley, Jenifer. *Gender, Pregnancy and Power in Eighteenth-Century Literature: The Maternal Imagination.* Cham: Springer, 2017.

Burton, John. *An Essay Towards a Complete New System of Midwifry, Theoretical and Practical.* London: printed for James Hodges, 1751.

———. *A Letter to William Smellie, M.D. Containing Critical and Practical Remarks Upon His Treatise on the Theory and Practice of Midwifery.* London: W. Owen, 1753.

Butter, Alexander. "The Description of a Forceps for Extracting Children by the Head When Lodged Low in the Pelvis of the Mother." In *Medical Essays and Observations.* Edinburgh: William Monro, 1737.

Bynum, Caroline. "Why All the Fuss About the Body? A Medievalist's Perspective." *Critical Inquiry* 22, no. 1 (1995): 1–33.

Bynum, W. F., and Roy Porter, eds. *Medicine and the Five Senses.* Cambridge: Cambridge University Press, 1993.

———, eds. *William Hunter and the Eighteenth-Century Medical World.* Cambridge: Cambridge University Press, 1985.

C., T., I. D., M. S., and T. B. *The Compleat Midwifes Practice Enlarged.* London: Nathaniel Brooke, 1659.

———. *The Compleat Midwifes Practice: In the Most Weighty and High Concernments of the Birth of Man.* London: Nathaniel Brooke, 1656.

Cannella, Anne-Françoise. "Alchemical Iconography at the Dawn of the Modern Age: The Splendor Solis of Salomon Trismosin." In *The Power of Images in Early Modern Science,* ed. Wolfgang Lefèvre, Jürgen Renn, and Urs Schoepflin, 107–16. Basel: Birkhäuser, 2003.

Carlino, Andrea. *Paper Bodies: A Catalogue of Anatomical Fugitive Sheets, 1538–1687.*

Trans. Noga Arikha. London: Wellcome Institute for the History of Medicine, 1999.

Carlyle, Margaret, and Brian Callender. "The Fetus in Utero: From Mystery to Social Media." *Know: A Journal on the Formation of Knowledge* 3, no. 1 (2019): 15–67.

Case, John. *The Angelical Guide Shewing Men and Women Their Lott or Chance, in This Elementary Life.* London: Printed by I. Dawkes, 1697.

Cavallo, Sandra. "Exhibit 17—Pregnant Stones as Wonders of Nature." In *Reproduction: Antiquity to the Present Day*, ed. Nick Hopwood, Rebecca Flemming, and Lauren Kassell, n.p., digital edition. Cambridge: Cambridge University Press, 2018.

Chapman, Edmund. *An Essay on the Improvement of Midwifery: Chiefly with Regard to the Operation; to Which Are Added Fifty Cases, Selected from Upwards of Twenty-Five Years Practice.* London: A. Bettesworth, C. Hitch, J. Walthor, and T. Cowper, 1733.

———. *A Treatise on the Improvement of Midwifery, Chiefly with Regard to the Operation. To Which Are Added Fifty-Seven Cases, Selected from Upwards of Twenty-Seven Years Practice. The Second Edition, with Large Additions and Improvements.* London: John Brindley, John Clarke, and Charles Borbett, 1735.

Chartier, Roger. *The Order of Books: Readers, Authors, and Libraries in Europe between the Fourteenth and Eighteenth Centuries.* Trans. Lydia G. Cochrane. Stanford: Stanford University Press, 1994.

Chilvers, Ian, ed. "Mandorla." In *The Oxford Dictionary of Art.* Oxford: Oxford University Press, 2004.

Choulant, Ludwig. *History and Bibliography of Anatomic Illustration.* Trans. Mortimer Frank. Cambridge, MA: Maurizio Martino, 1993.

Churchill, Wendy D. "The Medical Practice of the Sexed Body: Women, Men, and Disease in Britain, circa 1600–1740." *Social History of Medicine* 18, no. 1 (2005): 3–22.

Cislo, Amy Eisen. *Paracelsus's Theory of Embodiment: Conception and Gestation in Early Modern Europe.* London: Pickering & Chatto, 2010.

Classen, Constance. *The Deepest Sense: A Cultural History of Touch.* Urbana: University of Illinois Press, 2012.

Condrau, Flurin. "The Patient's View Meets the Clinical Gaze." *Social History of Medicine* 30, no. 3 (2007): 525–40.

Congourdeau, Marie-Hélène. "Debating the Soul in Late Antiquity." In *Reproduction: Antiquity to the Present Day*, ed. Nick Hopwood, Rebecca Flemming, and Lauren Kassell, 109–21. Cambridge: Cambridge University Press, 2018.

Cooke, James. *Mellificium Chirurgiae: Or, the Marrow of Chirurgery Much Enlarged.* London: Benj. Shirley, 1676.

Cooper, Alix. "Homes and Households." In *The Cambridge History of Science: Early Modern Science*, ed. Katharine Park and Lorraine Daston, 3: 224–37. Cambridge: Cambridge University Press, 2006.

Cooter, Roger. "The Turn of the Body: History and the Politics of the Corporeal." *Arbor: Ciencia, Pensamiento y Cultura* 186, no. 743 (2010): 393–405.

Copenhaver, Brian P. "Magic." In *The Cambridge History of Science: Early Modern Science*, ed. Katharine Park and Lorraine Daston, 3: 518–40. Cambridge: Cambridge University Press, 2006.

Corry, Maya, Deborah Howard, and Mary Laven, eds. *Madonnas and Miracles: The Holy Home in Renaissance Italy.* London: Philip Wilson, 2017.

Cressy, David. *Birth, Marriage and Death: Ritual, Religion, and the Life-Cycle in Tudor and Stuart England.* Oxford: Oxford University Press, 1997.

———. *Literacy and the Social Order: Reading and Writing in Tudor and Stuart England.* Cambridge: Cambridge University Press, 1980.

Crowther-Heyck, Kathleen. "'Be Fruitful and Multiply': Genesis and Generation in Reformation Germany." *Renaissance Quarterly* 55, no. 3 (2002): 904–35.

———. "Wonderful Secrets of Nature: Natural Knowledge and Religious Piety in Reformation Germany." *Isis* 94, no. 2 (2003): 253–73.

Crummer, LeRoy. "The Copper Plates in Raynalde and Geminus." *Proceedings of the Royal Society of Medicine* 20, no. 1 (1926): 53–56.

Culpeper, Nicholas. *A Directory for Midwives: Or, a Guide for Women, in Their Conception, Bearing and Suckling Their Children.* London: Peter Cole, 1651.

———. *Mr. Culpeper's Treatise of Aurum Potabile: Being a Description of the Three-Fold World. Viz. Elimentary, Celestiall, Intellectual Containing the Knowledge Necessary to the Study of Hermetick Philosophy.* London: G. Eversden, 1656.

Cunningham, Andrew. *The Anatomist Anatomis'd: An Experimental Discipline in Enlightenment Europe.* Farnham, UK: Ashgate, 2010.

———. "Petrus ('Peter') Camper: A Dutchman in the Medical World of Eighteenth-Century England." In *Petrus Camper in Context: Science, the Arts, and Society in the Eighteenth-Century Dutch Republic*, ed. Klaas van Berkel and Bart A. M. Ramakers, 111–28. Hilversum: Verloren, 2015.

D., S. I. M. *Kurtze, Jedoch Außführliche Abhandlung von Erzeugung Der Menschen Und Dem Kinder-Gebähren Nebst Deme, Was Sich Darbey Zuträgt.* Frankfurt am Main: Oehrling, 1700.

Dackerman, Susan. "Dürer's Indexical Fantasy: The Rhinoceros and Printmaking." In *Prints and the Pursuit of Knowledge in Early Modern Europe*, ed. Dackerman, 164–71. New Haven: Yale University Press, 2011.

———, ed. *Prints and the Pursuit of Knowledge in Early Modern Europe.* New Haven: Yale University Press, 2011.

Daston, Lorraine. "Epistemic Images." In *Vision and Its Instruments: Art, Science and Technology in Early Modern Europe*, ed. Alina Payne, 13–35. University Park: Pennsylvania State University Press, 2015.

Daston, Lorraine, and Peter Galison. *Objectivity.* New York: Zone Books, 2010.

Daston, Lorraine, and Elizabeth Lunbeck, eds. *Histories of Scientific Observation.* Chicago: University of Chicago Press, 2011.

Daston, Lorraine, and Katharine Park. *Wonders and the Order of Nature: 1150–1750.* New York: Zone Books, 1998.

Daston, Lorraine, and H. Otto Sibum. "Introduction: Scientific Personae and Their Histories." *Science in Context* 16, nos. 1/2 (2003): 1–8.

Davis, Isabel. "Love, Wind Eggs, and Mere Conceptions: Non-generation in William Harvey's De Conceptione." *Textual Practice* 33, no. 8 (2019): 1321–40.

Dawkes, Thomas. *The Midwife Rightly Instructed: Or, the Way, Which All Women Desirous to Learn, Should Take, To Acquire the True Knowledge and Be Successful in the Practice of, the Art of Midwifery.* London: Printed for J. Oswald, 1736.

Dempsey, Charles. *Inventing the Renaissance Putto.* Chapel Hill: University of North Carolina Press, 2001.

Deventer, Hendrik van. *The Art of Midwifery Improv'd: Fully and Plainly Laying Down Whatever Instructions Are Requisite to Make a Compleat Midwife and the Many Errors in All the Books Hitherto Written Upon This Subject Clearly Refuted.* London: E. Curll, J. Pemberton, and W. Taylor, 1716.

———. *Dageraet van vroet-vrouwen: Ofte voorlooper van het tractaet genaemt nieuw ligt der vroet-vrouwen.* Leiden: n.p., 1696.

———. *Manuale operatien, I. deel. Zijnde een nieuw ligt voor vroed-meesters en vroed-vrouwen, haar getrouwelijk ontdekkende al wat nodig is te doen om barende vrouwen te helpen verlossen.* [The Hague]: n.p., 1701.

———. *Nader vertoog van de sware baringen, en van de toetsteen en 't schild der vroed-vrouwen.* Delft: Reinier Boitet, 1719.

———. *New Improvements in the Art of Midwifery.* London: T. Warner, 1724.

———. *Operationes Chirurgicae Novum Lumen Exhibentes Obstetricantibus, Quo Fideliter Manifestatur Ars Obstetricandi.* Leiden: Andream Dyckhuisen, 1701.

"Diagram, n." In *Oxford English Dictionary.* Oxford: Oxford University Press, 2020. oed.com.

Ditzen, Stefan. "Instrument-Aided Vision and the Imagination: The Migration of Worms and Dragons in Early Microscopy." In *The Technical Image: A History of Styles in Scientific Imagery,* ed. Horst Bredekamp, Vera Dünkel, and Birgit Schneider, 130–41. Chicago: University of Chicago Press, 2015.

Dixon, Laurinda S. *Perilous Chastity: Women and Illness in Pre-Enlightenment Art and Medicine.* Ithaca, NY: Cornell University Press, 1995.

Doe, Janet. *A Bibliography, 1545–1940, of the Works of Ambroise Paré, 1510–1590: Premier Chirurgien & Conseiller Du Roi.* Amsterdam: Gérard Th. van Heusden, 1976.

Doherty, Terence. *The Anatomical Works of George Stubbs.* London: Secker & Warburg, 1974.

Donaghy, Paige. "Wind Eggs and False Conceptions: Thinking with Formless Births in Seventeenth-Century European Natural Philosophy." *Intellectual History Review* (2021): 1–22.

Donnison, Jean. *Midwives and Medical Men: A History of Inter-professional Rivalries and Women's Rights.* London: Heinemann, 1977.

Douglas, John. *A Short Account of the State of Midwifery in London, Westminster, &c.* London: The Author, 1736.

Douglas, William. *A Letter to Dr. Smellie: Shewing the Impropriety of His New-Invented Forceps; as Also, the Absurdity of His Method of Teaching and Practising Midwifery.* London: J. Roberts, 1748.

Duden, Barbara. "The Fetus as an Object of Our Time." *RES: Anthropology and Aesthetics* 25 (1994): 132–35.

———. "The Fetus on the 'Farther Shore': Toward a History of the Unborn." In *Fetal Subjects, Feminist Positions,* ed. Lynn M. Morgan and Meredith Michaels, 13–25. Philadelphia: University of Pennsylvania Press, 1999.

———. *The Woman beneath the Skin: A Doctor's Patients in Eighteenth-Century Germany.* Trans. Thomas Dunlap. Cambridge, MA: Harvard University Press, 1991.

Dunn, P. M. "Eucharius Rösslin (c. 1470–1626) of Germany and the Rebirth of Midwifery." *Archives of Disease in Childhood: Fetal and Neonatal Edition* 79, no. 1 (1998): 77–78.

Dyer, Richard. *White.* London: Routledge, 1997.

Eamon, William. "From the Secrets of Nature to Public Knowledge." In *Reapprais-*

als of the Scientific Revolution, ed. David C. Lindberg and Robert S. Westman, 333–65. Cambridge: Cambridge University Press, 1990.

Eccles, Audrey. *Obstetrics and Gynaecology in Tudor and Stuart England*. London: Croom Helm, 1982.

Egerton, Judy. *George Stubbs, Painter: Catalogue Raisonné*. New Haven: Yale University Press, 2007.

Eggert, Katherine. *Disknowledge: Literature, Alchemy and the End of Humanism in Renaissance England*. Philadelphia: University of Pennsylvania Press, 2015.

Eisenstein, Elizabeth L. *The Printing Press as an Agent of Change: Communications and Cultural Transformations in Early-Modern Europe*. 2 vols. Cambridge: Cambridge University Press, 1979.

Elkins, James. "Art History and Images That Are Not Art." *Art Bulletin* 77, no. 4 (1995): 553–71.

Eustachi, Bartolomeo. *Tabulae Anatomicae Clarissimi Viri Bartholomaei Eustachii Quas à Tenebris Tandem Vindicatas et Sanctissimi Domini Clementis XI, Pont. Max., Munificentiâ*. Rome: Francisci Gonzagae, 1714.

Evenden, Doreen. *The Midwives of Seventeenth-Century London*. Cambridge: Cambridge University Press, 2000.

Feldhay, Rivka. "Religion." In *The Cambridge History of Science: Early Modern Science*, ed. Katharine Park and Lorraine Daston, 3: 727–55. Cambridge: Cambridge University Press, 2006.

Fend, Mechthild. "Drawing the Cadaver 'Ad Vivum': Gérard de Lairesse's Illustrations for Govard Bidloo's Anatomia Humani Corporis." In *Ad Vivum? Visual Materials and the Vocabulary of Life-Likeness in Europe before 1800*, ed. Thomas Balfe, Joanna Woodall, and Claus Zittel, 294–327. Leiden: Brill, 2019.

Ferrell, Lori Anne. "Page Techne: Interpreting Diagrams in Early Modern English 'How-To' Books." In *Printed Images in Early Modern Britain: Essays in Interpretation*, ed. Michael Hunter, 113–26. Farnham, UK: Ashgate, 2010.

Fissell, Mary E. "Hairy Women and Naked Truths: Gender and the Politics of Knowledge in 'Aristotle's Masterpiece.'" *William and Mary Quarterly* 60, no. 1 (2003): 43–74.

———. "Man-Midwifery Revisited." In *Reproduction: Antiquity to the Present Day*, ed. Nick Hopwood, Rebecca Flemming, and Lauren Kassell, 319–32. Cambridge: Cambridge University Press, 2018.

———. "Remaking the Maternal Body in England, 1680–1730." *Journal of the History of Sexuality* 26, no. 1 (2017): 114–39.

———. *Vernacular Bodies: The Politics of Reproduction in Early Modern England*. Oxford: Oxford University Press, 2004.

———. "When the Birds and the Bees Were Not Enough: Aristotle's Masterpiece." *Public Domain Review*, 2015. http://publicdomainreview.org/2015/08/19/when -the-birds-and-the-bees-were-not-enough-aristotles-masterpiece/.

Forman Cody, Lisa. *Birthing the Nation: Sex, Science, and the Conception of Eighteenth-Century Britons*. Oxford: Oxford University Press, 2005.

———. "The Politics of Reproduction: From Midwives' Alternative Public Sphere to the Public Spectacle of Man-Midwifery." *Eighteenth-Century Studies* 43, no. 4 (1999): 477–95.

Foucault, Michel. *The Birth of the Clinic: An Archaeology of Medical Perception*. Trans. A. M. Sheridan. London: Routledge, 2003.

———. *The Order of Things: An Archaeology of the Human Sciences*. London: Routledge, 2005.

Fountain, R. B. "George Stubbs (1724–1806) as an Anatomist." *Proceedings of the Royal Society of Medicine Journal* 61 (1968): 629–46.

Fox, Adam. *Oral and Literate Culture in England, 1500–1700*. Oxford: Oxford University Press, 2011.

Fox, Sarah. *Giving Birth in Eighteenth-Century England*. London: University of London Press, 2022.

Freeman, Stephen. *The Ladies Friend, or, Complete Physical Library, for the Benefit and Particular Use of the Ladies of Great Britain and Ireland*. London: The Author, 1785.

———. *The New Good Samaritan: Or, Domestic Practical Physician; Extracted Chiefly from the Medical Essays of the Learned Academies in Europe*. London: The Author, 1780.

Fumerton, Patricia, and Megan E. Palmer. "Lasting Impressions of the Common Woodcut." In *The Routledge Handbook of Material Culture in Early Modern Europe*, ed. Catherine Richardson, Tara Hamling, and David Gaimster, 383–400. London: Routledge, 2017.

Gage, Frances. *Painting as Medicine in Early Modern Rome: Giulio Mancini and the Efficacy of Art*. University Park: Pennsylvania State University Press, 2016.

Galen. *Galen on the Usefulness of the Parts of the Body*. Trans. Margaret Tallmadge May. Ithaca, NY: Cornell University Press, 1968.

Galuzzi, Paolo. "Art and Artifice in the Depiction of Renaissance Machines." In *The Power of Images in Early Modern Science*, ed. Wolfgang Lefèvre, Jürgen Renn, and Urs Schoepflin, 47–68. Basel: Birkhäuser, 2003.

Gelbart, Nina Rattner. *The King's Midwife: A History and Mystery of Madame Du Coudray*. Berkeley: University of California Press, 1998.

Gélis, Jacques. *History of Childbirth: Fertility, Pregnancy and Birth in Early Modern Europe*. Trans. Rosemary Morris. Boston: Northeastern University Press, 1991.

Giffard, William. *Cases in Midwifry: Written by the Late Mr. William Giffard, Surgeon and Man-Midwife. Revis'd and Publish'd by Edward Hody, M.D. and Fellow of the Royal Society*. London: B. Motte, T. Wotton, L. Gilliver & J. Nourse, 1734.

Gombrich, E. H. *The Uses of Images: Studies in the Social Function of Art and Visual Communication*. London: Phaidon, 1999.

Gowing, Laura. *Common Bodies: Women, Touch, and Power in Seventeenth-Century England*. New Haven: Yale University Press, 2003.

Green, Monica. "Gendering the History of Women's Healthcare." *Gender & History* 20, no. 3 (2008): 487–518.

———. *Making Women's Medicine Masculine: The Rise of Male Authority in Premodern Gynaecology*. Oxford: Oxford University Press, 2008.

———. "The Sources of Eucharius Rösslin's 'Rosegarden for Pregnant Women and Midwives' (1513)." *Medical History* 53 (2009): 167–92.

"Grignion, Charles I." In *Benezit Dictionary of Artists*. Oxford: Oxford University Press, 2011. http://www.oxfordartonline.com.libproxy.ucl.ac.uk/subscriber/book/oao_benz.

Grigson, Caroline. "'An Universal Language': William Hunter and the Production of The Anatomy of the Human Gravid Uterus." In *William Hunter's World: The*

Art and Science of Eighteenth-Century Collecting, ed. E. Geoffrey Hancock, Nick Pearce, and Mungo Campbell, 59–80. Farnham, UK: Ashgate, 2015.

Groebner, Valentin. "Complexio/Complexion: Categorizing Individual Natures, 1250–1600." In *The Moral Authority of Nature*, ed. Lorraine Daston and Fernando Vidal, 362–83. Chicago: University of Chicago Press, 2003.

Guillemeau, Jacques. *Child-Birth, or the Happy Deliverie of Women*. London: Printed by A. Hatfield, 1612.

Gwara, Joseph J., and Mary Morse. "A Birth Girdle Printed by Wynkyn de Worde." *The Library* 13, no. 1 (2012): 33–62.

Hall, Bert S. "The Didactic and the Elegant: Some Thoughts on Scientific and Technological Illustrations in the Middle Ages and Renaissance." In *Picturing Knowledge: Historical and Philosophical Problems concerning the Use of Art in Science*, ed. Brian S. Baigrie, 3–39. Toronto: University of Toronto Press, 1996.

Hall, Kim F. *Things of Darkness: Economies of Race and Gender in Early Modern England*. Ithaca, NY: Cornell University Press, 1996.

Hallam, Elizabeth. *Anatomy Museum: Death and the Body Displayed*. London: Reaktion Books, 2016.

Hamilton, Darrick. "Post-racial Rhetoric, Racial Health Disparities, and Health Disparity Consequences of Stigma, Stress, and Racism." Washington, DC: Washington Center for Equitable Growth, 2017.

Hamling, Tara. *Decorating the "Godly" Household: Religious Art in Post-Reformation Britain*. New Haven: Yale University Press, 2010.

Hancock, E. Geoffrey, Nick Pearce, and Mungo Campbell, eds. *William Hunter's World: The Art and Science of Eighteenth-Century Collecting*. Farnham, UK: Ashgate, 2015.

Hansen, Morten Steen. "The Infant Christ with the 'Arma' Christi: François Duquesnoy and the Typology of the Putto." *Zeitschrift für Kunstgeschichte* 71, no. 1 (2008): 121–33.

Harley, David. "Provincial Midwives in England: Lancashire and Cheshire, 1660–1760." In *The Art of Midwifery: Early Modern Midwives in Europe*, ed. Hilary Marland, 27–48. London: Routledge, 1993.

Harvey, Elizabeth D. "Introduction: The 'Sense of All Senses.'" In *Sensible Flesh: On Touch in Early Modern Culture*, ed. Harvey, 1–21. Philadelphia: University of Pennsylvania Press, 2003.

———, ed. *Sensible Flesh: On Touch in Early Modern Culture*. Philadelphia: University of Pennsylvania Press, 2003.

———. "The Touching Organ: Allegory, Anatomy, and the Renaissance Skin Envelope." In *Sensible Flesh: On Touch in Early Modern Culture*, ed. Harvey, 81–102. Philadelphia: University of Pennsylvania Press, 2003.

Haslem, Lori Schroeder. "Monstrous Issues: The Uterus as Riddle in Early Modern Medical Texts." In *The Female Body in Medicine and Literature*, ed. Andrew Mangham and Greta Depledge, 34–50. Liverpool: Liverpool University Press, 2011.

Heilbron, John. "Domesticating Science in the Eighteenth Century." In *Science and the Visual Image in the Enlightenment*, ed. W.R. Shea, 1–24. Canton, MA: Science History Publications, 2000.

Heister, Lorenz. *A General System of Surgery: In Three Parts*. 2 vols. London: W. Innys, C. Davis, J. Clark, R. Manby, and J. Whiston, 1743.

Hellwarth, Jennifer Wynne. "'I Wyl Wright of Women Prevy Sekenes': Imagining Female Literacy and Textual Communities in Medieval and Early Modern Midwifery Manuals." *Critical Survey* 14, no. 1 (2002): 44–63.

———. *The Reproductive Unconscious in Medieval and Early Modern England*. London: Routledge, 2002.

Hendriksen, Marieke M.A. *Elegant Anatomy: The Eighteenth-Century Leiden Anatomical Collections*. Leiden: Brill, 2014.

———. "The Fate of the Beaded Babies: Forgotten Early Colonial Anatomy." In *The Fate of Anatomical Collections*, ed. Rina Knoeff and Robert Zwijnenberg, 179–94. Farnham, UK: Ashgate, 2015.

Hobby, Elaine. "'Secrets of the Female Sex': Jane Sharp, the Reproductive Female Body, and Early Modern Midwifery Manuals." *Women's Writing* 8, no. 2 (2001): 201–12.

Hogarth, William. *The Analysis of Beauty: Written with a View of Fixing the Fluctuating Ideas of Taste*. London: The Author, 1753.

Hopwood, Nick. *Haeckel's Embryos: Images, Evolution, and Fraud*. Chicago: University of Chicago Press, 2015.

Horstmanshoff, H. F. J., A. M. Luyendijk-Elshout, and F. G. Schlesinger, eds. *The Four Seasons of Human Life: Four Anonymous Engravings from the Trent Collection*. Rotterdam: Erasmus, 2002.

Hughes, Alicia. "Creating and Controlling a Visual Language: Image-Making and Authorial Control in William Hunter's Collection of Anatomical Drawings and Prints." PhD diss., University of Glasgow, 2019.

Huisman, Tim. "Squares and Diopters: The Drawing System of a Famous Anatomical Atlas." *Tractrix* 4 (1992): 1–12.

Hunter, Billie. "Midwifery, 1920–2000: The Reshaping of a Profession." In *Nursing and Midwifery in Britain since 1700*, ed. Anne Borsay and Billie Hunter, 151–76. Basingstoke, UK: Palgrave Macmillan, 2012.

Hunter, Matthew C. *Wicked Intelligence: Visual Art and the Science of Experiment in Restoration London*. Chicago: University of Chicago Press, 2013.

Hunter, William. *The Anatomy of the Human Gravid Uterus Exhibited in Figures*. Birmingham: John Baskerville, 1774.

———. "Lectures Anatomical and Chirurgical by William Hunter," 1775. MS Hunter 1(3). Glasgow University Library.

Irwin, David. *Neoclassicism*. London: Phaidon, 1997.

Israel, Jonathan I. "Enlightenment, Radical Enlightenment and the 'Medical Revolution' of the Late Seventeenth and Eighteenth Centuries." In *Medicine and Religion in Enlightenment Europe*, ed. Ole Peter Grell and Andrew Cunningham, 5–28. Aldershot, UK: Ashgate, 2007.

Ivins, William M., Jr. *Prints and Visual Communication*. Cambridge, MA: MIT Press, 1978.

James, Robert. *Dictionnaire universel de medecine, de chirurgie, de chymie, de botanique, d'anatomie, de pharmacie, d'histoire naturelle, &c.: Précédé, d'un discours historique sur l'origine & les progres de la medecine*. Trans. Diderot, Eidous, and Toussaint. Paris: Briasson, David, and Durand, 1746.

———. *A Medicinal Dictionary: Including Physic, Surgery, Anatomy, Chemistry, and Botany, in All Their Branches Relative to Medicine*. 3 vols. London: T. Osborne, 1743.

Jardine, Nicholas, and Isla Fay, eds. *Observing the World through Images: Diagrams and Figures in the Early-Modern Arts and Sciences*. Leiden: Brill, 2014.

Jewson, N. D. "The Disappearance of the Sick-Man from Medical Cosmology, 1770–1870." *International Journal of Epidemiology* 38 (2009): 622–33.

Jones, David Albert. *The Soul of the Embryo: An Enquiry into the Status of the Human Embryo in the Christian Tradition*. London: Continuum, 2004.

Jordanova, Ludmilla. *Nature Displayed: Gender, Science, and Medicine, 1760–1820*. New York: Longman, 1999.

———. *Sexual Visions: Images of Gender in Science and Medicine between the Eighteenth and Twentieth Centuries*. New York: Harvester Wheatsheaf, 1989.

Kaitaro, Timo. "'Man Is an Admirable Machine'—A Dangerous Idea?" *La Lettre de La Maison Française d'Oxford* 14 (2001): 105–22.

Kang, Minsoo. "From the Man-Machine to the Automaton-Man: The Enlightenment Origins of the Mechanistic Imagery of Humanity." In *Vital Matters: Eighteenth-Century Views of Conception, Life, and Death*, ed. Helen Deutsch and Mary Terrall, 148–73. Toronto: University of Toronto Press, 2012.

Karr Schmidt, Suzanne. *Altered and Adorned: Using Renaissance Prints in Daily Life*. New Haven: Yale University Press, 2011.

Kase, Oliver. "'Make the Knife Go with the Pencil': Science and Art in George Stubbs's 'Anatomy of the Horse.'" In *George Stubbs 1724–1806: Science into Art*, ed. Herbert W. Rott, 43–59. Munich: Prestel, 2012.

Kassell, Lauren. "Casebooks in Early Modern England: Medicine, Astrology, and Written Records." *Bulletin of the History of Medicine* 88, no. 4 (2014): 595–625.

———. "Fruitful Bodies and Astrological Medicine." In *Reproduction: Antiquity to the Present Day*, ed. Nick Hopwood, Rebecca Flemming, and Lauren Kassell, 225–40. Cambridge: Cambridge University Press, 2018.

Kassell, Lauren, Michael Hawkins, Robert Ralley, John Young, Joanne Edge, Janet Yvonne Martin-Portugues, and Natalie Koaukji, eds. *The Casebooks of Simon Forman and Richard Napier, 1596–1634: A Digital Edition*. Accessed 12 June 2019. https://casebooks.lib.cam.ac.uk.

Keller, Eve. "Embryonic Individuals: The Rhetoric of Seventeenth-Century Embryology and the Construction of Early-Modern Identity." *Eighteenth-Century Studies* 33, no. 3 (2000): 321–48.

———. *Generating Bodies and Gendered Selves: The Rhetoric of Reproduction in Early Modern England*. Seattle: University of Washington Press, 2007.

———. "The Subject of Touch: Medical Authority in Early Modern Midwifery." In *Sensible Flesh: On Touch in Early Modern Culture*, ed. Elizabeth D. Harvey, 62–80. Philadelphia: University of Pennsylvania Press, 2003.

Kemp, Martin. "Coming into Line: Graphic Demonstrations of Skill in Renaissance and Baroque Engravings." In *Sight & Insight: Essays on Art and Culture in Honour of E. H. Gombrich at 85*, ed. John Onians, 221–44. London: Phaidon, 1994.

———. "'The Mark of Truth': Looking and Learning in Some Anatomical Illustrations from the Renaissance and Eighteenth Century." In *Medicine and the Five Senses*, ed. W. F. Bynum and Roy Porter, 85–121. Cambridge: Cambridge University Press, 1993.

———. "Style and Non-style in Anatomical Illustration: From Renaissance Humanism to Henry Gray." *Journal of Anatomy* 216 (2010): 192–208.

———. "True to Their Natures: Sir Joshua Reynolds and Dr William Hunter at the

Royal Academy of Arts." *Notes and Records of the Royal Society of London* 46, no. 1 (1992): 77–88.

Kerckring, Theodor. *Anthropogeniae Ichnographia: Sive Conformation Foetus Ab Ovo Usque Ad Ossificationis Principa, in Supplementum Osteogeniae Foetum.* Amsterdam: Andreas Frisius, 1671.

King, Helen. *Midwifery, Obstetrics and the Rise of Gynaecology: The Uses of a Sixteenth-Century Compendium.* Aldershot, UK: Ashgate, 2007.

———. *The One-Sex Body on Trial: The Classical and Early Modern Evidence.* London: Routledge, 2013.

[Kirkpatric]. "Review of Burton's 'An Essay Towards a Complete New System of Midwifry.'" *Monthly Review,* September 1751, 286–92.

Kitch, Aaron. "The 'Ingendred' Stone: The Ripley Scrolls and the Generative Science of Alchemy." *Huntington Library Quarterly* 78, no. 1 (2015): 87–125.

Klestinec, Cynthia. "Practical Experience in Anatomy." In *The Body as Object and Instrument of Knowledge: Embodied Empiricism in Early Modern Science,* ed. Charles T. Wolfe and Ofer Gal, 33–58. Dordrecht: Springer, 2010.

———. "Sex, Medicine, and Disease: Welcoming Wombs and Vernacular Anatomies." In *A Cultural History of Sexuality in the Renaissance,* ed. Bette Talvacchia, 113–35. Oxford: Berg, 2011.

———. "Touch, Trust and Compliance in Early Modern Medical Practice." In *The Edinburgh Companion to the Critical Medical Humanities,* ed. Anne Whitehead and Angela Woods, 209–24. Edinburgh: Edinburgh University Press, 2016.

Knight, M., K. Bunch, D. Tuffnell, H. Jayakody, J. Shakespeare, R. Kotnis, S. Kenyon, and J. J. Kurinczuk. "Saving Lives, Improving Mothers' Care: Lessons Learned to Inform Maternity Care from the UK and Ireland Confidential Enquiries into Maternal Deaths and Morbidity, 2014–16." Oxford: National Perinatal Epidemiology Unit, University of Oxford, 2018.

Kostelnick, Charles, and Michael Hassett. *Shaping Information: The Rhetoric of Visual Conventions.* Carbondale: Southern Illinois University Press, 2003.

Krämer, Fabian. "The Persistent Image of an Unusual Centaur: A Biography of Aldrovandi's Two-Legged Centaur Woodcut." *Nuncius* 2 (2009): 313–40.

Krüger, Oliver. *Die mediale Religion: Probleme und Perspektiven der religionswissenschaftlichen und wissenssoziologischen Medienforschung.* Bielefeld: Transcript, 2012.

Kusukawa, Sachiko. "Copying as a Form of Knowing: Early Modern Scientific Images." Warburg Institute, 11 January 2017.

———. *Picturing the Book of Nature: Image, Text, and Argument in Sixteenth-Century Human Anatomy and Medical Botany.* Chicago: University of Chicago Press, 2012.

Laqueur, Thomas. *Making Sex: Body and Gender from the Greeks to Freud.* Cambridge, MA: Harvard University Press, 1990.

Latour, Bruno. "Visualisation and Cognition: Drawing Things Together." In *Knowledge and Society: Studies in the Sociology of Culture Past and Present,* ed. H. Kuklick, 6: 1–40. Greenwich, CT: Jai Press, 1986.

Lawrence, Susan C. "Educating the Senses: Students, Teachers and Medical Rhetoric in Eighteenth-Century London." In *Medicine and the Five Senses,* ed. W. F. Bynum and Roy Porter, 154–78. Cambridge: Cambridge University Press, 1993.

Leake, John. *The Description and Use of a Pair of New Forceps.* London: n.p., 1771.

Lechner, Gregor Martin. *Maria Gravida: Zum Schwangerschaftsmotiv in der bilden-den Kunst*. Zürich: Schnell & Steiner München, 1981.

Lefèvre, Wolfgang. "Introduction." In *Picturing Machines, 1400–1700*, ed. Wolfgang Lefèvre, 1–10. Cambridge, MA: MIT Press, 2004.

———, ed. *Picturing Machines, 1400–1700*. Cambridge, MA: MIT Press, 2004.

LeJacq, Seth Stein. "The Bounds of Domestic Healing: Medical Recipes, Storytell-ing and Surgery in Early Modern England." *Social History of Medicine* 26, no. 3 (2013): 451–68.

Lennox-Boyd, Christopher, Rob Dixon, and Tim Clayton. *George Stubbs: The Com-plete Engraved Works*. Culham, UK: Stipple, 1989.

Leong, Elaine. "Papering the Household: Paper, Recipes, and Everyday Technolo-gies in Early Modern England." In *Working with Paper: Gendered Practices in the History of Knowledge*, ed. Carla Bittel, Elaine Leong, and Christine von Oertzen, 32–45. Pittsburgh: University of Pittsburgh Press, 2019.

Leonhard, Karin. "Vermeer's Pregnant Women: On Human Generation and Picto-rial Representation." *Art History* 25, no. 3 (2002): 293–318.

Lewis, Flora. "The Wound in Christ's Side and the Instruments of the Passion: Gendered Experience and Response." In *Women and the Book: Assessing the Vi-sual Evidence*, ed. Lesley Smith and Jane H. M. Taylor, 204–29. London: British Library, 1996.

Lieske, Pam, ed. *Continental Midwives in Translation*. Vol. 3 of *Eighteenth-Century British Midwifery*. London: Pickering & Chatto, 2007.

———, ed. *Lying-In Hospitals, Male/Female Midwifery Debates*. Vol. 7. of *Eighteenth-Century British Midwifery*. London: Pickering & Chatto, 2007.

———. "'Made in Imitation of Real Women and Children': Obstetrical Machines in Eighteenth-Century Britain." In *The Female Body in Medicine and Literature*, ed. Andrew Mangham and Greta Depledge, 69–88. Liverpool: Liverpool University Press, 2011.

———, ed. *Midwifery Texts for Women*. Vol. 4 of *Eighteenth-Century British Mid-wifery*. London: Pickering & Chatto, 2007.

———, ed. *Midwifery Treatises: 1737-1784*. Vol. 9 of *Eighteenth-Century British Mid-wifery*. London: Pickering & Chatto, 2007.

———, ed. *The State of Midwifery Considered, William Smellie and His Critics*. Vol. 5 of *Eighteenth-Century British Midwifery*. London: Pickering & Chatto, 2007.

———. "William Smellie's Use of Obstetrical Machines and the Poor." *Studies in Eighteenth-Century Culture* 29 (2000): 65–86.

Lincoln, Evelyn. *Brilliant Discourse: Pictures and Readers in Early Modern Rome*. New Haven: Yale University Press, 2014.

Lo, Melissa. "Cut, Copy, and English Anatomy: Thomas Geminus and the Reor-dering of Vesalius's Canonical Body." In *Andreas Vesalius and the Fabrica in the Age of Printing: Art, Anatomy, and Printing in the Italian Renaissance*, ed. Rinaldo Fernando Canalis and Massimo Ciavolella, 225–56. Turnhout: Brepols, 2018.

———. "The Picture Multiple: Figuring, Thinking, and Knowing in Descartes's *Essais* (1637)." *Journal of the History of Ideas* 78, no. 3 (2017): 369–99.

Longo, Lawrence D., and Lawrence P. Reynolds. *Wombs with a View: Illustrations of the Gravid Uterus from the Renaissance through the Nineteenth Century*. Cham: Springer, 2016.

MacGregor, William B. "The Authority of Prints: An Early Modern Perspective." *Art History* 22, no. 3 (1999): 389–420.

Margócsy, Dániel. *Commercial Visions: Science, Trade, and Visual Culture in the Dutch Golden Age.* Chicago: University of Chicago Press, 2014.

Marr, Alexander. "Knowing Images." *Renaissance Quarterly*, no. 69 (2016): 1000–1013.

———. "Pregnant Wit: Ingegno in Renaissance England." *British Art Studies* 1 (2015).

Marsh, Christopher. "A Woodcut and Its Wanderings in Seventeenth-Century England." *Huntington Library Quarterly* 79, no. 2 (2016): 245–62.

Massey, Lyle. "Against the 'Statue Anatomized': The 'Art' of Eighteenth-Century Anatomy on Trial." *Art History* 40, no. 1 (2017): 68–103.

———. "The Alchemical Womb: Johann Remmelin's Catoptrum Microcosmicum." In *Visual Cultures of Secrecy in Early Modern Europe,* ed. Timothy McCall, Sean Roberts, and Giancarlo Fiorenza, 208–28. Kirksville, MO: Truman State University Press, 2013.

———. "Pregnancy and Pathology: Picturing Childbirth in Eighteenth-Century Obstetric Atlases." *Art Bulletin* 87, no. 1 (2005): 73–91.

Maubray, John. *The Female Physician, Containing All the Diseases Incident to That Sex, in Virgins, Wives and Widows.* London: James Holland, 1724.

Mauriceau, François. *Des maladies des femmes grosses et accouchées.* Paris: Jean Henault, Jean D'Houry, Robert de Ninville and Jean Baptiste Coginard, 1668.

———. *The Diseases of Women with Child, and in Child-Bed.* Trans. Hugh Chamberlen. London: Printed by John Darby, 1672.

———. *Observations sur la grossesse et l'accouchement des femmes, et sur leurs maladies et celles des enfans nouveaux-nez, etc.* Paris: n.p., 1694.

Maus, Katharine Eisaman. "A Womb of His Own: Male Renaissance Poets in the Female Body." In *Printing and Parenting in Early Modern England*, ed. Douglas Brooks, 89–108. Farnham, UK: Ashgate, 2005.

Maygrier, Jacques-Pierre. *Nouvelles demonstrations d'accouchemens, avec des planches en taille-douce, accompagnées d'un texte raisonné, proper à en faciliter l'explication, format in-folio.* Paris: Béchet, 1822.

McClive, Cathy. "The Hidden Truths of the Belly: The Uncertainties of Pregnancy in Early Modern Europe." *Social History of Medicine* 15, no. 2 (2002): 209–27.

———. *Menstruation and Procreation in Early Modern France.* Farnham, UK: Ashgate, 2015.

McCormack, Helen. "The Great Windmill Street Anatomy School and Museum." In *William Hunter's World: The Art and Science of Eighteenth-Century Collecting*, ed. E. Geoffrey Hancock, Nick Pearce, and Mungo Campbell, 13–28. Farnham, UK: Ashgate, 2015.

McDonald, Stewart W., and John W. Faithfull. "William Hunter's Sources of Pathological and Anatomical Specimens, with Particular Reference to Obstetric Subjects." In *William Hunter's World: The Art and Science of Eighteenth-Century Collecting*, ed. E. Geoffrey Hancock, Nick Pearce, and Mungo Campbell, 45–58. Farnham, UK: Ashgate, 2015.

McGrath, Roberta. *Seeing Her Sex: Medical Archives and the Female Body.* Manchester, UK: Manchester University Press, 2002.

McIntosh, Tania. "Profession, Skill or Domestic Duty? Midwifery in Sheffield, 1881–1936." *Social History of Medicine* 11, no. 3 (1998): 403–20.

McMath, James. *The Expert Mid-Wife: A Treatise of the Diseases of Women with Child, and in Child-Bed*. Edinburgh: George Mosman, 1694.

McTavish, Lianne. "Blame and Vindication in the Early Modern Birthing Chamber." *Medical History* 50 (2006): 447–64.

———. *Childbirth and the Display of Authority in Early Modern France*. Aldershot, UK: Ashgate, 2005.

———. "Concealing Spectacles: Childbirth and Visuality in Early Modern France." In *Editing the Image: Strategies in the Production and Reception of the Visual*, ed. Mark A. Cheetham, Elizabeth Legge, and Catherine M. Soussloff, 95–110. Toronto: University of Toronto Press, 2008.

———. "Practices of Looking and the Medical Humanities: Imagining the Unborn in France, 1550–1800." *Journal of Medical Humanities* 31 (2010): 11–26.

Mears, Martha. *The Pupil of Nature: Or Candid Advice to the Fair Sex, on the Subject of Pregnancy; Childbirth; the Diseases Incident to Both; the Fatal Effects of Ignorance and Quackery; and the Most Approved Means of Promoting the Health, Strength, and Beauty of Their Offspring, by Martha Mears, Practitioner in Midwifery*. London: The Author, 1797.

Melion, Walter S. "Meditative Images and the Portrayal of Image-Based Meditation." In *Ut Pictura Meditatio: The Meditative Image in Northern Art, 1500–1700*, ed. Melion, Ralph Dekoninck, and Agnes Guiderdoni-Bruslé, 1–60. Turnhout: Brepols, 2012.

Monteyne, Joseph. *The Printed Image in Early Modern London: Urban Space, Visual Representation and Social Exchange*. Aldershot, UK: Ashgate, 2007.

Moore, Rosemary. "Paper Cuts: The Early Modern Fugitive Print." *Object* 17 (2015): 54–76.

Morel, Marie-France. "Voir et entendre les foetus autrefois: Deux exemples." *Spirale* 36 (2005): 23–35.

Moscucci, Ornella. *The Science of Woman: Gynaecology and Gender in England, 1800–1929*. Cambridge: Cambridge University Press, 1990.

Mount, Harry. "Van Rymsdyk and the Nature-Menders: An Early Victim of the Two Cultures Divide." *British Journal for Eighteenth-Century Studies* 29 (2006): 79–96.

Murphy, Edward W. "Introductory Lecture on the History of Midwifery. Delivered at University College, May 1st, 1864. By Edward W. Murphy, M.A., M.D., Professor of Midwifery." *British Medical Journal* 176, no. 1 (1864): 523–28.

Muryn, Wiktoria. "Transparent Wombs, Holy (Mis)Conceptions: Representations of 'Foetus-Type' Visitation and Women's Monasticism in Late Medieval Germany." Glasgow, 2020.

Musacchio, Jacqueline Marie. *The Art and Ritual of Childbirth in Renaissance Italy*. New Haven: Yale University Press, 1999.

Newman, Karen. *Fetal Positions: Individualism, Science, Visuality*. Stanford: Stanford University Press, 1996.

Newman, William. *Promethean Ambitions: Alchemy and the Quest to Perfect Nature*. Chicago: University of Chicago Press, 2004.

Newton, Hannah. "'Nature Concocts and Expels': The Agents and Processes of Recovery from Disease in Early Modern England." *Social History of Medicine* 28, no. 3 (2015): 465–86.

[Nicholls, Frank]. *The Petition of the Unborn Babes to the Censors of the Royal College of Physicians of London*. London: M. Cooper, 1751.

Nickelsen, Kärin. *Draughtsmen, Botanists and Nature: The Construction of Eighteenth-Century Botanical Illustrations*. Dordrecht: Springer, 2006.

Niekrasz, Carmen, and Claudia Swan. "Art." In *The Cambridge History of Science: Early Modern Science*, ed. Katharine Park and Lorraine Daston, 3: 773–96. Cambridge: Cambridge University Press, 2006.

Nihell, Elizabeth. *A Treatise on the Art of Midwifery: Setting Forth Various Abuses Therein, Especially as to the Practice with Instruments*. London: A. Morley, 1760.

Nummedal, Tara E. "Alchemical Reproduction and the Career of Anna Maria Zieglerin." *Ambix* 48, no. 2 (2001): 56–68.

Nuttall, Alison. "Midwifery, 1800–1920: The Journey to Registration." In *Nursing and Midwifery in Britain since 1700*, ed. Anne Borsay and Billie Hunter, 128–50. Basingstoke: Palgrave Macmillan, 2012.

Ogilvie, Brian W. *The Science of Describing: Natural History in Renaissance Europe*. Chicago: University of Chicago Press, 2006.

Oliver, John. *A Present for Teeming Women: Or, Scripture-Directions for Women with Child, How to Prepare for the Houre of Travel*. London: Mary Rothwell, 1663.

Oosterwijk, Sophie. "Adult Appearances? The Representation of Children and Childhood in Medieval Art." In *The Oxford Handbook of the Archaeology of Childhood*, ed. Sally Crawford, Dawn M. Hadley, and Gillian Shepherd, 590–607. Oxford: Oxford University Press, 2018.

Ould, Fielding. *A Treatise of Midwifery, in Three Parts*. Dublin: Oli. Nelson and Charles Connor, 1742.

Outram, Dorinda. *The Enlightenment*. Cambridge: Cambridge University Press, 2013.

Palmer, Megan E. "Picturing Song across Species: Broadside Ballads in Image and Word." *Huntington Library Quarterly* 79, no. 2 (2016): 221–44.

Paré, Ambroise. *Deux livres de chirurgie*. Paris: André Wechel, 1573.

———. *The Workes of That Famous Chirurgion Ambrose Parey*. Trans. Th. Johnson. London: Th. Cotes and R. Young, 1634.

Park, Katharine. "Impressed Images: Reproducing Wonders." In *Picturing Science, Producing Art*, ed. Caroline A. Jones and Peter Galison, 254–71. New York: Routledge, 1998.

———. *Secrets of Women: Gender, Generation, and the Origins of Human Dissection*. New York: Zone Books, 2010.

Parshall, Peter. "Imago Contrafacta: Images and Facts in the Northern Renaissance." *Art History* 16, no. 4 (1993): 554–79.

Petchesky, Rosalind Pollack. "Fetal Images: The Power of Visual Culture in the Politics of Reproduction." *Feminist Studies* 13, no. 2 (1987): 263–92.

Peu, Philippe. *Réponse de Mr Peu aux observations particulieres de Mr Mauriceau sur la grossesse et l'accouchement des femmes*. Paris: Jean Boudot, 1694.

Pilloud, Séverine, and Micheline Louis-Courvoisier. "The Intimate Experience of the Body in the Eighteenth Century: Between Interiority and Exteriority." *Medical History* 47 (2003): 451–72.

Pomata, Gianna. "Observation Rising: Birth of an Epistemic Genre, 1500–1650." In *Histories of Scientific Observation*, ed. Lorraine Daston and Elizabeth Lunbeck, 45–80. Chicago: University of Chicago Press, 2011.

———. "Sharing Cases: The Observationes in Early Modern Medicine." *Early Science and Medicine* 15 (2010): 193–236.

Porter, Roy, ed. *The Cambridge History of Science*, vol. 4: *Eighteenth-Century Science*. Cambridge: Cambridge University Press, 2003.

———. "The Patient's View: Doing Medical History from Below." *Theory and Society* 14, no. 2 (1985): 175–98.

———. "The Rise of Physical Examination." In *Medicine and the Five Senses*, ed. W. F. Bynum and Roy Porter, 179–97. Cambridge: Cambridge University Press, 1993.

———. "A Touch of Danger: The Man-Midwife as Sexual Predator." In *Sexual Underworlds of the Enlightenment*, ed. G. S. Rousseau and Roy Porter, 206–32. Manchester: Manchester University Press, 1987.

———. "William Hunter: A Surgeon and a Gentleman." In *William Hunter and the Eighteenth-Century Medical World*, ed. W. F. Bynum and Roy Porter, 7–34. Cambridge: Cambridge University Press, 1985.

Postle, Martin. "Flayed for Art: The Écorché Figure in the English Art Academy." *British Art Journal* 5, no. 1 (2004): 55–63.

Punt, Hendrik. *Bernard Siegfried Albinus (1687–1770): On "Human Nature," Anatomical and Physiological Ideas in Eighteenth Century Leiden*. Amsterdam: Israël, 1983.

Rampling, Jennifer. "A Secret Language: The Ripley Scrolls." In *Art and Alchemy: The Mystery of Transformation*, ed. Dedo von Kerssenbrock-Krosigk, Beat Wismer, and Sven Dupré, trans. Susanna Rachel Michael, 38–45. Düsseldorf: Stiftung Museum Kunstpalast, 2014.

Raphael, Renée. "Teaching through Diagrams: Galileo's Dialogo and Discorsi and His Pisan Readers." In *Observing the World through Images: Diagrams and Figures in the Early-Modern Arts and Sciences*, ed. Isla Fay and Nicholas Jardine, 201–30. Leiden: Brill, 2014.

Read, Sara. *Menstruation and the Female Body in Early Modern England*. Basingstoke, UK: Palgrave Macmillan, 2013.

Reill, Peter Hanns. "The Legacy of the 'Scientific Revolution.'" In *The Cambridge History of Science: Eighteenth-Century Science*, ed. Roy Porter, 21–43. Cambridge: Cambridge University Press, 2003.

Reinke-Williams, Tim. *Women, Work and Sociability in Early Modern London*. Basingstoke, UK: Palgrave Macmillan, 2014.

Retford, Kate. *The Art of Domestic Life: Family Portraiture in Eighteenth-Century England*. New Haven: Yale University Press, 2006.

Richards, Jennifer. "Reading and Hearing The Womans Booke in Early Modern England." *Bulletin of the History of Medicine* 89 (2015): 434–62.

Riskin, Jessica. "Medical Knowledge: The Adventures of Mr. Machine, with Morals." In *A Cultural History of the Human Body in the Age of Enlightenment*, ed. Carole Reeves, 73–91. Oxford: Berg, 2010.

———. *The Restless Clock: A History of the Centuries-Long Argument over What Makes Living Things Tick*. Chicago: University of Chicago Press, 2016.

Roberts, K. B., and J. D. W. Tomlinson. *The Fabric of the Body: European Traditions of Anatomical Illustration*. Oxford: Clarendon Press, 1992.

Roberts, Sean. "Tricks of the Trade: The Technical Secrets of Early Engraving." In *Visual Cultures of Secrecy in Early Modern Europe*, ed. Timothy McCall, Sean

Roberts, and Giancarlo Fiorenza, 182–207. Kirksville, MO: Truman State University Press, 2013.

Roger, Jacques. *The Life Sciences in Eighteenth-Century French Thought*. Ed. Keith R. Benson. Trans. Robert Ellrich. Stanford: Stanford University Press, 1997.

Roodenburg, Herman, ed. *A Cultural History of the Senses in the Renaissance*. London: Bloomsbury, 2014.

Rosenthal, Angela. "Visceral Culture: Blushing and the Legibility of Whiteness in Eighteenth-Century British Portraiture." *Art History* 27, no. 4 (2004): 563–92.

Rösslin, Eucharius. *The Byrth of Mankynde: Newly Translated out of Laten into Englysshe: In the Which Is Entreated of All Suche Thynges the Which Chaunce to Women in Theyr Labor, and All Suche Infyrmitees Whiche Happen Unto the Infantes After They Be Delyvered*. Trans. Richard Jonas. London: Thomas Raynalde, 1540.

———. *The Byrth of Mankynde: Otherwyse Named the Womans Booke. Newly Set Furth, Corrected and Augmented*. Ed. Thomas Raynalde. London: Thomas Raynalde, 1545.

———. *Der Swangern Frawen und Hebammen Roszengarten*. Strasbourg and Hagenau: n.p., 1513.

Rösslin, Eucharius, and Thomas Raynalde. *The Birth of Mankind: Otherwise Named, the Woman's Book*. Ed. Elaine Hobby. Farnham, UK: Ashgate, 2009.

Rowe, Katherine. "'God's Handy Worke.'" In *The Body in Parts: Fantasies of Corporeality in Early Modern Europe*, ed. David Hillman and Carla Mazzio, 285–309. New York: Routledge, 1997.

Rubiés, Joan-Pau. "Were Early Modern Europeans Racist?" In *Ideas of "Race" in the History of the Humanities*, ed. Amos Morris-Reich and Dirk Rupnow, 33–87. Cham: Palgrave Macmillan, 2017.

Rublack, Ulinka. "Fluxes: The Early Modern Body and the Emotions." *History Workshop Journal* 53, no. 1 (2002): 1–16.

———. "Pregnancy, Childbirth and the Female Body in Early Modern Germany." *Past & Present* 150 (1996): 84–110.

Rüff, Jakob. *De Conceptu et Generatione Hominis et Iis Quae circa h[a]ec Potissimum Consyderantur, Libri Sex Congesti Opera Iacobi Rueff Chirurgi Tigurini*. Zurich: Christophorus Froschhoverus, 1554.

———. *The Expert Midwife or an Excellent and Most Necessary Treatise on the Generation and Birth of Man*. London: E.G., 1637.

———. *Ein Schön Lustig Trostbüchle von Den Empfengknussen Und Geburten Der Menschen*. Zurich: Christophorus Froschhoverus, 1554.

Rughalm, Benedictus. "Liber Quodlibetarius." Nüremberg, 1524. UER MS.B 200. Universitätsbibliothek Erlangen-Nürnberg.

Rutkin, H. Darrel. "Astrology." In *The Cambridge History of Science: Early Modern Science*, ed. Katharine Park and Lorraine Daston, 3: 541–61. Cambridge: Cambridge University Press, 2006.

San Juan, Rose Marie. *Vertiginous Mirrors: The Animation of the Visual Image and Early Modern Travel*. Manchester, UK: Manchester University Press, 2011.

Sarafianos, Aris. "George Stubbs's Dissection of the Horse and the Expressiveness of 'Facsimiles.'" In *Liberating Medicine, 1720–1835*, ed. Tristanne Connolly and Steve Clark. London: Pickering & Chatto, 2009.

Saumarez Smith, Charles. *The Company of Artists: The Origins of the Royal Academy of Arts in London*. London: Modern Art Press, 2012.

Sawday, Jonathan. *The Body Emblazoned: Dissection and the Human Body in Renaissance Culture*. London: Routledge, 1995.

Schiebinger, Londa. *The Mind Has No Sex? Women in the Origins of Modern Science*. Cambridge, MA: Harvard University Press, 1989.

———. "Women of Natural Knowledge." In *The Cambridge History of Science: Early Modern Science*, ed. Katharine Park and Lorraine Daston, 3: 192–205. Cambridge: Cambridge University Press, 2006.

Schupbach, William. "The Paradox of Rembrandt's 'Anatomy of Dr. Tulp.'" *Medical History*, supplement no. 2 (1982): 1–110.

Sermon, William. *The Ladies Companion, or the English Midwife*. London: Edward Thomas, 1671.

Shapin, Steven. *Never Pure: Historical Studies of Science As If It Was Produced by People with Bodies, Situated in Time, Space, Culture, and Society, and Struggling for Credibility and Authority*. Baltimore: Johns Hopkins University Press, 2010.

———. *A Social History of Truth*. Chicago: University of Chicago Press, 1994.

Sharp, Jane. *The Midwives Book: Or the Whole Art of Midwifry Discovered*. London: Simon Miller, 1671.

Sheriff, Mary D. *Moved by Love: Inspired Artists and Deviant Women in Eighteenth-Century France*. Chicago: University of Chicago Press, 2004.

Sherman, William H. *Used Books: Marking Readings in Renaissance England*. Philadelphia: University of Pennsylvania Press, 2008.

Shorter, Edward. "The Management of Normal Deliveries and the Generation of William Hunter." In *William Hunter and the Eighteenth-Century Medical World*, ed. W. F. Bynum and Roy Porter, 371–83. Cambridge: Cambridge University Press, 1985.

Siegemund, Justine. *The Court Midwife*. Ed. and trans. Lynne Tatlock. Chicago: University of Chicago Press, 2005.

Skemer, Don C. *Binding Words: Textual Amulets in the Middle Ages*. University Park: Pennsylvania State University Press, 2006.

Smellie, William. *A Collection of Cases and Observations in Midwifery*. 3 vols. Vol. 2. London: D. Wilson, 1754.

———. *A Collection of Preternatural Cases and Observations in Midwifery*. 3 vols. Vol. 3. London: D. Wilson and T. Durham, 1764.

———. *A Sett of Anatomical Tables, with Explanations, and an Abridgment, of the Practice of Midwifery, with a View to Illustrate a Treatise on That Subject, and Collection of Cases*. London: n.p., 1754.

———. *A Treatise on the Theory and Practice of Midwifery*. 3 vols. Vol. 1. London: D. Wilson, 1752.

Smith, Pamela H. *The Body of the Artisan: Art and Experience in the Scientific Revolution*. Chicago: University of Chicago Press, 2004.

[Smollett, Tobias]. "Art. IV. A Treatise on the Art of Midwifery." *The Critical Review, or, Annals of Literature* 9 (March 1760): 187–97.

Sommers, Sheena. "Transcending the Sexed Body: Reason, Sympathy, and 'Thinking Machines' in the Debates over Male Midwifery." In *The Female Body in Medicine and Literature*, ed. Andrew Mangham and Greta Depledge, 8–106. Liverpool: Liverpool University Press, 2011.

Speert, Harold. *Obstetrics and Gynecology: A History and Iconography*. San Francisco: Norman, 1994.

Spinks, Jennifer. "Jakob Rueff's 1554 Trostbüchle: A Zurich Physician Explains and Interprets Monstrous Births." *Intellectual History Review* 18, no. 1 (2008): 41–59.

Staub, Susan C. "Surveilling the Secrets of the Female Body: The Context for Reproductive Authority in the Popular Press of the Seventeenth Century." In *The Female Body in Medicine and Literature*, ed. Andrew Mangham and Greta Depledge, 51–68. Liverpool: Liverpool University Press, 2011.

Staubli, Thomas, ed. *Werbung für die Götter: Heilsbringer aus 4000 Jahren*. Freiburg: Universitätsverlag, 2003.

Stephen, Margaret. *Domestic Midwife: Or, the Best Means of Preventing Danger in Child-Birth*. London: S. W. Fores, 1795.

Sterne, Laurence. *The Life and Opinions of Tristram Shandy, Gentleman*. Ed. Ian Campbell Ross. Oxford: Oxford University Press, 2009.

Steward, James Christen. *The New Child: British Art and the Origins of Modern Childhood, 1730–1830*. Berkeley: University Art Museum and Pacific Film Archive, University of California, 1995.

Stoichita, Victor I. *Darker Shades: The Racial Other in Early Modern Art*. Trans. Samuel Trainor. London: Reaktion Books, 2019.

Stokes, Patricia R. "Pathology, Danger, and Power: Women's and Physicians' Views of Pregnancy and Childbirth in Weimar Germany." *Social History of Medicine* 13, no. 3 (2000): 359–80.

Stolberg, Michael. "Examining the Body, c. 1500–1750." In *The Routledge History of Sex and the Body*, ed. Sarah Toulalan and Kate Fisher, 91–105. Abingdon, UK: Routledge, 2013.

———. *Experiencing Illness and the Sick Body in Early Modern Europe*. Trans. Leonhard Unglaub and Logan Kennedy. Basingstoke, UK: Palgrave Macmillan, 2011.

———. *Uroscopy in Early Modern Europe*. Farnham, UK: Ashgate, 2015.

Stone, Sarah. *A Complete Practice of Midwifery: Consisting of Upwards of Forty Cases or Observations in That Valuable Art, Selected from Many Others, in the Course of a Very Extensive Practice*. London: T. Cooper, 1737.

Stubbs, George. *The Anatomy of the Horse: Including a Particular Description of the Bones, Cartilages, Muscles, Fascias, Ligaments, Nerves, Arteries, Veins and Glands; in Eighteen Tables, All Done from Nature, by George Stubbs, Painter*. London: The Author, 1766.

Summers, Anne. "The Mysterious Demise of Sarah Gamp: The Domiciliary Nurse and Her Detractors, c. 1830–1860." *Victorian Studies* 32, no. 3 (1989): 365–86.

Tanner, Jeremy. "Michael Baxandall and the Sociological Interpretation of Art." *Cultural Sociology* 4, no. 2 (2010): 231–56.

Tatlock, Lynne. "Volume Editor's Introduction." In *The Court Midwife*, ed. Tatlock, 1–26. Chicago: University of Chicago Press, 2005.

Taylor, Basil. *The Prints of George Stubbs*. London: Paul Mellon Foundation for British Art, 1969.

Taylor, Katie. "Reconstructing Vernacular Mathematics: The Case of Thomas Hood's Sector." In *Observing the World through Images: Diagrams and Figures in the Early-Modern Arts and Sciences*, ed. Isla Fay and Nicholas Jardine, 153–79. Leiden: Brill, 2014.

Thauvette, Chantelle. "Sexual Education and Erotica in the Popular Midwifery Manuals of Thomas Raynalde and Nicholas Culpeper." In *Eroticism in the Middle Ages and the Renaissance: Magic, Marriage, and Midwifery*, ed. Ian Frederick Moulton, 151–69. Turnhout: Brepols, 2016.

[Thicknesse, Philip]. *Man-Midwifery Analysed: And the Tendency of That Practice Detected and Exposed*. London: R. Davis, 1764.

Thomas, Keith. *Religion and the Decline of Magic: Studies in Popular Beliefs in Sixteenth- and Seventeenth-Century England*. London: Penguin Books, 1991.

Thomson, Ann. "Mechanistic Materialism vs Vitalistic Materialism?" *La Lettre de La Maison Française d'Oxford* 14 (2001): 21–36.

Thornton, Alice. *The Autobiography of Mrs. Alice Thornton, of East Newton, Co. York*. Durham: Surtees Society, 1875.

Tucker, Holly. *Pregnant Fictions: Childbirth and the Fairy Tale in Early-Modern France*. Detroit: Wayne State University Press, 2003.

Turner, Daniel. *De Morbis Cutaneis: A Treatise of Diseases Incident to the Skin*. London: R. Bonwicke et. al., 1714.

Turner, G. L'E. "Eighteenth-Century Scientific Instruments and Their Makers." In *The Cambridge History of Science: Eighteenth-Century Science*, ed. Roy Porter, 509–35. Cambridge: Cambridge University Press, 2003.

Ulrich, Laurel Thatcher. *A Midwife's Tale: The Life of Martha Ballard, Based on Her Diary, 1785–1812*. New York: Vintage Books, 1991.

Vauchez, André, ed. "Mandorla." In *Encyclopedia of the Middle Ages*. Cambridge: James Clarke, 2005.

Viardel, Cosme. *Observations sur la pratique des accouchemens naturels contre nature et monstrueux*. Paris: The Author, 1671.

Vincent, Susan. *Dressing the Elite: Clothes in Early Modern England*. Oxford: Berg, 2003.

Walsh, Katharine Phelps. "Marketing Midwives in Seventeenth-Century London: A Re-examination of Jane Sharp's The Midwives Book." *Gender & History* 26, no. 72 (2014): 223–41.

Walsham, Alexandra. *Providence in Early Modern England*. Oxford: Oxford University Press, 1999.

Walter, John. "Gesturing at Authority: Deciphering the Gestural Code of Early Modern England." *Past & Present* 4 (2009): 96–127.

Watt, Tessa. *Cheap Print and Popular Piety, 1550–1640*. Cambridge: Cambridge University Press, 1991.

Wellmann, Janina. *The Form of Becoming: Embryology and the Epistemology of Rhythm, 1760–1830*. Trans. Kate Sturge. New York: Zone Books, 2017.

Wells-Cole, Anthony. *Art and Decoration in Elizabethan and Jacobean England: The Influence of Continental Prints, 1558–1625*. New Haven: Yale University Press, 1997.

Werrett, Simon. "The Sociomateriality of Waste and Scrap Paper in Eighteenth-Century England." In *Working with Paper: Gendered Practices in the History of Knowledge*, ed. Carla Bittel, Elaine Leong, and Christine von Oertzen, 46–59. Pittsburgh: University of Pittsburgh Press, 2019.

Whiteley, Rebecca. "The Limits of Seeing and Knowing: Early Modern Anatomy and the Uterine Membranes." *Object* 19 (2017): 95–119.

———. "Prayer, Pregnancy and Print." In *Religion and Life Cycles in Early Modern England*, ed. Caroline Bowden, Emily Vine, and Tessa Whitehouse, 38–62. Manchester, UK: Manchester University Press, 2021.

Wilkens, Katharina. "Drinking the Quran, Swallowing the Madonna: Embodied Aesthetics of Popular Healing Practices." In *Alternative Voices: A Plurality Approach for Religious Studies. Essays in Honor of Ulrich Berner*, ed. Afe Adogame, Magnus Echtler, and Oliver Freiberger, 243–59. Göttingen: Vandenhoeck & Ruprecht, 2013.

Wilkin, Rebecca M. "Essaying the Mechanical Hypothesis: Descartes, La Forge, and Malebranche on the Formation of Birthmarks." *Early Science and Medicine* 13, no. 6 (2008): 533–67.

Willughby, Percival. *Observations in Midwifery*. Ed. Henry Blenkinsop. Wakefield, UK: S. R. Publishers, 1972.

Wilson, Adrian. *The Making of Man-Midwifery: Childbirth in England, 1660–1770*. London: UCL Press, 1995.

———. "A Memorial of Eleanor Willughby, a Seventeenth-Century Midwife." In *Women, Science and Medicine, 1500–1700*, ed. Lynette Hunter and Sarah Hutton, 138–77. Stroud, UK: Sutton, 1997.

———. *Ritual and Conflict: The Social Relations of Childbirth in Early Modern England*. Farnham, UK: Ashgate, 2013.

Wolfe, Charles T., and Ofer Gal, eds. *The Body as Object and Instrument of Knowledge: Embodied Empiricism in Early Modern Science*. Dordrecht: Springer, 2010.

[Wolveridge, James]. *The English Midwife Enlarged: Containing Directions to Midwives*. London: Rowland Reynold, 1682.

Wolveridge, James. *Speculum Matricis: Or, the Expert Midwives Handmaid*. London: n.p., 1671.

Woods, Robert, and Chris Galley. *Mrs Stone & Dr Smellie: Eighteenth-Century Midwives and Their Patients*. Liverpool: Liverpool University Press, 2014.

Wouk, Edward H. "Toward an Anthropology of Print." In *Prints in Translation, 1450–1750: Image, Materiality, Space*, ed. Suzanne Karr Schmidt and Edward H. Wouk, 1–18. London: Routledge, 2017.

Wragge-Morley, Alexander. *Aesthetic Science: Representing Nature in the Royal Society of London, 1650–1720*. Chicago: University of Chicago Press, 2020.

Zorach, Rebecca. "'A Secret Kind of Charm Not to Be Expressed or Discerned': On Claude Mellan's Insinuating Lines." *RES: Anthropology and Aesthetics* 55/56 (2009): 235–51.

Index